ROBERT BRAIN

Art and Society in Africa

KU-250-231

LONGMAN

Longman Group Limited
London and New York

Associated companies, branches and
representatives throughout the world

© Robert Brain 1980

All rights reserved. No part of this
publication may be reproduced, stored
in a retrieval system, or transmitted
in any form or by any means, electronic,
mechanical, photocopying, recording, or
otherwise, without the prior permission
of the Copyright owner.

First published 1980

ISBN 0 582 64578 6 (cased)
ISBN 0 582 64579 4 (paper)

709.96
BRA

24937

Printed in Hong Kong by
Sheck Wah Tong Printing Press Ltd

CONTENTS

ACKNOWLEDGEMENTS

The publishers wish to acknowledge particularly the invaluable help given in illustrating this book by the following individuals:

David Attenborough; Marie Louise Bastin; Mrs. R. J. Bradbury; the author; Father Kevin Carroll; Pat Carter; Bernard Fagg; Perkins and Susan Foss; Pierre Harter; John Hutchings; G. I. Jones; Malcolm McLeod; Peter Morton-Williams; Klaus Paysan; John and Susan Picton; Adam Pollock; Audrey Richards; Marc Schiltz; Philip Stevens; Phillips Stevens Jr.; Doig Simmonds; Joan Wescott; Frank Willett;

and by the following institutions:

Agence Hoa Qui; Alan Hutchison Library; Frobenius Institut, Frankfurt; Hamlyn Group; Museu do Dundo duanda, Angola; Musée de l'Homme, Paris; Museum of Mankind, British Museum, London; Musée Royal de l'Afrique Central, Tervuren, Belgium; Nigerian Federal Department of Antiquities; Peabody Museum, Harvard University; University Museum of Archaeology and Ethnology, Cambridge; Wallace Collection; Werner Forman Archive.

The cover photograph is by David Attenborough and shows masqueraders of the Dogon, Mali. All the line drawings were drawn by Adam Pollock.

LIST OF PLATES

LIST OF FIGURES

Each community
has own style of
art each
village

also different
jobs etc. fisherman
hunters, farmers
cattle Herders
all to do with
same ideas
but different ways.

INTRODUCTION

The simple aim of this book is to put African art firmly in its social context. Art in Africa has always been very much a part of the people's life, manifest in every aspect of their working, playing and believing worlds; yet almost every general survey by art historian or ethnologist has been primarily devoted to the aesthetic appeal of the work of art or the peculiarities of its style and form. Through the detailed material provided by anthropologists I wish to explore the socio-aesthetic connection as carefully as possible, presenting sculpture and other art forms in their political, economic, social and religious context. The approach is a practical one, involving no great artistic insight or sensitivity on the part of the author. The words 'mystery', 'awe', 'serenity', 'vigour', 'calm', 'beseeching' find no place in this book, although I do not deny that subjective and aesthetic explanations also have their value. Writers about the arts of the West not only describe the formal qualities of a painting or a sculpture but pay heed to the date and place of composition, the patron, the purpose and meaning of the artist. Moreover, in Europe much art represents symbols which are immediately meaningful to the ordinary educated person—symbols of the life of Christ, the saints, historical episodes. Students of African art forget that knowledge of this kind—even if not formally expressed —plays a vital part in our appreciation of works of art.

It is therefore a strange fact that many writers and art historians, when they come to 'primitive art', imagine that it is possible to appreciate it without any knowledge of the social background and the world of ideas which they reflect. The magic of African art 'disappears under analysis', they say. 'The sensitive and thoughtful alien can as readily as the maker observe the essential conditions of the work's quality as an object of art.' It may be true that great art has an immediate impact on the observer whatever its cultural background. My own view, however, is that no amount of socio-logical analysis can harm a 'serious' work of art and the best kind of explanation can only extend our appreciation and under-standing. Unless a mask or a statue is going to appeal to us for very

basic reasons—because it is mysterious or sexually exciting—we must find out if it was made to entertain, to frighten, to promote fertility, kill witches or merely 'be beautiful'. I have seen male figures with swollen bellies described as pregnant hermaphrodites when investigation shows that they are fetishes depicting a victim of dropsy. Statues with their arms in the air have been said to be ancestors praying to the Sky God when the society has no ancestor cult and believes in an Earth Goddess, and the sky is the abode of witches. While it is clearly possible to enjoy an *objet trouvé* in a museum it must increase our enjoyment to find out what the artist's purpose was. Is he portraying a chief, a god, a slave, an animal? How is the mask to be worn or the statue to be viewed? Is the mask smiling or grimacing? Moreover, the stylisation of African masks is often so extreme that without instruction it is difficult to understand the meaning unless we become intimate with the social and symbolic systems. At the same time it must be admitted that a cultural explanation may not provide even half of the answers. There is rarely a neat fit between social function and symbolism. Masks may perform multiple functions, changing their rank and meaning according to situation—one mask may entertain, frighten or promote fertility according to the social context.

Art in Africa, therefore, fulfils a multitude of functions. It may be a symbol of status and prestige, a means of acquiring and maintaining political power, a stimulus to farming or trading, a piece of entertainment. African art has never been merely 'religious'. 'Nearly all traditional African statuary, no matter in what media, is magico-religious.' Art for art's sake implies that the artist produces an object which is valued for itself, which attempts neither to edify or to induce religious awe; and although the final object will have a social function, many African works of art have no overtly social or magical purpose; as in Europe they may be made by artists concerned with the solution of artistic problems alone. At this level a functional analysis, such as this one, cannot 'explain' works of art. In presenting art as an integral element of economic, social or political institution, I remain aware that the prime element must be the aesthetic in the final analysis. At the same time I have been forced to keep aesthetic appreciation to the minimum not only because I am not equipped for such a task but because the field has been covered well and often by others. I shall not discourse on the 'concave' and the 'heartshape' in the mask, exponential curves, 'pole sculpture' or African rococo. This book will deal summarily,

or not at all, with problems of diffusion, provenance dating, style areas, period. Techniques, materials, structure, physical properties, detailed analyses of iconography have been neglected in favour of detailed social explanation.

Because of the need to provide as much background material as possible, this book is by no means a survey and the selection I have made has been determined primarily by the material available. As far as possible I have used ethnography which is complete but often difficult of access to the ordinary student of African art—material tucked away in learned journals, out-of-print studies, works in French and German. Sadly most accounts— Dogon, Bambara, Ekoi, Bamileke art—are primarily historical ones and if I sometimes use the ethnographic present it is purely for convenience and for the sake of immediacy in presentation. The collapse of traditional art in the past fifty to a hundred years means that the amount of really detailed ethnography is very limited.

Economic and social change has caused a real break in cultural continuity in Africa. There has been a steady conversion to Christianity and Islam. Few villages lack a mosque or a church and only in rare cases does the old religion flourish as before. More importantly, all over Africa the artist has been forced to turn away from his traditional preoccupations and carve for a new world, more and more frequently a world of tourists. The reasons are economic, rather than 'religious'. The farmer and his wife and children no longer have time to attend long rites, since modern conditions demand that he works to pay taxes and that his children go to school. Ceremonies involving the great African masks often went on for months—nowadays if they exist they last only a few days and items which need elaborate preparation (such as art objects) may be omitted. Figures are roughly made and the rites scarcely remembered. More seriously, the artist has stopped working in his traditional way; he too has to pay taxes and fulfil labour obligations and has no time or money to pay attention to the finer points of his work. Whatever may happen to the new African art, the traditional one is gone for ever. As villagers are forced into a cash and market economy and learn new ideas, the values behind the cult associations and masked dances disappear. Metaphysical beliefs are not passed on and masks are not made. The forces of modern western society have had their effect upon African art as they have upon most other aspects of traditional culture.

'Classical' African art

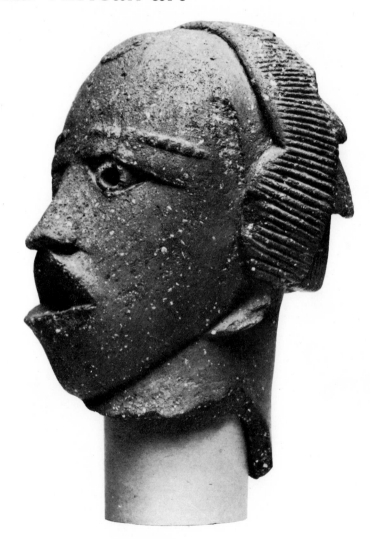

I have written that this book is an 'historical' study in so far as the social world to which the masks and statues belong has disappeared or is fast disappearing. Nevertheless, apart from this initial chapter, I shall be dealing with art and culture which until recent years was very much alive and was observed more or less in a flourishing state by ethnographers and art historians. In this section, however, I wish to present, very briefly, some bronze, stone and wooden sculptures which really belong to an unknown past, which have no continuing traditions to explain them, no literature to place them in an historical context (see, however, Benin, p. 15). A book on African art, whatever its declared limitations, cannot ignore these masterpieces—masterpieces which I have conveniently labelled 'classical'.

'Classical' is a hugely convenient term which has several meanings in general use. Here I use it to refer to art objects, the origins of which are lost in the past; masks and statues which are so well known and universally accepted as *chefs d'oeuvre* that they need no introduction in a new book; as well as 'classical' works of art which have an immediately universal appeal, like the Baoule and Ife heads, which like Greek art appeals through the beauty—or rather idealisation—of the physical features. I realise that my use of the term 'classical' is idiosyncratic, enabling me to include hackneyed art forms, pieces known only from archaeology and a kind of art which is the portrayal of ideal human types without the emotional and expressive elements usually associated with African art. These various meanings of 'classical' are convenient labels from my point of view since it enables me to leave to archaeologists and art historians the detailed study and description of art works about which we know too little or have read too much. Margaret Trowell, indeed, has simply attributed the epithet 'classical' to all African art which is worthy of a place among other great arts of the world.

African art as 'antiquities'—and little else—may still be found in Western museums, unlabelled and forgotten. Over the past four hundred years explorers, missionaries and traders have collected

1.1 Terracotta head, Nok culture, found in the course of tin-mining near Jemaa in Northern Nigeria, 1943 (see page 4).

curiosities or art objects which have impressed them in some way, never, however, bothering to note down information about them. These works of art must remain *objets trouvés* since we are often uncertain even of their provenance; they remain in their glass cases, labelled as 'fetish objects', 'sacred masks', 'juju figures', 'fertility statuettes' and all the art historian or anthropologist can do is to try to link them, through their physical similarities, to known collections of art. The same ignorance, however, applies to great art styles and forms which have become 'antiquities' only in the last half century. In modern surveys of famous sculptures—Fang statuary is an example—the student or the compiler is mostly reduced to 'It seems to have been . . .' or 'It is likely that . . .' Often we know more about archaeologists' discoveries than about a group of masks which have fallen into disuse only in this century.

Nok

The earliest and best known African sculptural tradition is found in West Africa where pottery sculptures, often on a large scale, of human and animal figures have been found widely distributed across northern Nigeria. These sculptures first came to light in the tin mines near the village of Nok in Zaria province which has given its name to this tradition. Pottery heads were excavated thirty feet deep in the tin mines with other sculptures in water-lain deposits, mixed up with finely polished stone axes and the remains of an iron-working industry. Nok culture deposits are reckoned to be between 900 BC and AD 200.

It appears that the Nok sculptures in terracotta are derived from a tradition of wood sculpture, an unknown tradition, however, since no carved wood of such antiquity has been preserved.

The Nok sculptures vary in size from four inches to four feet. The head of the figures is usually cylindrical, spherical or conical in form with an elaborate headdress and ears placed in a great variety of positions. The lips, ears, nostrils and pupils of the eyes are usually pierced. The eye is represented as a segment of a sphere with the upper lid usually horizontal, the lower lid forming a segment of a circle. Human figures are usually stylised, while animals are remarkably naturalistic. Some art historians have found similarities between Nok sculpture and the undated stone sculptures of Esie, the *nomoli* figures of Sierra Leone and the Afro-

Portuguese ivories carved at Sherbo. Moreover, the art style of Ife, the religious, and earlier the political, capital of the Yoruba people of Nigeria, has many features in common with Nok—an art style characterised by idealised naturalism in both human and animal representations, yet alongside this there is, right through the whole period when Ife art flourished, a tradition of extreme stylisation.

Sao

Another civilisation, whose existence is known to us through the work of archaeologists, has been discovered in the Chari delta south-east of Lake Chad and is known as Sao after the people who elaborated this interesting culture—their descendants, mostly living in northern Cameroon, are the Kotoko. This geographical area was an important cross-cultural focus in ancient Africa, criss-crossed by trade routes, most of which led towards Kano and from there to the north of Africa, and the western Sudan. Dates for this civilisation are rare, although we know that there was a massacre of a group of Sao in the seventh century at the Bilma oasis. Towards 950 they settled permanently in the Chari delta and lived there peaceably until the thirteenth century after which they suffered from the expansionist policies of the Kanem- Bornu empire and are no longer heard of.

Sao art was an authentically African art, influenced by cultural currents from the Nile and the Mediterranean world, although their pottery, copper and bronze are all that remains of this remarkable culture. Pottery was an important medium for its artists and crafts-men—funerary urns, jewellery and even money were made of this clay. Bronze artifacts which have been turned up by archaeologists include hoes, harpoons, fishhooks, knives and spearheads. The most spectacular objects are statuettes which appear to represent sacralised ancestors.

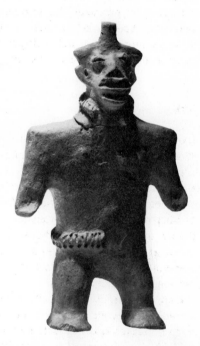

1.2 Pottery masked figure, Sao culture. Lake Fitri, Batha region, Chad.

Zimbabwe

Archaeology is also extending our knowledge of another African culture, at Zimbabwe, where steatite bird pillars and decorated bowl fragments have been found but are relatively minor features of this ancient ruin. The Zimbabwe culture developed over 1500

years ago in the open savannah of Rhodesia, to be finally obliterated by the holocaust of the Ngoni peoples who devastated this part of Africa in the nineteenth century. The inhabitants of Zimbabwe were Bantu-speaking ancestors of the Karanga, who are a section of the great Shona nation which inhabits central Africa today.

The Zimbabwe site is only one of many in south-eastern Rhodesia and the northern Transvaal associated with ancient gold-mining and an overseas gold trade. In fact the first rumours of the stone buildings of East Africa filtered back to Europe through the early Arab gold and ivory traders of East Africa. Little remained at Zimbabwe, however, and by 1891 all had disappeared and in the surviving archaeological record, artistic achievement at Zimbabwe is limited to soapstone objects; architectural styles and free stone walling testify to outstanding abilities in stone building and the evidence contains glimpses of fine art reflected in numerous gold-foil fragments which once adorned the wooden objects owned by the inhabitants. Beams were covered with engraved cross-

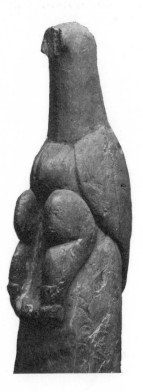

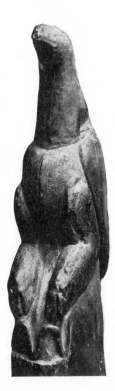

1.3 Steatite bird pillars. Zimbabwe, Rhodesia.

hatching, chevrons, diamond and other geometrical decorations. Apart from the soapstone bird figures on their pillars, there are two stylised human figures, male and female. The stylised birds are portrayed with straight backs, and folded wings, their beaks and feathered legs identifying them as hawks, crowned hornbills or eagles. It has been suggested that they may have figured in some form of ancestor or rainmaking ceremonies such as are practised by the contemporary Venda.

As far as Zimbabwe culture is concerned no-one any longer invokes Egyptian or Phoenician influence when explaining the significance of this plastic art. Archaeology has shown that its walls and towers were raised by African builders and African inspiration; it can therefore be reasonably supposed that the minor arts also were involved in such African institutions as an ancestor cult, initiation rites and the practice of divination.

African stone carving

Apart from Zimbabwe, there are only a few archaeological sites where stone carvings have been found. There are only three zones in the Guinea forest, a fourth near the mouth of the Zaire and one in the highlands of Ethiopia. South of Sidamo, southern Ethiopia, now occupied by the Derassa, stone posts have been found depicting life-sized figures. Unlike woodcarving, no general principles based on cultural dispersion or parallel developments are possible to link any of these dispersed groups since the occurrence of stone working seems completely sporadic. Only in Nigeria are cultural connections possible.

Nomoli and pomtan

The stone figures of Sierra Leone and Guinea are known as *nomoli* and *pomtan* and *mahan yafe*. Thousands of these stone figures are found over an area stretching from Sherbo Island off the coast of Sierra Leone to the Kissi country of Guinea. The great majority, like the Zimbabwe birds, are made of steatite or soapstone. The Mende nomoli are generally about six inches high and consist of disproportionately large heads, with large bulging eyes, broad flat nose and jutting jaw. The figure sits or squats and has a body and limbs consisting of rather formless round masses. They are found

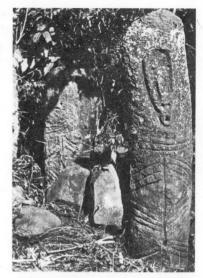

1.4 Stone post representing a human figure. Derassa, S. Ethiopia.

from time to time in the ground during farming and are said by Mende farmers to have been 'made of God'. They are worshipped in that they are given offerings of food; in some cases they are flogged ceremonially so that they may bring a good rice harvest.

Pomtan (or pomtam) are cylindrical, and many have a feature-less globular head leading from phallus-like objects to fully realised representations of the human figure. Some have elaborate head-gear and dressed hair, beads and ornamental body scars. They may have a large, forward-thrusting head, with attention focused on the face with bulbous eyes, flared nostrils and overted lips. The figure, when completed, is seated, sometimes on a stool or in a crouched position, although some examples do not fit into this typical scheme. They can be dated to as far back as four hundred years ago to distinct but related metal-using cultures of the high forest which were at a primitive stage of political development.

Mintadi

From northern Angola and the Mayombe, these stone sculptures by historical association can be included within the large and distinctive corpora of Kongo wood carving. True *mintadi* represent a seated male figure often cross-legged with head inclined to one side and resting on one hand, the other hand on the hips. Others include a female suckling a child and kneeling male figures. Stone mintadi have been found in burial places of chiefs and are said to embody the spirit of a dead ancestor whose influence can be directed to afford protection and assistance to living descendants. Mother and child figures have been found in a house connected with female cults of fertility and childbirth.

Yoruba stone sculpture

Several stone carvings found in Nigeria can be fairly certainly connected with the classical age of Ife, although they are not in the same stylistic class. They are all found within sixty miles of Ife in the central Yoruba forest. Two figures, one of them in a local granite-gneiss stand in the sacred Ore grove and are naturalistic with negroid features. Grouped around the two figures in other groves are other stone objects—standing stones, a three foot granite mud-fish and two rectangular stone boxes. One of the best examples of

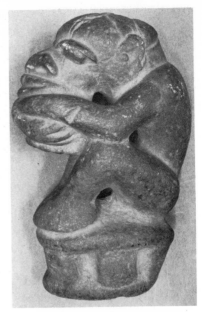

1.5 *Nomoli* figure, carved from a dark grey stone. Sherbro Island, Sierra Leone.

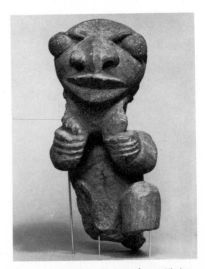

1.6 *Pomtan* carving of human figure. Kissi, Guinea.

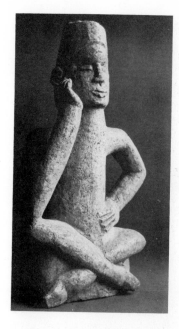

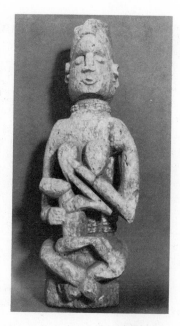

1.7 (far left) *Mintadi* male figure. Bamboma, N. Angola.

1.8 (left) *Mintadi* female figure. Bamboma, N. Angola.

the technical skill of the ancient Ife artist is the quartz stool, a pedestal stool the shape of a cotton reel from one side of which projects a loop of stone. This type of stool was made together with a four-legged stool which fitted under the projecting loop. The king sat on the round stool with his feet on the four-legged one on each side of the projection. There are representations of this strange seat in terracotta and in brass.

The Eshure figures (1.10) are hardstone carvings found roughly in a straight line strung out over a mile through dense secondary forest near the dwindling Ekiti Yoruba community Eshure. Unlike the Ore figures, they no longer have any religious significance, but they have obvious affinities with Ife sculpture. Quite separate from this Ife group are the Eshu of Igbajo (1.11) where the proportions of body to head, the ovoid form of the head, the eyes and deeply modelled lips reflect modern Yoruba wood carvings. The universally recognised Yoruba deity Eshu is the spirit of chance and uncertainty, the Yoruba trickster.

The Esie sculptures (1.12) are the largest group of stone carvings in Yoruba country. There are about eight hundred of them. Most are about 60 cm high, some only 20 cm, others over a metre. The majority are seated on stools. They are of both sexes and wear

1.9 Quartz stool, originally from the shrine of Oluorogbo, who carried messages between heaven and earth. Presented by the Oni of Ife to Captain Bower in 1896. Ile-Ife, Nigeria.

THE LIBRARY
West Surrey College of Art and Design

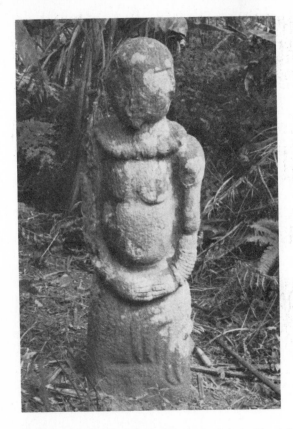

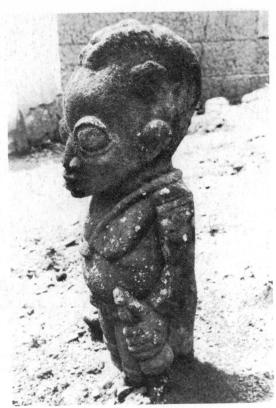

headgear or have elaborately dressed hair. The inhabitants say they found them in the bush or offer mythical origins and they are part of a local cult for the town's prosperity and well-being, but these ceremonies afford no clue to the historic origins of the images.

1.10 Above left: Stone figure at Eshure, Ekiti, Nigeria.

1.11 Above: Carved stone figure of Eshu at Igbajo. Yoruba, Nigeria.

The Cross River akwanshi

Three hundred miles to the east of Ife in a restricted area of the Cross River stand groups of stone carvings which resemble no other works of art in any medium in the whole of West Africa. They are found in areas now inhabited by the northern section of the Ekoi who sparsely inhabit this forest lying within the bend of the Cross River at the south-eastern extremity of Nigeria and adjacent Cameroon.

Akwanshi stone figures are found in isolated occurrence, in 29

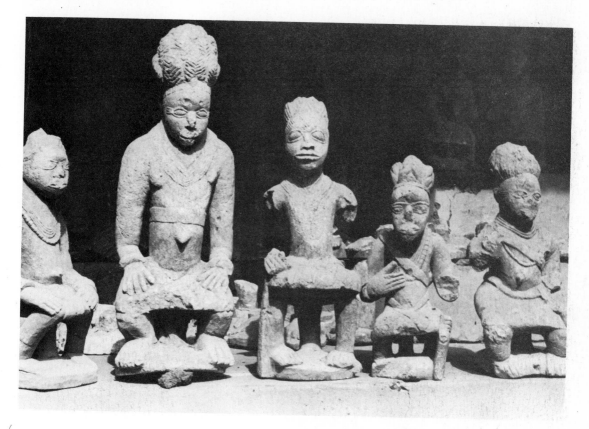

1.12 A group of steatite figures from Esie. Igbomina, Yoruba, Nigeria.

separate groups and eleven single specimens. There are almost three hundred of them all told and they stand in abandoned or existing village sites. They are mostly made of basalt. The peculiar grain of basalts, when subject to natural weathering and erosion, give rise to the emergence of regular columnar forms, and are starting points for the carving of these stones.

They are all phallic in shape, particularly the akwanshi of the Nta and Nselle groups, but there is a general progression from phallus to human form. Some are, in fact, dressed and decorated boulders rather than figure carvings and are distinguished by profuse and well-handled surface decoration centred on the face, breasts and navel. Their common features are a protuberant navel and the lack of genitalia. Their function is unknown although further across the Cross River in the Bamenda and Bamileke escarpment region, several stones of this nature have been found. They are phallic in

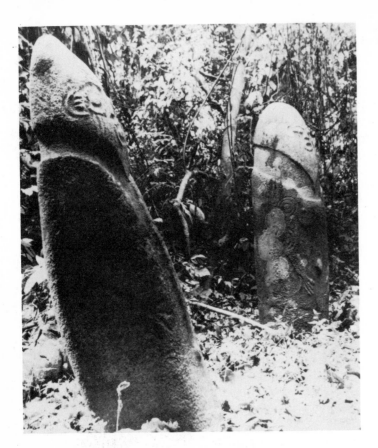

shape, and at least among the Bangwa, are supposed to represent the power of the chief.

Brass casting in Ife and Benin

Unlike stone carving, brass casting is a continuing tradition in Africa although it has only been found in limited areas, primarily the Guinea forests and the adjacent highlands of the Cameroon and certain localities of the savannah hinterland. Wrought iron work is widespread and found among the Fon of Dahomey, the Ibo of Nigeria, the Bambara, Senufo and Dogon of Mali. The blacksmith, whose prime role was to make agricultural tools, spears, arrows and arms was often at the centre of religious life, making objects which

served as elements of important cults. In some areas, as in the Cameroon Grasslands today, the blacksmiths worked under the aegis of the chief who monopolised the products of their crafts. In other zones the blacksmith also carved wooden masks and figures as among the Bambara.

A continuing cultural tradition seems to link the Nok sculptures, the Esie stone figures and the brass sculptures of Ife, although we have no idea of the date of the Esie figures. Approximately thirty ancient brass castings are known from Ife together with several hundred pottery fragments representing several scores of distinct sculptures. In Benin we have, on the contrary, a few thousand brass castings, but only a score or two of terracotta sculptures. Of the Ife and Benin human figures represented, nearly all are royals, court attendants or sacrificial victims. Figures from Benin even

1.14 (below left) Brass figure of an Oni of Ofe, excavated at Ita Yemoo in 1957. Ile-Ife, Nigeria.

1.15 Pair of brass figures of an Oni of Ife and his Queen, excavated at Ita Yemoo in 1957. In parts this cast is barely $\frac{1}{16}$ in. thick. Ile-Ife, Nigeria.

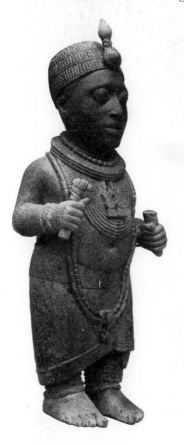

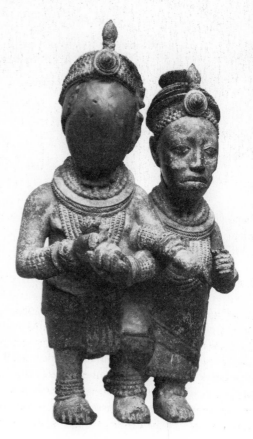

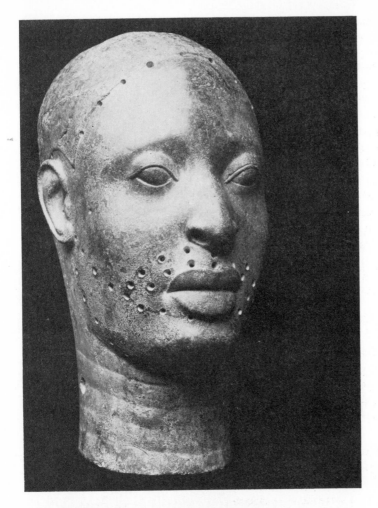

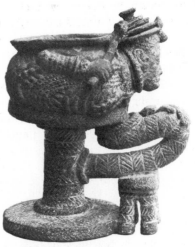

1.16 Left: Naturalistic brass head found at Wunmonije compound, Ile-Ife, Nigeria. Willett suggests that the holes around the head were probably used to attach a real crown and that the holes around the lips and jaw probably had beads strung from them to represent hair.

1.17 Vessel in the form of a queen curled round a pot, set on a pair of stools of characteristic Ife shape. Excavated at Ita Yemoo in 1957. Ile-Ife, Nigeria.

represent gods conceived as kings and queens as well as *vice versa*. However, although certain of these words are still used in various Ife shrines, the historical and religious traditions of the current worshippers are no help in determining whether a god or a king is represented since the intentions of the artist are lost to antiquity.

In analysing classical African art, art historians are often forced to make deductions and hypotheses. Willett, for example, makes inferences about the art of Ife from an examination of the social factors affecting Benin art, because of persistent traditions describing the close connections between the Benin and Ife royal families.

His hypothesis, which seems quite a sound one, is that customs of considerable antiquity may be found in one group (i.e. Benin), yet lost in another (Ife).

Even with little historical or sociological material, the brass images themselves may shed light on Ife society. The brass figures of Ita Yemoo include a figure of a standing Ife king (Oni) in his regalia; an Oni and his queen with their legs and arms intertwined; and a queen curled around a pot which is set upon a pair of stools. There are also stylised figures and heads—the latter having little more than symbols of faces with holes for the eyes and a slit for the mouth. Around the top of each head is a series of points which seem to represent crowns. Willett has shown with little doubt that the casting of life-sized naturalistic brass heads was flourishing in Ife between the tenth and fourteenth centuries before the advent of Europeans. Moreover, the brass figures from Ita Yemoo were in a layer corresponding to that in which terracotta sculptures lay with charcoal which produced radio-carbon dates indicating a twelfth-century date for the occupation.

Ibo and Nupe bronzes

A number of brass-casting traditions are still awaiting detailed investigation in Africa. Bronze figures have been found among the Nupe. The figure of a woman holding a fan in her left hand (1.19) is one of the largest bronze castings ever made in Africa. It is kept in the Nupe village on Jebba Island, to which legend says it was brought from Idah by the great founder of the Nupe kingdom, Tsoede, in the sixteenth century. We know a good deal more about the Ibo bronzes. The bronzes of Igbo Ukwu were discovered in 1938 when a cistern was being dug. Later archaeological investigations in 1959 by Thurstan Shaw show that this site was a storehouse for elaborately decorated objects—vessels, mace-heads, a belt and other items for ceremonial wear. At the same time in a nearby compound, a grave of a personage buried with various indications of his office was excavated—a crown, a pectoral, a fan, a fly-whisk, beaded metal armlets, together with more than ten thousand beads.

Four radio-carbon dates agree in dating these sites to the end of the first millennium AD, which makes this the earliest bronze-using culture we know so far from Nigeria. The technical skill is high, most of the metal objects in the grave being worked by smithing and chasing and are made of almost pure copper. Other metal

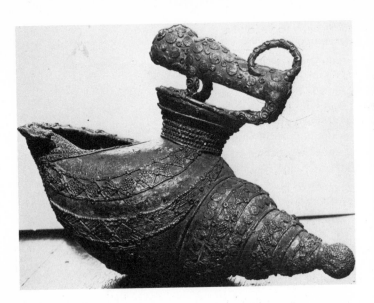

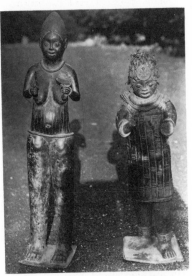

1.18 Ceremonial vessel, in the form of a shell surmounted by a leopard, probably ninth century A.D. Igbo Ukwu, Nigeria.

1.19 Left: Bronze figure of a woman holding a fan. Right: Bronze male figure with a quiver on his back. From the Nupe village of Tada, on Jebba Island, River Niger, Nigeria.

objects were cast by the lost wax process from leaded tin-bronze.

These bronzes from Igbo Ukwu are extremely detailed castings with elaborate surface decoration—different from other West African traditions of casting. Moreover, the standard of wealth represented by the art has no parallel in Ibo land. Neighbouring towns such as Aguku-Nri have competing priest-kings associated with the conferring of titles and they may well relate to the Igbo-Ukwu finds. Nevertheless there is no comparative ethnological data and the finds remain archaeological objects.

Classical wood sculpture

It is understandable that an isolated bronze figure or pieces discovered in archaeological sites should still be sparsely documented. What is more extraordinary is that whole corpora of wooden sculpture are also almost entirely without any documentation whatsoever. Sometimes this is because the masks or figurines were discovered during a period when they were no longer used in the ceremonies or rites of the people involved—a famous example are the *tellem* figures of the Dogon. In other instances works of art were merely collected as curiosities or even souvenirs without any pertinent information being collected. For this reason our know-

ledge of the function of some masks and figures is sadly lacking, yet we are talking of a period of less than a hundred years.

Many 'classical' works belong more to that sphere of archaeology, 'survived art' and unlike archaeological finds we are unlikely ever to know any more since these wooden objects have not been found in historical sites but have been collected from a people who no longer have a recollection of their use or a tradition of their symbolic meaning.

Among the Dogon, for example, a number of the old tellem have been found in large numbers. The Dogon believe they were carved by an earlier and different group of people who earlier occupied their territory. Their style, however, seems to have close links with that of modern Dogon carvings. A fragment of one subjected to the radio-carbon test was found to date from the second half of the fifteenth century—the time of the earliest European exploration of the West African coast. Neither archaeology or the Dogon, however, can tell us anything about these tellem figures. The art historian tells us that the types of tellem are very varied, each village having its special style. The most common are figures with uplifted arms, usually female and sometimes hermaphrodite. Others include animals and kneeling women, anthropomorphic figures with the shape of the original bent wood, the arms stuck to the side of the body. Apart from this all we can do is to make stylistic comparisons and aesthetic appreciations— the rest is mere hypothesis.

A lot of nonsense has been written about the meaning of groups of sculpture of which we should admit our almost complete ignorance. Fang statuary, for example, have been studied in minute detail. We know their provenance in so far as they come from the Fang of northern Gaboon, southern Cameroon and Rio Muni. We may be able to say that they have a 'harmonious, and expressive' style. But after this, apart from structural and stylistic studies, there is little to add. And yet these statues were the idols of Derain and Epstein and were among the first negro *chefs d'oeuvre* to become known in Europe in the twentieth century. The modern Fang themselves have no memory whatsoever of the famous masks which so stir the Western art world and have resulted in the most far-fetched hypotheses.

Our information on other famous African art corpora is often equally limited. The Kota figures are an example where attempts are constantly and contradictorily made to attempt an explanation

Fig. 1.1 Tellem style figure, Dogon, Mali.

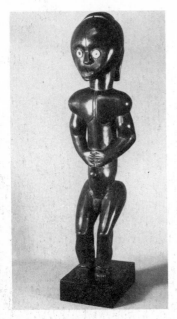

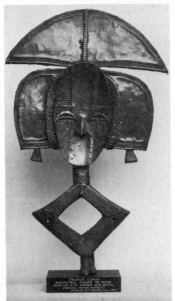

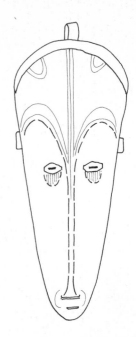

1.20 Wood statue, Fang, Gabon.

1.21 Bakota reliquary figure carved in wood and covered in brass and copper. Gabon.

Fig. 1.2 Wood mask, painted white. One of the pieces that so excited the Parisian art world in the early twentieth century. Fang, Gabon.

without any background knowledge. The plaque behind the head of the Kota figure, for example, has been confidently described as the rays of the sun, the horns of a goat, a crescent moon, while some experts maintain that the figure is derived from Christ on the Cross.

Partly because of analyses of this kind, contradictory and over-scholarly, I have become convinced that any future studies of African art must begin with detailed, and as far as possible complete, ethnographic surveys which place the art object in its social and cultural context. For this reason I have concentrated on a limited number of art styles which have been amply studied by anthropologists and art historians who can combine contemporary ethnography and historical materials to provide valid hypotheses.

The art of hunters and gatherers

Are ecological and technological factors important for our under-standing of African art? In this chapter and the next I want to see how far a dependence on animals for a basic source of food is reflected in the art of hunters, fishermen and pastoralists and whether a reliance on game animals, fish or cattle differentiates these people's art from that of those settled agriculturalists who constitute the vast majority of Africa's population. My examples in this chapter are the Bushmen of southern Africa, hunters and gatherers of the Kalahari desert; the Tshokwe of Angola and Zaïre, manioc farmers today but until two generations ago, nomadic hunters; and in Chapter Three, the Kalabari Ijo, fishermen of the delta region of south-eastern Nigeria; and the nomadic cattle herders of West Africa, the Fulani. As hunters, fishermen and pastoralists they are all parasites on nature, who harvest but do not sow. Even the Fulani with their domesticated cattle belong to a grouping including hunters and fishermen through their absolute dependence on their beasts. They are all, more or less, nomadic. Neither the Bushmen nor the Fulani have a permanent home, although they utilise specific tracts of hunting and grazing lands. The Tshokwe, until the beginning of this century, roamed the equatorial forests of central Africa, exhausting the land with their extravagant methods of hunting and their shifting cultivation of manioc. And the Kalabari Ijo, while they have permanent villages in the delta mangrove swamps move around for months on end, following the movements of fish shoals.

The Bushmen and their rock art

True hunting and gathering economies are today restricted to marginal regions in Africa, although this has not always been so. Hunters (Bushmen, Pygmies and Negroes) once roamed freely over the entire continent—in the once-fertile desert, across orchard bush savannah and in the equatorial forests of central Africa. As a

2.1 Dogon cave painting from Songo, Mali. The objects represented include the decorated leather bags used in the Sigi rites, masks, lizards and other animals.

result of an agrarian revolution brought about by the introduction of superior techniques associated with iron tools and new crops introduced from Asia and America, farmers gradually took over from the hunters; those who wished to maintain their old way of life were restricted to zones where the farmers did not wish to farm or where the domestication of plants was not possible. Some of the hunters adapted farming; others like the Pygmies of the Cameroon continued hunting but came to an understanding with the farmers and exchanged their game for farm products.

The Bushmen

The Bushmen in southern and south-western Africa continued their hunting life for many hundred years undisturbed although some are now attached to Negro farmers and whites as servants or serfs. Nonetheless a few thousand still live their essentially nomadic way of life in the Kalahari desert. They and the Hottentots are the earliest human inhabitants still living in southern Africa. Today they hunt game and harvest wild crops in the dry bush desert of the Kalahari, a landscape of flat plains and sand dunes, thousands of miles of hostile country with little water and great heat for most of the year. Instead of permanent houses or caves the Bushman camps in the shade of a baobab tree, behind a simple windbreak consisting of a semi-circle of saplings set in the ground and covered with grass. Although they once occupied an environment which offered greater opportunities for hunting and collecting—

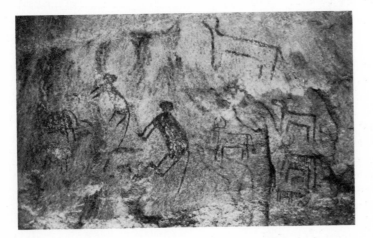

2.2 Rock painting from Geji, near Bauchi, Nigeria.

they were harassed into this harsh environment by Negro and European farmers and pastoralists—they have achieved a remarkable adaptation to the desert. Indeed in many ways the Bushman prefers the more arid region of the Kalahari since the water holes offer more favourable ambushes if they are far apart—the hunter does not need to pursue his prey across well-watered grasslands.

The Bushmen who still hunt the desert are palaeolithic hunters—they make no iron, have no farms and rely exclusively on wild products. Hunting with bow and arrow is enormously difficult but the men are stubborn and cunning hunters and rarely return without their prey. Since the presence of game determines their habits, they are continually on the move, moving camp every few days or so in search of food. Nevertheless each group has its own 'home territory' and in this territory each person will either be related by blood or marriage or will know the other Bushmen. They do not, however, recognise as their own people any strange Bushmen who speak their language; in fact they suspect them and fear them as dangerous strangers.

The life of the Bushmen is dominated by their absolute dependence on immediately available resources for survival and there is consequently an intense and intimate relationship between the life of the hunters and that of animals and plants, and between all life and rain. The hunter is unable to control nature but is dependent upon the unpredictable—rain, drought, the decimation of game by fire or disease, the luck of the hunt. Their anxieties are expressed in their myths, their ceremonies and their rites, and are also represented in their paintings and engravings.

Bushman rock art

Rock art (or glyptic or parietal art) has been practised throughout the African continent for thousands of years, on natural features such as outcrops of rock or the walls of cave shelters, in northern Africa, in Egypt, in the Horn, West Africa and southern Africa. The most famous of these are the paintings attributed to the Bushmen and have been known for hundreds of years. The Tassili and Fezzan paintings of North Africa (see p. 61) were only discovered in the second half of the nineteenth century and were not described by French and Italian researchers until the 1950s. We also have contemporary evidence from Nigeria and Mali that peoples still paint

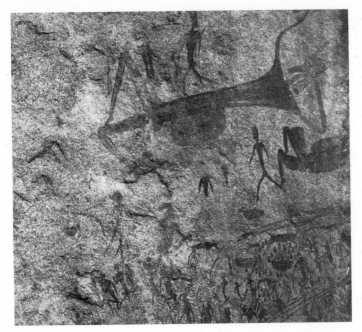

Fig. 2.1 Disguised Bushman hunting ostriches. Witteberg, Herschel, Cape Province, S. Africa.

2.3 Rock painting of Negro-type human figures. Marandellas District, Rhodesia.

and engrave in the same way. Near Bauchi in northern Nigeria there are paintings of antelopes, monkeys, cows and men done in reddish pigments; and among the Marghi in the same region boys retire to rock shelters up the face of a nearby mountain and as part of their initiation rites paint simple stick figures of men, weapons, shields and animals on their walls. In Mali, the Dogon also paint on the surfaces of rock shelters where the Great Mask of the *sigi* initiation rites are kept (see 2.1).

Nevertheless we know most about the Bushmen paintings and studies of their myths, their way of life and their art have been used to illuminate rock art and archaeology in widely separated palaeo-lithic sites. In southern Africa archaeologists, art historians and anthropologists have been able to reveal a surprising amount about the context and meaning of the paintings despite the fact that by the middle of the nineteenth century pressure from Negroes and Europeans meant the end of the old Bushman way of life in most regions, the decline of their myths and the death of an ancient art.

The surviving paintings date back at least two thousand years, although dating is difficult, even impossible in many cases, the only sure indications of their age being the depiction of new immigrants

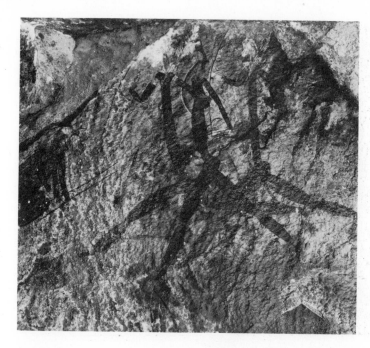

2.4 Rock painting of Bushmen hunters with bows. Mahahla's Shelter, Belleview, East Grigualand, South Africa.

or animals—the fat-tailed sheep, the horse, the Boer and his wife, portraits of Queen Victoria, English soldiers. The oldest paintings are probably the work of unknown peoples, but there is no doubt that the ancestors of the contemporary Bushman painted the majority of them before they were harassed by invading peoples into the Kalahari. The paintings depict the life of the Bushmen, as some of them live today, their animals, rain rituals; men in masks seem to be the Bushmen themselves since they have a hunting technique whereby the hunter disguises himself as an animal in order to approach close enough to the grazing herds to make his bow and arrow effective. The paintings depict both Negro and Bushman: the former is usually painted in black with ornaments on his arms and legs and armed with spears and shields. The Bushman is painted shorter than the Negro and in yellows, reds and browns, carrying the bow and arrow.

Both Negro and European traditions acknowledge the Bushman authorship of the paintings of the largest concentrations of paintings found in the south-east, in the valleys and foothills of the Drakensberg mountains and the associated ranges, as well as the Brandberg of south-western Africa. At the time of the first contacts

THE ART OF HUNTERS AND GATHERERS

25

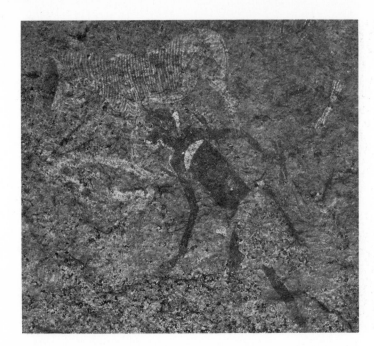

Fig. 2.2 Painted ostrich egg shell.

2.5 Detail of a rock painting showing a human figure and a zebra. The White Lady Shelter, Brandberg, South West Africa.

with Europeans in the sixteenth and seventeenth centuries Bushmen occupied the mountainous sections of the land where these paintings are found and explorers and hunters of later generations refer to their art and the artists who created it. Moreover, archaeologists have shown that stone tools found in sites associated with the paintings correspond to those used by Bushmen. In 1866 a Maluti Bushman, shot dead by whites, was wearing a belt from which hung ten antelope horns, each filled with a different pigment, and even in the 1870s painters were reported still at work. Today the Bushman does not paint on rocks, but they are still artists and the Kung Bushmen paint designs on the bark of trees and on their ostrich eggshell containers. Paintings, which Elizabeth Marshall Thomas persuaded Bushmen to draw, 'could be said to resemble the paintings and engravings on rocks'.

The rock overhangs, and caves where the art is found were once the habitat of Bushmen hunters who occupied them for a day or two during hunting trips or for longer periods if the supply of game was constant. These caves not only provided the hunters with casual shelter but almost certainly provided a ritual focus, probably for initiation rites or other ceremonies. Thousands of pictures,

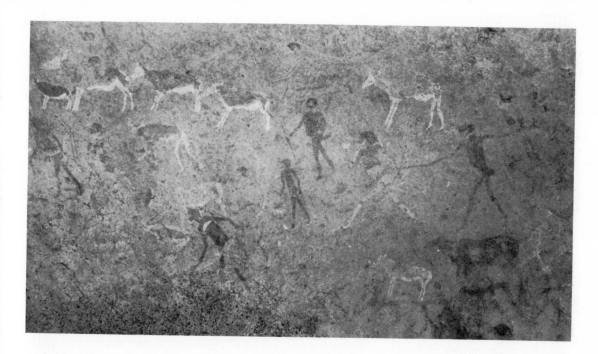

probably only a fraction of those drawn by Bushmen, have been found and one rock shelter may have hundreds of paintings of game animals, giraffe, elephant, antelope and human figures. The largest are usually of single animals, mostly eland, their size varying from 20 to 240 centimetres. Most of them, however, are between 20 and 40 centimetres from nose to tail, while human figures tend to be between 15 and 30 centimetres tall. The techniques are both naturalistic and decorative: the pictures of antelope in particular are seen in all aspects—from the side, behind, in front, running, sitting, browsing, in herds; a crowded appearance is obtained by overlapping the animals. Some paintings are expressionistic—large snakes, some with horns and with humans on their backs, antelopes with wings. Human beings are depicted in elaborate masks and other paraphernalia. They are rarely shown hunting. In one painting a hunter is posed with his legs crossed, grasping an eland by the tail, while a second figure, wearing a buckhead mask, appears to be making a sweeping bow to a third figure in a striking costume.

Unlike the paintings in the deep caves of northern Spain and France, Bushman paintings are usually in the open and easily visible. The colours are natural earth hues, red, black and white, yellow,

2.6 Rock painting of human figures among a herd of eland and other antelope. The White Lady Shelter, Brandberg, South West Africa.

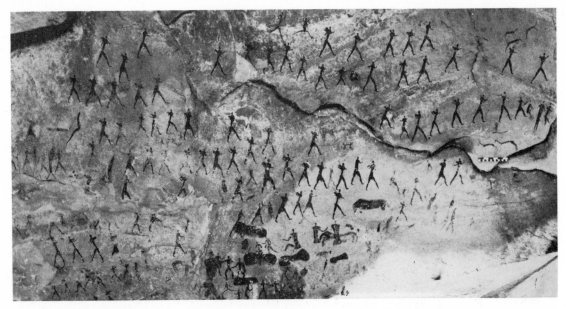

2.7 A frieze of marching Bushmen. Rock painting from Ikanti mountain, Underberg District, Natal, South Africa.

orange, brown and pink—sometimes grey-blue. The pigments, derived from red iron ore, nodules in sandstone and oxides of manganese and zinc, were ground by the Bushman artist in stone mortars, using a stone as a pestle and stored in antelope horns. When in use the colours were mixed with tree sap, ostrich egg, blood or animal fat, thereby producing a fairly stable 'oil paint'. The paint was generally applied with the finger, although brushes of animal hair and flexible bones were also used. Most of the pictures are paintings, some monochrome, some polychrome. In the monochrome pictures the outline drawings are scratched on the rock or picked out by repeated blows which dislodged tiny fragments of rock.

Function and meaning

Bushman rock art has been fully described by art historians and archaeologists, recorded by painters, analysed chemically by scientists and compared stylistically with rock art in other parts of the world. Countless more or less wild hypotheses have been made as to their function and meaning, but few attempts have been made to pursue systematically the relationship between the paintings and Bushman patterns of thought and their social life.

Brentjes saw the need for this when he pointed out that the Bushmen masked dancers, animals and half-animals are 'possibly to be explained in terms of the mythological traditions of individual Bushman clans' which will, however, have varied greatly from one district to another. More recently, Vinnicombe, in her much more refined analysis of Bushman paintings, has pointed out that to discover the nature of the man who created the art or the art created by the man we must understand how that man was related to nature. I want now to look at some attempts to apply various theories to the study of Bushman paintings.

Art for art's sake

A popular theory of rock art is the one which simply proclaims the Bushman artist as an exponent of 'pure art' who lived a happy, primitive life, in peace with his environment and with sufficient leisure from the food quest to enjoy the decorating and beautifying of his rock shelters and personal possessions. Followers of this 'art for art's sake' theory argue that in the past the rich environmental conditions and freedom from war and want—before their lands were taken from them by invaders—allowed the artist to indulge his innate artistic instincts. The abundance of game explains the abundance of paintings and in order to understand Bushman rock art, all we have to appreciate is the Bushman's love of decoration and ornament. While this theory—like all theories which claim to be exclusive—cannot be considered seriously as the sole explanation of Bushman painting, it does have the advantage of stressing the importance of those purely aesthetic aspects of Bushman painting—and most African art for that matter. The Bushman artist was concerned with form and style—for its own sake, no doubt; in many paintings there is an emphasis on pure decoration which makes it clear the paintings did not have a purely ritual or economic function. Woodhouse points out that there was an apparent desire for self-expression in the patterned interlacing of the legs of running figures and the symmetry of two rows of heads, and even in the patient delineation of the special attitudes of an eland towards its calf.

It is salutary to remember the importance of this desire to please, the enjoyment of painting for its own sake, since art is rarely a mere handmaiden of religion or government. Certainly the contemporary Bushman decorates his ostrich eggshell containers and ornaments

his body with shell beads in order to please himself and his friends. However, as an exclusive answer to the problem of Bushman rock art, this theory hardly stands up to close investigation. (See Vinnicombe, 1972, and Ucko and Rosenfeld; the latter authors' critique of similar theories and interpretations applied to palae-olithic cave art in France and Spain is on the whole valid for the many theories dealing with the origin, source of inspiration, func-tion and meaning of Bushman rock art.)

Sympathetic magic

In Europe, as a contradiction to the art for art's sake theory, it was pointed out that rock paintings, deep in the recesses of dark caves, must have been inspired by magic. Instead of painting animals for purely luxurious enjoyment, the artist painted them so as to gain some kind of control over the subjects he painted. This theory involves totemic beliefs (the association of human groups with animal species) and the notion of sympathetic magic (which depends on concepts of similarity and contact—like producing like and an effect resembling a cause). The pictures of animals and hunting scenes found in Europe, Algeria and southern Africa were all explained as a desire to control the movements of animals, provide magical help in hunting and bring about increase in game herds. The principle involved is that the properties of an object (the game animal) can be conveyed from it to another object by simulated contact (to the painting). This purely functional and utilitarian theory saw fertility magic, totemism and sympathetic magic working together to increase the supply of game or aid in the kill. Incidentally, it also attempted to explain by the same principles why paintings on the rocks are made, then left, rubbed out and painted over.

One art historian, Brentjes, supports this viewpoint as far as the Bushman rock art is concerned with historical material. The Bushman conjured up dead animals, resurrecting them as future game. Living in the pictures, they would live again in fact, so the Bushman hoped. In support of this increase theory Brentjes quotes Frobenius who describes the ceremonies of a group of hunters who had no rocks to paint on, but performed a ritual after an antelope had been killed. After it was skinned a piece of hide was cut off with the hoof. It was scraped smooth and dried over the fire and after-wards a little picture of the antelope was painted on the scrap of

hide, a bone tied up in it and the whole buried in damp ground near a water hole. Clearly the intention is that from the skin and bone a new live antelope would arise as in the picture.

Brentjes also quotes an old diamond prospector who knew the Bushmen: 'Before they go out to hunt they draw the outline of the beast in the sand, then with all sorts of ceremonies, they shoot an arrow at the drawing. And the place where the arrow strikes the drawing is the part of the living animal they wish to shoot.' Brentjes concludes that for the Bushman 'art was an imaginative means to an end, that end being success in the hunt—his object was not artistic achievement, but quite simply blood'. It is true that in many parts of Africa hunting peoples attempt to increase magically supplies of game and 'recreate' dead animals once they have been shot. Among the Dogon, at the end of a hunt when an antelope was killed, the diviners advised that a wooden mask imitating the animal's head be carved—the head at the moment of death constituted the last refuge of the animal's force. Moreover, it is interesting that blood and fat were used by Bushmen as components of their paint; the blood of a freshly killed eland was requested by an old Mosotho when asked to demonstrate Bushman painting, and blood has been established as a chemical component of the paint in Bushman shelters.

Unfortunately theories deriving from sympathetic magic and fertility rites cannot provide the whole answer. As Ucko points out for European rock art, they cannot explain the paintings of animals which were never eaten. In Bushman painting, scenes of hunting are rare and even humans depicted in hunting gear are not actually hunting. More importantly the predominant species painted are not the predominant species eaten. 'Although all the animals portrayed would have formed a part of the diet of the hunters, there was a notable lack of the smaller animal species, the bones of which predominate among food refuse in archaeological excavations of late stone age shelters. The faunal component of the painted sample was not a true reflection of the faunal population of the area or of the diet of the hunters.'

Thus in western Lesotho a count of themes and subjects found that the majority of animals were eland, while in the Drakensberg, antelope dominated the wild animals depicted, with the emphasis on eland in the southern area. These facts and other data indicate that artists selected certain animals for particular emphasis while others, equally important as food, were almost entirely

neglected as themes in the painting. Modern social anthropology has shown without a doubt that people 'do not necessarily relate life to the rumblings of their stomach' and Levi-Strauss has pointed out that totems are 'good to think', not 'good to eat'. Totemic societies, such as the Tallensi of Northern Ghana select species as totems and give them social value which has nothing to do with their economic value, totem animals mostly being of little or no practical importance to human beings.

What has been quite clearly established, therefore, is that while intimate relations between man and animals do exist they are not based on the roles of these animals as food, nor their place in the environment. It might, therefore, be a less biased approach to Bushman art to consider the role of these special animals, such as the eland, in myths, stories and ritual. As far as Bushman art is concerned I am indebted to Vinnicombe for this approach, which I have also used in discussing the plastic art of the Tshokwe and the Kalabari Ijo.

Bushman cosmology

What can we find out about the eland and other significant animals in Bushman paintings? In the myths of these African hunters we find accounts of the creation and subsequent killing of the first eland which immediately indicate a ritual relationship between man, the eland, and their creator god. The /Xam Bushmen of the Southern Cape, for example, observed a complex set of rules when hunting eland which confirms this special ritual association—shooting an eland with a bow and arrow entailed a very close self-identification between hunter and prey, while the poison was taking effect. By killing the animal which had been created by God with such particular care, the hunter suffered a temporary pollution and castigation: God is angered by the death of the eland, but not by the death of the smaller antelope.

Another eland creation myth, from another area in south-east Lesotho, where the rock paintings of the eland are common, tells how more eland were created from the blood and fat of the first eland, and in this physical act of re-creation the conflict of re-creating that which had been destroyed in the hunt was ritually solved. This ties in with the incident described by a European hunter and quoted by Brentjes (see p. 30). In another Lesotho myth, an eland was killed and a purification ceremony was re-

enacted, 'and all the elands that had died became alive again and it was a place enclosed with hills and precipices'—a good description of the landscape and sites where the rock paintings are commonly found. The inclusion of blood in the composition of the paint probably has some significance for these mythical increase ceremonies. On the whole, however, we may conclude from the evidence assembled by Vinnicombe that in the paintings the emphasis on the eland derives from its mythical and ritual significance. In the Kalahari where gemsbok replace eland as media for ritual and as symbols in puberty ceremonies, the gemsbok also appears more frequently in rock art.

We can pursue the subject further. From the work of Lorna Marshall we know that the Kung Bushmen believe in a complex spiritual force which is associated with birth and death, and which affects the weather and links human beings and specific game animals. The animals endowed with this force (no!ow) include the giraffe, the eland, gemsbok, kudu, hartebeest and wildebeest. Small animals entirely lack it, an observation which is of particular interest with reference to the lack of small antelope in the rock art of the northern Cape and the general absence of small mammals in all the art samples. The Bushmen also make an explicit connection between the hunter, the killing of the 'great antelope', rain and childbirth. The no!ow of the hunter interacts with the no!ow of the antelope, causing a change in the weather when an antelope is killed and its blood falls upon the ground. In the same way as women may cause rain or drought when they bear children, hunters bring rain or drought when they kill antelope. Among the Bushmen, the burning of the horns of an antelope in a fire is thought to influence the weather and the sacrifice of such a special animal is intended to bring rain. This may be associated with rock paintings interpreted as rainmaking scenes which have been found over a wide area in southern Africa.

This approach to Bushman paintings is illuminating and could profitably be followed in analysing a good deal of African art which has so far been studied from a purely stylistic or functional point of view. There are of course many explanations for all art: for Bushmen rock art they include the aesthetic pleasure of painting family life and animals of the veldt; the need to record special occasions such as the arrival of the Negro and their cattle, the Boer farmer; as a backdrop to initiation rites; to increase game, soothe or divert the soul of a dead animal, bring luck to the hunter; and to

reflect their cosmology in terms of the mythical relations between man and nature.

Tshokwe hamba figurines

Insights from studies of hunting peoples such as the Bushmen may have more than a local significance. There are few African peoples where hunting plays no part in the economy and in myth, ritual and art it often plays a role out of all proportion to its contribution to the livelihood of a group. Animals play major roles in myths and folk tales; not infrequently hunters are remembered as founding ancestors of farming communities, even complex states; in farming tribes hunting groups often survive as prestigious diviners and priests and farmers may show an exaggerated respect for neighbours who are hunters. Moreover, many sedentary farmers were primarily hunters and gatherers until recent times and it has only been the scarcity of game, pressure of population, or the laws of governments that have forced them to become settled farmers. Examples include the Bassari of Ivory Coast, the Baboudjé of Cameroon and the Tshokwe of Angola.

Throughout Africa game animals provide metaphors, symbols and identification in initiation rites; they play roles in ceremonial feasts, ritual exchanges, sacrifice, as well as witchcraft and shape-changing beliefs. The durable parts of game—hides, teeth, scales, claws and horns—are used as ritual adornment and elements of divining, prestige symbols or as an element in art objects. In contemporary African farming communities, as well as hunting bands, a successful hunter, particularly an old and famous hunter, is given special honours and his knowledge of the forest and his symbiotic life with nature make him an often awe-inspiring figure. Hunters may be diviners, heads of secret societies, village heads. Frequently their magical qualities are expressed by special burials. Great hunters among the Baboudjé are known as 'hunt masters' and are considered to have magical abilities through their intimacy with the forest; they are given special burials in the hollow trunks of giant forest trees. Among the Yoruba, a densely populated—by African standards—farming people, where hunting is becoming more and more difficult, Willett and Fagg have both reported hunter shrines which are associated with carved figures, called *ipade*, which are erected when the oldest hunter in the community

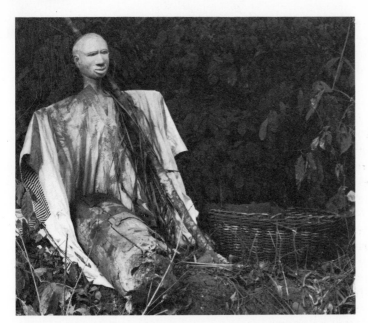

2.8 Wood *ipade* figure in the shrine to a deceased Yoruba hunter. Nigeria.

died. The carved figure is provided by his successor and the shrine where it is kept is erected about three months after the hunter's death and burial. Willett describes how the figure is set up—before dawn, with hunters firing their guns, the effigy is carried in procession to the site at the base of a forest tree outside the village.

Tshokwe hunters

A close analysis of the relation between hunting and art in a contemporary community would obviously be of considerable significance for African art as a whole. Unfortunately despite the wealth of details on social organisation, cosmology and ecology of such hunters and gatherers as the pygmy, the Baboudjé and the Hadsa, we have little or no information on their art. Gabus gives us a tantalising reference to Lulwa figurines (see 2.9) which work on behalf of the communal hunt and are placed on a mound of earth while the hunters are away. These figurines guarantee the efficacy of the hunt and to this end magical ingredients are placed on its head, including a dog's snout to smell the game and the teeth of the hyena to represent cunning. Individual Luluwa hunters wear figurines as companions during the hunt from whom they receive

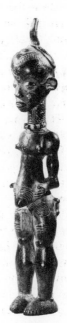
2.9 Wood figure with elaborate scarifications. Luluwa, Zaire.

'advice'; apparently they represent a hunter at rest, smoking hemp and dreaming. Equally brief descriptions are available for other peoples. Bastin refers to a Songe charm of 'great interest' which belongs to a hunting cult and is covered with the blood of animals killed through its powers. The charm consists of woven bands which tie a small skull to several ornamental clubs carved with human heads and a pair of facing birds.

Fortunately the art of one Angolan society with important hunting traditions has been studied in detail and depth by art historians and anthropologists. Tshokwe art occupies a distinguished place in the history of African art—there are Tshokwe pieces in every survey, profane and sacred figurines, anthropomorphic and zoomorphic sculptures, face masks, helmet masks, masks of wood, resin, beaten bark, cloth, skins, basketry. One remarkable style of mask, the *pwo* mask, representing Lweji the female ancestor, has been introduced into many non-Tshokwe areas of Angola, the Kasai and even the upper Zambesi and is worn by professional male dancers. In all their art works their is undoubtedly a feeling of vigour and aggressive power which seems to translate certain features of Tshokwe culture and society.

Here I am concerned exclusively with Tshokwe sculpture to do with the hunt—primarily the figurines used as amulets, diviners'

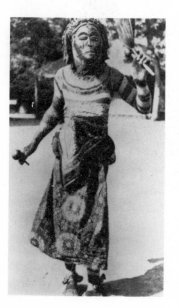

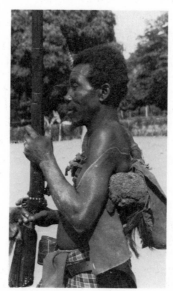

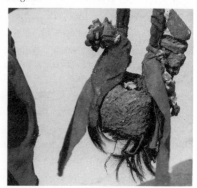

2.10 Far left: *Pwo* masquerader. Tshokwe, Angola.

2.11 a) Chief Mwafima ready to go hunting. He has hunting charms—*mukata wa yanga*—hung around his body and the gun has a charm near the trigger. Tshokwe, Angola.
2.11 b) Close-up of *mukata wa yanga*. Note zoomorphic wood figurine to the right.

images, shrine statuettes, known as *hamba*—in order to explore their significance for Tshokwe society and cosmology. Moreover, until recently the Tshokwe have been given the reputation by art historians of having an art which shows a 'courtly style'; in fact it seems that hunting provides most of the cultural elements in their myths and rituals and influences the whole range of their art.

Hamba figurines to do with the hunt are numerous. Many of the figurines in the Tshokwe divining basket have a direct reference to hunting. Hunters carry guns hung with charms which include anthropomorphic and zoomorphic figurines, usually associated with antelope horns. We learn from Marie Louise Bastin's monumental work on Tshokwe 'decorative art' that when hunters return from the hunt they place some of the blood of the animals slain on their figurines, and also a piece of the heart and some cooked manioc. Bastin also points out that ancestor figures are supposed to protect hunters and women in childbirth—even the famous Tshokwe *cikunza* mask, an ancestral spirit which symbolises fertility, is invoked by sterile women and hunters. If figurines of his same spirit appear on the edge of the diviner's tray during a seance the hunter must wear amulets representing the cikunza or put them on his gun.

Despite Bastin's fine work in assembling so many examples of Tshokwe hunting art we are still not very advanced as to their meaning and function. A description of Tshokwe hunting whistles by Söderberg takes us a little further—but on the same path hewn by the art historian. Tshokwe hunters have carved whistles which are frequently decorated with the head of the cikunza mask, but with a towering headdress representing an antelope's horn. Most of the sculptured whistles also have small antelope horns attached to them. Söderberg suggests that the horns give the hunters endurance when stalking game and stresses that they are an intrinsic part of the sculpture. The whistles themselves depict men and women, family scenes, coitus, face masks. We learn very little about the whistles, apart from the fact that they are accredited with 'magical power'. However interesting the analyses of Bastin and Söderberg the figurines associated with hunting and the hamba cult must remain 'found objects' without further information based on detailed anthropological and aesthetic studies similar to the work of Vinnicombe on the Bushmen cave paintings.

Fortunately these hamba figurines have been studied intensively along these lines by an anthropologist, Misquitela Lima, who spent

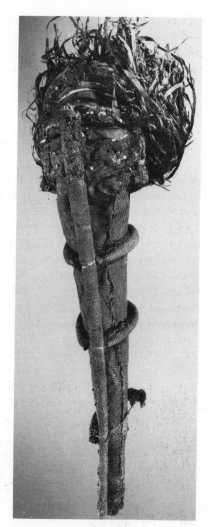

2.12 *Cikunza* mask. Tshokwe, Zaire.

many years on an exclusive study of hamba figurines in Tshokwe culture, with special reference to hunting. Our knowledge of the meaning and context of the figurines has been brilliantly extended in this work which is of prime importance for our understanding of the whole corpus of Tshokwe art, since the hamba appear to be the basic form of Tshokwe art and provide much of the inspiration for the more famous masks and ancestor statues. Lima also questions the acceptance of the notion of Tshokwe 'courtly art'.

The hamba figurines and hunting

Despite the multiple form and function of these figurines Lima shows that they are primarily concerned with the hunt and human fertility. They are important elements of village hunting shrines and are carried by hunters to receive the blood of game which must be immediately killed and bled onto the ground where it dies. Personal figurines are made for hunters—or made by themselves— on the advice of a diviner who is called when the 'luck of the hunt' seems to have left them. The making of the hamba figurine is supervised by the diviner who shows the man the correct tree and tells him how to cut it down without letting any pieces of wood drop on to the earth. When the figurine is completed the diviner purifies it with a libation of wine and, during a special feast, while the hunter's friends drink, dance and play music, the owner of the new figurine becomes possessed by the spirit of the hamba.

All Tshokwe hunters and their apprentices are organised in associations under the 'father of the hunt' (tata wa wiyanga). Although hunting is primarily a group activity, 'great hunters' with their special powers and the aid of their hamba figurines may hunt individually and trap a lot of game. In the communal hunt the 'father of the hunt' travels in the midst of the huntsmen and since he is thought to be possessed by the spirit of a dead hunter he succeeded as 'father of the hunt' he becomes in fact a symbol of past hunters. While all hunters may carry figurines or attach them to their guns the 'greater hunter', who is usually the village head, is in charge of the village shrine and sacrifices to it at the beginning and end of a communal hunt, placing part of the meat on the hamba figurine. When a 'great hunter' or a 'father of the hunt' dies there is a ceremonial hunt and pieces of the game caught are put on pieces of a termite mound in the man's hamba shrine. If possible he should be buried with a game animal, the one carrying the most

2.13 Wood whistle depicting *cikunza* mask. Tshokwe, Zaire.

Fig. 2.3 Hamba figurine. Tshokwe.

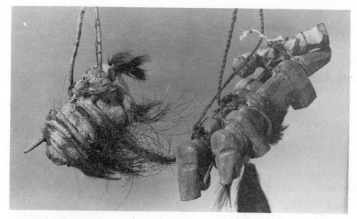

2.14 a) *Hamba* figurines in the form of a dog *mita*, honoured by hunters.

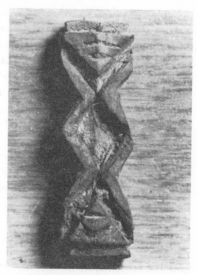

2.14 b) A two-faced object, a variation of *Hamba tshitanga*, carved by women to guard them against sterility and illness. Tshokwe, Angola.

prestige being the eagle.

Hamba figurines associated with hunting are also closely bound up with a man's potency. Once a hunter grows old and begins to find himself weakening he is duty bound to hand on his figurines to his heir, usually his sister's son: if he fails to do this the villagers will become ill and may even die, game will disappear from the forests and manioc will not germinate in the farms. During the ceremony of handing over the figurines to an old man's heir all the fires of the village are put out, and once the fires are relit all the men must sleep with their wives. Later the hunters go on a ceremonial hunt so as to be able to offer meat to the hamba figurines: not any kind of animal, a 'certain kind of antelope' and never the wild boar. (Although Lima does not specify the species it is certain that we are concerned with a mythical representation here on the same lines as the Bushman eland. See p. 31.) The power of the figurines depends on the man's potency as well as his power as a hunter: a great hunter will have rubbed large quantities of blood on his figurine. A poor hunter will have 'done nothing'.

The myth of Ilunga and Lweji

From Lima's material we can pursue our analysis of the hamba in their relation to Tshokwe cosmology and their myths in particular. The Tshokwe past is told in the form of a myth which can be divided into four sequences. The earliest period was one of primeval hunting when the ancestors hunted with traps and catapults, and

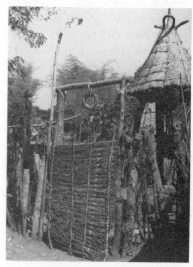

2.15 A village hunting shrine for the *hamba* spirits. Near the fence can be seen an anthropormorphic post representing the spirit *samuhangi* that helps hunters. Tshokwe, Angola.

cultivated some sorghum and millet. With the arrival of the culture hero, the hunter Ilunga, the second phase opens with the introduction—by Ilunga—of the bow and arrow, hunting amulets and the marriage of Ilunga and the local queen Lweji. In the third phase we have the introduction of the gun and the zenith of Tshokwe power. The fourth began with the arrival of Europeans, the introduction of manioc and the occupation of the country by the Portuguese. This period saw the 'settling' of the nomadic, hunting Tshokwe.

Throughout this myth the importance of hunting to the Tshokwe is stressed: Ilunga, the most important ancestor and culture hero, was a foreign hunter who arrived bearing the bow and arrow, hunting amulets and the *tshimbiuya* axe, the symbol of Tshokwe hunting and Tshokwe chiefs. Ilunga's other name is Tshibunda which means 'hunter' and his role in Tshokwe myth is that of a person who represents the zero point of Tshokwe culture history and traditional explanation. From archaeological sources we may locate this period before the fourth century AD since iron became known in this region at that time and the cultural innovation of the bow and arrow must have occurred before then.

Ilunga is associated with the origin of the hamba figurines. Arriving at a river on the day before his meeting with the queen he cuts a forked stick and places it in the earth. On this 'peg' he hangs his hunting equipment and his charms and goes to sleep with his head resting on a termite mound. The myth concentrates on these practical objects and today Tshokwe hunting shrines are made of a similar forked stick and sculptured representations of the hunter-hero are shown with the same stick. And his head-rest, the termite mound, has become a symbol of the hunter-ancestor in the same shrine. Associated with the shrine are the hamba figurines which are propitious for hunting. According to the hunters, the hamba represent famous hunters who were 'masters of the hunt' and killed much game, including a particular species of antelope.

As we have seen, hamba shrines are associated with hunting, virility and fertility (hunting, its success or failure is linked with the fertility of women) and hunters and owners of figurines have to be strong otherwise their power causes evil and death. The strongest hunter was Ilunga who introduced the bow and arrow, which became the mainstay of the Tshokwe hunting economy. Moreover, Ilunga fecundated the mythical mother Lweji, which some hamba are said to represent.

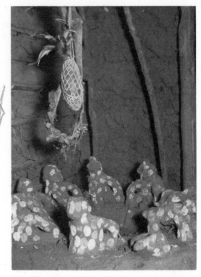

2.16 A private *hamba* shrine. For the *hamba* spirits *saliyinga* and *kajiya*. This shrine is to ensure fertility. Tshokwe, Angola.

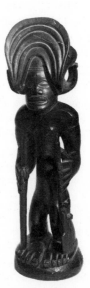

2.17 Ilunga statuette. Tshokwe.

More importantly, there are another set of statuettes in museums and private collections which have been thought to be representative of a Tshokwe royal style. Lima shows conclusively that these are portraits of Ilunga the mythical hunter and not of a royal ancestor like the Bakuba and Bushoong statues. Lima also shows that there is a stylistic continuity between these representations of Ilunga and the hamba figurines—introduced by this culture hero. Further, as we saw, the Tshokwe 'ancestor mask', cikunza, is directly associated by both Tshokwe and European observers with the Ilunga statues, which are also similar stylistically. Most of the other figurines depicting chiefs, hunters and women are based on models of these two archetypes of Ilunga and his consort Lweji.

The relationship of Ilunga and the hamba can also be traced to the diviner's basket, which contains several hamba figurines introduced by the hunter-hero. The basket and its objects must be seen as a symbol—a microcosm Lima says—of the new culture stage introduced with the arrival of the bow and arrow. Many of the figurines are made of the clay of the termite mound which served as Ilunga's headrest and which is a major component of village hunting shrines. As far as the figurines are concerned the use of termite mound symbolises Ilunga. Moreover, most of the symbolic elements refer to nature and hunting, elements which have not been transformed by man into cultural items—the termite mound and the forked stick are good examples of these natural, 'untransformable' items. The hamba, therefore, are affirmations of those links with the ancestors and Ilunga who are the supports of culture and the living people who activate it. In the mythical creation of the hamba figurines the forked stick and the antelope horn were the first charms or amulets; then came the figurines in the diviner's basket, and finally the cikunza. In Tshokwe ethnography we have an interesting parallel with the Bushman's predilection in myth and ritual for a special kind of antelope. The horn used as an attachment to hamba figurines and sculptured whistles come from a specific type of antelope known in Tshokwe as *ntengo* and the killing of ntengo is the dream of all hunters since it is mentioned in the myth and was hunted by Ilunga.

If we look at other examples of Tshokwe art beside the hamba figurines we find reference to hunting or the Ilunga myth. Carved anthropomorphic pillars, several metres high, are associated with fertility and hunting and constitute a defence against a dangerous one-eyed spirit of the forest. Zoomorphic representations symbolise

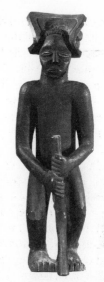

2.18 Statue of a chief, based on the archetype of Ilunga. Tshokwe, Zaire.

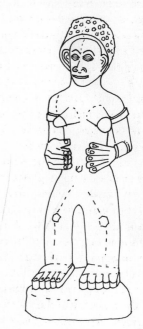

Fig. 2.4 Iweji, consort of Ilunga. Tshokwe.

hunting and fertility: the lion is invoked by unlucky hunters and women who want children, by rubbing the sculpture with the blood of dead animals. The dog is associated with Ilunga. If either the lion or the dog appears on the edge of the diviner's basket, a man must fashion them into figurines and attach them to his gun. The eagle helps hunters in trouble and should, if possible be buried with a great hunter. In myth the eagle is said to have supplied magical forest fruits and abundant game to the hunter. More indirectly

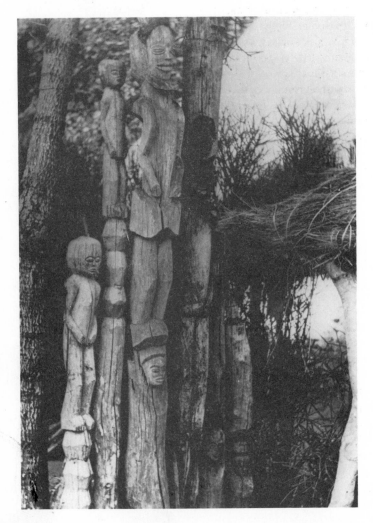

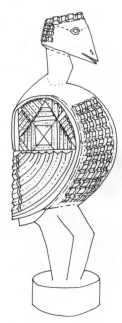

2.19 Carved anthropomorphic pillars. They represent *hamba wa suku*, spirits that ensure the success of hunting and childbirth, and protect the village against illness. Tshokwe, Angola.

Fig. 2.5 *Hamba* figurine representing an eagle. Tshokwe.

fetish figures are thought to protect the hunt against the evil machinations of witches, who are also responsible for sterility in women.

A hunting art or a court art?

Through a close analysis of hunting, myth and art objects, the whole complex of Tshokwe art can be seen in perspective. It is not an esoteric, courtly art, but a public and popular one, open to all and closely associated with patterns of thought and mythical elements of a hunting people. According to both myth and tradition, the hamba figurines were the first form of sculpture—Ilunga hunted with their help and Lweji consulted her hamba before she had recourse to the Ilunga statue. Lima argues persuasively that the figurines stand at the most archaic level of Tshokwe art: most of their symbols refer to their myth of origin, whose principal elements may be reduced to two opposing models represented by Ilunga and Lweji: the latter represents womanhood, fertility and changing society, the former the hunter who is the admired model for Tshokwe behaviour, the mythical hero, consecrated as a primary element in all Tshokwe art.

CHAPTER THREE

The art of fishermen and cattle herders

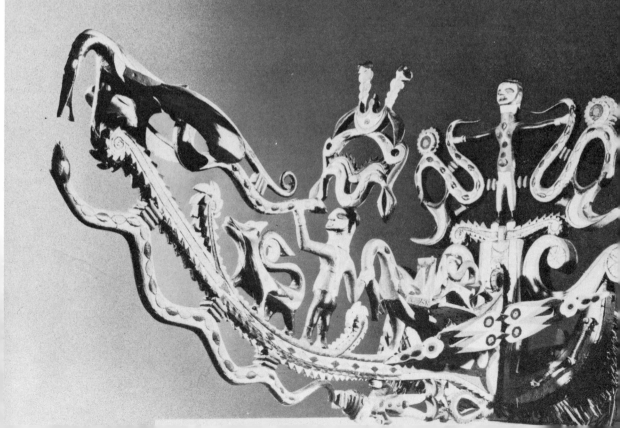

Throughout Africa many communities subsist entirely, or almost entirely, on fishing—coastal peoples (such as the Douala and Adjikru), delta fishermen (Ijo and Efik of south-eastern Nigeria), lacustrine peoples (particularly the lakes of east-central Africa) and riverine groups (along the Congo, the Niger and the Zambesi). Many of them live in close trading relations with farming neighbours and coastal tribes, in particular, have been affected by European traders and colonialists with their persistent demands for slaves and plantation labour.

I have bracketed fishermen with 'hunters' in so far as they 'harvest' the sea, taking advantage of nature's bounty without putting anything back. Chance, tides, the shifting location of fish shoals, the dangers of the hunt—particularly in sea fishing—are all factors which align them with hunters and gatherers rather than farmers. Nevertheless, while fishermen might be technically classified as hunters, they are usually able to achieve a higher standard of living than people dependent on animals and plants of the forest and veldt. An abundance of fish enables them to build semipermanent villages, and they have greater leisure to develop elaborate material cultures.

Kalabari Ijo water spirits

The art of some fisherpeople often directly reflects their way of life. The Niominka of Senegal decorate their canoes with carved pieces which they place upright in the central point of the prow when the canoe is baptised before its trial run. The Douala of Cameroon made pirogue ornaments which include elements of their myths, their fishing life and their commercial contacts with Europeans—sometimes in a phantasmagorical way. In this section I shall consider the art of the Kalabari Ijo of the delta region of the Niger in south eastern Nigeria; moreover, I shall only deal in any detail with the masks, headdresses and sculptures of the cult associated with their water

3.1 Elaborate pirogue ornament from Douala, Cameroun. Late nineteenth-century painted wood. European figures are combined with mythological motifs.

spirits (*owu*) since they are specifically associated with the sea and Ijo fishing economy. There are also important cults associated with Kalabari ancestors and village heroes which are discussed in a later section (see p. 102).

The Kalabari Ijo live in some thirty villages in the tidal zone of the delta and form a distinct sub-group and culture among other Ijo. Although the majority of the villages still depend on fishing, one or two abandoned this occupation as far back as the sixteenth century due to their advantageous geographical position at the mouth of the New Calabar estuary, taking up trade with Europeans and acting as middlemen in the sale of slaves and oil which came down from the hinterland. The rest of the villages are small, self-contained communities engaged in fishing and trading their fish surpluses with farming peoples inland. The greater part of the delta is a barren waste of mangrove forest in which the villages are dispersed and isolated. Despite this isolation—and the fear of head-hunting in the past—the fishermen travelled widely in their canoes since the habits of different fish vary. They spend months of the year away from home looking for better fishing grounds or exchanging their dried and smoked fish and salt for foodstuffs and tools. In the past even skilled carvers came from the hinterland to work in the coastal regions in return for fish. The possibility of wide communications in the delta and along the coast is important in any study of south-east Nigerian art, particularly in understanding the movement of masquerades and art forms from tribe to tribe. Water is almost never an obstacle in the diffusion of culture; an example of this is the spread of a belief in a water goddess, *mami wata* (pidgin English for 'mother of the waters'!) which we find in some form or other from the Ivory Coast to the Cameroon.

A Kalabari fishing village is a mass of mangrove poles and thatch houses, huddled together wall-to-wall on a patch of raised mud with a central square for assemblies, religious ceremonies and masquerades. Typically, a village has from two hundred to a thousand inhabitants and is divided into a number of patrilineages usually of different size and importance. Each village has a strong sense of community, with common traditions and myths; its identity in the past was probably bolstered by inter-village head-hunting, but today it is derived from a sense of isolation in the creeks, village autonomy under its own laws, special village skills and a unique culture, one of the most vital elements of which is the *Ekine* society, an association representing the water spirits.

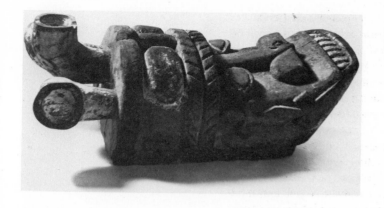

The Ekine society, according to the Kalabari, was introduced by a goddess similar in nature to the village heroes who came from out-side the village, taught men how to make the masks, dance the masquerades and care for the shrines—and then left. This, as Holas has pointed out, is a recurrent mythical pattern in West Africa whereby men assume control of what women originate, and reflects that women are all-important in so far as they bring men into the world, but men, through cunning, have acquired domi-nance. Among other south-eastern Nigerian people, the Urhobo, have a similar myth behind their water spirit masquerade. The spirit of the deep waters appeared to a fisherman who was taught

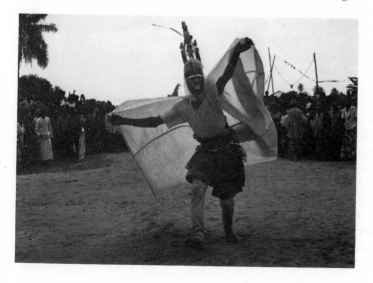

3.3 Urhobo water spirit masquerade. This mask is known as 'Ugo Biebi', the black fishing eagle. It is dancing during the Ohworhu festival at Evwreni, Nigeria.

THE ART OF
FISHERMEN AND CATTLE HERDERS

49

the dances and music by strange non-human, non-animal creatures who danced on the surface of the creeks and banks and when he returned to his village he took with him two face masks and a slit drum, plus medicine to control the water spirits. Before a masquerade in honour of the water spirit in Urhobo, she has to be attracted from her normal abode in the water; this is done by putting the slit drum in the water for six months, the goddess leaving a 'sign' in the drum in the form of a fish.

The Urhobo water spirit masquerade came from the Ijo originally. In Kalabari Ijo villages, the water spirits are guests of the villagers who are honoured by being imitated by the masks which are the faces of spirit. They mime and dance once a year and at the end of the cycle are returned, by members of the Ekine society, to the waters where they live. (In special cases a performance is given every twenty-five years.) The name 'Ekine' comes from the goddess or spirit of the water, but within the masquerade each of the numerous water spirits or water people has its own dance in which he or she is entertained by the members. The majority of the adult members of the community are members or performers of the society, which consists of several grades; initiates remain in subordinate grades, as novices, until they master the dances, songs and mimes as well as the interpretation of complex drum signals.

Who are these water spirits who are represented in mask and mime? First of all they are the 'lords of the creeks' who are thought to live in fabulous villages under the water, decked out in coral and gold and fine cloth. They are anthropomorphic and zoomorphic or a mixture of the two—natural forces, human characters, rainbows, pythons, fish. The fact that they are the 'owners of the creeks' is shown in the opening ceremony when Ekine members take out a large canoe and go with it to a spot some way away in the creeks—known as the 'beach of the water spirits'—where Ekine members offer a goat to the water people, begging them to come in from their various creek homes as their entertainment is about to begin. Getting into the boat, the Kalabari men start singing the Ekine songs and the water people are thought to follow them back to the village. Then next day the first part of the cycle of masquerades begins and masqueraders dance to the beat of the Ekine drum. At the end of the cycle, when all the masks have come out and all the water spirits have been entertained, the dancers perform together before the water people depart ceremonially from the village. This ceremony of leave-taking is known as 'filling

the canoe of water people': the whole group of maskers goes down to a special beach known as the 'resting place of the water people' where, screened from the eyes of women and children, they take off their masks and dip them in the water, a symbolic gesture designed to speed the water spirits back to their homes and creeks.

Each performance in this cycle of dances and mime begins with preliminary singing and chanting in aid of the spirit involved—the words allude to their character and achievement. Then we have the dramatisation of the god's presence by the dancer who goes through sequences of behaviour which in some way or other typify their character and attributes. During this dance the spirit of the water person enters the mask, induced by the symbols of the sculpture, the dancing and the possessed state of the dancer. In all the masquerades there is the not unusual African combination of great seriousness and great hilarity; many aspects of the Ekine performances are pure entertainment—the ugly water doctor, the libertine, the self-pitying women are all stock comic characters.

Creek shrines, village shrines and masks

Water spirits are represented in shrines in the creeks and shrines in the village, but the essence of the spirits is thought to be contained in the masks and sculpted headdresses which perform during these masquerades and function as symbols of the spirit during invocation and sacrifice before the dance. The priest of a cult at the beginning of a masquerade calls the spirits to 'come and eat'. The first step is to remove the mask from store, strip off the old paint, wash the sculpture and repaint it, 'dressing' the mask and purifying it through sacrifice. The refurbishing and the libation of blood is thought to make the mask 'work well'. The priest prays that pollution should be taken away from those persons who have handled it and that prosperity and issue should come to the owners of the land. A procession of local people then files past the shrine, dropping coins and begging the water spirits to take sickness away from their children and protect their unborn babies. The priest, who is usually also the masker, then dresses in clothes symbolic of the spirit and gives the performance often in a state of possession. It is thought that the mask 'leads' the dancers since he is possessed by the masquerade's spirit owner; the head has secured the presence and help of the spirit.

Water spirits and the village heroes and ancestors

Kalabari water spirits are specifically concerned with the creeks and fishing, while village ancestors are to do with the invention and maintenance of human skills, trade, the role of lineages—you might say that the water spirits reflect nature and the heroes and ancestors culture. While I have deliberately restricted description and analysis of masks and sculpture to those associated with water people, in performance, if not in art style and function, heroes and water people may play complementary roles. For example, during the creek 'swimming festival' for the village heroes, the whole community prepares a large canoe for a masker to ride across the creek, towed by swimming members of the cult. The masker, who is the 'hero', pours libations of gin to the water people, but at one stage the canoe is forcibly stopped by one of the most powerful water spirits who is angry at not being invited to the festival and has to be consoled by copious libations of gin. The symbolism here is clear: man, the bearer of culture, is guided by the heroes, striving to impose his techniques and skills on nature—the creek and the fish—but the water spirits continually oppose him until both he and his village gods recognise their dependence on them and pay their respects accordingly.

> Whereas the dead are guardians of the most permanent values of the social order, the water spirits are above all forces of the extra-social. They mould and control the environment from which men try and wrest a living.

It is this aspect of the water spirits which is represented in their cults and sculpture.

The mask and the spirit

As we have seen, Kalabari sculpture is first and foremost an instrument for localising the spirit it represents. But the spirit, what is it? The spirit of a person, a thing, an animal or an abstract concept? Although Horton says that the water animals are thought to become spirits through metamorphosis after reaching a certain age, we have no evidence of the exact nature of these animals apart from the elements in the masks. It would be clear, however, from the type of animals depicted in the mask and their role in myth and ritual—crocodile, hippopotamus, shark, jellyfish—that they are not of great economic significance. The fact that the water spirits

are depicted with features of water animals combined with features of the human head reflects Kalabari belief that the spirits are half-human and half-animal.

The *otobo* mask, for example, represents a water spirit with hippo features. When it appears the masker wades up to his mouth in the swampy waters around the village, wearing his mask horizontally, facing the sky and moves across the water like a vision. The mask, localising the spirit of the animal becomes the important element in the dramatic representation. The spirit is summoned and controlled and confined to the sculpture and it is the spirit which guides or possesses the actor who is the vehicle only for its dramatic presentation. The costume of the dancer also emphasises his role as the vehicle of an animal spirit: he wears a skin-tight tunic covering the arms and hands, leaving only the feet free. The dancer is sewn into this sheath—like a fish. Strapped on over this is a narrow cone made of palm midrib sections which project backwards horizontally from the buttocks and forms the masker's tail. The upper part of the costume is sewn to the headdress.

All kinds of spiritual manifestations are involved in the performance of an Ekine masquerade. Masks clearly represent the half-man, half-animal water spirits—the wood used is the tough heartwood of the common mangrove and is the standard wood for the sculptures of the water spirits since 'emo (mangrove) comes from the creeks and that is the place of the water spirits'. Nevertheless the dancer is also considered to represent the ancestor who 'introduced the water spirit' and is nervous of the reaction of the spirit to his performance, expressed by the applause or abuse of his audience. And at the same time he receives support and encouragement from the Ekine goddess whose shrine at the foot of a tree he visits before the masquerade. He gives gin to the priest who invokes the goddess on his behalf.

Fulani pastoralists

Like hunters and gatherers, and unlike most settled farmers, African cattle-herders such as the Masai of Kenya and the Fulani of western Africa, cannot be burdened with an elaborate material culture. Bulky, heavy possessions need a permanent home and cattle-herders, preoccupied with the search for pasture and water for their stock, are always moving, indifferent to material comforts.

Fig. 3.1 Kalabari Ekine mask called 'Emele'. This mask represents a crocodile. Niger Delta, Nigeria.

Fig. 3.2 Kalabari Ekine mask called 'Otobo'. This mask represents a hippopotamus. Niger Delta, Nigeria.

For the Fulani the important things are purity of race, the training of the cowherd, their language and traditions, their ceremonial patterns—and above all their cattle. Despite an extreme poverty of material culture, there is no feeling of deprivation, the Fulani making the austerity of their life a *raison d'être* in itself and a basis for their cultural uniqueness and independence. Moreover, poverty of material objects does not mean cultural poverty and literature, rather than sculpture and painting, in the form of bucolic poems, epics, tales and satirical pieces, express more completely the Fulani aesthetic—along with their love of music and their sensitive approach to the aesthetics of the body and human relations. The combination of physical mobility and artistic mobility in fact gives the Fulani art a considerable originality.

The Fulani also show a disdain towards manual labour of any kind—the working of wood, iron, leather or clay—and the few cultural objects they possess are made by Negro groups on whose lands they graze their cattle. Even Fulani who have settled in villages have expressed their artistic bent in architecture, elaborate clothes and ornaments, and not wooden or clay sculpture. Authentic Fulani art works are therefore rare and are restricted to certain details of their dress, their amulets, their headdresses of ostrich feathers, girls' anklets, and the gerewol axe.

For the Fulani a scorn for craft work is part of their general xenophobic attitude towards outsiders and their cultural and racial pride. For hundreds of years they have lived among Negro farmers, always proud and exclusive, exchanging their dairy products for farm goods and craft goods in the Negro markets. Cloth, beads, jewellery and ornaments are made for them according to their instructions and based on traditional designs and symbols. Jewellery, for example, is made on Fulani models by Bambara and Songhai craftsmen with traditional patterns of triangles, lozenges, spirals, crescents, discs, crosses and trefoils. A caste of weavers living among the Fulani of central Niger make elaborately designed blankets according to the taste of the pastoralists who use them during the dry season for protection against the cold and mosquitoes.

The Bororo Fulani

The Fulani, once a small community of northern Africa migrant pastoralists who originated from the east, have expanded over a

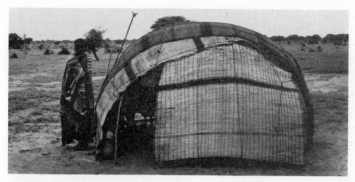

3.4 Fulani 'tent', Mali.

wide area from Senegal to the Central African Republic and number over six million. Among these it is the Bororo or Cattle Fulani who still live in small patrilineal extended families and temporarily inhabit camouflaged homesteads of rough shelters on a 'patch of earth' which they share with their cattle, who have retained their unique racial and cultural traits to the highest degree. This 'patch of earth' is an important ritual space within which the Bororo family and their herd act out their strictly patterned lives. One of the most important symbols of this pattern is the calf-rope to which young calves are tethered and which separates the men's and women's world.

The aesthetic of the body

Among the Bororo Fulani any temptation to settle in villages is countered by an intensive propaganda to encourage a confidence in the beauty and happiness of their way of life, bolstered by a pride in Fulani racial characteristics. They have an aesthetic of the body which has helped them retain their particular Mediterranean features to a remarkable extent. Young mothers massage the crania of their babies as if to model them into the desired shape—a kind of elongated sphere. They also manipulate the nose, as if they are trying to make it long and thin, giving it an elegant, aristocratic (non-Negroid) line with the forehead. From childhood the Fulani are taught to care for their bodies—they decorate and paint them- selves, fashion their hair into attractive shapes and patterns; the women cultivate the splendid undulating walk which is a feature of these people; during male beauty competitions old women

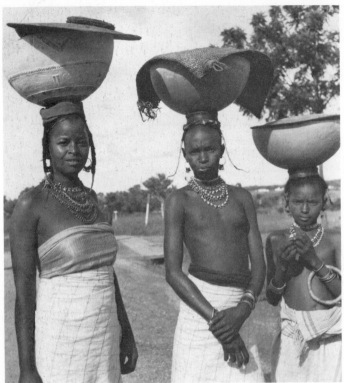

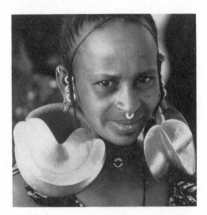

3.5 Fulani woman and girls carrying decorated calabashes to market. Keffi, Nigeria.

3.6 A Fulani woman's earrings. Mopti, Mali.

berate youths who do not come up to the highest Fulani standards.

Body decoration is eminently transportable and the Bororo Fulani, individually and collectively spend a lot of time on their hair, bodies and skin, through manipulation, painting and ornament. A typical figure in the savannah pastures is a lone, naked Bororo child, leaning on a stick, impassively watching his father's herd; he inevitably wears a bead necklace, strung with leather pendants and amulets. The women wandering across the skyline on their way to market wear elaborate bead necklaces, their arms loaded with bracelets, ears laden with brass rings—*princesses minces et lointaines*, carrying milk in decorated calabashes to sell to Negro farmers. Their indigo veils hide their bodies and fall in folds held together with finely worked chains and bead ropes. Young girls wear anklets of copper, ornaments which indicate their age and status.

The elaborate hairstyles of both men and women in many ways

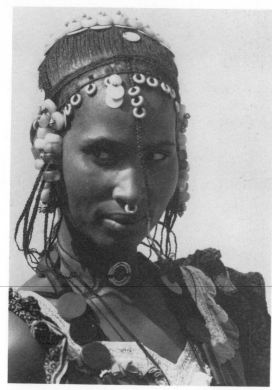

3.7 A Fulani woman's hairstyle, showing the elaborate plaiting and use of beads. Djenne, Mali.

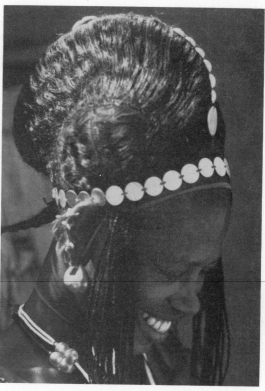

3.8 Another Fulani hairstyle showing the use of padding, plaiting, and silver. Mali.

replace the clay and wood sculptures of other African peoples. Hair is coaxed and teased into fantastic shapes, plaited, padded, held back with combs, decorated. Butter, charcoal, pieces of bamboo, silver, beads—all are indispensable items in the sculpture, which varies according to the age of the person or her social status. Hence a woman who has given birth to her first child has two strands of hair over her cheeks and fixed under her chin with a white bead; on the nape of the neck the hair is arranged in folds and is decorated with white stones: the hairstyle is meant to portray a new mother's calm and wisdom. Other hairstyles may attempt to induce child-bearing. There are also fantastically elaborate coiffures which are pure examples of art for art's sake and change after a few years with the fashion.

THE ART OF
FISHERMEN AND CATTLE HERDERS

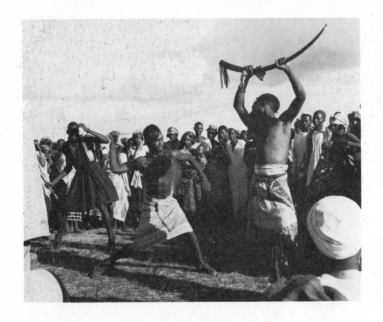

3.9 Fulani *gerewol* endurance test. The youth in the centre is about to beat the 'unconcerned' youth on the right. Nigeria.

The gerewol initiation rite and beauty contest

Among the Bororo Fulani the *gerewol* is an initiation rite which may involve sado-masochistic tests of endurance in some communities or in others is merely a dance and an occasion for romantic escapades. In either case, however, male beauty is paraded. During the tests of endurance a boy chooses a challenger to whip him— while the challenger deals vicious cuts across his ochre-painted ribs, he expresses his manhood by submitting without flinching, holding his arms above his head or languidly fingering a necklace, gazing at his painted face in a mirror. In the beauty contest of the gerewol the most handsome youths of the group use all their arts of personal decoration—the body is cleansed, oiled and elaborately painted and ornamented. They line up before the judges 'like sumptuous images of gods', their faces painted in reds and indigo, shining with butter. Their hair is decorated with cowries and sur-mounted by long, airy ostrich feathers. At each side of their face hang fringes of ram's beard, chains, beads and rings. Their faces are painted with a small stick in red stripes, delicately bordered with indigo and the same indigo is used to darken the lips. At the corners of the mouth are dark, triangular patterns; other designs are painted on the nose and the cheeks. The basic complexion colour is ochre

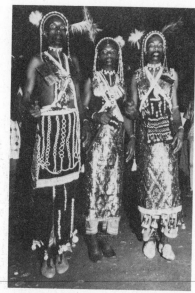

and the upper part of the body, the chest and neck are polished like mahogany. The whole costume, with its belts and amulets, necklaces and chains, contributes to the embellishment of the youths, constitutes a work of art in itself and, besides, has a magical function. The youths carry an anthropomorphous ceremonial axe, the crest of which represents a man's coiffure, while the patterns in the body paintings are pokerworked onto it. During the beauty contests the baring of the eyes and teeth reflect the fact that these are the focal points of Fulani male beauty.

Art and cattle

Most of the objects and symbols of Fulani art reflect their pastoral experience in a much more direct way that the Bushmen paintings or the Kalabari and Tshokwe sculpture do for their economies. The humblest possessions may become art objects—their multi-purpose tools, their vessels for containing fats and liquids, their containers for clothes are all embellished. Even the baggage piled on a pack-ox prior to moving camp is arranged into an aesthetic whole—bark gourds, calabashes and blankets tied together into a complex pattern. Cattle brands serve as marks of ownership, pro-

3.10 Left. A Fulani decorated calabash. N. Cameroun.

3.11 Fulani youths' beauty line-up during the *gerewol*. In their hands can be seen the ceremonial axes. N. Cameroun.

THE ART OF
FISHERMEN AND CATTLE HERDERS
59

vide magical protection for the milk when worked on calabashes and serve as a sign of belonging to a community of descendants of the ancestors of one particular lineage—they have artistic and symbolic significance as well.

The practical and noble calabash takes pride of place among the many symbols of Bororo pastoralism. It is practical because it is cheap and light; it is noble because it contains the only food worthy of mankind—milk. Some oaths are taken over decorated calabashes, which are inherited through women. The most beautiful of them, with elaborate designs engraved on them, are arranged on mats for admiration during reunions of the lineage or at gerewol dances when several lineages come together for communal activities. Their numbers and their decoration are a witness to the wealth of the lineage in terms of people and cattle and also to the importance of milk, the basic food of the people.

Many of the graphic elements in the patterns worked on calabashes derive from the group's brandmark, while common Fulani symbols such as the sun, the moon, chevrons and triangles are used. They are worked by Negro craftsmen although sometimes young Fulani girls engrave stylised patterns.

The choice of symbols and signs on the calabash reflects the passionate care with which the Fulani have worked out their relationship with nature and the universe. They reflect their ideas of God, family, fertility, social rank, milk, cattle, water and tracks—with God, water and milk as the predominant symbols. Water is represented by the universal wavy line. A triangle symbolises the nick made in the ear of a young calf—and hence the calf itself. Other lines are images of the ropes to which calves of less than two years are tied at the homestead.

In one calabash the base has a brand mark surrounded by stylised persons. The first section shows two men and a child. Instead of faces the men have representations of an embroidered design which decorates the blouses of the young men, dividing it down the back. In another section, there are four persons: from left to right they are a young girl, a man, a woman (recognisable because of the bracelets and anklets shown by a series of dots) and then by a young girl wearing an embroidered blouse for the gerewol ceremony and with a triangular facial pattern. In this design the triangles above the figures represent the calves. On a single calabash therefore we have a whole configuration of Fulani life and family and cosmology: a man with his wife and child, the gerewol feast

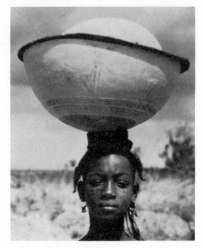

3.12 A Fulani decorated calabash showing representations of people and animals. Nigeria.

Fig. 3.3 Fulani calabash ornament showing boy in *gerewol* costume.

with its special character of racial pride and emphasis on fertility; and the calves, the economic source of Fulani economy. In another, we have gerewol dancers represented by a new kind of pattern, a line of triangles attached to a central axis, ending with two superimposed triangles attached to a central axis which represent the ceremonial of the gerewol dance.

The Fulani and the Tassili frescoes

There is another side to Fulani art, which curiously enough brings us back to the Bushmen and their rock painting (see Chapter Two). It has been suggested that the Fulani painted some of the important rock paintings discovered in the mountains of northern Africa, a suggestion which if true has important implications for Fulani history and West African art. These paintings and engravings in Algeria and the Fezzan show elephants, hippopotamus, and other water animals, along with common savannah game, horses, cattle, even

3.13 Rock painting of human figures with bracelets, hair and shoulder ornament, and markings on breast, stomach, legs and arms that are found in West African farming communities today. Tassili plateau, Algeria.

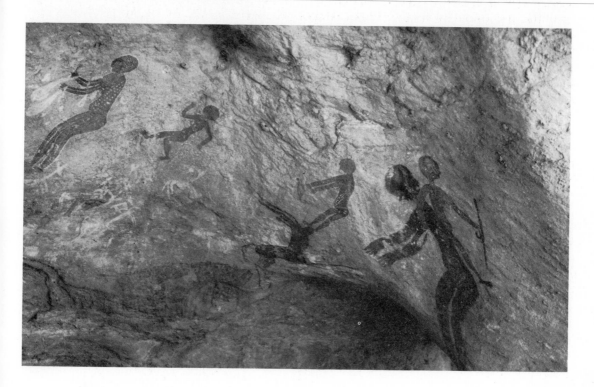

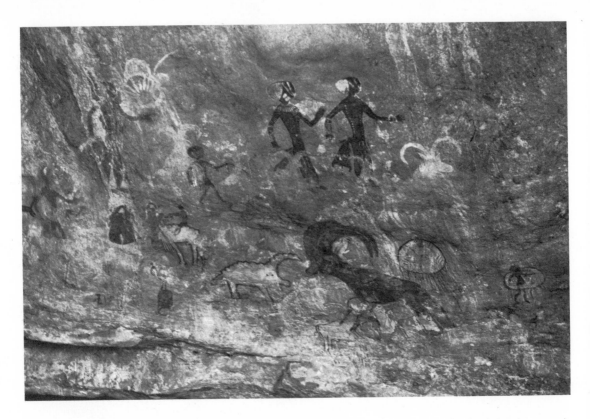

3.14 The central rock painting of two round-headed figures. Tasoumatiak, Tassili plateau, Algeria.

camels and chariots. In the great variety of animals, painted singly and in herds, battle and hunting scenes, there are many points of comparison with the southern African pictures.

The best known centre of these paintings is the Tassili plateau, explored and described by Henri Lhote in the 1950s. This mountainous area is five thousand square km of rock and shifting sand, now inhabited by a few Tuareg families, who manage to survive in this waterless zone by grazing small herds of goats on the scant pasture and drinking from a few permanent water holes. Thousands of years ago when the paintings were made, the land was fruitful, covered with forest, the rivers alive with fish. At Tasoumatiak, for example, we find paintings of several different themes and phases from well drawn figures in finery to the crude attempts at depicting camels and strange horned beasts. There is a central painting (see 3.14) of two round-headed figures about 75 cm high, with hair decorated and double stripes coming down from their high fore-

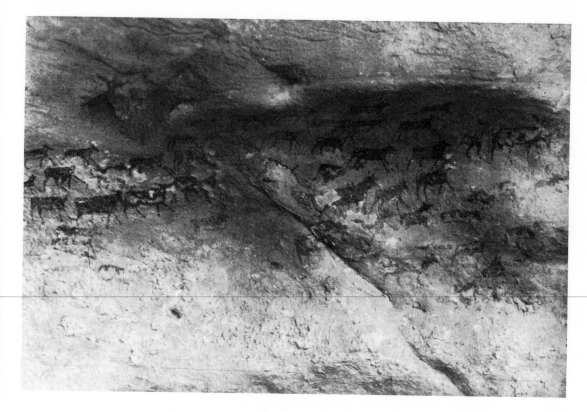

heads. They are adorned with bracelets, loincloths and necklaces. At the base of the painting moufflons (a kind of wild sheep) and other figures in white seem to have been superimposed at a later stage. Below and to the left of the two figures the wall of the shelter is covered with a maze of shapes. Many of the animals and human figures are painted in white with darker outlines; hundreds of paintings in this style are found across the plateau.

The Saharan paintings of this early period depict Negroes and a hunting way of life. Lhote named this period the Roundhead Period due to the representations of the heads of the hunters and dancers as circular discs. On these human figures bracelets, anklets, hair and shoulder ornament, markings on breast and stomach, legs and arms (see 3.13), are elements found in West African farming commodities today; they cannot of course be pin-pointed to any specific Negro group. For Lhote one painting in particular clearly indicates that the artists were of Negro stock—a masked figure stands before a

3.15 Rock painting of the Cattle period. Tassili plateau, Algeria.

THE ART OF
FISHERMEN AND CATTLE HERDERS

63

'roundhead' woman, his body painted in red clay, chequered with white. From his arms and legs sprout stylised flowers. Lhote claims that the severely abstract mask on the man is the oldest example we have depicting an African dance mask.

However, it is with the Cattle Period that we are concerned here, a later period in which hunters and pastoralists are both depicted. Various themes in the paintings, the ethnographic types, the hair-styles and ornaments of the female figures, plus the clothes and the presence of the long-horned ox (bos africanus) have suggested to experts such as Lhote, Brentjes and Dieterlen that the artists of this middle period of north African rock art were ancestors of the Fulani, a branch of an 'Ethiopian' group which migrated from east to west across North Africa in waves from about 4000 BC until the eighth century, when the Fulani arrived in Senegal.

Can ethnography provide any clues to prove or disprove this fascinating conjecture? Apparently the pastoralists depicted in the paintings returned time after time to the same place which provided a focal ritual point for their pastoral communities and a site for initiation ceremonies. The fact that they have no permanent ritual centres today may be explained by their need to search further and further afield for pasture and water; during the time of the rock paintings the cattle could have been fed and watered in a much more restricted zone since rainfall was plentiful and grass richer.

The figures of the paintings, if we can assume that the painters portrayed themselves, have copper-coloured skin and straight hair and certainly look like the Fulani cattle-herders. According to Lhote (1970), the headdress of the young girls in the paintings is still worn by Fulani girls in Mali. Brentjes writes of the girls' slim bodies, painted in red with or without white clothing—'master-pieces of ancient paintings'—and maintains that the young girls and what seems to be a bridal couple are Fulani. Moreover, since cattle are depicted in large herds with herdsmen carrying bows and arrows, and occupy an obviously important place in men's life, we are told this is further indication of Fulani authorship.

Art historians have shown understandable caution in accepting these theories. However, a publication of an initiatory text of Fulani pastoralists in the region of Senegal and Gambia seems to confirm the hypotheses of Lhote and Brentjes that the paintings were made by ancestors of the Fulani and represent Fulani symbols and myths. During contemporary rites, Fulani youths are taught the values and knowledge of the tribe, the secrets of the gods and

elements of the structure of the universe. The text of these initiatory rites, presented by Hampaté Ba who has himself been initiated, shows that the different scenes in the paintings, and even individual objects, correspond to representations in the initiation rites, particularly those evocations to do with clothes, the formation and malformation of cattle horn, sacrifices and shrines. Moreover, there are details in the paintings which correspond to elements from Fulani myths taught during the initiation rites: such as the hermaphroditic cow (Fig. 3.4) and the graphic portrayal of the Fulani initiation field, a circle with the sun in the centre and heads of cows, as different phases of the moon, spaced around it (Fig. 3.5).

Fig. 3.4 Detail of rock painting showing the hermaphrodite cow with domestic animals emerging from its chest.

Is there a typical kind of art associated with nomadic peoples dependent on animals for their livelihood? Clearly, whatever their inclinations or skills, bands of hunters wandering through semi-desert in search of game and wild plants are not going to make unwieldy ancestor statues, heavy masks or anything which heeds ease of movement. This was also found to be true of the Fulani, while the Ijo with their wealthier culture and permanent swamp villages were able to develop an elaborate corpus of sculpture.

Inevitably the art of the Bushmen, Tshokwe hunters, Ijo fishermen and Bororo cattleherders reflect directly and indirectly their dependence on animals. In the Fulani case the cow is at the centre of both mythical and artistic representations. However, it has been enlightening to find that as far as hunters and fishermen are concerned, symbols and elements of their painting and sculpture are bound up with *certain* animals only, and involve ritual and mythical concepts. The artist, in attempting to solve the problem of man in his physical and supernatural world, selects items which best reflect his cosmology and create a feeling of security and cohesion in the face of the inevitable danger and doubt associated with a hunter's life. While artists work for their own and others' pleasure, and create works which are associated with human and animal fertility, their art uses important mythological elements—the eland, Ilunga the original culture-hero, a hippopotamus—to express and order relations between man and nature and man and man, an ordering which seems to be as important for survival as the successful killing and increase of game. At the same time art reflects an emphatic distinction made by hunters and fishermen between the worlds of nature (the forest, the sea) and of culture (the home, transformed goods, inventions)—the relationship between water spirits and ancestors and culture heroes among the Kalabari reflects this well.

Fig. 3.5 Detail of a rock painting giving a graphic portrayal of the Fulani initiation field.

Bambara farmers and their art

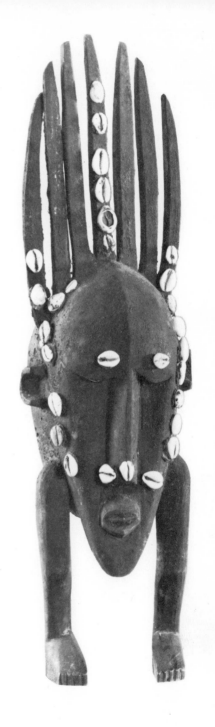

Except for a certain number of hunter groups and a few fishing and cattle herding communities, agriculture is practised throughout the continent, and in our attempt to understand African art, we should not forget that the majority of Africans are simple farmers who spend the greater part of their lives cultivating grain or roots and subsidiary crops—they are not all kings and witch doctors, long-distance traders or primitive hunters. In this chapter I want to consider to what extent subsistence farming affects the form and nature of art, using as a single example the Bambara (or Bamana) of Mali.

In the African continent there is a gradation of climate and vegetation from a humid forest belt along the West African coast and central area, where more than 250 cm of rain may fall in the wet season, to the savannah and desert margin on either side, where rain is scarce and grain grows briefly during two to three months of showers each year. Orchard bush and scrubland of the Western Sudan extend across West Africa, beyond Lake Chad and the Nile Valley and Ethiopian Highlands and are repeated in the savannah islands between the Indian Ocean and the depression around the Great Lakes and in the south west, gradually merging into the desert regions of the Kalahari. In the equatorial forest zone, rain is an ever-present condition of life; in the Bambara savannah in the Western Sudan it is awaited with anxiety, its arrival celebrated with joyful ceremony and its delay mourned as a bringer of starvation and death.

The Bambara form part of the great Manding linguistic group which includes the Mandinka and the Dyula. They number over a million and live in an inverted triangle-shaped area covering 60 000 square kilometres in west-central Mali. As their name implies—Bambara, or more correctly Bamana, means pagan—they have been converted to Islam only recently. Specialised pastoralists, the Fulani, live in symbiotic relations with these grain farmers, while other caste groups—troubadours, blacksmiths and leatherworkers —fulfil other specialised functions. They have become well-known

4.1 *Ndomo* mask, unusual in that it has legs. Bambara, Mali.

for their art and technology, metal-work, wood-carving, pottery, basketry, leatherwork, weaving and dyeing. Some of the greatest sculptural traditions are represented by their wooden masks, frequently carved by blacksmiths for the use of their cult associations which are closely associated with their subsistence farming activities.

The land of the Mali savannah, though not rich, constitutes the primary life-giving resources of the Bambara. The farmer cultivates grain, practising an advanced agriculture with deep hoeing and ridging for millet and irrigation for special crops—his skill is such that the economy is able to maintain specialists in craft, ritual and government. The major fields are cultivated by shifting cultivation associated with the burning of the bush during the dry season, after which the trees are chopped down to within a metre of the soil. When dry it is set alight. In the old fields, millet sticks and weeds are piled up and burnt and then hoed in. The preparation of the soil and the sowing is done quickly—during a period of three weeks at the beginning of the wet season, the time determined by the position of the sun. When a certain weed appears in the field, it is time to leave it fallow and proceed to a new district.

Here, naturally, we are more interested in the role of farming on a symbolic rather than a technical level. For the Bambara, farming is the oldest and the noblest profession; though other African peoples are also traders and craftsmen, the Bambara believes that only the man who works the fields with a hoe merits the term 'worker'. The farmer 'works' while other people, like the Fulani nomads and the blacksmith, merely 'do things'. Farming has inspired the development among them of religious beliefs and rituals and an art which glorifies agriculture and honours those who perform it well. Agriculture has been the inspiration for the best known of all Bambara sculpture and a distinctive style in African art.

Farming and its origins are described very clearly in the myths of Bambara protohistory in which the stages in the development of their technology are sung. I wish to include an account of part of these myths since it is the kind of religious expression which pervades the ritual of their cult associations and the symbolism of their art.

Before the invention of agriculture, people were thought to live without the aid of articulated limbs, worshipping their Creator God. One day, this god, wishing for total domination of the earth people, took root in the ground and became the first of all trees. The

original human beings, living among the burning rocks of the new world, sought shelter and solace under this wonderful tree which needed no water to become green (in fact this particular tree is without leaves in the rainy season and remains green during the dry season) and which became the earthly representative of the Creator God, the image of fertilising masculinity, the first people praying to it and receiving counsel. At that time everyone was immortal, but they lived naked and had no means of verbal communication, uttering only grunts and gestures. In order to recognise each other and display their sex, they introduced facial scarification of three or four spots—three being the sexual symbol of men (his penis and two testicles) and four that of women (her two pairs of lips).

In the beginning there was no millet and the first people received food from heaven in the wet season in stones which contained the shea-butter nut. One day, during the dry season, a woman who had expressed the oil from the nuts wiped her hands on the tree and the spirit from that time on demanded oil as an offering. The tree spirit also demanded that the women should make love to him in order for his strength to grow. However, the jealousy of his original consort in the sky, Musso Koroni, led her to inflict wounds on the earth men and women with her nails and teeth and they became circumcised and excised, the women experiencing their first menstruation. Evil, unhappiness and death came to earth as a result of Musso Koroni's fury, but the women continued to copulate with the tree and produce children. Eventually the tree demanded blood sacrifices twice a year and all menstrual blood. The men, who had learnt to make stone axes, fashioned wooden penises and inserted them in the tree god, who not only gained strength from his contact with the women, but also pleasure.

Musso Koroni, the tree's jealous wife, originated certain farming techniques and her role is remembered in some parts of Bambara during the harvesting of grain. An old woman, dressed in rags, wearing odd sandals and carrying broken calabashes, goes around the country pretending to be mad. From west to south and east to north she travels and then sits down near a storehouse. For the Bambara, farming, which was only partly originated by Musso Koroni, implies disorder as well as progress since each blow from the hoe is a wound inflicted on the impure earth. It also implies order since the cultivation of millet, the noble activity, is a purification and reordering of the earth. It was another great god, Faro, the real

father of mankind, who introduced millet and it is he who watches over the soul and the vital force of the grain and provides the rain for its germination. First fruits are offered to him as a sign of his beneficence in providing water and inventing millet. Faro is a spirit of order which triumphed over primordial lust, symbolised by the phallic tree. He introduced techniques which brought further order to the cosmic chaos. Men originally hunted and fished without tools, using their hands to get their prey and their nails and teeth to cut them up. Faro provided the fishing net and invented the techniques for the proper cultivation of the earth with a rudimentary tool. Weaving, pottery, stone, iron are all due to him. As a result, a number of agricultural rites, involving the use of masks, are performed in order to seek the protection of Faro. In the rites and ceremonies of the cult associations and in the education of the young men, this myth and its elements form a precious basis for the history of the Bambara and in the performance of the masked societies, the actions of Faro in creating an ordered agriculture, and hence an ordered world, are symbolically celebrated.

The cosmological system of the Bambara is extremely rich in ritual and symbolism and in this short essay, I must stress that I am mainly concerned with those aspects which reflect the inter-relationship between art and agriculture. While we may fully agree with Dominique Zahan in his profound studies of Bambara religion, that cult ritual is never merely a crude parallelism between human and crop fertility and that ultimately the masks and the symbolism of the rites aim at 'an identification of Man and God', we must not ignore the more overt aspects of these rites which are concerned with the basic facts of life such as birth, death, food and rain.

Among the Bambara there are six major initiatory grades—the N'domo, the Komo, the Tyi Wara, the Nama and the Kore. In each of these, rites are found which are closely related to farming and the cycle of the seasons and are oriented towards the same gods and the same mythology, part of which I briefly summarised above, and it is for the observance of these beliefs that the masks are made. The one prosaic theme running through these rites and masquerades is agriculture; masks appear in the dry season and celebrate various aspects of the new farming season—the end of the rain, the sowing; in the wet season, masks 'help' with the weeding and the harvest as well as appearing during the ordeals of initiation and

funerals of great initiates. Moreover, village associations, of less ritual significance than these cult associations, are concerned with communal labour—collective work takes the form of farming fields of families which lack able-bodied men. They are paid in cash or kind and the receipts become the communal property of the associations and help pay for feasts, materials for making dance costumes, masks, and purchase gifts for members who are to be married. In societies concerned primarily with initiation, such as the Kore, the connection between farming and symbolism may not be so obvious but fertility, crops, rain and farm labour are *always* celebrated in their performances and their sacrifices.

The N'domo

The first of the Bambara cult associations—first in the sense that its members are boys and youths—is *N'domo*. After spending the first years of his life with his mother, gradually a boy leaves her to spend more time with his friends and neighbours, 'playing' at being grown-up, a magician, a hunter, killing rats and lizards and carrying his bow and arrow and a little bunch of roots to render hunting more fruitful. Towards the age of seven or eight he undergoes the rite of circumcision, after which he is ready to join the N'domo society. This group of young boys, most of them under fourteen, has little or no hierarchy apart from the 'chief', usually the eldest and also the most energetic farmer, and his 'follower'. Each year when the new boys are received, they hand over a chicken and some cowries and take an oath of fidelity. N'domo has five grades and five shrines. It takes five years to go through N'domo, after which the boys are free to join other societies.

This association of youths is based on the more serious adult societies and they are guided by older men when they farm their special fields and cook their ceremonial meals. The spiritual patron of N'domo is the tree under which they meet; the young leader of the association is its priest. From an early age, therefore, the Bambara wear masks, perform ceremonies and are subjected to farming duties and a corporate discipline which will continue all their life in one or more of the initiatory associations. The boys farm their ritual fields with special care and the food produced is considered as sacred first fruits, eaten with care and treated as symbols of the earth and of the sun which nourishes the fruit. The

N'domo field is said to evoke the memory of the first field possessed by man, a gift of Faro, and is thought of as the first plot cleared by human hands after the Bambara abandoned their nomadic life of hunting. The N'domo members are given a clear and concise history of their agriculture in the form of the creation myth which is played out in the rites. The N'domo children in the field are compared with the 'New Man' who escaped from the limited un-social world of the beginnings of humanity. Knowing this, we can appreciate the great attention given by the N'domo to the products of their ritual plot and their consummation during the threshing of the millet. The meal of millet from this field which makes enough porridge for a few people only, is symbolic rather than real and is a kind of communion aiming at renewing the faith of the individual in the rules of the society.

The preparations for this feast and the dancing and wearing of masks play an important part in the education of future farmers. The ceremonies proceed in this way: in the early morning or during the previous days, the boys of N'domo prepare their masks in the shade of the village trees, lovingly oiling them with shea butter to give them a shining varnished appearance and adding further decoration of cowries, leather strips and red seeds. The whole is then rubbed with powder and the red juice of the kola nut. During the ritual farming the cult objects—the masks and the sticks and costumes—are taken to the N'domo fields, the boys accompanied by young girls who act as their partners. Coming back from the fields they dance and rattle their instruments and in this way regain the strength they lost during farming. The strength to farm, which they received from the N'domo spirit, is thought to be bad for the earth and affects germination and this ceremony extracts the force back from the earth through the agitation of bullroarers and other instruments.

N'domo also performs during the winnowing of the grain. On the chosen day, the women begin to winnow and the masks of the society are brought out and dance towards the village crossroads. They then dance around the women's grain, gyrating and leaping, placing the mask in front of them and pretending to copulate with it. During the dance they advance towards the pile of grain, kneel in it and thrust the horns of the mask into the grain. Then the owner of the millet, carrying a calabash full of precious cereal, comes towards the masker, throwing millet at him as the figure chants: 'If you are sown on stone, Great Millet, let God fructify

your sowing, Great Millet. Little Key of the Sky, Great Millet, let God give you this key in your hand, Great Millet. Let this be next year's glume.' As they dance, one of them twirls a wooden phallus attached to a string making a high-pitched whine. It is known as the dog of N'domo, although the word may also mean penis. In this way the group of N'domo dancers go from place to place collecting food for their feast.

At this feast, the boys eat beneath the sacred tree of the society, its protective spirit, which is honoured by sacrifice, dancing and offerings, and recalls the tree in the myth of creation. 'N'domo,' they chant, 'look at this chicken, a beautiful chicken. Isn't it fat? From all of us I offer this chicken in sacrifice. Look after us, protect us from the fury of the spirits of the bush and against evil ones. Make us strong and healthy and give us plenty of things to eat and drink and ward off illness. Bring us water and wonderful harvests. N'domo will bring wealth to our families.' Each child then dances, jumping and twisting and waving a flexible wand, some of them wearing the horned mask. Each has a girl partner who acts as his servant and with whom he flirts. After the meal there is a test of endurance during which the boys violently beat each other until they run away or blood appears. Some of the children, as young as six or seven, soon give up this game, while the older ones take it without a murmur.

Such a brief exposition of these N'domo cult activities perhaps over-emphasises the element of sex which the Bambara associate with crop fertility. As Zahan pointed out, these children are not just performing a colourful erotic dance, nor are they merely begging when they go round seeking food. They are beginning a symbolic cycle which links millet with the sky and the pere-grination of the sun and other cosmic forces linked with the grow-ing of their precious staple crop. In the dance, Man is compared with a great seed which falls from the hands of the Creator, germinates, grows and becomes fruitful to end in ultimate death under the hands of the Flail. The growth of millet and the life of man are symbolised by the wild dancing of the N'domo masker which always ends with a joyful gesture of coitus. Death at the hands of the Flail is not the end, however, since dying also means being reborn and this comes out in the final rite when man's immortality is expressed by the phrase 'this Little Key of the Sky'.

The masker and the mask, therefore, represent man and grain. They also represent the sun, the dancer following the movements

of the sun from east to west and from south to north. According to Zahan, the dance establishes a kind of reciprocity between men and the sun and millet. Man borrows qualities from the sun and grain and in return gives them something of himself. Importantly the dance and the ceremonies of N'domo also depict the progress of the androgynous child towards manhood.

The final feast is also symbolic. In taking the food, Man is commemorating the beginning of his social life, since the earth from which the cooked grain comes, is the image of the first field of social man, that is man living with his fellows in villages. These children, under the guidance of their elders are commemorating the relationships and exchanges between human beings—social life itself—since what they are eating is the counterpart of men's labour and sweat. Finally, in eating the food of the sacred field, the children remember the ties linking him to the sky and the earth. The sacrificial meat consecrates these ideas and makes them durable realities. Together the meat and grain are signs of the richness of man and his relationship to God and must be shared not only with members of the association but external elements such as the chief, slaves and caste members, such as blacksmiths. In this way the meal becomes a communion in which different categories of social beings share food. Each of the children keeps a piece of the bone of the meat they eat as a sign of their acceptance into the N'domo association.

The mask

What about the symbolism of the N'domo mask? Each grade of N'domo owns one mask, which always appears with its emblem—a stick which is also used for flagellation and symbolises the flaying of the millet. The mask itself is said to symbolise the millet and presage the growth of the next season's corn—the corn will stand up strong and erect like the horns of the N'domo mask. In Plate 4.2 the animal represented is the antelope and the horns are found on the forehead. More commonly, however, the N'domo mask has an anthropomorphic rather than zoomorphic face and is usually oval in shape with an oblong or otherwise exaggerated nose. The mouth is rarely important and is often missed out altogether. The most symbolic features are the horns, carved from the same piece of wood and rising up straight in one row, like stretched fingers, above the top of the head and on the same plane as the ears. The

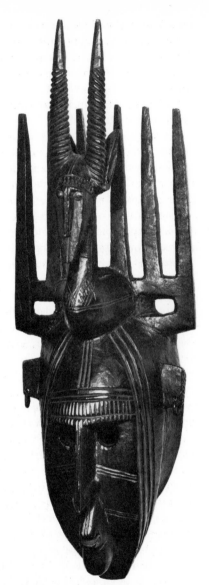

4.2 *Ndomo* mask showing antelope. Carved in the Segu substyle. Bambara, Mali.

horns are usually of the same length—from ten to fifteen centimetres—and may number from two to eight in number, the latter being more usual. The costume of the N'domo mask is composed of a sort of blouse with ample sleeves, worn with long-legged trousers.

According to Dieterlen, the masks, with their horns, recall in a schematic way the various episodes of the creation myth. The horns should strictly be eight in number, images of the eight primordial seeds, created by God for the building of the universe. The person who wears it portrays the sower of discord, the first child of God who stole the seeds from the sky in an attempt to take possession of the universe. The female figure sometimes shown between the horns is the twin of this fallen ancestor. The cowries are symbols of his adversary and vanquisher, the god who re-ordered the universe and recaptured the mythical seeds.

Zahan gives a different explanation. The basic meaning of the horn symbolism for the Bambara, at least as far as the N'domo is concerned, derives from the assimilation of these organs to the growth of grain and an analogical relationship with the human liver. Bambara farmers say that animal horns are to animals what vegetable shoots are to the earth. Ideas about animal nature derive from the observation of the plants which are nourished by the earth and similar observations about the quality and nature of animals may be made by observing their horns. Horns are considered by the Bambara hunters to be extensions of the liver. The same applies to human beings, where the liver is viewed as a connecting link between a man's soul and his body and is the meeting point of the spiritual and physical principles which are represented in blood. The liver is also a reservoir of forces which are released in animals during blood sacrifice. In these cases the liver of the victim is always very carefully removed; a part is given to the shrine, while the rest is eaten by the priest and other ritual experts. Rather than the blood, it is the liver—for the Bambara—which is properly speaking the important element in the communion between men and their gods.

This explanation provides a fresh insight into the significance of horned masks. The horns can be seen as appendages which plunge their roots into the deepest part of a person's being; they are manifestations of the liver of their owner and reveal a person's depths as the plants in the fields reveal the nature of the earth out of which they grow.

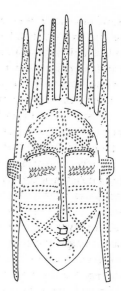

Fig. 4.1 *Ndomo* mask with copper foil overlay. Bambara, Mali.

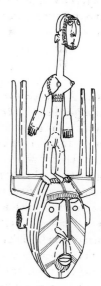

Fig. 4.2 *Ndomo* mask showing the twin of the first fallen ancestor. Bambara, Mali.

The Komo

The symbolism and rites of other initiation societies are also closely related to agriculture and the cycle of the seasons and are oriented towards similar gods and a similar mythology. All deal implicitly and often explicitly with agriculture, although unfortunately they have not all been studied in the same depth as the N'domo and in many cases we have lost the key to their symbolism.

The *Komo,* with its *boli* altars, has judicial functions and performs during passage rites. It may be joined by adult males.

Primarily, Komo is a society of initiation and education in which Bambara cosmology is taught by the use of hundreds of signs. A certain number of these signs taught in the Komo are drawn in the earth before sowing in order to encourage a bumper harvest; they are said to represent the descent of Faro and the primordial eight millet seeds. There is also an annual rite when a sacrifice is made to the earth, grass is ritually burnt and prayers are said at village shrines.

During Komo rites, the complex cosmology of the Bambara becomes explicit. The earth is conceived as egg-shaped and the habitable world as a cylindrical area which extends north and south of the equator between the tropics. The observed notions of the sun, both diurnal and annual, are represented diagonally by a zig-zag line in the Komo signs. This notion of the sun's movements is found in all agrarian rites and rain-making rites and is also engraved on farm tools and traced in millet porridge during ceremonies in the huts of certain religious chiefs. The sculpture of the snake is typical of Komo and the animal is associated by the Bambara with the annual movement of the sun and the equinoxes.

The Komo association, like the N'domo, also cultivates a ritual garden. In this field all edible plants are cultivated—millet, maize, rice fonio, manioc, sweet potatoes, yams, tomatoes—and the field is subject to intense competition and much ritual. There is a shrine with an attached mask and stone objects representing primitive tools. The hollow-headed mask represents the ancestors who first used the tools. The head of this mask is on a stick pole, which is embedded in the soil, establishing contact with the earth, the dead and the living, by pouring sacrifices into the soil through the hollow stick. The mask—really a head—is also supposed to represent another mythical ancestor who was the 'lord of the world'. It has seven cicatrised lines on the forehead, and these lines

Fig. 4.3 *Komo* shrine. Bambara, Mali.

symbolise the first Bambara word. The same lines are traced on the forehead of a newborn baby and are a sign of 'Bambara-ness'. On the Komo head two lines are incised under the eyes to give it double sight so that it can watch everything that occurs in the field, even at night.

Our information about Komo masks proper is sparse. The mask is said to be a representation of the hyaena, the great labourer of the earth and the guardian of life. As a result the masks are seen as guardians of continuity and tradition, cohesion and order. At the same time the Komo masks are associated with an increase cult and a general belief in Faro, the great creator. The masks are said to be created from the elements of the universe—water, earth and the sun.

The Kore

The most significant and the most complex of the Bambara cult associations is the *Kore*. Its functions are diffuse, although outwardly it appears to be a cult particularly oriented towards rain. Its rites are carried out at the end of the dry season around a tree within a sacred grove to the east of the village, and the symbolism of the ritual suggests space, the sky, rain, fire, thunder and fertility. To many students, therefore, Kore is a nature god, a god of vegetation and growth, who is honoured annually with elaborate rites which are accompanied by sexual extravagance. Monteil describes Kore rites as directly promoting rainfall. According to Tauxier, Kore is the spirit of the bush and vegetation in general, with 'obscene' rites centring on the tree. Dieterlen says that the Kore rites overlap and complement those of the Komo, the Kore spirit watching over the progress of the crops, its shrines watching the soul of the grain. According to her, the burning and the whipping during the rites symbolise the celestial combats of the spirits of the unchained elements of fire. Henry also states that Kore's main role is concerned with germination and a successful harvest of the millet crop, the principal protective spirit being the Kore tree.

During the initiation rites into Kore which take place during the end of the dry season, a complex series of events, sacrifices and masquerades occur including the story of Mussa Koroni and her jealousies. Initiation into the Kore takes place in the evening to the accompaniment of music, dancing and wild activity although the

serious inculcation of precepts has taken place during quieter moments. The new members, adult men, enter the sacred grove with the maskers following them. They are huddled together under a huge skin, up to fifteen metres long, which is impregnated with pepper and other irritants, while members run up and down on top of them, kicking them and sticking thorns into them. After this they go through a series of traumatic beatings and burnings. All the time the masked dancers, the hyaenas, frighten off the uninitiated, moving their masked heads backwards and forward and grunting. The clowns run around calling out obscenities, shaking their calabash rattles and blowing furiously on their gourd flutes. The costume of the clowns includes red-bean necklaces, plumes, vultures' wings, whole birds, rats' skulls, beaks. Lions, with their larger masks, roar behind the hyaenas. The monkey maskers, also bizarrely costumed with robes of reeds and conical hats, carry long sticks with which to flagellate the participants. Others carry torches which they wave through the air, scorching people as they go.

This description of a Kore rite has been put together from many accounts recorded over the past century. The assumption has always been that the rite is implicitly linked to fertility. Monteil maintains that during the orgies, the inhabitants copulate at sowing time in order to have children during the harvest period. In fact although the sexuality and abandon have been exaggerated in these accounts, the ritual mimicry of two series of activities—human sexuality and agricultural fertility—are clearly prominent in the Kore rites.

More recently, Zahan has strongly denied that the major *raison d'être* of the Kore initiation rites is mere fertility, farming rites and rain. He tells a different—or at least a more profound—story in which the long process of initiation in extraordinary detail convince us that initiation is not just a hymn to fertility. The postulant who submits to a discipline of iron, painful trials, who accomplishes complex rituals and learns a multitude of facts, is plunged deep into Bambara cosmology and philosophy. The initiation of a Bambara man into the Kore achieves his complete moral and intellectual formation. Kore aims at providing the adult Bambara with a harmonious duality which was destroyed by circumcision and allows them to return to an original femininity, at least on a spiritual plane. The Kore ritual, according to Zahan, is not one of orgy, flagellation and fertility, but involves a mystical union with God and a triumph over imminent death. The Kore ceremonial aims at man's

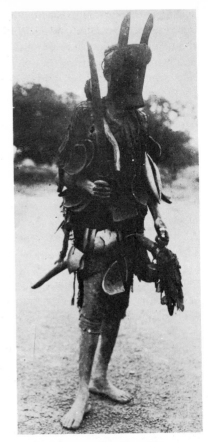

4.3 *Kore* masquerade costume. This masquerade, called *Kore Duga*, is seen riding a 'hobby horse' and carrying a sword. (See Ch. 12). Bambara, Sagosa, Mali.

sublimation and his conquest of supreme knowledge and hence immortality. On a ritual and social plane, the Kore rites celebrate the ultimate limits of human perfectability. Man is raised above material contingencies so that he may fully enjoy the pleasures offered by sovereign knowledge. Moreover, the maskers represent Bambara 'classes'. The elders of the Kore provide instruction and wisdom. Under them come the men with firebrands who represent 'famous men' of the past. The lions are the nobles who incarnate serenity. The hyaenas are the slaves who guard Bambara knowledge. Other maskers are warriors. The vultures represent women and therefore fulfil domestic functions. The monkeys represent the common people, liberty and freedom.

I have intentionally presented several views of Bambara cult associations to emphasise the immense difficulty of providing a clear-cut background to the study of African art objects. In art there are no 'simple explanations' and no straightforward correlations between cultural, social function and form. As we have seen for the Kore, studied by Tauxier, Henry, Monteil, Dieterlen, de Ganay and Zahan, the interpretations and even the facts change according to the point of view, emphasis or degree of involvement of the author. In so many cases, these societies are secret and rituals are not observed but recounted at second hand. Moreover, they vary from region to region and also from year to year. Today the rites of the Kore are rarely performed and if they are, only in a truncated fashion.

The mask

The typical Kore mask is worn by the hyaena group throughout the initiation. It is human rather than animal, although it has two zoomorphic pointed ears and no horns. The major feature of these masks is their harmonious proportions—formed of an isosceles triangle—the small base is the lower part of the face and there are four sections almost equally delimited by the mouth, the eyes and the nose, the forehead and the ears. Seen in profile the hyaena mask looks like the half-open mouth of an animal. The forehead is usually prominent, the eyes are square and there is an elongated muzzle projecting straight down, the bulbous forehead is pointed at the top. The ears—seen from the front—continue the outline of the face. The two sticks carried by the hyaenas are said to be the front legs of the animal. The woods used in making the mask are

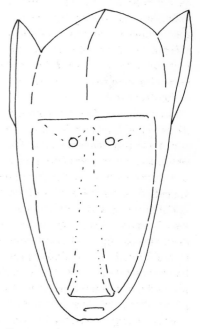

Fig. 4.4 *Kore* hyaena mask. Bambara, Mali.

different—one is the same as the wood used to make the mortars and pestles to grind millet—another is the tree involved in the myth of origins which has leaves during the dry season and informs the Bambara of the approach of winter. The symbolism of the wood is certainly concerned with agriculture. Other protagonists of the Kore rites carry long painted planks or wear extravagant costumes. The lions sometimes wear hyaena masks and the monkeys have another type of mask and a tail of plaited grasses. According to Monteil, although the masks are all anthropomorphic, they are meant to represent the supernatural forces of the bush.

The Tyi Wara

As we have seen, a close analysis of mask, society, function and symbolism becomes very difficult when we are confronted with a wealth of confusing, even contradictory evidence. In our study of the Kore and even the N'domo, the background information provided by the anthropologist remains little more than that—social background, without any possibility of a neat tie-up between the symbolism, actions, words of rite and the mask. With the *Flan n Kuru* and the *Tyi Wara*, pragmatic societies explicitly concerned with agricultural labour and fertility, the problems are less serious.

Subsidiary farming groups known as flan n kuru are societies of young men which perform communal tasks such as clearing and tilling the land, sowing and harvesting. Flan n kuru is a straightforward mutual aid society with little religious or symbolic meaning, although even the scarification on the faces of the members of these work parties recalls the agricultural myth. To the expert, the marks are connected with one of the myths of the origin of agriculture and they are also painted on masks. They consist of eight small scars, two vertical ones at the roots of the nose and three under each eye and are said to represent a fabulous being, half-man, half-animal, who taught men how to cultivate the earth.

This being was Tyi Wara, the best known of all Bambara farming spirits and the inspiration for the wonderful antelope masks and the society known by the same name. Tyi Wara was the offspring of the hooded snake and inherited its shape of head though with human ears. The mother of Tyi Wara was Musso Koroni, the first of the earth's creatures, in one form of the myth. She had issued from a piece of wood, the material form of the creator of which she then

became the wife. From her are descended all living things, human, vegetable and animal. This woman decided on the suggestion of the creator to cultivate the wild grasses and improve them. She even copulated with the snake when she found out she could farm better with his help, and delivered Tyi Wara.

From birth, Tyi Wara cultivated the soil with his animal claws and his feet and a pointed stick in his hand. With his neck and head dilated in the form of a hoe, he tilled the soil, fertilising it at the same time, phallically, with his venom, as his father had done before him. In one myth it was through the work of Tyi Wara that the grasses became edible grains. He also taught the techniques to men and gave them a liking for agriculture. However, as corn became plentiful, man grew lazy and frivolous and they began throwing the grain at each other and using the cobs to clean their bottoms. Tyi Wara dug a hole and buried himself in it and men, finding they had lost him for ever, made a mask in his memory.

The Tyi Wara mask was then used in farming contests between young men, the masker representing the tireless snake-farmer of the legend. It was also thought that the imitation of the Tyi Wara signs would give human beings his gift for work. For this reason the same scarifications appear on the human face and on shrines and represents one of the Bambara primordial ancestors. The reproduction of the tattooed face of Tyi Wara, particularly on some sanctuaries and granaries, ensures the persistence of his activity and the continued efficacy of the cicatrisations by means of which man acquired his ability to be a good farmer. The designs on the granaries conserve the soul and life force of the grain—a granary on which the paintings were not renewed each year would be like a man deprived at once of clothing and all means of sustaining life.

Already in this brief exposé of Bambara culture we have found several parallel myths which credit a creator god, a woman, a snake with the origin of agriculture. Some say that a supernatural being, half-animal and half-man, taught the Bambara how to cultivate land, while others that the antelope figure represented in the Tyi Wara mask was the offspring of the woman known as Musso Koroni and a snake. Nowadays the myths are being forgotten and people say that Tyi Wara means good farmer or 'farm lion', or a Tyi Wara is a man who spends the farm day from sunrise to sunset bending over his hoe, not stopping to rest or drink, hoeing with joy and pride. His harvest is the best, his fields are free of weeds and the quality of his millet and corn is superlative.

Tyi Wara, properly speaking, is a cult association into which all adults are initiated. Its chief is frequently the blacksmith, who is also the sculptor of the masks, but Bambara elders direct the ritual. During the sowing and harvest seasons, the Tyi Wara masks are employed in fertility rites and represent the spirits of the forest and water, assuring fertility to both men and fields. In its purest form, the dance of the Tyi Wara was a secret dance of an initiation society, like the Kore, since originally it was a secret society, whose main function was ritualistic—the dancing of the mask invoked the blessing of Tyi Wara on man's farming efforts. Nowadays, however, the mask performs in the open in the presence of women and children and is often taken to neighbouring villages where the uninitiated are allowed to watch. Tyi Wara has therefore become a dance association which performs whenever land is communally farmed, and in this it is hardly distinguishable from mutual aid societies in that it has assumed a non-religious character to encourage farmers to work hard.

The Tyi Wara dance is performed during the latter part of April or during the month of May just before the beginning of the rains. It is also performed during the rainy season and up to the month of October when harvesting begins. In the symbolism of the mask and in the actions of the dances, we can still glimpse the mythological nature of the ceremony as the dancers imitate the leaps and bounds of an antelope; in this way they are honouring the animal, which in their tradition was sent by the creator god to their ancestors to teach them the cultivation of grain.

There is a communal field, known as the Great Field, where the Tyi Wara dances to encourage the menfolk to imitate the virtues of the original Tyi Wara. The head of the association first buries a piece of the Tyi Wara fetish on the path leading to the field. Then women arrive, carrying food and water for the men who are their 'companions' in the association—as in the N'domo each initiate has a female partner. The men follow them, accompanied by the village drummers and bell-ringers and as the orchestra plays the women sing and the men hoe. Finally, in the middle of the tilling and singing, a figure wearing the male antelope headdress appears from the bush to the great excitement of the crowd followed by the female figure, both leaning low on their sticks. The male figure makes loud screeching noises. Women sing in praise of the Tyi Wara, the most powerful being on earth, stronger than all men and stronger than the lion. They sing of the exploits of their ancestors,

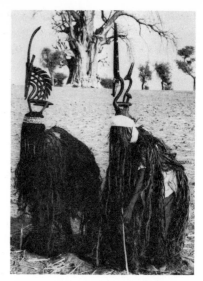

4.4 *Tyi Wara* male and female antelope masqueraders dancing in the Great Field. These masks are carved in the Segu substyle. Bambara, Mali.

mentioning the names of famous hoers, great farmers. The men cultivating the field are teased for their weakness: 'They are like women.' Each girl tries to encourage her companion—her *fla*. All the time the dancers are supposed to imitate the movements of the antelope—screaming the wild cries of the animal, leaping and jumping, running around the field. They end the dance by jumping into the air and coming down to the ground in a squatting position. The dancers, bent double and gyrating, are said to represent the primaeval farmer. At another stage, the movements of the masker are supposed to represent the antelopes being hunted out of their home in the bush during the burning before tilling the ground.

Despite the increased secularisation of the Tyi Wara dances, we can learn a lot about the beliefs associated with the Tyi Wara rites. Tyi Wara associates man with the cosmos through his activities as a farmer—through farming they are put in contact with all the elements of the cosmos, the earth, the sky, the sun, the stars, the moon, the flora and fauna, the seasons, along with iron and smithying. Again the most profound analysis of the Tyi Wara society has been made by Zahan; according to him the Tyi Wara rites and masks exult the marriage of the sun and the earth, a marriage which brought forth humanity. Moreover the Tyi Wara is also connected with hearing: hearing the recital of their ancestors' achievements by the Tyi Wara performers the Bambara farmers are encouraged to emulate them. The Tyi Wara mask is therefore centred on a narration of the work of man, the sun and the earth—the main actors in farm work. The Tyi Wara also manifests analogies with the hand and the stomach—the hand, because it is the work tool *par excellence*, the stomach because it is the place for the elaboration of life, as the earth, which is glorified as the Tyi Wara is for grain.

Thus in the Tyi Wara performance, consciousness becomes exteriorised and the mask and the masquerade aim at manipulating the sun and persuading it to fertilise the earth. Sun and earth is the source of subsistence and the same union provides a model for men's association with women, the basis of life's renewal through procreation. The kinship of this society with the hand and the stomach places the emphasis on the idea of work, the germinating of the millet seed inside the earth, as well as the process of the formation of a human life and the transformation of food into life—gestation and digestion both take place in the stomach. In brief, the Tyi Wara is merely synthesising man's activities in so far as they are to do with grain and the nourishing of human beings.

Despite the relative complexity of meaning of the Tyi Wara rites and the various myths which support it, the masks are remarkably homogeneous. The male and female masks respectively represent the sun and the earth using the antelope as an intermediary and instructor on agricultural affairs. The roan antelope symbolises the sun and embodies male qualities while the waterbuck symbolises the earth and the female. Sometimes, again because of its solar symbolism, a third animal, the aardvark, is shown on the male mask.

The style of the Tyi Wara mask is immediately recognisable. It is carved semi-naturalistically or abstractly, in the same style, but never identical. The famous antelope is provided with a mane, the construction of which lends itself to an extremely stylised design executed in openwork. They are also 'scarified' with the eight marks, which recall the original agricultural myth and are intended to confer on the bearer the qualities of which they are the symbols—mainly a relentless zeal for farmwork. The male mask is sometimes provided with a penis, the female with a child. In the vertical mask, the sculptor reduces body and legs to minimal proportions and develops the neck, muzzle and horns and mane in a pattern of flowing lines within an elongated vertical curve. The female usually has no mane but is given an elegant neck and a drawn-out snout. In the vertical masks, the long horns represent the hippotragus with a series of triangular forms representing the fur mane found on the neck and back of this roan antelope. Horizontal antelope masks are more naturalistic and in these, the head and neck of the hornbill is often represented.

The masks are made by the blacksmith for members of the association to a design chosen by them. Nowadays the sculptor is paid. Once carved, the mask is decorated with designs and the wood blackened by placing it in front of the smouldering emblems of his forge. The headpieces are decorated with pieces of red cloth and are worn with a costume composed of black-dyed fibres which are also used for making the circular veil which hangs from the basket cap below the mask. They are kept with the Tyi Wara shrine figure in the Tyi Wara house. This figure—or fetish—may consist of a mound built up over the years with caked blood, mud, bones and cotton. In south-eastern Bambara, the fetish is made in the form of a man carrying a hoe. The statue's head is a combination of animal and human characteristics and is given a pair of circular

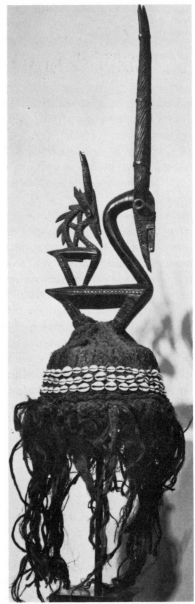

4.5 *Tyi Wara* female vertical mask. The female has a male child on her back. The basket cap and fibre veil remains attached to this headpiece. Bambara, Mali.

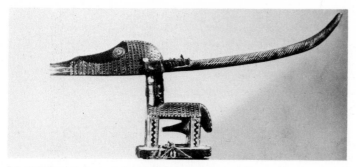

4.6 *Tyi Wara* male horizontal mask decorated with metal, fibre and beads. Bambara, Mali.

horns. Older masks associated with shrines are considered more powerful because they have acquired strength due to sacrifices performed over them. The prestige of a mask also increases by linking it to various supernatural phenomena associated with agriculture or by a plentiful harvest.

The Tyi Wara dance headdresses, therefore, symbolise a magical being often conceptualised as part-man, part-antelope, a creature who brought to man the concept of soil cultivation. An interesting substyle of the Tyi Wara is found in the rare headdresses made primarily in the Bougouni area. This is a stylised male and female torso with carved horns over which are superimposed real antelope horns. More naturalistic than the usual Tyi Wara masks, these headdresses are carved in what most authorities consider to be the oldest style of Bambara figurative carving. Some Bougouni masks are so abstract, however, that the natural sources are not recognisable. Sometimes antelopes are carved on the backs of lizards or tortoises. The variety among the masks—within the general framework of the antelope style—is therefore remarkable.

Little else can be said about the symbolism of the antelope masks. The largeness of the ears has been said to be related to hearing, the sense with which the Tyi Wara is associated. The horns and similar curving motifs create an endless source of artistic inspiration and seem directly concerned with fertility. Thus, while accepting Zahan's warning that Tyi Wara, like the other Bambara cult associations, may have a deep metaphysical significance, it is clear that the activities of the Tyi Wara and the symbolism of the mask —the horns, the eight scars, the antelope itself—are concerned with increased agricultural labour and prosperity.

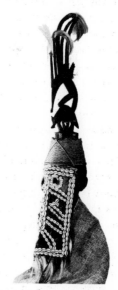

4.7 *Tyi Wara* mask in Bougouni substyle, showing an antelope on the back of an aardvark. Early twentieth century.

Commerce and art

Most of the criteria we apply to European and classical art must also be applied to African art—whether they be aesthetic, sociological or economical. Thus, brilliant works of art in Africa are not just accidental products of certain religious preoccupations, a kind of 'primitive mentality' which throws up stupendous stylised masks or abstract figurines as if by magic. The African sculptor normally works for gain—money, goods in kind, a wife, or at least prestige. In Africa, as in Europe, art needs patronage; works of art are commissioned by chiefs, elders, societies or lineages before they are made and it is the disappearance of the patron in some form or other which has caused the decline in African art in the twentieth century, not the incapacity or the loss of vision of the artists.

Patronage, on the whole, exists or at least flourishes best when there is a surplus of economic goods, a surplus usually associated with trade and exchange. Even the Bambara blacksmith-sculptors receive surplus millet and other food in exchange for his craft. The Fulani cattle herders pay for their decorated calabashes in milk. The Bushmen exchanged ostrich eggs for valued goods possessed by their Bantu neighbours. In Africa large-scale commerce, centralised states, kings, the centralisation of wealth in the hands of a few—whatever the social and economic disadvantage to a peasant or working class—have frequently resulted in the development of important bodies of art. Economic triumphs as in Greece and medieval Italy provided a background and an obvious system of patronage for local artists and craftsmen which have parallels in Africa. In Benin or Ife or among the Asante where there was prosperity and trade and a degree of urbanisation we have a flowering of art.

It is no accident, for example, that one of the greatest art styles—that of the Yoruba—should have been created by a nation of traders and shopkeepers. Even in the first quarter of the nineteenth century when Clapperton and Lander visited Oyo—then in decline—they were amazed at the well-organised and peaceful flow of trade and also the urban developments associated with this

5.1 Mask of Kofi Kakari. Asante, Ghana.

commerce. The Yoruba, numbering almost ten million today, lived in large towns such as Ibadan and Ogbomosho with developed political institutions. Their urbanisation index today is higher, at 37-4, than that of France. We shall discuss one aspect of Yoruba art in chapter

In fact the whole of the West African coastal zone or equatorial forest between Cameroon and Sierra Leone, was dominated by trading empires, commercial ports and market towns. It was in the forest countries to the west and east of the Dahomey Gap, a corridor of open savannah country which leads from the interior to the sea coast, that there arose the famous kingdom of the Akan (Asante), on the one hand, and Benin on the other. Oyo, in western Yorubaland, dominated the important trade route down through the Dahomey Gap until the beginning of the nineteenth century when challenged by Dahomey and beset by Fulani incursions from the north. In other parts of Africa, although urbanisation may not have been so strongly developed, the existence of an international commerce led to the growth of cultural centres, often based on the palace of a king or trading princes. Good examples of these cultural centres can be seen in Cameroon— Fumban, the capital of Bamum, for example, has a sultan who protects and encourages a large number of artisans organised into craft groups and settled in a special part of the town. As in the neighbouring Bamileke kingdoms, the wealth of Fumban grew up from intensive trading in slaves, salt, kola nuts as well as European goods and luxury items.

Archaeology is gradually showing us that early artistic triumphs were probably based on a lively commercial exchange—Sao and Nok are two examples. We have much more information on early medieval trading empires which produced elaborate political systems and cities—the empires of Songhai, Mali and ancient Ghana are examples. In these cities there were artisan groups which had mastered techniques of working iron and bronze, ivory and gold. Commercial networks early on provided iron and the copper necessary for working bronze. The governments had enormous surpluses due to a prosperous transcontinental or Atlantic commerce in slaves, salt and gold, which enabled them to support specialised groups. The ruins of great towns, which have been known in Africa for over a thousand years, are found on key commercial routes. In the eleventh century, Kumbi, the capital of the ancient Ghana empire, had almost a quarter of a million inhabitants.

Mali, the name of the town where the king resided as well as the state, moved its site successively from Jeriba, to Niani and to Kangaba, each time in an attempt to control important trade routes. Timbuktu and Djenne became centres of cultural life. These empires rose and fell in almost regular waves, depending on trading fortunes.

Gold

Gold is a shining thread in the commercial history of Africa in its relations with Europe and the Middle East. Zimbabwe provided Arabs with gold ore. Gold was also a determining factor in the history of West Africa—the Romans desired it and so did the Carthaginians, the Arabs, the Moroccans, the Portuguese and the English. Gold, along with slaves and salt, kept the ancient desert routes open in the Western Sudan. Morocco, for example, traded with the shadowy kingdom of Ghana, in spite of its remoteness and the barrier of the desert and the fact that the African kingdoms successfully kept the secret of the source of gold from the northern traders.

There were occasional glimpses of African gold in quantities which clearly betrayed the fabulous wealth hidden away in the interior. In 1324, for example, Mansa Musa of Mali came out of the Western Sudan to astonish Egypt and the Muslim world with a prodigious display of gold in the form of gold dust and ornaments. The source of the gold—the mysterious Wangara—remained only a name. The exchange was done by the strange system of silent trading. The gold merchants would be taken by their local agents on a journey of some weeks until they reached a quiet spot by a river—the merchants announcing their arrival by a loud beating of drums. They then laid out piles of goods and merchandise along the bank and retired out of sight. The locals would emerge and place a heap of gold dust beside each pile and withdraw until the merchants could examine the gold and, if satisfied, take it and leave, beating their drums as a sign that trade was over.

This situation was described for the West African coasts during the time of Phoenician trading. Herodotus writes:

Off their coast as the Carthaginians report lies an island by name Cyraunia . . . and there is in the island a lake, from which the young

maidens of the country draw up gold dust by dipping into the mud birds' feathers smeared with pitch . . . There is a country . . . where they no sooner arrive but forthwith they unlade their wares and having disposed them after an orderly fashion along the beach, leave them and, returning aboard their ships raise a great smoke. The natives when they see the smoke come down to the shore and laying out to view so much gold they think the worth of the wares, withdraw to a distance. The Carthaginians upon this take it and go their way. But if it does not seem to them sufficient they go aboard ship once more and wait patiently. Then the others approach and add to their gold till the Carthaginians are content. Neither party deals unfairly with the other. For they themselves never touch the gold till it comes up to the worth of their goods, nor do the natives ever carry off the goods until the gold is taken away.

In exchange for the gold, the northern merchants mostly brought salt. The natives of the Sudan were self-sufficient in everything except salt, which could only be easily obtained by the people living near the sea. Salt was a real craving and a luxury often only the rich could enjoy. It was not practicable to transport sea salt for long distances so the Sudan negroes sought the bulk of the salt from the deposits of rock salt in the Sahara. The salt of Taghaza, essential to the gold trade, is described by Ibn Battuta in the fourteenth century as a monstrous village with houses and mosques built of blocks of salt, roofed with camel skins. There were no trees, nothing but sand and salt dug up in thick slabs by the Negro slaves.

The reports of early travellers and recent archaeology has shown that the towns and palaces of these Sudanese African kings were embellished by works of art and ornament, the main element being, of course, gold. El Bekri described Kumbi, the original capital of Ghana, as a hive of commercial activity centring on a splendid court. The city was divided into two parts, one centred on the Muslim traders and the other on the pagan king. The city of the king was built primarily of clay although there were some stone buildings; the houses surrounded a sacred copse where priests lived and looked after the burial places of the kings. Surrounded by his retainers, the king was the centre of ceremonial and gorgeous pageantry which combined to present a scene designed to give an impression of wealth and economic resources. El Bekri described the king at an audience, adorned in jewellery and a golden head-dress, in a pavilion around which stood ten horses in gold trappings.

Behind the throne were ten pages, holding shields and gold-hilted swords. On the right were the sons of vassal princes and in front the viziers. The pavilion was guarded by hounds wearing collars of gold. The royal treasure included a gold nugget of huge size. Ibn Haukal, in an earlier century, wrote that the king of Ghana was the richest king on earth because of his wealth and stocks of gold. He was said to keep a thousand horses stabled in the palace, each of the animals always sleeping on a mat lightly secured by a silken cord around the neck and feet. Leon Africanus reported that the king of Timbuktu had many plates and sceptres of gold, some weighing over five hundred kilos.

While these medieval Sudanic emperors encouraged artisans and artists to embellish their cities and palaces, particularly with gold objects, we have very little first-hand or archaeological information. Moreover, since gold is of such great value, in times of financial crisis and during wars the objects would almost certainly have been melted down. Nevertheless, after the discovery of the Atlantic sea route, Europeans, also hungry for gold, bypassed the ancient desert routes and approached the Western Sudan and its gold mines from the sea. We have first-hand knowledge of the trade between these Europeans and Africans and the palace and court of the Akan kingdoms which is of much greater detail than the sparse reports of the Muslim travellers.

The Asante

In the Akan kingdoms, the colonial Gold Coast and even in modern Ghana, one of the foundations of the state continued to be the working and trading of gold. Most Akan towns had goldsmith quarters, at least until the end of the nineteenth century. Gold was traditionally mined by local peoples using the old techniques and keeping their secrets assiduously; when the first colonial prospectors arrived, they found that all potential mine locations had already been honeycombed with pits made by local workers.

Both men and women worked the gold, although the chiefs employed male slaves. The soil was dug out of the pits with hoes and digging sticks and hauled up in baskets. Because of the ever present danger of the pits caving in, protection was sought by sacrifices and personal taboos such as abstinence from sex before working in the mines. The men usually did the digging while the women carried it to the nearest source of water in bowls. In the

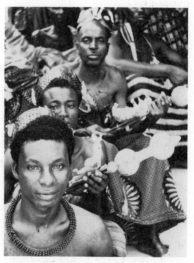

5.2 Sword bearers of the Omanhene of Kumawu State (see 6.1), holding gold-plated ceremonial swords. Asante, Ghana.

1900s, however, mining as a source of income for Ghana collapsed and was replaced by the commercial growing of rubber and cacao. Today the Ghanaian industry is in the hands of large corporations.

For hundreds of years, gold had been the principal economic bulwark of the Akan states. Trade in the metal had been systematically set up by the Portuguese as early as the fifteenth century and its prodigal use, which so astonished early travellers, was a political and artistic sign of divine authority. Gold, for the Akan, was the source of life, its colour was the same as that of the king, and was a symbol of absolute power. Unfortunately many of the greatest art objects in gold have disappeared—melted down, stolen or sold. The most splendid which remains is the mask of Kofi Kakari (Plate 5.1), almost the only surviving evidence in gold of a splendour and ostentation based on the economic hegemony and political divine kingship of the Asante. On festive occasions the Asantehene, ruler of Asante, wore large embossed and hammered or cast gold breast-plates; his robes and his ceremonial weapons were decorated with gold and his throne was ornamented with gilt bosses and other designs. Splendid ornaments were covered with gold-foil, hammered fine. The Asante also used *cire perdue* techniques for casting small gold figures and masks, a technique which was also known to other peoples, such as the Anyi and the Baule. This process, in which a single casting is produced each time, the model being destroyed in the process, was used for the Ife, Benin, and

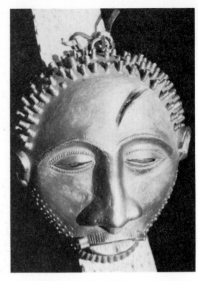

5.3 Small gold mask, depicting a conquered chief, fixed to a ceremonial sword covered with ray skin. Part of the regalia of Ejisu state. Asante, Ghana.

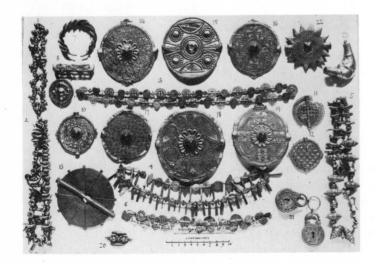

5.4 Gold jewellery of the Asante, Ghana.

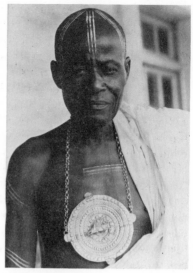

5.5 Gold jewellery worn by the Omanhene of Bekwai State. The medals were awarded to his predecessors by the British Crown. Asante, Ghana.

5.6 Asante priest wearing a gold disc-shaped pendant. Ghana.

Nupe bronzes and is a process found principally in the western part of the Sudan, in Nigeria, Benin and parts of the Cameroon, the Ivory Coast and Ghana.

Goldsmiths were a privileged caste among the Akan, constituting a kind of fraternity which passed on their skill and their art to sons or nephews, apprentices—always kin—learning the craft for two or three years in the house of craftsmen. The goldsmith worked the gold into delicate jewellery as well as massive royal ornaments —chevrons, stars, lozenges, circles and fringes are worked on to a background of delicate threads. One disc-shaped pendant shows symmetrical motifs grouped around a central boss. Rings or cylindrical tubes were strung on fibres. Pennants were made. Miniature masks depicted conquered chiefs or ancestors, usually bearded with plaited hair. This jewellery, worn by the aristocrats, was associated with their special status. The pieces carrying the most prestige were worn only by high dignitaries or members of the royal family during periodic national festivals. Gold thread was also used for ritual pottery and printed materials.

COMMERCE AND ART

Gold-weights

There is another aspect of the Akan gold trade which had an artistic expression; these are the well-known gold-weights. As long as gold dust was used in Ghana as a currency, every adult who had anything to do with trade—either local or international—had to have a set of weights, the quantity, size and artistic value depending on personal rank and wealth. Poor people used seeds and other natural weights. Others used small brass or bronze castings portraying animals, insects, objects and situations from their daily lives. These gold-weights—and it must be remembered that they are called 'gold' weights because they were used to measure gold, not because they were made of gold—were cast by the lost wax method. Unfortunately, along with the abolition of gold dust as a currency, the art has steadily declined. Today the weights are collectors' items. New ones are now being made for tourists, but since they lack their original functional values as weights, most of them also lack real aesthetic value.

The small models, the weights themselves, were treasured by Akan traders and used wherever gold dust was the normal medium of exchange. They are known all over this Akan zone; it is only because their use by the Asante has been best documented that they have come to be known as 'Asante' gold-weights. A trader's kit included not only the weights, but simple beam scales with circular pans, cast or riveted brass boxes used for storing the gold dust, the broad shallow scoops for blowing down to remove impurities and the spoons for putting the dust on to the scales. In the past every senior man who was regularly involved in trade had to have his own set of weights or at least have access to a set. In some Akan areas, when a boy grew up, his father gave him a small quantity of gold dust and a set of small weights and miniature scales, spoons and scoops so that he could learn the correct way to handle the dust and carry out commercial transactions.

Kings and princes also had their sets and elaborate ones have been found hidden away in the treasuries of kings and chiefs. Merchants and traders were checked by the weights of their patrons, most of which were slightly heavier in order to favour the purses of the royals. Kings also had treasury officials who looked after, as state property, one or more sets of weights covering a wide range of values—far more than the dozen or so needed by an ordinary trader. The weights of chiefs and officials, carefully wrapped up in protective cloth or skins, were crucial for the

functioning of the financial operations of the court—taxation and levies—and were regarded as royal property and were kept in trust for royal ancestors who had reigned in the past and continued to rule through their living descendants. Among commoners, weights were passed down within the matrilineal descent groups, and were highly valued for their artistic, religious and practical worth.

The Asante relied on other things as well as weights to measure their gold dust. Seeds, small brass pendants in human form (usually from the northern Senufo areas), European cartridge cases, buttons and buckles, military equipments, stones and scraps of metal were used. As far as ordinary people were concerned, market women for example, considerations of cheapness and convenience overrode the expense and prestige of owning specially manufactured weights. The basic unit in the Asante system of weights was the tiny red seed of the *abrus precatorius*, a tree found very widely in the tropics and much used in decorative work. The smallest brass weight weighed ten of these seeds and was worth a shilling. Many of these metal weights have been buried for years, often with their owner. Some of them are very old and can be dated by such features as details of eighteenth-century European dress. Others made from seeds or wood have not of course survived.

The size and mass of the gold-weights are, of course, determined by practical considerations. They are first and foremost weights, not art objects. Most of them are only an inch or so high, but their casting is usually of great merit. Some are made directly from objects like beetles or groundnuts and show sharp detail.

In the nineteenth century, European-made weights were introduced—nests of graduated brass weights from England and Germany. In the 1880s Richard Burton reported that European adaptation to local needs had gone too far—even fake gold dust was being manufactured in Birmingham for sale to Africans who tricked each other as well as Europeans with it. In any case the use and manufacture of the weights declined rapidly after the British colonial conquest at the turn of the century. By 1920, if not before, weights were being made almost solely to sell to Europeans.

The weights therefore once occupied a special position in Asante society. Kumasi, the capital, attracted brassworkers or bought them as slaves. Others came as captives from other defeated Akan states and were forced to work for the kings and the chiefs and the great traders. Kumasi in the nineteenth century was a highly cosmopolitan city from which great trade routes stretched out in every

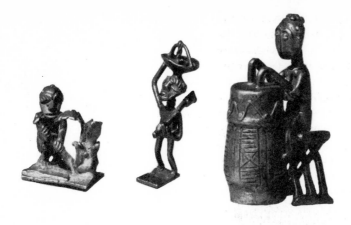

5.7 Gold-weights of the Asante, Ghana.
Left: people engaged in various activities;
above: fish.

direction, maintained and policed by the royal bureaucracy.

The gold-weights were inventive, and owners valued the originality of their sets. The users, too, wanted them distinctive since they showed them off as prestige objects while the artist also wanted his work to be distinctive and hence identifiable as coming from his atelier. The symbolism of the weights is not always easy to decipher, although the common Asante symbols are used. They are either in the form of real objects, animals, or humans or are abstract forms in geometrical shapes. Models of not more than an inch long are made of swords, shields, guns, hammers and bellows, chicken, fish, crocodiles and antelopes. The most impressive are perhaps of human beings going about their daily business—sacrificing to their gods, scraping bark to make medicines, carrying loads to the farm, tapping wine from palm trees, making love. Some of them have symbolic value or refer to proverbs. Certain signs refer to the movements of the stars and the sun. Sometimes the weight used imparts a message to the recipient of the gold dust. Thus, while these weights may seem merely a curious or amusing representation of objects and people from Akan life, they meant much more to those who used them. They represented or called to mind a vast range of evaluations and associations. Divorced from this, the weights inevitably lose much of their value and meaning.

Trade and art styles

It is not only in empires and royal palaces that trade has inspired great art. Even local commerce, based on markets and the ex-

change of subsistence, as well as luxury goods, has had a direct effect on aesthetic representations. A good example are the ancestral screens of the Kalabari Ijo or New Calabar; a section of these people turned from subsistence fishing and the making of the headpieces and masks, as described in Chapter Two to trading with European merchants in slaves and later in palm oil. The Ijo were conveniently situated near the mouth of one of the largest estuaries of the Niger Delta and as a result of the switch in economy, social structure and art, developed contrasts with that of the original villages of fishermen. From the loose-knit, lineage-based

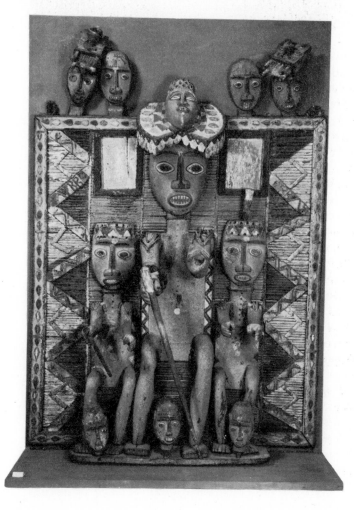

5.8 Kalabari Ijo ancestral screen. The central figure is wearing a replica of a mask as are two of the heads on the top of the screen. The heads indicate that this ancestor traded and owned slaves. Nigeria.

villages, there developed the New Calabar towns, composed of 'houses', close-knit trading corporations and war-canoe teams whose elected head was given a high degree of control over internal affairs. The New Calabar househead was more or less a chief, chosen above all for his abilities in trade and war. He and the traders under him were constantly buying slaves for incorporation in the 'house', whose power in the community they aimed to increase in this way. Government in the coastal towns was carried out, not by an assembly of the entire adult population as in the fishing villages, but by the house head. This contrast between fishing community and commercial town, reflects a concentration of power in the hands of the limited number of people who controlled the local trade.

The New Calabar city state, therefore, had a different type of social organisation from the fishing villages. The Ekine society in the city state remained one of the most important communal institutions, its role however, becoming more diverse and with fewer political functions.

The concentration of power in the hands of traders and their successors was reflected in their religion and their art. The house head built up a team of slaves and family to operate his trading canoes, and when he died his successor, usually his son, assumed authority over these retainers and descendants. More important than the water spirits for the New Calabar chiefs were the cults of the ancestors and the heroes. Thus in the city state of Awome the *oru* or hero who brought the skill of trade is given a good deal of ritual attention. To a trader, the oru, concerned with the invention and maintenance of human skills, is much more important than the water spirits (or *owu*) who are concerned with nature. At the same time the cult of the family ancestors took on a new importance. The dead were believed to hold the same values as they held when alive and look after the lineage and house descendants like living househeads. Ancestors of the city state houses demanded more respect than the ancestors of the lineages based in the fishing villages, and as a result carved figures of ancestors and their attendants were made by Kalabari artists to demonstrate this respect and act as centres for ancestor worship.

Consequently Kalabari ancestor memorial screens (Plate 5.8), unlike Ekine society masks, are not spirit-directed but person-directed. These memorial screens are made for the most prominent ancestors, always traders, and kept in a prominent position in the

assembly hall of the house. His role as leader and chief, as well as trader, is exemplified in the screens: a ship reflects his power in commerce; heads indicate that he traded and owned slaves. The carved figures of the ancestors and their attendants are usually lashed to a large patterned wicker screen, and are the highest flights of 'assemblage' achieved in West African art; unlike almost all other West African sculpture, they are not carved from a single block of wood. The Delta carvers, in contact with seamen and traders for hundreds of years, were probably influenced by the introduction of carpentry to invent these curiously impressive scenes made up of separately carved figures, heads and motifs. It has also been suggested that the artists were inspired by Benin bronze plaques.

The art of these plaques, glorifying ancestors and traders and house heads, is a public art, unlike the masks of the water spirits. Before its installation in a prominent place in the hall of the 'house' it is paraded with great pomp from the house where the carver has been working through the town. In manufacture, symbolism, meaning and function these plaques which have been made in trading city states for two hundred years, are interesting as they are a perfect example of an artistic tradition adapting to changes in social structure and function.

This is not rare. Among the Ibo, sculpture styles vary enormously and more or less reflect the requirements of the cult associations, the chiefs, the lineages or other groups for which they are designed. In Awka and Onitsha, famous commercial centres, we find *Eke* figures which reflect the important commercial role of Ibo men. Towns in this area have cults addressed to 'gods of the market and the town' as opposed to fertility and lineage cults (see Chapter Eight).

These cults and their spirits are usually symbolised by wooden figures between two and five feet in height, professionally carved in hardwood, freshly painted and polished in camwood, red, blue and white. Eke, the leading spirit, is a trader, an idealised man living with his family near the market as a normal Ibo trader does. He is the guardian, the saviour, the spiritual father of the people living near and depending on the market. He is both good and bad. Every four days, on market day, also called Eke, the priest brings out the statue dressed in tribal regalia to receive libations and offerings. Periodically, Eke is washed and purified. His constant changes of clothes, and the amount of material which goes into

5.9 A village and market deity. It is kept in the priest's house and displayed on festival occasions. An Orlu village, S. Igbo, Nigeria.

them reflect the importance of the cloth trade in this area.

Eke and his family live in a compound specially built for them on a sacred spot near the centre of the village, where there are three houses. His personal house has the principal shrine; his meeting house is the rendezvous for priest and cult members, and there is his slave house, a replica of the slave house of any important Ibo slaver. Eke is the most important object and shrine at the annual village renewal ceremony. Eke, his immediate 'family' and sculptured members of his extended family residing in the compounds of lineage heads all converge on the god's house for a major feast. Afterwards, the elaborately dressed deity and his 'family' are carried around the town to receive alms and prayers from the townspeople.

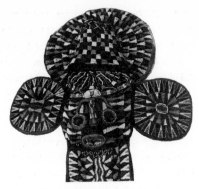

5.10 Mask of *Aka* (see 6.8 for costume). Bangwa, Cameroun.

We have seen how trade has encouraged and altered traditional modes of art, new sources of wealth often inspiring new art styles. Bamileke posts and friezes depict the activity of the local trader, and his goods, which, in this case, are mostly slaves. Traders and wealthy men also formed special closed societies in order to form cooperative groups and also display their wealth in tangible forms. Among the Bangwa a society of this kind was known as *Aka* and its masks were beaded representations of the elephant (symbol of power and economic increase) sewn onto fibre cloth on a frame of bamboo or raffia. This society was the property of the chief and only very prosperous men—not necessarily royal or nobles—could belong to it, the membership fee being a female slave who has given to the chief her future as payment. Appropriately enough, the beads used to decorate this elephant were the beads used as currency in the slave-salt-gun trade.

Not only does commerce encourage and influence art; the existence of markets and commercial networks also means that art objects may become part of a wide-flung trading network. This latter aspect has a very important significance for the study of art styles and culture areas. The whole of the south-eastern corner of Nigeria and neighbouring Cameroon is a good example. Here we have a congeries of tribes, dominated numerically by the Ibo, which for centuries has been involved in a complex trading network. Most of these commercially-minded peoples have spent some of their surplus on a varied and elaborate art corpus and individual styles and have frequently travelled in a bewildering fashion along the trading networks. This is a region of diverse environments—the sea, mangrove swamps, rivers, forests, plateau

land, savannah—where crops are diversified and exchange is basic to the way of life. Fish is exchanged for palm oil, livestock for yams, craft goods for wine. In the past, slaves were exchanged for guns and European goods. And along with these more prosaic objects, art objects and even the artist himself were often traded. The forest affords protection to isolated peoples who may develop their own social and religious institutions but it has never inhibited communication when it is stimulated by opportunities for trade.

In this Nigerian-Cameroon forest zone where the main link was the Cross River, until a motor road was finally built after the second world war, a system of trading existed despite the lack of any centralised authority in the area. The Ekoi had no chiefs and warfare, law and order were in the hands of the various societies, directed by the elders of the community, and it was these societies or 'jujus' which patronised the artist. Villages and village groups, devoted to headhunting, were autonomous and considered themselves free to make their own choice regarding political and religious and recreational associations. The openmindedness extended to sculpture and the artist had a wide choice of forms than he would have had in a more homogeneous area. Trading and cultural contact in the forest probably sharpened the imagination of local carvers. Moreover, a uniform, natural environment over vast areas, as in the savannah, offers little stimulus to diversity in trade and probably explains the lack of variety in sculpture over large parts of the African savannah.

The Ekoi Cross River style, for example, is not limited to the former band of headhunters of the Cameroon-Nigerian border. Their famous skin-covered headpieces and masks with the fibre costumes have travelled as far afield as the Cameroon savannah and the Ibo. These masks and costumes are often associated with the society known as the *Ekpe* or *Egbo* (leopard) which spread as a kind of trade good, under various names—*Akang, Okonko, Mbon*. The society originally seems to have been developed by the Efik of Old Calabar from the original Ngbe society of the Ekoi. The Efik formerly dominated the trade of the Cross River and its hinterland and were in contact with the Dutch and English traders probably from the late seventeenth century onwards. Direct trade with the Europeans was an Efik monopoly and until the middle of the last century the peoples of the Cross River—wild and intractable—had no contact with the white man. The Efik society and its masquerades and carvings were diffused up the Cross River as far as Mamfe to

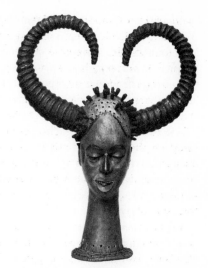

5.11 Ekoi skin-covered headpiece. Cross River, Nigeria.

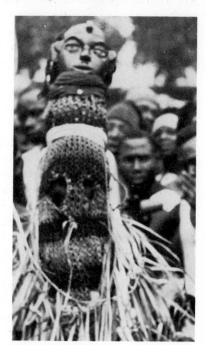

5.12 Skin-covered headpiece in Ekoi Cross River style, Ibo, from Ohaffia, Nigeria.

Arochuku and to the Ibibio. Under the name of Okonko the Ekpe masquerade diffused westward as far as the Isuana Ibo.

Through trade, particular characters in a masquerade as well as the masks representing them, can become separated and diffused individually, becoming incorporated into the masquerades of other areas where they become alien elements for a period until they become accepted into the general style of the area.

The Ekoi style even reached the Bamileke in Cameroon. The Bamileke are nothing if not traders and between the highland peoples and the forest dwellers, there has always been a constant exchange of goods down the escarpment divide—yams, oil, livestock, slaves, guns, cloth, and art objects. Between the Bamileke and the Ekoi, therefore, there has been a long history of cultural communication despite the fact that most authorities have considered the peoples and their art styles as entirely alien. It is clear now that the artist and his work followed exactly the same trade routes as palm oil and slaves. Arrangements to buy a masquerade could be made in the market; chiefs 'owned' sculptors and frequently lent them to their friends or allies or hired them out ti the best bidder.

All this was not a one-way movement. Forest traders and elders who wanted to adopt the trappings of chiefship sent to the Bamileke zone to buy the paraphernalia of royalty—known as 'king things' in the local pidjin—which included carved flywhisks, statuary ornaments and utensils. At the same time the masks and societies of the forest had a fascination for the grassland kings, which explains why mask styles, which we associate with southeast Nigeria, are found so far afield. Skin-covered masks were probably not an original element of Bangwa culture, but for a long period now their sculptors have turned out these distinctive Ekoi-type masks, with their long heads, their high foreheads and pointed chins, the thin noses and the wide-open mouth, showing teeth. The head is carved in soft wood and covered with skin, leaving bare the horns or crests in some cases. The eyes, like the Ekoi heads, may be made of metal or hardwood plugs, the teeth are canes, while the hair and eyebrows and tribal markings are painted or worked on. To the Bangwa these are Bangwa masks although some elders are aware that the original inspiration was from the forest. In the helmet masks of the Royal society, however, a genuine adaptation of the Ekoi Cross River style has been made, creating a mask form which is predominantly their own.

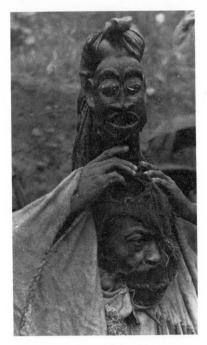

5.13 Ekoi Cross River style headpiece dancing for *Ngkpwe*. The horns on top of the headpiece are partially covered by cloth. Bangwa, Cameroun.

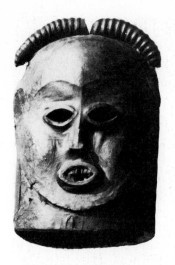
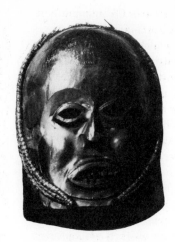

Africa and Europe

The theme of this chapter has been that of exchange, communication, trade, inspiring and transforming art. What about the confrontation between the African and the European, the most long-lasting and traumatic confrontation that Africa has experienced? It has become almost a truism that the European presence 'ruined' African art. If the circulation of ideas and goods is the stuff of African art, why has the European influence been degenerative?

In fact, it is not true that Europe ruined African art, or was not true until the period of intense colonial penetration after 1880. Before this, while there had been a long incubation of European influences, the changes were more or less controllable by the African who did not feel dominated or constrained in his relations with the trader. The exchange of ideas and goods between the African and the European was still two-way until the conquests of the late nineteenth century. Before then, the European monopoly had stopped at the coast and African kings and merchants carried on from there. Colonialisation destroyed these states and African

COMMERCE AND ART

107

commercial enterprise and replaced them with the administrator, white trader, soldier, and missionary. Once economic initiative was taken away from the African, their art inevitably degenerated. In fact, early commercial penetration from Europe gave a fresh impetus to some aspects of African art and European culture traits and ideas were incorporated into the art styles of the continent without damaging their traditional inspiration.

Our knowledge of African art and the Africans' knowledge of ours dates from the fifteenth century. In 1470, for example, Charles the Bold bought from a Portuguese several wooden sculptures and in 1486 Diego Cao collected ivories from the Congo. In 1695 four stone figures arrived in the Luigi Pigorini museum in Rome from the Lower Congo which are similar to the *mintadi* carvings of stone made by the Bakongo to act as guardians of their graves. From Ghana two ceremonial swords were collected and preserved in the Royal Danish collection in 1672, and at the same period an Ifa divination tray from the Yoruba region was collected along with two ivory bracelets. We must not imagine that these objects were collected purely as weird curiosities. They were part of a two-way exchange, although of course it is the European element in African sculpture which concerns us here, the real impact of African art on Europe not coming until the twentieth century. Very early on European contact was even advantageous, providing patrons for African artists who worked within traditional contexts. The craftsmen adapted traditional modes to new formats. The results were sometimes foreign, but often the shaping of the eyes and the nose of the human figures seem to relate to older African carving. Ivory objects such as spoons and salt cellars were carved for Portuguese patrons by Sherbro and Benin artists who were not loath to add Portuguese details to their own work.

Mostly European influence can be discerned in subject matter rather than style, at least during the early period. Some very fine art was inspired by Christianity from the fifteenth century until the present. The Christian kingdom of Kongo, for example, reached its height in the sixteenth century, but after a war with Portugal in 1665, Christianity declined. That Christianity influenced Kongo art is undoubted, particularly in the number of locally made crucifixes and in the rock paintings at Mbafu, but this influence has sometimes been exaggerated. The suggestion that the naturalism of Kongo sculpture is due to European influence is surely unfounded. It must also surely be an exaggeration to see the typical mother and child

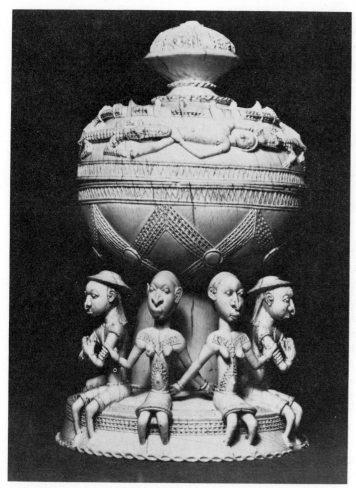

5.15 Ivory salt cellar carved for the Portuguese in sixteenth-century Sherbro, Sierra Leone.

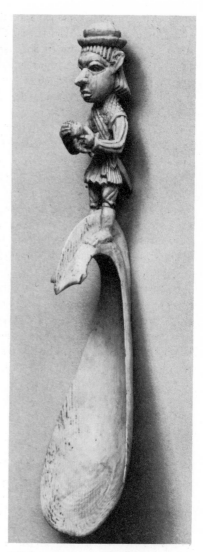

5.16 Ivory spoon carved for the Portuguese in sixteenth-century Benin, Nigeria.

figures and the konde nail fetishes as copies of the Madonna of the Humility and the crucified Christ.

Nevertheless in many famous art corpora we have important European traits. Among the Songe there is an original series of figures, which includes a white trader who became a kind of fetish or increase figure which had magical powers which could be transferred to the owner during sacrifices. Tshokwe hunters, desirous of

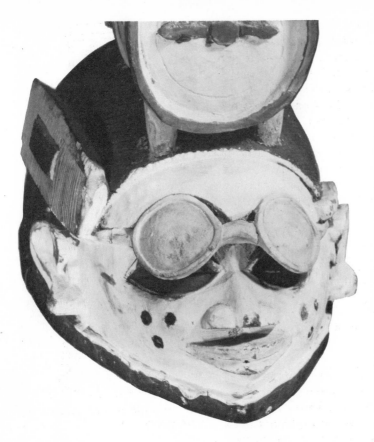

5.17 Gelede society mask, illustrating symbols of European power: the brandy barrel, spectacles and the pen behind the ear. Yoruba, Dahomey.

representing the hunting spirit of the forest, made a canoe in miniature representing wealthy white traders. Shrines to the Europeans or to his wealth and power were made and symbols of increase (pieces of newspaper or a cigarette, even beer) were offered to them. Figurines of Europeans were even placed on graves for remembrance of the dead. The power and magic of Europeans was attributed to their possessions, so that bottles, letters, keys, helmets, waistcoats, and umbrellas became symbols of the white man's superior power. The helmet in particular is used as a symbol of the white man. Some Tshokwe statues are obvious imitations of the Virgin or St Anthony. In some cases the madonna and child inspired African artists; in others the crucifix was used as a fetish. Throughout Africa, Christianity left its mark, but not only on obvious things like crucifixes. The missionary himself was seen

5.18 Wood figure of the Virgin. The Bangwa carver, Ben of Fontem, carves these madonnas alongside fetishes. His main interest in life is the supernatural and his inspiration comes from both Christian and traditional religion.

as a powerful figure, even though he did not trade or carry guns. Figure 5.1 shows a decorative monk, a missionary with a camera.

From a different point of view, of course, both Christian and Muslim missionaries have a bad record as far as African art is concerned. It is only in recent years that they have started to take advantage of the African's gift for carving. On the whole they have shown a dreadful ignorance of the significance of African beliefs and works of art, attacking all Africans as fetish worshippers. Missionaries arrogantly burnt the sculptures which gave expression to African ideas in the mistaken belief that they were idols and objects of worship. In fact, gods as such are hardly ever represented in African sculpture any more than God is represented in Western art.

When the white man first came as a trader, missionary, explorer, slaver, therefore, the Africans, who first met this oddly garbed creature, saw him as a superior being even if he did bring suffering in the form of epidemics and misfortune. The arrival of the first ships, for example, had a great initial impact which has been reproduced in many pieces of sculpture—sailing vessels, steamers, anchors. This, I must stress again, was in no way the beginning of a degeneration but was merely an example of the adaptive and innovating nature of the artist.

The European was depicted as a soldier, a priest, a trader—not only in respect but also in fun. We see him in uniform with his rifle, the latter being his most powerful weapon in the conquest of Africa and the most powerful symbol in these early sculptures. The soldiers are shown in serried ranks as uniformed rifle carriers. There is a splendid bronze relief from the royal palace in Benin, the typical figure, familiar throughout the west coast, of a long-haired bearded soldier with a lance (Plate 5.19). Another Benin statue represents a Portuguese soldier levelling a matchlock or arquebus. He is shown wearing an iron helmet; his clothing is designed for protection against arrows and he wears a dagger with a pincer-like handle in his leather girdle (Plate 5.21). The Benin plaques are of historical as well as aesthetic interest. Another European carries a walking stick, another wears a pleated coat, the costume of a trader. Another wears the Portuguese order of Christ and a European laced stomacher.

The trader himself is also commonly represented. From Angola we have a merchant with account book and pen. A detail of an elephant tusk (Fig. 5.2) shows the merchant holding a beer glass,

Fig. 5.1 Missionary with a camera, carved in wood. Lower Congo.

Fig. 5.2 Trader with a pipe and beer glass (detail of a carved ivory tusk).

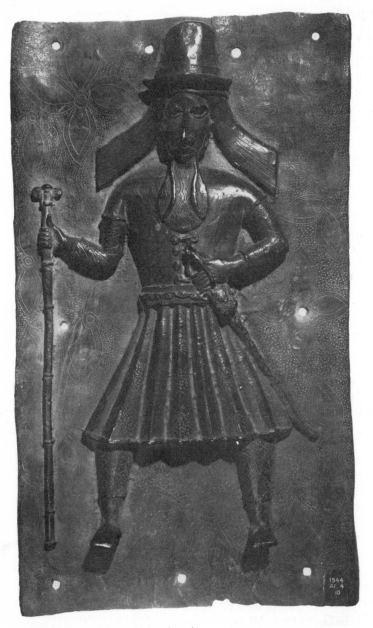

5.19 Benin bronze plaque of a long-haired Portuguese soldier with storming lance. Nigeria.

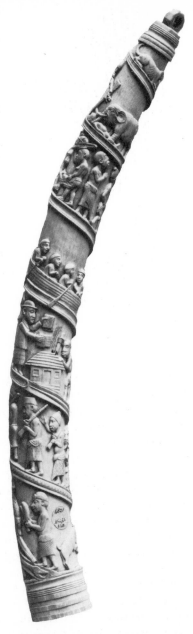

5.20 Loango carved ivory tusk depicting the burning of a mission. Congo-Brazzaville.

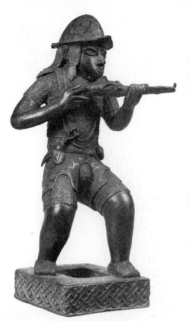

5.21 Benin bronze figure of a Portuguese soldier. Nigeria.

5.22 Sculptured representation of a District Officer on tour in the Nigerian Creeks in a canoe. Carved by Thomas Ona, Ijebu Yoruba, Nigeria.

Fig. 5.3 French soldier complete with cigarette, carved in wood. Dahomey,

Fig. 5.4 Trader in a hammock (detail of a carved ivory tusk).

pipe in mouth and wearing a beard and side whiskers. Fig. 5.4 shows the trader in a hammock with his dog. From Benin we have a merchant holding a manilla, the copper curency which was the symbol of the European and his trade.

More recently the Ijebu Yoruba have sculptured representations of the white man showing similar patterns of stylisation shown in the Benin plaques—the long, narrow-hooked nose, the face basically calm. The colonial governor is shown in his formal clothes; there is the gentleman with his pipe, the district officer reading the letter of the law, the priest, the corporal with his kit and rifle. At the same time as the subject matter is European, the style remains authentically African—each image, for example, shows the drooping eye of the Ijebu-Ode style.

As for the white woman, of course, she hardly existed, or in fact did not exist until the nineteenth century. When she was depicted, though, she was done in cunning detail, every change of fashion beautifully recorded. A figure from Dahamey (Fig. 5.5) shows leg of mutton sleeves, wasp waist, high collar, straw hat and braid.

COMMERCE AND ART

113

Perhaps the most famous woman—even person—in Africa was Victoria, Queen of England. There is a series of Queen Victoria statues mostly derived from one famous photograph which hung in the district officer's office or was handed out to chiefs on the Queen's birthday—a general holiday. Even the Bushman cave artist painted her, although when an explorer first discovered the paintings in the late nineteenth century he wrote: 'They all bear traces of extreme antiquity—but despite continual exposure to wind and rain they are remarkably vivid.' This strange deception is clarified by comparison of the cave painting with the royal portrait —the 'ancient' cave painting could not have been more than twenty years old. Yet the painting is perfect, with all the essentials of the British Queen noted—the rounded face, the conspicuous cheeks, the flowing veils behind the crown on the head, the puffed folds of the skirt.

Elsewhere the same portrait has been copied with attention to detail, with the fan and decorations and jewellery. In some cases there were distortions, the fan for example being turned into an elongated hand; these are some of the dangers of translating from a two-dimensional to a three-dimensional imagination. The Queen's left hand is partly obscured and in some examples disappears from the sculpture entirely. The earrings are copied and sometimes modified. In one sculpture the Queen seems to have been turned into a man. In many others legs and feet have been carved beneath the skirt which is cut off short, however, since the photograph was only knee-length.

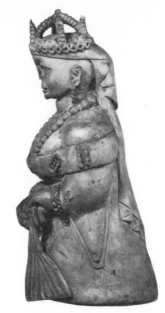

5.23 Wood figure of Queen Victoria, possibly Yoruba. Nigeria.

Fig. 5.5 Wood figure of a white woman. Dahomey.

Fig. 5.6 Bushman rock painting of Queen Victoria.

CHAPTER SIX

Palace art

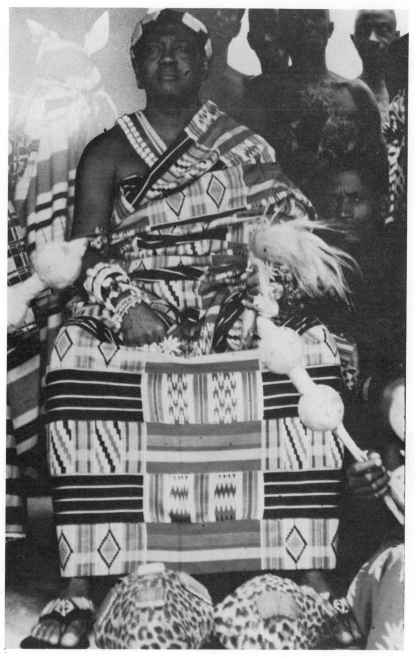

In Africa as well as Europe the concentration of wealth and political power into the hands of Central Government has frequently resulted in a splendid renaissance of the arts. Chiefs and their relatives, as well as titled men in more or less subordinate positions, have always sought to make themselves outlast the short period of their lifetimes by commemorating themselves in art, an art that has special characteristics. Aesthetic criteria for portraits of kings and queens could be expected to include smoothness, shininess, beauty, plus an elaboration of royal symbols. The king and ancestors will be depicted as powerful idealised persons without wrinkles, blemishes and emotional expression. It would seem that there is also an increase in elaboration of ornament and detail as such which 'strongly suggests that complexity of grouping and proliferation of detail correspond in the aesthetic realm to the elaboration and differentiation of roles and institutions in the sociopolitical sphere'.

It will be clear, though, that there can be no direct correlation between art style and social structure; the nuances and complexities of government are not related to manifestations of art in a cause and effect manner. Leaders, kings and chiefs do not have to express their hegemony and power through sculpture and art— they may do it equally well through a stone or a tree, a horse or a dance—but art is one of the obvious means of glorifying persons of rank. And the presence of carved objects in precious materials such as brass, bronze, gold and silver, ivory and beadwork usually indicates the presence of a ruling class, a surplus and the wherewithal to employ specialised craftsmen. Lost wax castings, for example, require a highly specialised production technique, and although it is not necessarily restricted to kingdoms, they receive their greatest elaboration where the chief and a wealthy caste can afford to pay.

One of the possible reasons for a coordinated royal style is that the artist was a full-time specialist under the protection of a chief or king. In some cases they were caste-like artisan groups repre-

6.1 The Omanhene of Kumanu, one of the major states in the Asante confederacy. The chief is shown sitting on his throne surrounded by retainers with an umbrella and gold-plated ceremonial weapons. His splendid cloth, elaborate jewellery and flywhisk all serve to emphasise his wealth and power. Asante, Ghana.

sented at the court. In Benin bronze working was reserved to corporations who came under the direct control of the Oba and lived in a special quarter of the town and worked only for the king. In Bangwa the sculptor lived outside the palace but sold his work through the chief; some sculptors were slaves sold by chiefs to chiefs for high prices. However, in these societies the sculptor, even if a servant, caste-member or slave, was given great prestige as an artist. At the same time they were forced to follow the royal line and carve objects to glorify their master and his court. Certainly in these palaces African art was not a matter of 'instinct', capturing the 'soul' of an object through a primitive ecstatic imagination, but the result of long training and apprenticeship and a close adherence to tradition.

Powerful kingdoms flourished in Africa until the beginning of the twentieth century. Less powerful ones were also common, some of them having little political power, but often quite a degree of ritual and ceremonial importance. Even a lowly village headman had an element of sacredness, even if he did not approach the divine nature of a Shilluk who was regarded with awe and worship and symbolically identified with the whole country. Sacred kingship is a relative matter, from the powerful Congo, Asante, Dahomey, Oyo and other Yoruba kingdoms, to the tiny chiefdoms, sometimes numbering no more than a few hundred persons, of the Bamileke plateau.

Whatever the size of his realm and the extent of his power, African rulers share many common themes. The chief is usually the 'owner of the land' with rights to tribute; he carries out ceremonies for his people; he is often kept away from *hoi polloi*, eating in private, curtained off from the public or wearing a veil. His palace is set off from the people, if only by a higher hedge, and is more elaborate in design. In the palace, his servants, pages and wives form a special court with special functions. There may be a proliferation of titles for members of the royal family and palace dignitaries. There is usually a queen mother or a queen sister with political and ritual roles.

These are the features of African chiefship which are reflected in royal art. Sculpture, architecture, insignia and emblems all aim to make the king a special, awe-inspiring figure. Royal portraits celebrate his dignity and beauty. As far as possible royal paraphernalia are reserved solely for the use of the king and his close relatives and advisers. The servants and wives wear their own

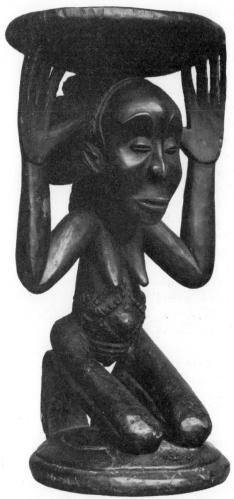

6.2 Chief's stool, carved in a style associated with the village of Buli. Baluba, Zaire.

insignia. The chief wears splendid clothes and ornaments, sits on high and ornate stools and sleeps on carved beds.

Art, therefore, aims to glorify kings, elevating them on elaborate thrones and litters, surrounding them with symbols of wealth and power. Retainers hold umbrellas and flutter fans. Guns, flywhisks and spears are part of royal paraphernalia and appear on portrait statues. The king's control over subchiefs and titleholders is expressed through his power to give them the right to wear or own certain art objects. Chiefs also pass down art works, along with their skeletons and skulls, to commemorate themselves and give a

solid basis to the royal lineage. The Asante did this with royal stools, but any gold, silver, brass, or ivory object may be associated with royal cults and form part of a chief's treasury and inheritance. Ancestors of the kings are usually carved as statue portraits or masks, and these memorials are stored along with other relics in elaborate ancestor shrines.

Other aspects of royal art accentuate the chief's need to control his subjects. Art objects may be used by secret societies to terrify his subjects. The chief may use masks or figurines in adjudicating between subjects or enforcing his laws. These regulatory art objects include the masks of police societies, the carvings in public places, and fetishes used for oath-taking rites.

Chiefs also use art to entertain their subjects. Masquerades, annual dances, even funerals are occasions for the palace masks, statues, costumes and insignia to be brought out to entertain the public. Chiefs, as the wealthiest men in the community—at least as a general rule—are also the greatest patrons of the arts, a factor which becomes clear when the economic basis of a chiefdom has been removed and the degeneration of the art form follows swiftly behind the decline in power of the traditional rulers. A close correlation can be made between a chief's power and the standard of art in colonial and independent Africa.

The Bakuba-Booshong

One of the richest artistic zones of Africa cover the basins of the Kwango, the Kasai, the Katanga and northwestern Angola. In this large area where the equatorial forest meets the savannah live farmers whose ancestors were once the subjects of powerful kingdoms. In this zone there are four major art areas: the Luba, the Kuba, the Pende-Yaka-Suku-Mbala and the Tshokwe-Lunda in the south (see Delange). The art of the kingdoms is closely tied in to the exalted life of the chief and his court and the royal cults— among the Luba statues of kings and queens, caryatid stools, headrests, sceptres, maces and arms all reflected the might and glory of the rulers. Artists were royal functionaries and made royal emblems and insignia such as drums, arms and domestic stools. Women subjects were scarred with royal emblems.

Even more than the Luba, however, the art of the Kuba, and particularly the ruling clan the Bushoong, was constantly employed

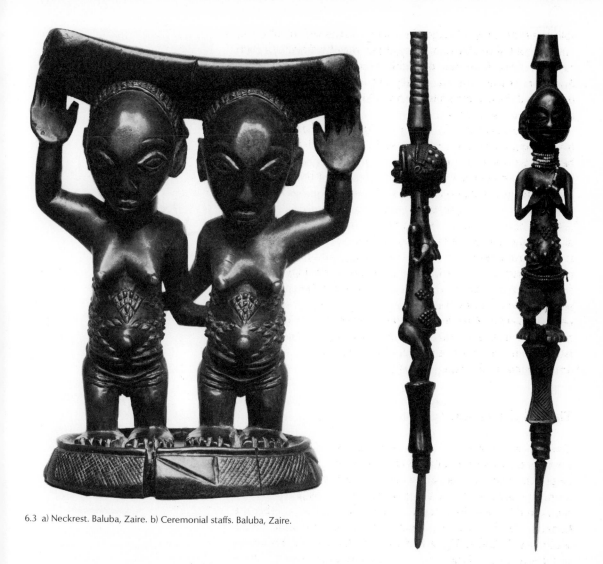

6.3 a) Neckrest. Baluba, Zaire. b) Ceremonial staffs. Baluba, Zaire.

in the service of the king, a royal personage surrounded by a court of officials and councillors all living in a palace area where craftsmen and artists formed a kind of caste under the direct power of the king.

When the Kuba settled in their territory around 1600 they already had a centralised political organisation. Their 'leaders of migration' became chiefs in a two-level political organisation. The villages

were built round one section of a single matrilineage while the chiefdom encompassed one or many villages and was led by a chief who had sacred regalia but was not himself sacred. He was chosen from among the members of founding clans who had accompanied the royal clan in its migration. After the arrival in central Kuba, the Bushoong group gained paramountcy over all the other chiefdoms and instituted a more autocratic structure, diminishing the power of the councils.

In the later political structure of the Kuba-Bushoong, the two most remarkable features are the proliferation of titles, the institution of a greater number of councils and a unique set of courts which helped to check and counterbalance excessive royal authority. Nevertheless, in the Kuba-Bushoong kingdom, the weakest feature was that every chiefdom enjoyed complete autonomy, the central kingship having the power to arbitrate among the others only when they were at war. The king gradually began to acquire the characteristics of the divine kingship common in this part of Africa. There was, however, no ancestor worship at all and the kings derived their power, not from acceptance by ancestors and nature spirits but from a Creator God who was supposed to put the right candidate on the throne.

The organisation, both political and administrative of the Kuba kingdom was as complex as any in Africa. At the head we had Nyimi, the direct descendant of the god who created the earth and living beings. The Nyimi was an absolute monarch whose theoretical powers were limited by the council of officials, representing the commoner lineages and subchiefdoms. The people thought of the king as incarnating supreme power.

The king was responsible for the good functioning of society and also for the regularity of the elements—particularly the rain and sun and rich harvests. He had to observe taboos, such as not speaking when he held a knife in his hand, not shedding male blood, not touching the soil. When he was ill, even slightly, his illness was seen as a danger for the whole country.

The Kuba kingdom was a federation and not highly centralised, but the Bushoong group dominated and in the seventeenth century began a surprising flourishing culture under their hegemony. The chiefs are glorified in history—by the special functionaries who relate the legends of the state, particularly in the realm of aesthetics and crafts, metal working, weaving of raffia cloths, the creation of certain styles of sculpture, and new types of masks.

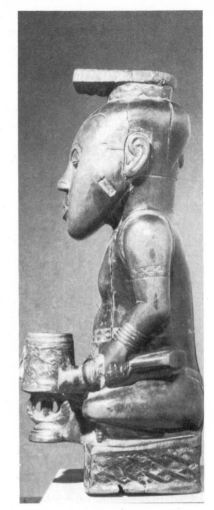

6.4 Bushoong-Kuba king. Side-view of a statue of King Bom Bosh, 96th Nyimi of Bakuba, who lived about 1650 AD. Zaire.

The whole of social life is concerned with beauty which may be explained by the dynamic commercial economy of the Kuba. Centralisation encouraged trade, which encouraged the flow of art goods, and also supported and encouraged corporations of sculptors and other workers and artists; specialisation was thereby encouraged.

Kuba art is an aristocratic art since only a section of society was allowed the possession of luxury objects, the commoners being allowed only goods of a lesser quality. Religion did not play a large part. Statuary mainly represented kings going back to the beginning of the seventeenth century, although only a few of them are contemporary. All show the king seated, cross-legged, and wearing the emblems of his sacred kingship. They are probably memorial statues, but contained the essence of kingship which could be transferred from them to the new king.

The statues of the Kuba-Bushoong kings are the great works of Kuba art. They are not large, most of them being about half a metre high. Each of the kings portrayed is shown seated on a cubic pedestal whose sides are worked. They are calm, serene, with a timeless repose, a deep gravity. Each statue has distinctive signs of royalty. There are bracelets, anklets, belts and necklaces. The king is fat like all good kings. His face is expressionless, the lids half-closed and the lips strangely carved. These statues are more political than religious, they are archival pieces which relate to the history of the kings and people among the Kuba. The royal quality is implicit in the pose of the figure, the hairstyle, the cowries in his bracelet and belt and his cap and the knife in his left hand. Each king can be identified by special attributes—a game he is supposed to have invented, a special drum, a slave girl he was in love with. The statues have the same general form but do not resemble each other; individual details have been given the faces to make them seem to be portraits. However, they are not portraits but conventionalised representations with distinguishing characteristics, venerated by generations of Bushoong and carefully preserved.

Although they are not religious, they may incarnate mythical values, as they are seen in a political context. It is the king who had control over life, human and cosmic, and this must be represented in the statues. Kuba art decoration flourishes in all aspects of architecture and sculpture, in metal working, basket work and weaving. Art played a large part in the life of the Kuba court.

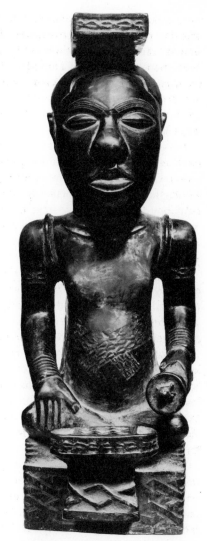

6.5 Bushoong-Kuba king. A similar statue seen from the front. Zaire.

Aesthetics seemed to be a major preoccupation of these people. The ancestors of the first craftsmen are remembered and celebrated. Chiefs themselves may be artists or sculptors. Here symbolism is not explicit—it is the fact of decorating which is important. Kuba art was a sumptuous, aristocratic art.

The Bamileke

In the Cameroon Grassfields over a hundred independent chiefdoms numbering anything from a hundred thousand to only a few hundred continued to function as political entities until the twentieth century. My own researches were carried out in a group of Bamileke chiefdoms, known as the Bangwa, where art objects still played an important role in upholding the prestige of the chief, maintaining social control and entertaining his subjects.

That sculpture was still an alive tradition in the 1960s was mainly due to the fact that the chiefs, under the British system of indirect rule, had not had their authority completely undermined. In fact it was only at the very end of the nineteenth century that the first European explorers stumbled out of the forest of the German Kamerun into the romantic world of princes and queens, palaces and large royal harems, where there were wide vistas of perfectly cultivated gardens and farms. For hundreds of years the coastal tribes had dominated the commerce with Europeans and until this part of Africa had been 'carved up' by the major European powers (Kamerun to Germany, Nigeria to Great Britain and Gabon to France), trade in slaves, oil, guns and cloth between Bangwa and the white man was carried on through these intermediaries. After the annexation by Germany, the Bangwa chiefdoms suffered direct colonial rule for twenty years—the events included the murder of a labour agent, a disastrous war, the burning of the palaces, the pillaging of ivory and art objects and the exiling of the most powerful chief for twelve years in an arid zone in northern Cameroon. However, by 1915 the British had defeated the Germans, taken over this part of the Kamerun, reinstated the king and instituted their convenient system of indirect rule.

When I, in turn, stumbled into this world in 1965 the changes did not seem very great. Most of the people lived in their tall, thatched houses, dotted like red mushrooms in the thick foliage of the escarpment vegetation. There were no missionaries, no white

traders, no administrators, no peace corps. The environment is impressive—great valleys, mountains, rushing torrents and waterfalls, and in the compounds in the forest, where every man lives alone with his wife or wives and servants, is the palace of the chief.

These Bamileke chiefdoms were self-contained and independent. A chief had a council of hereditary dignitaries consisting of the descendants of the servants of the first chief who formed the inner sanctum of the executive society known as Kwifo (although in Bangwa it is known as tro or Night) and normally number nine members. In each of these small chiefdoms there are political divisions headed by subchiefs and important powers are delegated to these sub-chiefs. Because of the small numbers and great political fragmentation in the chiefdom, everything somehow appears in miniature. The chief was a grand, powerful, wealthy figure, but it was also possible for him to know all his subjects and take an interest in them personally. In administering the chiefdom, the chief depended on his subchiefs and local notables who settled local disputes and collected tributes and rounded up warriors in case of war. He also depended on a body of servants and pages who inhabited the palace precincts—some were descendants of slaves, others free men who chose to become servants. The retainers were ranked from the grand palace chamberlain to the lowliest slave, the statuses being distinguished according to special necklaces and costumes.

A Bamileke chief is wealthy and since women are a source of prestige and wealth, bridewealth is high and most is channelled through to the chief. He also owns most livestock, most land, most of the artworks. He receives special financial dues when people die and regular gifts and tribute. He is always splendidly dressed and a creature of whom his subjects normally go in awe, mostly because of his reputation for supernatural exploits (see Chapter Ten).

French art historians, anthropologists and collectors have brought together a deal of material on Bamileke art, although any serious study of the distributions of styles and form among these chiefdoms has become difficult after years of depredations by traders, without adequate documentation, as well as the recent period of rebellion which led to the assassination or flight of chiefs and drastic repression on the part of the authorities. Nevertheless there is more than sufficient material for a description of the interrelationship of social stratification and art. Here I can only give an outline, based on my work among the Western Bamileke.

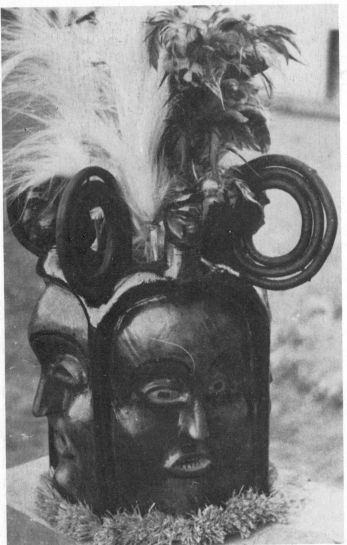

6.7 Night Society mask. Bangwa, Cameroun.

It is the chief's role as ruler which primarily influences the form and style of Bamileke art. Most of the sculpture, heterogeneous as it is, reflects in some way the hierarchical society of which the chief is the summit. These include masks made for the dance society of princes and princesses, the terror masks of the Night society, the elaborate stools, drums and other paraphernalia

ART AND SOCIETY IN AFRICA

126

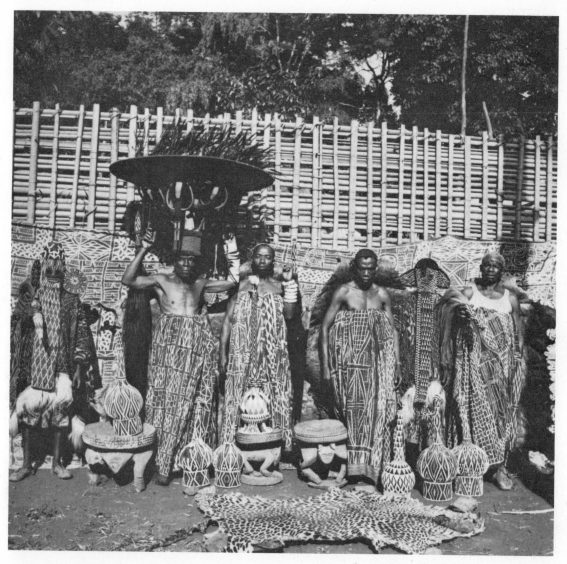

known as 'king things' which are found in the palace, the embellishment, usually in the form of sculpted house posts of the palace itself, innumerable other forms of 'king things'—made from beads, feathers, cloth, brass—the portraits of the kings themselves, and decorated heads either covering a skull or designed to represent a skull which may reflect the head-hunting society or the royal skull

6.8 A group of Bamileke chiefs with their 'king things'. The chiefs are wearing the royal cloth and are surrounded by the beaded calabashes, carved stools, flywhisks, an Albin Society headdress and Aka masqueraders (see 5.10) that are all limited to those of wealth and rank. Batoufam chiefdom, Cameroun.

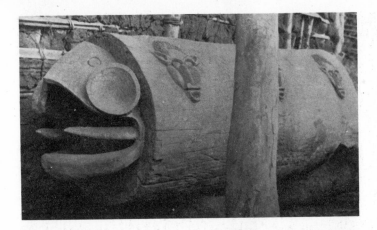

6.9 Huge carved elephant drum (the trunk has broken) facing the palace. Bangwa, Cameroun.

cult. It should be remembered that it is not the paramount chief only who embellishes his palace and his person, his skull house and his association cult houses with works of art, but also the subchiefs, the titled commoners and even the titled retainers, although certain masks, certain statues are the prerogatives of certain ranks of chiefs. Nevertheless payments to the chief in the form of livestock, women or money enabled any man to climb up these echelons of power, although having reached the rank directly below that of paramount chief, his only choice was to break away from the parent chiefdom, and this is in fact the basis of Bamileke segmentation and migration.

The palace is the centre of the country. In the market beside the sacred copse stand the huge carved drums facing the palace entrance which is flanked by a row of servants' huts in front of which people congregate and gossip, waiting to visit the palace or to speak to the chief. Everything seems designed to impress. The servants' huts have painted scenes in red and white and carved pole supports. Even a simple wife's hut—fifty of them are not unusual—is a harmonious architectural whole, the walls constructed of interlaced mud-covered poles, surmounted by a tall conical roof. The public buildings, however, tower above them and are supported by stout poles. The most important of them is the 'house of the country', which must be large enough to hold all the subchiefs, nobles and notables of the chiefdoms. In some cases the meeting houses or the houses of the men's associations are painted with persons or geometrical patterns. In figure 6.3 the chief, wearing the emblems of office, is attended by his servants and

6.10 Opposite: Ancestor statues, carved door frame and verandah posts on a chief's house. Bafoussam chiefdom, Bamileke, Cameroun.

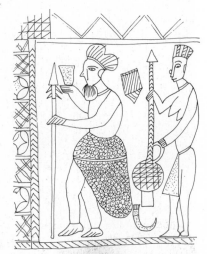

Fig. 6.1 Wall painting from a chief's meeting house. Bamileke, Cameroun.

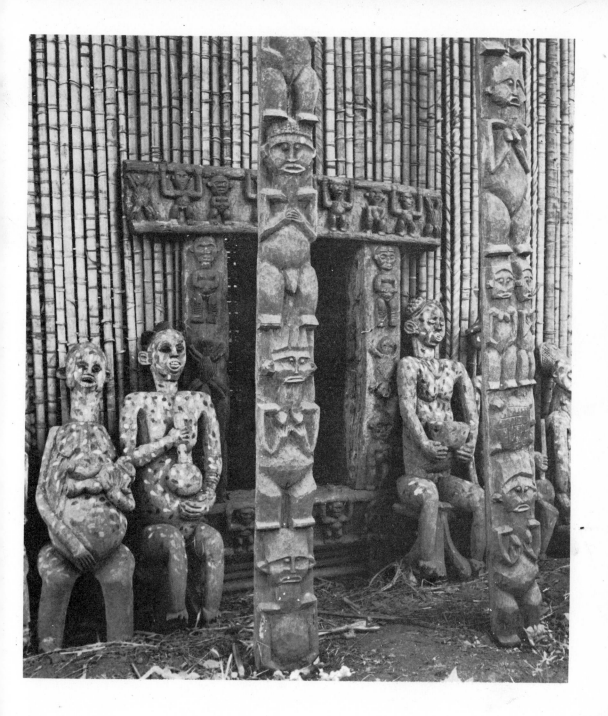

wives. On the whole, however, the Bamileke preferred to embellish their houses through carving rather than painting. Even door frames were carved—the usual Bamileke door is a rectangular opening, half a metre above the ground. An ordinary hut—of a woman or a commoner or a slave—has a single door and no carving. The house of a minor noble is allowed two doors. The house of a subchief has three and the right to carvings on its posts and doors. Only a paramount chief may have four doors. In the sculpture we have hints of the legends, myths and history of the chiefdom. In one the chief and his great wife and servants are surrounded by the royal animals—the chameleon, the leopard, the elephant and the snake—all media by which they travel into the world of witches and spirits. The poles which support the conical roofs of the Bamileke house are primarily decorative and again it depends on the rank and title of the householder whether he may have four, three or no poles and whether they may be carved. In the houses of chiefs, they are carved into lively vertical scenes with the royal symbols predominating.

Inside the Bamileke meeting houses, the walls are panelled. Members keep their special, often elaborately carved stools here, their form indicating the rank of the owner either in the association or the kingdom. Only the chief can sit on a chair, the base of which is a leopard and the attached footstool is a human skull. These splendid stools are made from a single log and may have elaborate scenes such as a series of slaves or retainers with their hands to their chins in the usual stance of subservience. Some of the beaded stools are spectacular and may depict a retainer carved in the form of a stool, or a royal chameleon, the chief himself. The thrones of former chiefs are kept in the treasury or the skull house.

Not only the stools, but also the beds, hats, skirts, pipes and flywhisks of chiefs are subject to sumptuary laws and are always more elaborate than a commoner's or a lesser chief's. The pipe, either in clay or brass, is one of the major attributes of royalty and chiefs and queen mothers, when appearing in state, are attended by pipe bearers and the pipe with a long beaded handle, sometimes a metre in length. Flywhisks, another emblem of royalty, fashioned in the form of slaves, birds or German soldiers, are only carried by ranking dignitaries. Royals may carry two. This royal paraphernalia, known as 'king things' in pidjin, is basic to the concept of chiefship and in aspiring to chiefship the right to possess them must be brought from the paramount chief.

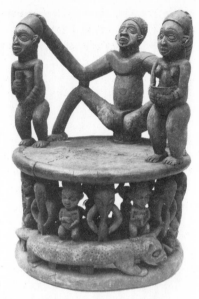

6.11 Bamileke carved stool for a chief. Cameroun.

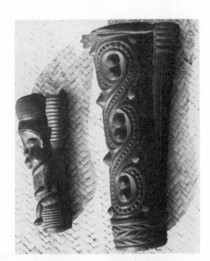

6.12 Bamileke clay pipe bowls. Cameroun.

ART AND SOCIETY IN AFRICA

'King things', the physical manifestations and symbols of a chief's right to office, kept with his ancestors' skulls, are silent witnesses at the daily sacrifices made by the chief and his prime minister to departed rulers. The most valuable and revered of them are the portrait statues of the chiefs, the queen mothers and distinguished court retainers. The prime minister calls the attention of the spirits (through the skulls) with a piercing blast on a carved ivory trumpet. Less regularly, the statues are taken out of the skull house to a performance of a Gong society which celebrates the ancestors in a more splendid and public way. They are also brought out at funerals from their dark hiding places in the skull house and placed inside the palace sacred copse under an awning to shelter them when they attend the Gong society's performance the next day. One figure is always placed at the entrance to warn off women and children. These statues, along with the huge and melodious gongs, are the symbols of chiefdom *par excellence*. Unlike the masks of the Night society, they are symbols of the good, benevolent aspects of chiefship. As well as protecting the royal family, they also play their part in a wider cult involving the ancestors of the land and centred on this sacred copse. The figures arrayed there are not only of royal ancestors but may portray important retainers, royal wives or a chief's titled sister.

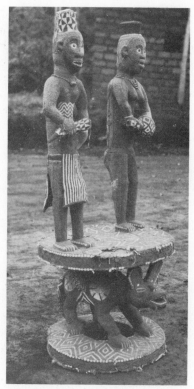

6.13 Bamileke beaded stool for a chief. Cameroun.

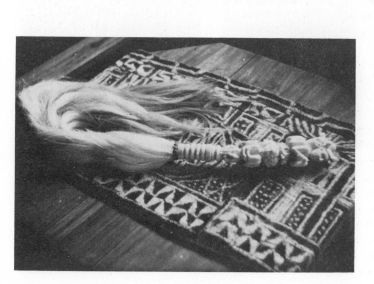

6.14 Ivory flywhisk. Bangwa, Cameroun.

PALACE ART

131

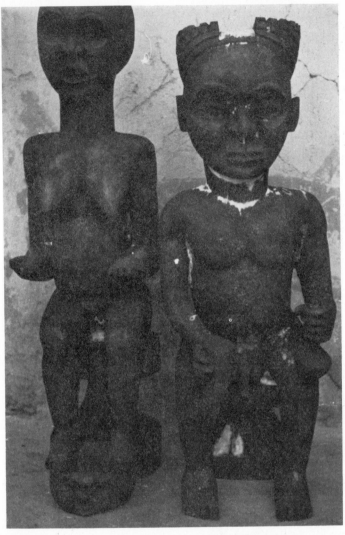

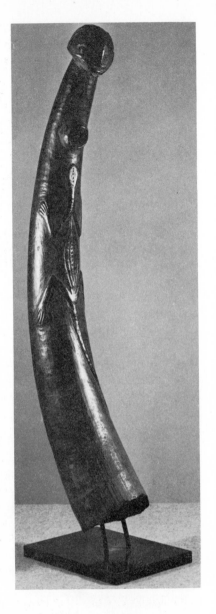

6.15 Portrait statue of a chief and queen mother. Bangwa, Cameroun.

6.16 Carved ivory trumpet. Cameroun.

These portrait statues are *chefs d'oeuvre* of Bamileke art. Like the Bushoong figures, the portraits act as concentrated symbols of a dynasty's power and history. If a Bangwa chief has seven skulls, he has seven patrilineal ancestors and should therefore have seven

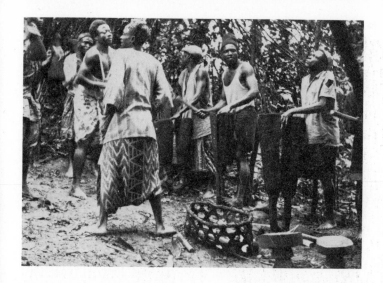

wooden portraits of these ancestors. Only a few chiefs have complete sets, however—many have rotted away, been lost in fires or sold to collectors. In some cases a figure which has been sold or destroyed is 'recarved' to add to the collection. In others, chiefs who have recently acquired wealth and power commission a sculptor to make up a 'set'; this is clear from the homogeneous style of some of the memorial figures.

These ancestral portraits are not shrines, but memorials to the dead, rather like effigies in an English church or on Etruscan burial urns. The Bangwa ancestral shrines proper are the skulls, and it is the skulls which are fed in times of misfortune and through which the Bangwa are brought into direct contact with the world of the dead. Nevertheless, the figures are not just works of art. They are treated as persons, called by name and deemed to possess the character of the original sitter. Handling them involves ritual precautions and they are usually cared for by a special retainer to whom the chief makes special payments when they are brought out for use.

The figures average a little over a metre in height and typically show the chiefs seated on a royal stool which is itself often intricately carved. In these carvings, the values of chiefship are reflected —they have an imposing elegance; a bangled arm rests on a naked knee, the other hand supporting a contemplative chin in a typical

Fig. 6.2 Ancestor statue, Bangwa, Cameroun.

PALACE ART

133

royal pose; a broad, smooth brow spreads back from almond-shaped eyes. In these representations are seen both the serene power of the chiefs and—in the elaborate detailing of ornament and cloth—their great wealth. The ceremonial dress includes a royal head-dress, a necklet of royal beads, leopard skin anklets. The arms are sometimes encased in ivory bracelets made from a single elephant's tusk. In the chiefs hands he holds a calabash or a drinking horn or a pipe. He wears the traditional loincloth, knotted at the waist and drawn up between the legs from behind and allowed to hang in folds in front. In other statues he is naked with a leopard-skin belt.

The figures of Bangwa chiefs show features which distinguish them from all other Bangwa sculpture. First and foremost they are meant to portray royalty. When on view during a performance of the Gong society they are seen by the public from all directions and are therefore carved to be impressive from all angles. The interesting thing about these memorials is that they are also meant to be portraits, to show the sitter's private gestures and expressions. As a result of this, perhaps, the style of these Bamileke figures is very individual, contrasting with those of most other African areas by their great vivacity and movement. Moreover, they are often dramatically asymmetrical, with heads and bodies that twist and turn in unexpected rhythms. In this respect, although the sculpture is bold and massive, suggesting the dignity and power of the kings, it is not the calm, beautiful, repetitive royal sculpture common in other series of royal portraits. Some are commanding and composed, others are aggressive. The artist treats each one differently, combining rounded forms with angular movement while a preference for rough faceted surfaces adds boldness to the presentation and distinguishes them from the steadfast, static figures of the Kuba. Nevertheless, despite the lack of a refined courtly style, the statues do convey authority and kings and queens, princesses and court retainers are portrayed in postures and with gestures of command or obeisance which contribute to the grandeur of the figures and serve as a source of knowledge concerning Bamileke values of kingship and nobility. Chiefs are shown seated, an indication of their authority. Retainers are shown kneeling or crouching with their hands to their mouths in submission.

The Bamileke chief, therefore, is surrounded by elaborate ornament, monumental sculptures and architectural reliefs which all proclaim his political, economic and religious ascendancy.

Fig. 6.3 Ancestor statue, Bangwa, Cameroun.

Minute details help in this aim—special earrings for his wives, special cicatrisations for his chest, special caps for his slaves, special hairstyles for his sons. On the sculptures and on utensils are depicted skulls, trophy heads, leopard's teeth, horns, cowrie shells —all emblems of royal might, fertility and wealth. Animals represented are 'royal beasts' which are associated with the chief's greatness, his supernatural powers, his virility. The chameleon, the leopard, the snake are all *alter egos* of the king. Other symbols are obvious—the executioner with a cutlass in one hand and a head in the other, a naked slave squatting on the ground, a retainer blowing a trumpet, women bent low in a position of respect, a figure with no arms—he has been punished for thieving from the palace—a couple caught in adultery, the chief coupled with an alligator, showing his power to transform himself into this animal and enter the deep pools where the were-animals dwell.

Bamileke art not only glorifies the Bamileke chief but comes directly under his control. He tries as far as possible to control the output of local carvers. In the past he could even own them and it is recorded that some of the famous carvers were actually slaves. Even up till the present time, some carvers worked exclusively for the chief or at least selling his work through the palace. Occasionally, well-known sculptors were loaned out to other chiefs to carve for him a set of masks or a portrait figure. Chiefs still say they 'own' the sculptors. In the past they were rewarded by gifts from the palace and the free presentation of a wife. Nowadays the artist uses the chief as his agent, even with European collectors.

Moreover, some of the work of Bangwa carvers, including important items of royal paraphernalia to which sumptuary laws apply, may only be carved in the palace and sold by the chief. Work made from ivory and leopard's teeth—a royal monopoly— has to be done in the palace. On the whole carvers prefer to use the chief as their agent and will stress a kinship or retainer connection with him to bolster this link. The chief today carries out important services, buying the masks for societies from the carvers and then selling them to subchiefs, other chiefs and societies. Moreover, chiefs control the form of the mask to a certain extent. Today when standards are slipping somewhat, he alone insists that the artist uses seasoned wood, that the skin-covering is done with care and the masks are correctly finished off. In some cases there is a polite fiction that the chief himself has carved the best pieces. In fact, carving is an honourable occupation and could be done

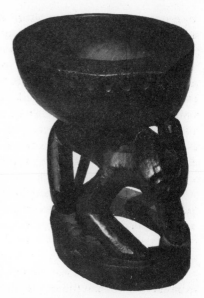

6.18 Food bowl for a chief, supported by a leopard. Bangwa, Cameroun.

by chiefs and royals to whom all other work was undignified if not taboo. Carving is a pleasant relaxation to occupy him as he patiently attends interminable court cases or witchcraft inquests.

The chief of Fontem in Bangwa is often seen at work carving an ivory ring or a fixture to be added to a complete helmet mask. He frequently puts the finishing touches to the masks which are sold under his aegis at the palace. He dyes plumes for the helmet masks, making detachable horns, covering them with antelope skin. Before he became chief he was a full-time carver. In the past chiefs encouraged their sons to take up carving as a dignified means of earning a living and were trained by resident sculptors. Some knowledge of special sculptural and other techniques are in fact preserved by rulers as is also the knowledge of the old songs, myths and the playing of more esoteric musical instruments.

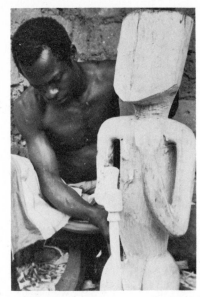

6.19 Bangwa carver working on an ancestor statue. Cameroun.

The court art of Benin

With Benin art we have a unique case in the history of African art —a large body of sculpture made over five centuries which can be studied in relation to historical records, oral tradition and the evidence of rites and features of kingship. Moreover the kingdom of Benin provides us with a body of non-perishable material— bronzes, plaques and ivories—which have allowed art historians to work out a relatively detailed chronology for Benin art from its origins in the thirteenth–fourteenth century to its decline in the nineteenth.

In the beginning the artistic and political influence of Ife was strong. The kingdom of Benin was ruled by a dynasty of Ife origin and tradition has it that the fifth king of the dynasty sent to Ife for a brass caster to come and teach the Benin artisans. Moreover, when the Oba of Benin was enthroned or buried the Oni of Ife sent (in the first case) precious gifts and insignia of power to the king and (in the second case) a portrait of the dead king in bronze. However, as the Benin kingdom organised itself and grew more powerful, so did artistic inspiration detach itself from Ife. By the time of Ewuare, in the middle of the fifteenth century, Benin bronze and ivory artifacts had developed a style of their own. This first period of Benin court art is characterised by very delicate casting and a sensibility of the treatment of the face, with a general trend away from Ife styles and naturalism towards stylisation. The early period includes the queen mother heads and the best ivory pieces.

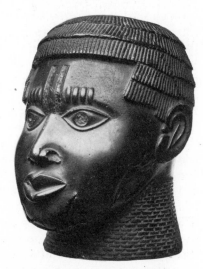

6.20 Benin bronze head, early period. Nigeria.

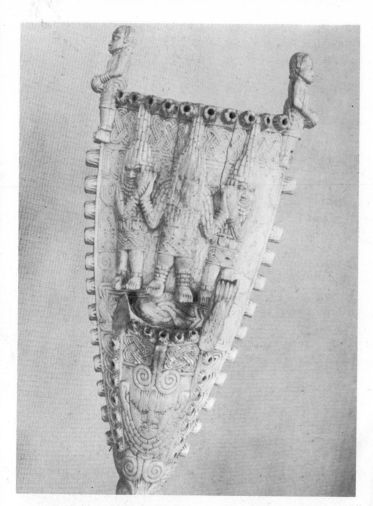

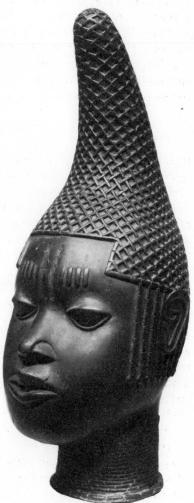

6.21 Ivory double bell (striker not shown). Benin, Nigeria.

Then came the Portuguese influence—ambassadors, missionaries and traders—and important political and economic changes. There was a development in art which included a greater heaviness of the objects and an increasing elaboration of ornament. This middle period, during which the Portuguese exchanged brass or copper manillas (a kind of bracelet used as currency) for slaves has a direct relationship with the slave trade. Decorative and descriptive art in the form of rectangular plaques and sculpted ivories became important, along with statues, equestrian figures, animals and heavy ornamented heads.

6.22 Bronze head of a Queen Mother. Benin, Nigeria.

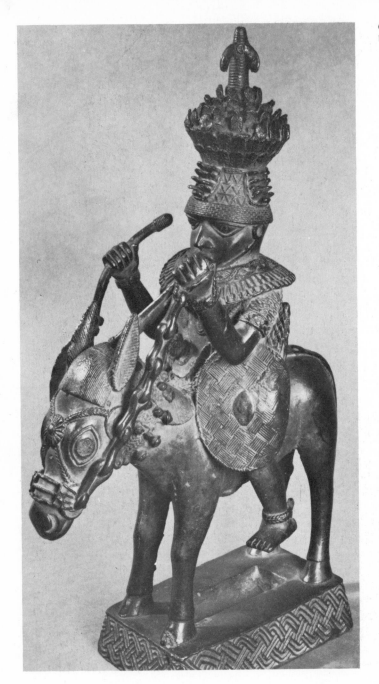

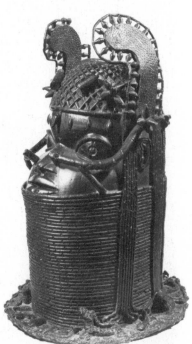

6.23 Bronze equestrian figure, middle period. Benin, Nigeria.

6.24 Bronze head, late period. These heads were cast to support ivory tusks on a royal ancestor altar. Heads of the late period (eighteenth to nineteenth century) show increasing size and ornamentation. The projecting decorations on the crown are said to have been introduced by Oba Osemwede (1816–48) (see 6.28). Benin, Nigeria.

ART AND SOCIETY IN AFRICA

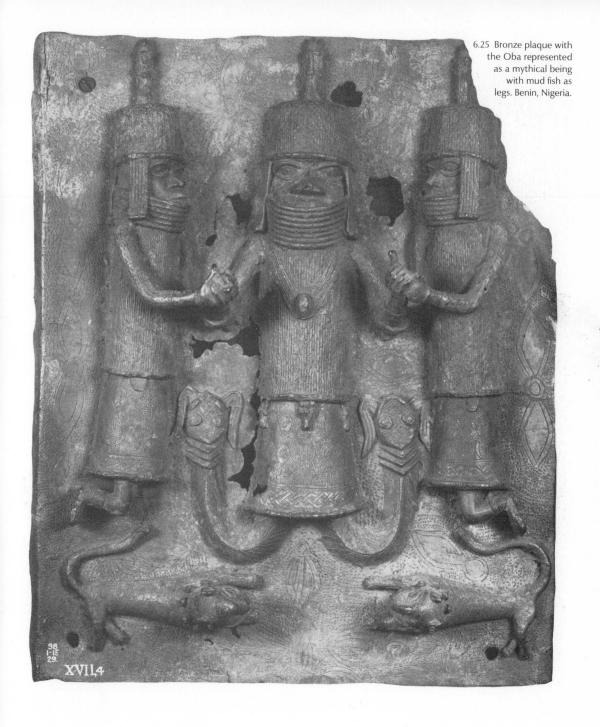

6.25 Bronze plaque with the Oba represented as a mythical being with mud fish as legs. Benin, Nigeria.

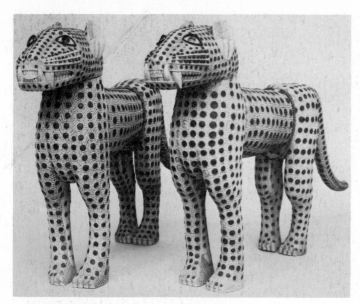

6.26 Pair of ivory leopards. Benin, Nigeria.

Benin art reflected the importance of the monarchy. Along with a number of other African monarchs (of whom the shilluk king is the best known), the Oba of Benin was regarded as a sacred or divine ruler. Spiritual and temporal ruler of his people until exiled by the British in 1897, he was a direct descendant of the first king who ruled in the thirteenth century, and considered as the sacred reincarnation of the founder of the dynasty and the godhead of the kingdom. The Oba controlled a state police, exercised a monopoly over external commerce, maintained direct control of his military officers and was head of state religious cults which centred on himself and his ancestors.

The palace was the centre of the Benin kingdom and universe and its symbol was the king. Logically Benin art was almost entirely devoted to the celebration of the kingship and its elaboration, decadence and final disappearance is closely associated with the fortunes of the monarchy. As the wealthiest man in the country the Oba was determined to display the symbols of his power, and the best way to do this was through art. The Benin artist devoted himself to decorating the palace, celebrating the feats of the Obas in plaques, portraying the kings and queen mothers. Art exalted

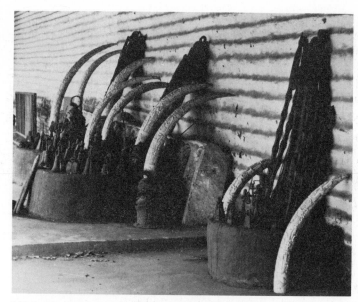

6.27 Ancestors' shrines in the Oba's palace. Benin, Nigeria.

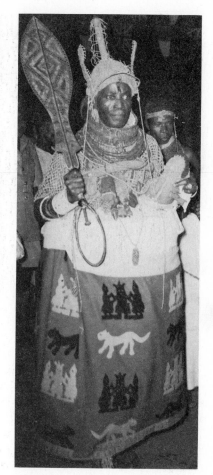

6.28 Oba in ceremonial costume.

the king and the royal household, as well as his councillors, his retainers and his army commanders. The plaques which were nailed to the pillars of the palace courtyards related the main events in the history of the kingdom and the Oba and his court. In his sacred aspect the Oba is represented with leopards or as a mythical being with fish instead of legs. Regalia, swords, coral-bead clothing, flywhisks, ivory tusks, aquamaniles for ritual lustrations, ivory and bronze hip masks and other ornaments all served to glorify the king. The most splendid examples of royal symbols are the Benin ivory leopards, made from five separate tusks, with the spots formed from copper discs tapped into depressions in the ivory (see Plate 6.26).

Ivory, in general, was a royal material, reserved for the Oba's use or for use in connection with the fulfilment of duties. Ivory armlets and other carved ivory objects differentiate him from his attendants and officials. Of great importance to the Benin people are also the shrines of past Obas, located in special compounds in the palace grounds, where carved tusks, staves and human heads are found. Even the costume of the Oba was created by artists to convert the human being into a god-like personage. It was heavy

PALACE ART

141

and impressive with a coral crown, coral neckbands, coral shirt, coral pendants from the crown, necklaces, cloths around the waist with tassels, ivory pendants, ivory armlets—all of which made him a regal and sacred figure.

The art of secret societies

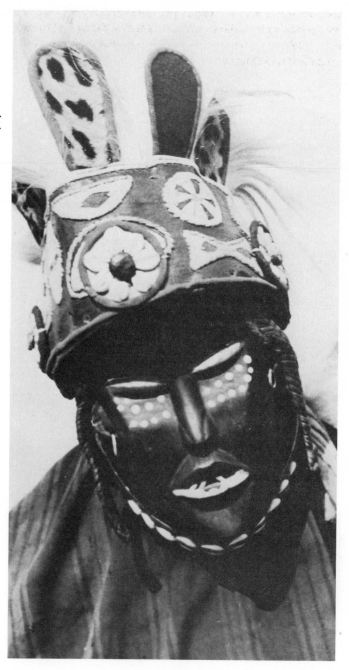

Chiefs, kings and wealthy individuals are not the only patrons of African art. A mask or figurine need not be owned by an individual or a lineage, but jointly by members of an association. In Africa associations perform a multitude of functions from entertaining to governing. In fact there are many societies which have no central political institutions; members are related to one another through various economic and kinship ties and belong to associations of initiates. Eligibility to join these associations varies: sometimes the whole group of adult males is included, sometimes descent is important, sometimes age, sometimes social pre-eminence or wealth, ability or the possession of certain sacra. These kind of communities, which include many advanced peoples such as the Ibo and the Yakö, may be as complex as a centralised chiefdom and show a wide range of political, religious and economic specialisation.

In other societies a state system with chiefs and councils may co-operate, as well as compete, with these associations which are formed for initiation and semi-political roles. The Mende have chiefs and the powerful *Poro* secret society; Benin has the *Ovia* society; the Bamileke have innumerable associations, most of which are more or less under the control of the chief.

These and other African societies are politically organised in age set systems—the Kikuyu and Masai of Kenya are two well-known examples. The basic rule is that all men born within a certain number of years come within one set. At the end of this five, six or seven year period (although it may go as far as fifteen), recruitment to the set is closed. Admission to one of these sets usually involves some initiation ritual, often circumcision or other body mutilation. One of the effects of the initiation rite is to mark the emergence of children from childhood—we have already had an example of the N'domo association of the Bambara—and the assumption of full adulthood status. These age sets are normally named and a man and his fellows of the same age remain in the same set all his life. The named sets also go through grades which are distinguished

7.1 Dan style mask in use. This photograph was taken at N'zo in Guinea, on the periphery of the area of the mask's distribution, but is a good example of the sleek naturalistic style.

from each other so that a man and his set occupy one grade at a time: adolescent, warrior, junior elder, senior elder. Specific roles are associated with each grade—communal work, fighting, settling disputes, making decisions, making sacrifices. Age set systems which provide for the easy formation of armed warriors are particularly characteristic of pastoral peoples since cattle-herders, unlike farmers, can move quickly from place to place with their property.

The essential character of the age set system—as opposed to the association or secret society—is that the former is egalitarian —every man is a member of his age set and as the set rises in rank, he passes through every grade of seniority in his tribe with all its other members. Most associations, on the other hand, are selective and exercise power over persons who may never be able to enter their ranks.

The Bangwa, as we have seen in the last chapter, is a chiefdom, yet this does not preclude the existence of both age sets and associations, which have economic, religious, social and political functions, sometimes dependent on, sometimes independent of, the chief. We have already mentioned the Gong society which meets in order to propitiate the gods through music and sacrifice and ensure the land's fertility. Although this society of wealthy elders meets in exaggerated secrecy and a good deal of importance is placed on the sacred paraphernalia, it is not a 'secret society' in the usual sense of the phrase. Membership is acquired by succession to one's father and is validated by formal payments and a feast in honour of the other members. The Gong society plays its music, sacrifices to its statues and discusses state policy in cooperation with the chief. It may also punish members and non-members. The Gong society is an association closely associated with the palace and the statues and other art objects are kept by the chief on behalf of the members.

There are two warrior societies among the Bangwa, one based on age and the other on individual achievement. *Ngkpwe* glorifies individual warriors, while *Manjong* is a nation-wide association of soldiers open to all men and based on age. The slaying of an enemy and the presentation of his skull to the chief gave a warrior the right to perform the Ngkpwe dance. The association seems to date from the time when the Bangwa and their Mbo neighbours fought incessant guerilla wars for human booty and rights over rich forest palm groves. The Bangwa claim that the Mbo kidnapped their men

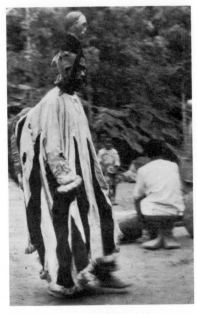

7.2 *Ngkpwe* masquerade dancing at a funeral. Bangwa, Cameroun.

and women to satisfy their lust for human flesh. The Mbo, who admit to cannibalism in the past, declare that the Bangwa raided for slaves and also acquired a taste for human flesh. Today the past activities of this headhunting society are only a dim memory. It has no regular social or economic function in the community at large. The members meet at funerals where they dance with their skulls and the masks or headdresses. Preceded by heralds the dancers and maskers form a line, dancing on tiptoe, their feet wide apart, leaning forward slightly, their bodies vibrating as they frenziedly beat their feet on the ground as though on the taut membrane of a drum. The mask is worn high on the head of a robed figure, who wears a large circular foodbasket tied to his shoulders, giving him a monstrous humpbacked appearance. Slowly the dancers and maskers move across the field, the heralds whirling around the latter with a tinkling brass bell in each hand. At the climax their hands fumble at the cloth caught at the top of the mask, which falls down and reveals the Ngkpwe mask.

The masks are owned by the society. They are in fact never masks but wooden heads tied on to a cane platform. They are small, usually surmounted by horns—or an approximation of horns—which symbolises the physical prowess of the wearer. The classic face shows a human head with horns sweeping up from the forehead and then to the back of the head. Other features of the masks include raised eyes and finely chiselled noses. Some have separately inserted bamboo or wooden teeth, others have real hair. The variety is overwhelming but their relation to many examples of published Ekoi work is clear.

Manjong is not a select group of warriors but an age association of the men of the chiefdom. This age-based society is found in some form or another throughout the Bamileke-Bamenda zone of Cameroon. These age sets normally group all the youths of a chiefdom or subchiefdom at five year intervals. In times of war, the Manjong groups of the subchiefdoms and villages came under the authority of a national leader who was usually a titled retainer.

Nowadays the functions of Manjong have changed—the young men meet weekly or monthly to organise dances and feasts associated with savings clubs. When a member dies, the group prepares the body and buries it. Manjong members also perform communal tasks such as road-clearing and other work for the benefit of the entire community.

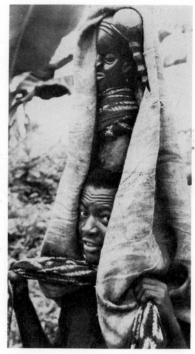

7.3 *Ngkpwe* mask (see also 5.13). Bangwa, Cameroun.

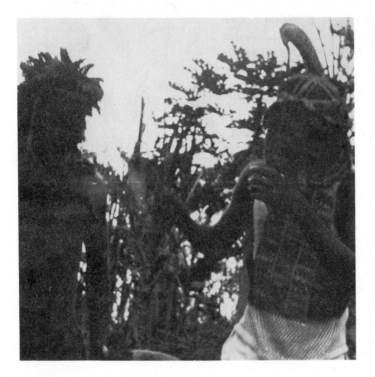

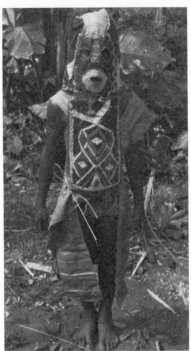

7.4 *Manjong* costume and mask, made of patchwork and embroidery. Bangwa, Cameroun.

7.5 *Manjong* beaded mask dancing with a mask similar to 7.4. Bangwa, Cameroun.

Manjong dances are highly organised. There are captains, lieutenants, messengers—the ranks all have their own insignia worked into their costumes. The dancing consists primarily of a mock battle, spears held high and brandished at each other and the spectators. During a funeral they have the right to attack the dead man's banana plantation, cutting down the trees with their cutlass—this is explained as 'their right to a share of the dead man's property'. In the past Manjong costumes consisted of beaded masks, but most of these have rotted away and been replaced by patchwork, raffia or embroidered masks. There are no wooden masks associated with Manjong. The elaborate patterns are supposed to be a kind of camouflage.

This does not exhaust the list of Bangwa societies. There are literally dozens of them. Some are restricted to wealthy men. Others exist purely to entertain. Another is only open to relatives of the chief. Women have their own dance and mask societies. (The most powerful, the Night, the Bangwa police society, I shall

discuss in the next section.) In most of these societies the masks are bought and belong to the members as a whole and are kept either in their meeting house or by an official of the association.

Social control

Masks not only provide associations with prestige, and serve as entertainment to non-members. They may provide elders and chiefs with weighty supernatural sanctions and uphold order and punish crimes. Many of the best known African secret societies played important governing and regulatory roles—they punished criminals, collected fines, enforced law and order, sometimes terrorising non-members, particularly women and children. Among the Bamileke peoples, chiefs ruled with the aid of secret associations of anonymous men, who behind their masks, administered the sasswood ordeal to suspected witches and adulterers, hanged murderers, punished thieves and settled land disputes. Like the Great Mask of the Poro, the terror masks of these secret societies were considered to be responsible for these fearful deeds. This society—known as the Night among the Bangwa—also buried and crowned chiefs, attended funerals to collect death dues for the chief, and performed lengthy rites after polluting deaths. Most people saw the members of the Night Society only when they attended the funeral of a relative. Dressed in voluminous gowns of coarsely woven material, their faces covered with blackened nets, the group looked even more awesome by wearing blackened masks and carrying with them in procession long staves carved into grotesque shapes.

The masks of the Night Society have nothing at all in common with the masks of the other Bangwa associations or the statues of the royal ancestors. They are awe-inspiring symbols of the worldly and supernatural powers of the chiefs and this secret society of executioners. The inner council of the Night Society has nine members, and should own nine masks which are the symbols of the power of state as expressed through the chief's secret regulatory society. These masks are powerful and hence dangerous. They are stored, not in the palace where their power may harm the chief and his family, but hidden away in the huts of menial servants, and they are moved only after members have taken strict ritual precautions. The chief, pretending great fear of the masks, would

never touch them; a non-member would suffer automatically afflictions such as blood-spitting and dizziness if he came in contact with one.

Night masks are unadorned with mirrors, skin, feathers or paint. Years of accumulated soot and libations give them, instead, a thick patina which is believed to add to their effectiveness as emblems of the Night Society. Since many of these masks were carved to be worn on the head with holes for raffia veils, it is assumed that they were once so worn. However, today they are said to have acquired such lethal powers that it is too dangerous to place them on the head, the part of the body most sensitive to mystical danger. The actual 'masking' of the Night Society is achieved by a filthy knotted cap which hangs bedraggled over the shoulders and which is made from a worn-out tadpole net used by women. For the Bangwa the Night mask is an object of terror—it has a contained energy which immediately transmits itself to the spectator. As instruments of social control the masks are startlingly efficacious.

Witchcraft beliefs partly explain the horror in which the Night Society's masks are held. The chief and his retinue achieve their transformation into leopards, elephants, rainbows and chameleons through the medium of this set of masks. Moreover, public appearances of the members are arranged in a theatrical manner and aim at inspiring fear. Their movements are weird and indecorous and the language of the masker is full of esoteric allusions to witchcraft and cannibalism which are only half grasped by the onlookers because his voice is altered to a weird guttural. Even today, the passing of a single Night figure on an innocuous errand strikes panic to the heart of a person who happens to meet him on the path. The members meet at night, supposedly for witchcraft purposes, under the protection and inspiration of the society's masks; the members attend meetings daubed in red camwood and white chalk.

The Night masks have an aesthetic which glorifies the ugly. Bared teeth, blown-out cheeks, overhanging brows—all transform the human being into a supernatural one, its features distorted with lust or fury. The masks are explicitly said to represent humans, not animals, in spite of the fact that they are so closely associated with beliefs in animal metamorphosis. The grotesque abstractions of the features might lead one to think they are depicting were-animals, but this is not so, for, according to the Bangwa, they are all men—terrifying, powerful men. The Bangwa point to the nose,

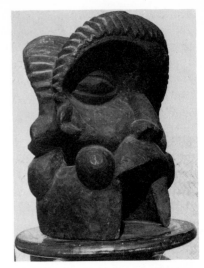

7.6 Night Society mask. Bangwa, Cameroun.

eyes and mouth which despite distortion are decidedly human. The features are exaggerated and moved around the face in order to stress the supernatural attributes of Night Society members. The blown-out cheeks are a good example. Most Bangwa say they are carved this way so as to frighten women and children. Others point out that fat cheeks are a sign of wealth and power—great chiefs are always fat of face.

The Night terror masks are astonishingly varied in form. Most of them show an extreme, even violent abstraction which corresponds to their role as agents of the Bangwa police. Others are less alarming. Nevertheless, a detailed study of the Night masks shows that there is a common theme running through them—the power of the chief and his government.

The Mandinka masked figure

Throughout West Africa masked figures may be found which play a positive role in social control. In each context it seems that masked figures prevent conflict by converting secular judicial decisions into supernatural, superhuman decisions. Masked figures apply rules and remain above the community.

The Mandinka of Gambia, although they do not have carved masks (they are made of bark and leaves), provide a well documented account of this situation. The masks are said to have the power to see into the past, present and future and perceive evil, identify sorcerers or witches and detect the presence of spirits. The power of the masker and the mask is linked with possession— spirits commonly living in bushes and trees bend the will of the masker to their own. A section of the young men's age grade is responsible for applying rules created by the village council. In applying rules, the young men's age grade must punish adulterous women, sorcerers, gossips, since these may come from any level of the stratifications system. The masked figure enables them to do so without conflict.

The Mandinka masked figure appears on several public occasions: during a rain ceremony he dances for three days while members of the association usually redig the driest well in the community, the masked figure urging the labourers on until they find water. They also play important parts during circumcision rites. During the years before attendance at the spirit camp little boys are told that they are to be devoured by a monster and spat out

7.7 Night Society mask. Bangwa, Cameroun.

whole. After the boys at the camp have healed they are forced to kneel face down in a row pointing east while the masked dancer uses a cutlass or a stick to make a cutting motion on the neck or back of each initiand, symbolically killing each one.

Poro and Sande

Similar functions of maskers are to be found throughout a wide area of western Africa. Perhaps the most famous secret society is the *Poro* and related associations. This has its most intensive distribution among the Mande- and Mel-speaking peoples of Liberia and southern Sierra Leone, but also spreads—sometimes under different names—into Guinea and the Ivory Coast.

Closely connected with Poro are the *Sande* female associations which are localised as lodges among the women of specific chiefdoms. They are also spread throughout the region and have an even wider distribution than Poro. The tribes of this cluster are divided into petty chiefdoms traditionally controlled by the land owning patrilineages of the founders of each unit. The economy is based upon intensive slash and burn agriculture with supplementary hunting and fishing. Warfare, trade, population mobility and periodic confederacies have characterised relations among groups for centuries.

There is a cycle of ceremonies connected with the recruitment and maintenance of members in the all powerful and universal male and female secret associations. These are the 'secret societies' of the exciting art book. Initiation and life-long membership in one or other of the mutually exclusive organisations is compulsory for all citizens. They are only 'secret' in the sense that non-members are rigorously denied knowledge of rites and lore and that 'secrecy' is an attribute of the society much valued by members. Each of the tribes of the Poro cluster of peoples in this region have their own names for these associations.

The actors in these ceremonies are the uninitiated youth, all the adult men of the Poro, all the adult women of Sande, the sacred elders representing the ancestors and the masked impersonators of the nature spirits who are allied with the founders of the country.

Throughout this area we find two general types of Poro mask— the sleek naturalistic style associated with the name Dan (see Plate 7.1) and the violently contrasting masks (*ngyere* or go

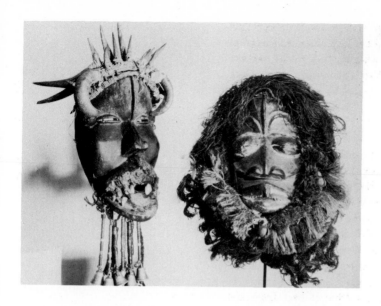

7.8 *Ngyere* style masks. E. Liberia.

masks) which are roughly finished, highly abstract. The ethnographic confusion about these masks is quite forbidding, but here I am only concerned with the latter type of mask and its role as an agent of social control. I am not concerned with the labyrinth of different functions and bewildering variations of style of a mask type which is used from Sierra Leone to the Upper Volta nor whether the masks represent bush spirits, the human soul, the collective force of the ancestors, a creator god or culture heroes. The differences in style, functioning and origin of this mask must depend on the variations in the development of the Poro. At all events, I am here concerned with the Great Mask, described most satisfactorily by Harley for the Mano of Liberia, which is used to enforce law and order, to intimidate women and children and furnishes the central figure at crisis rites, particularly the initiation of young boys into the Poro.

The Great Mask of the Poro among the Mano, therefore, was controlled by the Zo priest, head of each Poro chapter. When appearing in public he wears a state dress consisting of wide knee breeches, a narrow jacket with short sleeves and a headdress in the form of a cylindrical hat of metal plates, ornamented with the skull of a hornbill and trimmed with cowrie shells and white otter or monkey skin. The Zo priest is associated with avenging masks which

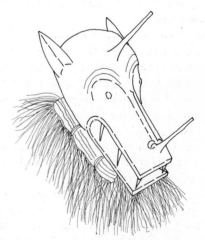

Fig. 7.1 Great Mask of the Poro, Liberia.

THE ART OF SECRET SOCIETIES

153

act as a police and judiciary combined and are thought to be able to act independently of the masker. This Great Mask is associated with the 'demon of the forest' and is the most revered object. Its conventionalised face is also supposed to represent a long dead, almost mythical, man of great wisdom—this was the culture hero who introduced the Poro.

The Great Mask of the Poro, therefore, is the symbol and oracle of the Zo priest, who, as hereditary keeper of the mask is judge and clan leader, and as high priest of the mask he could obtain the sanction of the ancestral spirits, to punish criminal and civil offences. In fact there were two systems of law, one administered through the chief and elders in councils which gave everyone a chance to participate, in a more or less democratic manner—the second was an extension of the Poro. The latter system functioned in secret through a high court of elders meeting at night in a sacred place called together and presided over by the high priest of the mask. When there was to be a meeting of the elders, he carried this mask to a secret place, laid it on the mat on the ground, covered it with a white cloth, and around it the elders sat and discussed the special palaver for which they had been called together. The chairman guided their opinions towards a judgment which was always considered tentative until approved by the mask.

The mask thus became a law maker, since the session of elders hearing a case and rendering judgment would have to have the decree recognised by the mask before it was announced by the town crier and had the effect of law. The high priest of the Great Mask also held control of lesser masks which he could send out as his messengers, policemen or deputies. While the priest of the Great Mask was the 'big man' of the Poro, his power was great only because of the moral power conferred on him through the masks of which he was the keeper. Lesser masks of lesser officials were used as badges of office in the Poro.

The Great Mask, like the Bangwa Night masks, controlled the poison wood ordeal which was administered to suspected criminals. In other serious delicts and disputes, when a problem threatened to cause disagreement or resentment on the part of the eventual loser or his friends, the use of the mask as a judge served a useful purpose. The judgment and the action of execution was thought to come from the spirit world via the mask. A mask was *ipso facto* impersonal; at the death of a person after the sasswood ordeal, for example, the responsibility for the poisoned cup was automatically

assumed by the mask. The identity of the individual under the Great Mask was unimportant—it was kept secret, since it was on the authority of the mask alone that the trial was conducted. At important councils the mask was carried to the meeting in order to ensure the presence and the approval of the ancestor spirits. In other cases the mask was placed on the ground and people talked to it. Its answer of agreement or disagreement to a decision was given by the mask through cowrie divination. Often the divination was something of a formality but it always meant that the decisions were being made through an extrahuman agency. The Great Mask was also used in times of crop failure or during witchcraft panics. It could also be used to collect debts and in cases concerning adultery with the chief's wives. At public functions the mask would be present and also watch over crisis rites such as births, deaths, or the coronation of a new chief.

The priest and the Great Mask had a very important role to play in the initiation rites and meetings of the Poro which had its sacred grove on one side of the town—the women's initiatory association had its grove on the other (see p. 162). The masked members acted under the instructions of the priest and the Poro was unable to make preparations for a session without his consent.

With the Great Mask, the priest could walk into a session of the Poro where a quarrel was brewing and stop the litigants at the word *dunuma*. All present prostrated themselves before him. He could stop fighting bands outside the Poro by appearing in his mask. When settling palavers he actually wore the mask with a costume completely covering him, even his hands and feet. The elders were also present and the dispute was translated to the mask by an interpreter since he spoke only a secret language and always in a high trilling falsetto or a low growl. When fines were imposed, usually in the form of livestock, the meat was eaten by the elders. During the trial the mask did not dance or move, but merely sat in judgment. In its presence no man could tell a lie.

The Great Mask, which had attributes of a living spirit, as well as a sacred oracle and supreme judge, was the object of blood sacrifice and prayer. When it changed hands—from father to son or mother's brother to sister's son—a special sacrament was eaten. The mask itself was characterised by protuberant eyes, faced with perforated china or metal discs, red felt lips and a long beard hung with beans, palm nuts or heavy beads. Black dried blood from sacrifices and the reddish remains of chewed kola nuts—which

were spat into the mouth of the mask by the priest—gave it a thick patina. The priest of the Great Mask gave instructions to the carver when a new mask was required. A suitable tree was selected and a sacrifice prepared for the propitiation of the tree. The carving was hedged in by taboos. Next the character of the wood was changed by staining, the beginning of acquiring its essential patina.

During the Poro initiation, the Great Mask appeared mysteriously four times—merely to utter the dunuma at which all the boys fell prostrate on the ground. Dunuma is the name of the powerful fetish alongside which the mask is kept and whose name is the password to all power in the Poro ritual. Minor masks—the ge—were used in the Poro bush school to discipline and educate the boys and inculcate respect for the ancestors. These masks acted as Poro officials, controlling women and children outside in the village. It was the ge mask which caught the boys prior to initiation, who marched them to the edge of the Poro bush where they had to fight and overcome three more ge masks. Inside, other masks made them swear they would never tell any woman the things they would see in the bush. The ge masks were revered, and treated like real gods by the boys. The masks controlled both outsiders and neophytes, did the teaching, provided the food and protected the group from evil forces. To outsiders the ge were fearful ogres, particularly as they were immune from all normal regulations and laws during the duration of the school. The masks themselves are considered hideous, like the Bangwa Night masks, but obviously there is more than ugliness in the style, form and symbolism of the masks. Harley says that 'the combination of human and animal features in these masks is a visible attempt to recognise spirit power as having both human and animal attributes'. The combination of human and animal features, plus distortion, suggested certain un-explained phenomena and capacities pointing to a force more potent than that possessed by either human beings or animals.

During the long rites, the women imagined that their sons had actually been swallowed by the masks. They were supposed to be marked by scars caused by the masks when they ingested them and later gave birth to them. Other masks acted as scavengers, rounding up food, begging, borrowing and extorting from the citizens. Others prepared medicines. After their rebirth, towards the end of the initiation the boys were made to sit on mats with blankets over their faces. In two days they were taught everything all over again—even how to walk, to eat and to defecate. Near the

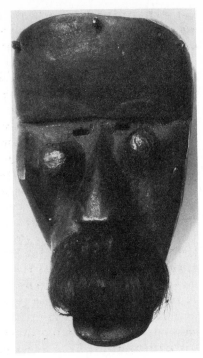

7.9 Ge mask. Liberia.

end of the session the Great Mask, with his deep voice growling like a leopard, came and took the boys to the waterside where they were washed and given new names.

Both male and female symbols entered the Poro. It was on the Big *ma* (the mother of all masks and symbol of the female ancestors) that the young boys swore they would never reveal the secrets of the Poro. The *ma* of the Poro had a woman's face and its keeper had power of life and death over the neophytes and that power was exercised in the name of their masks. If a culprit fled, its keeper could send the mask to the clan where he hid and the entire power of the Poro which extended beyond tribal boundaries could then be invoked to bring him back to justice.

The masks of the Poro and the masks of the Bangwa Night Society had many functions, in controlling society on religious, executive and judicial levels. Among the Liberian Mano the guardian of the great masks could send his mask as his messenger, his police magistrate, his extortioner or his entertainer. The Bangwa night masks executed adulterers, placed injunctions on disputed plots of land, collected fines, stopped disputes. Masks provided anonymity and continuity. If the wearer of the mask died, there was no problem, since his place was taken by another and the mask continued to function without interruption. The wearer merely assumed the character of the mask and could not act out of character. In the Poro, the symbolism of the masks work in a different, slightly more subtle way. Through the masks, elders communicated with the young and transmitted socio-political messages. Initiation with the aid of masks illuminated the social order with the aid of mythological teachings about cosmology, the origins of the gods and people and their social divisions. Masked dancers recreated cosmic beginnings for the edification of the neophytes. Art works thus became part of a complex system of learning about activities, moral principles, myths and history. Art was used for external purposes of social control and as a means of learning and as symbols and *aides mémoire* for knowledge.

The Bundin or Sande women's initiation societies are even more widespread than the Poro and play an important complementary role to this men's association. D'Azevedo's account of the Poro and Sande among the Gola clarifies many of the gaps.

In myth, for example, the Sande seems to have been more important than the Poro. Long ago Sande was the single and all-powerful sacred institution. Though men ruled, women controlled

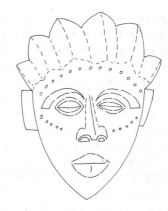

Fig. 7.2 Big Ma of the Poro, Liberia.

all communal intercourse with the ancestors and their spirit guardians, and men submitted to female domination in ritual matters. But there came a time of terrible wars in which enemies attacked and tried to destroy the country. When the men of the Gola chiefdoms attempted to organise themselves for defence, the women resisted because it interfered with the activities of Sande. In their view Sande alone, with its powerful spirit guardians, would be sufficient to protect the land and its people. But the attacks continued and the situation became desperate. Furthermore men learned that women cannot be trusted with the secrets of war, for though they jealously kept the secrets of Sande from men, they would speak out the plans of men to their enemies.

Thus men and women together brought about the Poro. With war, however, came disaster and women could not understand it or cope with it. The Sande therefore is associated with those ancient days of peace and perfect social order. As a consequence it was necessary for men to find a special instrument of power of their own. They searched the forests of the interior until they discovered an awful being, much like the monsters which had once roamed the land and had been driven out by the ancestors and their spirit allies. This being was captured and certain brave men assigned the task of subduing and tending it. They and certain qualified descendants of their lineages came to be known as the Dazo of Poro, the highest and most sacred officials of the men's organisation. The strange being they had captured became the Great Spirit of the Poro whose aspect was so frightful that women could not look upon it. Armed with their new spirit the men were able to subdue women. Boys began to be taken from the care of their mothers at an early age in order to prepare them for the rigours of manhood. They were removed from all female company to teach them obedience to their elders, secret signs by which they would recognise their fellows, endurance of all kinds of hardship, self-reliance, the arts of war, as well as cooperation and absolute loyalty to the Poro. The women and strangers were told that the boys had been eaten by the Poro spirit which would eventually give birth to them in a new adult form and circumcision was explained as part of the process of being reborn. The Poro spirit removed all that was 'childish and useless' in order to produce men. During the Poro session, the Great Spirit was never seen by outsiders. It remained in the secret forest grove of Poro guarded by a priest, but its terrible voice could be heard admonishing the boys

and raging to be set free among the uninitiated of the community.

The women of Sande sought to get rid of the Great Spirit; the men refused, but agreed to an arrangement. The priestess of the Sande and the new priest of Poro decided that each association would take its turn in controlling the country. The Poro would have four years to carry out its tasks and the Sande three years. At the end of its session the presiding association would remove its spiritual powers from its grove to allow for the entrance of the other.

Thus after a year's rest, the priest of the Poro sent word throughout the chiefdom that 'Poro is about to claim the country'. Just as in the ancient days the Poro spirit is led stealthily into the chiefdom and confined to the local Poro grove. Word spreads that it has been brought from the interior forests, wild and hungry after its long absence. Boys and uninitiated men begin to disappear, causing consternation to mothers and quiet satisfaction to fathers.

When all is ready a priest appears and announces that the time has come for men to assume leadership once again. At the sacred towns of the groves he heads a procession of all the men of Poro to the Sande enclosure where the priestess and the leading women of Sande are waiting. The Great Spirit of the men moves into the Poro grove and the boys are ready for their training. At the moment the Poro spirit is heard in the grove. It sings of its hunger, and begs that uninitiated boys be brought to it for food.

During the following weeks all the boys of appropriate age disappear from the villages of the chiefdom and the uninitiated men are ambushed on the roads and will not be seen again until the end of the session. It is explained to the women that though they have been eaten by the Poro spirit, they will be born again from its stomach in a new manly form. It is a time when women weep for their lost sons and men smile wisely because of the return of masculine principles to the world. There is much rejoicing among men and the emblems of male supremacy and strength appear at all feasts and public ceremony. Foremost among these are the masked figures the 'dancing images' which represent spirits controlled by the various subgroups of the local Poro.

One of these is known as *Gbetu*, whose magnificent helmet masks and awesome acrobatic feats create an atmosphere of intense excitement at feasts and other ceremonies. The Gbetu represents a mountain spirit and was used as a 'messenger' of Poro and local rulers in the past. It is one of five or six subsidiary spirits of Poro each 'owned' by a small cooperative group of local

members. These masks do not have the great ritual significance of the Zogbe or the Sande or the invisible Great Spirit of the Poro. They are entertainers or 'mummers' of Poro and represent minor spirits who have been brought to enhance the ceremonies of the men. They are handled by their attendants as scarcely tamed animals who must be whipped, cajoled and contained. This is a symbolic projection of the role of the great Poro spirit which must be rigorously controlled by the men of Poro to restrain it from doing harm to the community.

At the end of the four-year Poro session it is announced that the Great Spirit is about to give birth to newly adult males. A mass mourning ceremony takes place as a wake for the boys who had 'died' four years before. The ceremony concludes with the entrance of the initiates into town, their bodies rubbed with clay and their faces and movements those of dazed strangers. They do not recognise their mother or other female relatives and must be encouraged with gifts and endearments to speak or to look at human beings. This condition lasts for days until they are ritually washed by the elders of Poro. They are dressed in all the finery their families can afford and are placed on display in the centre of the town. Their first act is to demand food, but they show their new independence and male vigour by wringing the necks of chickens brought to them as gifts. They address their female relatives authoritatively and maintain an attitude of aloof contempt for all commonplace human emotions.

The final ceremony is marked by their public performance of the skills they have learned. There are exhibitions of dancing, musicianship and crafts after which they return to their homes.

The Sande myth explains the origin of important institutions. In the beginning there was Sande and women were the custodians of all ritual powers necessary for defending sacred traditions in the interests of the ancestors. The initiation and training of females for their roles as wives and mothers was a central task in which the entire community participated; the generations spring from the wombs of women, and it is the secret knowledge of women which ensures the fertility of families, of the land, and of all nature. For this reason, women have always been more diligent than men in the tending of ancestral graves and in the guarding of the shrines of spirits who protect the land.

D'Azevedo, for the Gola, clarifies the relationship between ancestor spirits and nature spirits. The original lineages and

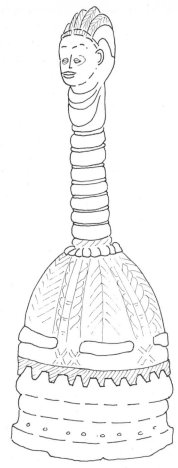

Fig. 7.3 *Gbetu* of the Gola. W. Liberia.

chiefdoms owe their beginning to a pact between the migrant founders and the nature spirits whose land they occupied. These spirits helped the Gola to drive away monsters from the territory and guaranteed the fertility of the land. The first *Mazo*, or head of Sande, and her male assistant (a lineage brother) were responsible for the organisation and control of all women of the legendary Gola chiefdoms in order to inculcate in them the crucial alliance with the nature spirits, their sacred role as potential wives and procreators and their special responsibilities with regard to the propitiation of the lineage ancestors and the nature spirits.

Local Sande lodges are led by a succession of women who inherit the title from a core lineage of the founder often the same lineage from which kings and other officials are selected. Emphasis is placed on obligations to local ancestors and nature spirits. In Sande ritual the *Zogbe* is the masked impersonation of the male water spirit impersonated by a high-ranking woman of Sande. During sessions of Sande or when his services are required, he asserts the ancient rights of his 'people' by venturing into the human community in visible form to officiate and to ensure the continuity of the charter. The women of Sande are referred to as his wives and human males are not to interfere with any of the demands that might be made upon their own wives or their female relatives while Sande is in session. During the session women are said to 'control the country'. Their normal activities are curtailed by rigorous involvement in the complex rites and numerous tasks of 'cleansing the land', training initiates and tending ancestral shrines. Men complain that their own interests are being neglected, but the powers of Sande are great and its work must be carried out for the good of all.

Every four years, therefore, it is Sande's turn to take over from the Poro. When the time comes the Poro priest, with annoyed reluctance, comes to remove the great Poro spirit from the country. Each day he dances in the central clearing of the town surrounded by his musicians and the men of Poro. At last he relents and the spirit is removed, the women are ordered into their houses with all the uninitiated and the Great Spirit can be heard singing sadly as it is led by the men through the town. It is dragged forcibly and its teeth carve long grooves in the dirt of the paths.

The priestess of Sande meets the elders of Poro and they hand her the emblem of power of the secret societies. The moment this transaction takes place she and her attendants shriek with joy and call the women to take over the country. The men fall into the

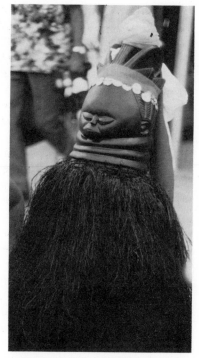

7.10 A *Zogbe*. This masquerade was photographed in Sierra Leone but the general form is identical to that found in Liberia, with perhaps differences in detail, e.g. hairstyle or neck wrinkles.

houses as the singing women attendants stream from the sacred Sande grove and their houses in the town. The masks rush here and there waving their spears at tardy men, and the women cry warning that the country will now return to proper leadership. The men join the women in a festival that night but are warned to remain respectful and humble before the mask, 'our new husbands who have come to rule the land'.

This cycle of male and female secret society activity is part of the rhythm of life. The institutionalism of male and female principles in two compulsory organisations, each with its own structure of administration and its own secret body of knowledge, has a profoundly pervasive influence throughout every aspect of culture. It qualifies all interpersonal relationships by rigorous codification of male and female roles and by its pressure to conformity with traditional concepts of an ideal social order involving absolute obedience to authority as represented by the hierarchies of age, lineage, status and official position. The notion of 'secrecy' is a paramount value of the system—secrecy between men and women, secrecy between the aged and the young, and secrecy between the initiated and uninitiated.

The most common expression of this mutual exclusiveness of spheres of knowledge is the continual reference to 'women's business', 'men's business' or 'society business'. Men will disclaim any knowledge of the content of Sande ritual or training and women adamantly deny any curiosity concerning the mysteries of Poro. Children must never inquire into these matters and non-initiates are warned that banishment or worse will befall anyone whose eyes, ears and minds are not closed to all mysteries which lie behind the public performances of the secret associations.

The organisation of a Sande lodge is maintained under the authority of the priestess and her titled assistants. The initiated women of the community are ranged in three degrees, in accordance with their age, lineage, status and dutiful service to Sande. The women of the third degree usually constitute a body of the leading matrons of the community. It is from this group that the maskers are chosen. They must be great dancers, show endurance and a forceful personality and be beyond reproach in performance of Sande tasks. They also must belong to the priestess's lineage.

A mask presides over a group of from ten to fifteen followers of second degree status and is attended by a few assistants of the third degree. The leader of the group who is also the masker is

responsible for the care of the mask and costume of the image. Many of the masks of a given local lodge are ancient and have appeared for generations in each Sande session. Upon the death or the upgrading of the leader of a group, a new leader and impersonator must be chosen. This person must be of the correct status and one who has learned the style and behaviour or the personality of the mask she is to impersonate. Masks and costumes must be renewed frequently, for the life of a mask in active service is seldom as long as twenty years and should the female membership of the community increase, it may be necessary to 'bring out' new masks.

At the beginning of the Sande session, the women repair and commission new masks. The prestige of each group depends a lot on the fame of the sculptor and the splendour of the new mask. The masker, however, must be chosen and must work in secret— fear of exposure is intense with heavy fines and, even worse, the disgrace if they are discovered. Usually the sculptor is chosen from a kinsman of one of the titleholders or they may commission him through the good offices of an elder of Poro or a local dignitary. Such a man may persuade him to accept the commission. The sculptor has to be wooed with presents, food and money.

When the artist agrees to start work, the women may attempt to demand particular stylistic elements—horns, fish or snake scales, neck wrinkles and special hair-plaiting but on the whole the form and style is fairly standard. When the mask is completed, it is named by the carver unless the women have already selected a name for their spiritual husband, in which case they must pay a special fee to him. The artist instructs the women in the care of the mask and informs them of the rules which govern its 'life'—how it must be stored, oiled, honoured.

The head mask of the Bundu or Sande, therefore, incarnates the spirit of their society and appears during the great feast at the end of initiation. The coming out of the initiation is a great festival; the girls are anointed with oil, their hair beautifully coiffed, wearing rich cloths and jewellery they parade to the accompaniment of songs, dances and acrobatic displays from the maskers. The mask continues to display its splendours while the girls sit at their mother's huts to be admitted. The mask is shining black, the woman wearing it hidden by a cloth costume and raffia veils. The form and symbolism varies little and is found on figurines and other carved objects—the spiral neck, the complicated decoration of the hairstyle and the small triangle face.

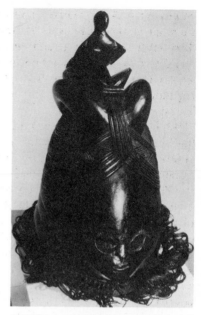

7.11 A *Zogbe* mask representing, at the top of the helmet, the vulva and a traditional Mende hairstyle. Mende, Sierra Leone.

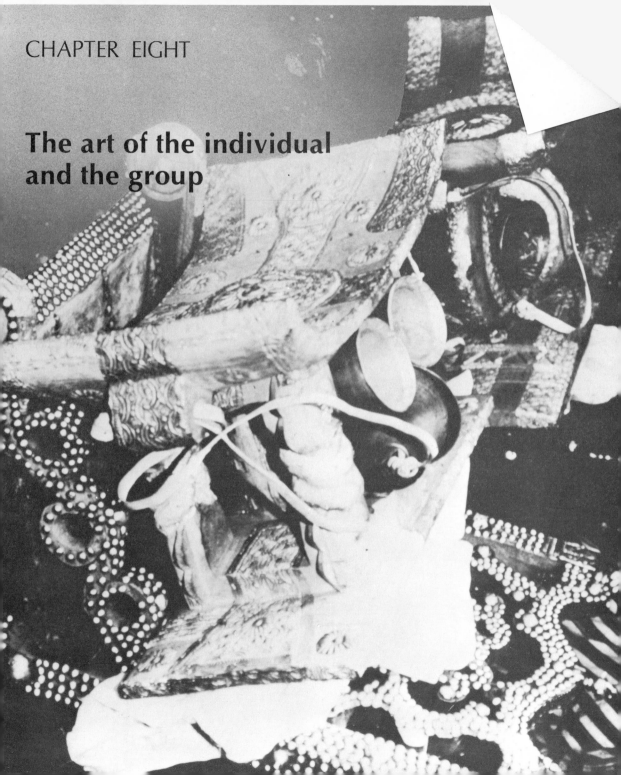

CHAPTER EIGHT

The art of the individual and the group

The Great Mask of the Poro is only one of a great variety of masks with a great variety of functions, among these societies linked together by common languages, a common art style or merely a similar initiation association. Harley, Himmelheber and Vandenhoute have shown that masks have a hundred different origins and functions that vary from clan oracle to personal fetish; moreover their public duties ranged from the punishment of criminals to entertainment by clowns and dancers.

Many of these masks could be owned by individuals. These were usually small carved wooden masks just big enough to fit into the palm of the hand. No-one except the owner should see it except during times of important ritual and women should never cast eyes on them or hear their names. Each month a sacrifice was made to these personal masks and they were prayed to every morning by their owners with a short petition for good luck, protection from witchcraft and health. These masks were given to boys when they were very young and kept for them by their mentors, bound with cotton string, until they were old enough to be taught how to care for them, pray to them and make the monthly sacrifice. Apparently these small masks were a kind of portrait of the owner since his own soul or spirit was supposed to be contained in it. It was also a place where he individually consulted the spirit world in general, and the ancestor spirits in particular. In the case of twins a single mask represented their single soul. A special portrait mask, however, was made for an old man who had attained some special kind of distinction; it was often made with a row of antelope horns on a plaited headpiece. When the man died his mask had to be either turned over to someone who would care for it or put on top of his grave.

Among the Wobe, neighbours of the Dan and related to the Guere masks play similar roles. According to legend the first beings on earth were human in spirit but animal in form and came down from the sky. Some of the spirits had a human appearance and brought law, humanity and culture. Each law brought by men was

8.1 Personal stool of the late Asantehene, Osei Ageyman Prempeh II. The iron and brass bells attached to the stool indicate the status of the owner (see page 183). Ghana.

Fig. 8.1 Great Mask of the Wobe. Ivory Coast.

symbolised by a Great Mask which represented the well-being of the group. Apart from the Great Masks there were individual masks destined to represent the individual powers of a single man, and his spirit. These masks contained part of their owner and for that reason should never be given away or sold. These masks could be made by the individual concerned and children practised for years to make themselves their own individual, beautiful masks. They were supposed to be made in a specific style with bulbous cheeks and foreheads.

The personal mask is of great importance to the Wobe individual. He is allowed to wear it after he has been circumcised and initiated. If a man's social status is low the mask takes on added significance since it gives him moral and physical powers. Once made, the mask receives a name, usually heard in a dream—if a man dreams of a squirrel, for example, then the mask is called Squirrel and becomes a kind of second totem, the animal not being killed or eaten. The mask and even the person are thought to acquire something of the qualities of squirrels. When a person dies the family keeps them, destroys them or gives them away to strangers.

Fig. 8.2 An individual mask of the Wobe. Ivory Coast.

Thus we see that masks are not only the property of chiefs and secret societies but also of individuals. Even within some associations, such as the Wobe *gla*, a possession cult which aims at acquiring individual strength and individual happiness, each member of the society wears his own mask, not the society's. And along with the mask he wears things symbolising the success of the individual in the modern world such as glasses, false moustaches and fearful metallic teeth. There is one type of mask where the owner wears the costume, but the mask is kept inside his own house where it has become an object of an individual, secret cult. These masks are of great significance to the Wobe who, outside these societies and the possession of masks, has little opportunity for expressing personal initiative. All actions are limited by his belonging to a lineage and since childhood he has been rigidly moulded to group action and suffered collective reprobation should he give rein to individual ideas.

In fact membership of associations and ownership of masks frequently express an individual's individuality outside of his role as a subject of a chief or a member of a lineage. In Bangwa, membership of recently introduced dance groups allows commoners to escape from the control of the hierarchical organisation of the chiefdom. In these societies the only prerequisite for joining is a

small membership fee, not being the son of chiefs or having inherited a certain title. In this way individual expression is not denied and even the masks are privately owned. Personal adornment becomes an individual expression. Among the Ibo this is given even greater expression in the Ozo title society where individuals accumulate symbols such as carved stools, spears and elephant tusks. Membership of societies and ownership of their emblems, therefore, helps cut across territorial and kinship ties and becomes a framework for individual ambition. Moreover, a man's position as an individual and ultimately as an ancestor is recognised and ritualised by the celebration of his death and his assumption as an ancestor at the funerals provided by the societies of which he was a member.

Nevertheless this is only part of the picture. The Lega, discussed later on in this chapter, are permitted to hold sculpture and other paraphernalia which express a man's private role as a member of the grades of *Bwame*. However, ultimately these prestige symbols are lineage property as the man merges into his lineage. The family and the lineage play as great a role, or greater, as patron and prop of African art as the individual, association or chief.

Kinship, lineages, families

Some of the best known names in African art did not acquire their pre-eminence through an art patronised, subsidised or even encouraged by wealthy men or powerful chiefs, secret societies or age grades. The Dogon or the Fang certainly never founded states but have developed as important an art form and a collection of masterpieces as any divine kingdom or Poro association. One of the most significant features of African political organisation is the corporate lineage organisation and in these 'tribes without rulers' art objects have their special role to play. In times of war and crisis, leaders of lineages among the Bakwele, for example, came together to decide how to circumvent the trouble through the use of masking. And this masking becomes a serious part of competition for political influence among lineages, lineages attaining power through the use of masks. In some societies such as the Fang where power is transmitted hereditarily within lineages, masks and statues are symbols of the lineage head's right to succeed and are used in his administration of social affairs.

In Africa the family is of prime importance and takes care of an individual's initial needs for nurture, education and companionship. It is within the nuclear family that the most intimate kinship relations are forged, the most affectionate and enduring of which are those between a mother and her children and brothers and sisters. However, it is larger groupings, based on descent rather than kinship, which are significant politically and religiously and frequently inspire works of art. These descent groups, based on matrilineal (through women) patrilineal (through men) or dual lines of descent, often control large numbers of people using the sanctions of kinship rather than of politics to bind them together. These lineages and groups of lineages (clans) may form political groups, religious cult associations and production and land-owning corporations.

In some societies, political order is only thought of and maintained within the lineage organisation, and provides the idiom for inter-group and even international relations. In this chapter we shall be mainly concerned with societies where unilineal descent is the main principle of social organisation, but also in societies where other principles are operative—age grades, state systems—unilineal descent may still have social significance even if it is religious and economic rather than political. In fact most African societies show a high value to unilineal descent, at least in so far as the worship of the ancestors is concerned. Ancestor cults are known from all over the world and all periods of history—the Greeks and Romans and Chinese had attitudes of piety and respect towards their ancestors—and in Africa today ancestors of several generations back may be important for the living in defining lineage boundaries and validating the rights of their descendants. When there is an ancestor cult, the spirits are believed to be concerned with the unity and well-being of the lineages. They are believed to punish with illness or other misfortune any behaviour by their living descendants which harms the solidarity of the lineage group. Quarrelling, theft, breaking exogamous rules may call down the wrath of these ancestors, who act as a social sanction for proper behaviour and help maintain the existing social system.

The Tiv

Perhaps one of the best known and best described segmentary lineage systems in Africa is that of the Tiv of the middle Benue Valley. They number roughly a million and are the largest non-

Muslim people of northern Nigeria. The entire population of Tivland believes itself to be descended from a single male ancestor—also called Tiv—who lived from fourteen to seventeen generations ago and as a result all Tiv form a single lineage and could be put on a single agnatic genealogical chart. Every patrilineage, which forms a segment of this super-lineage is said to be constituted by the descendants of a single ancestor and each ancestor is a point of separation of one group from another group descended from his brother. The smaller lineages, which contain only four hundred or six hundred people, are associated with ancestors, therefore, which differentiate their group from all other groups. These lineages are segmented into yet further groups or lineages by his descendants. Lineages therefore can be of any size according to the ancestor referrent. Some lineage groups farm together, others own land together, some share the same exogamic laws, other larger ones permit fighting within their segments. This wider and wider encompassment of the lineage goes back until we reach the ancestor of all Tiv, when we have the whole population of Tivland as a single lineage.

The interesting thing about the Tiv segmentary lineage system is that it can function without any leaders in authority, even to assign land or settle disputes. Elders associated with different lineage levels exist, but a non-centralised society such as the Tiv cannot allow permanent offices. Nothing resembling chiefship exists; there are only men of prestige, who gain influence through their age, their magic, their witchcraft and their ownership of art objects.

Much of Tiv art is associated with the segmentary lineage system. The *imborivungu* owl pipe is one example. According to legend, the son of Tiv, Poor, died without issue and his surviving brothers took one of his bones to keep his memory fresh, placing it in a hidden basket. Nobody was permitted to look at it on pain of death and it was believed that if this taboo were broken the fertility of the people and the crops would suffer and all the Tiv would perish. However, this magical bone was destroyed in a fire and the successors of Poor's brothers substituted two other bones from the bodies of later ancestors.

Now this original ancestral bone is represented by the *imborivungu*. In fact, this rather unprepossessing art object is a human relic to which has been added moulding and decoration to represent a human figure. It is usually a bone with a head made of metal,

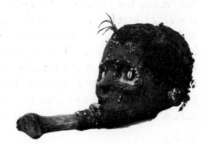

8.2 Tiv *imborivungu* pipe. Made of human femur and skull, with moulding applied in wax and decorated with cowries, abrus seeds and human hair. Nigeria.

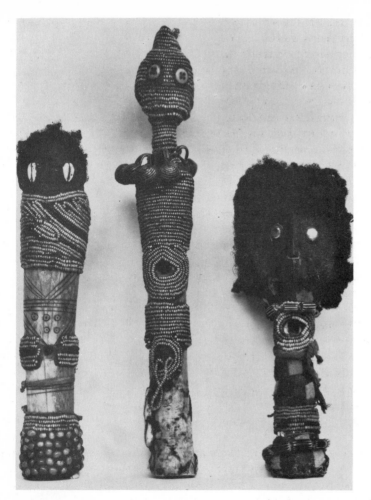

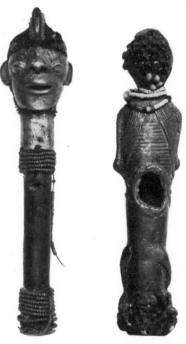

8.3 Tiv *imborivungu* pipes. Made of bone with moulded heads and decorated with beads, cowries, bells, abrus seeds and human hair. Nigeria.

8.4 Tiv *imborivungu* pipes. Right: Cast in metal. Left: Head cast in metal and welded to a piece of old gas pipe. Both are decorated with beads and abrus seeds. Nigeria.

the features being made of stones or cowries and with real human hair. The surface of the bone below the artificial head is sometimes incised with linear designs, but more often the portion of the bone representing the human body is adorned with strings of pink, scarlet and blue beads. Little squares of multicoloured seeds are often placed alternately with the beads just below the chin, halfway down the figure. Other imborivungu or owl pipes are made entirely of metal skilfully cast in the *cire perdue* method. Some have male heads and some female.

Most of these owl pipes are owned by individuals but they are

considered to be holding them in trust for the whole patrilineage. The holder is an elder, or otherwise honoured member of the lineage, who considers that its possession brings him prosperity in crops and children and ensures the well-being of the whole of his patrilineage. In fact, the benefits of the imborivungu are communal. It is supposed to 'set right the land' and unites the community and living with the community of the dead, through the pipe being fashioned from the body of an ancestor and charged with his personal essence. In the language of the Tiv witchcraft society the owl pipe is known as the 'earth' and is supposed to affect the fertility of communally held land.

The pipes are still made, particularly in a certain area of Tivland. However, the pipes which are considered of real efficacy are those which have been inherited for generations, since their power is supposed to go on increasing indefinitely. These are jealously prized.

The owl pipe, which is supposed to ensure the prosperity of the lineages, is also believed to be bound up with the eating of human flesh. The beliefs (and we must only accept them as such) are that when one of the pipes are inherited the change of ownership necessitates human sacrifice for the renewal of its powers. Thus if a man dies leaving a son who is a minor, the imborivungu is kept by the deceased's brother until the boy comes of age. This regent must himself provide one or two human 'lives' and when the object is handed over, the rightful owner must find five or six. The imborivungu pipe still belongs to the lineage concerned, however, but the pipe may not be looked at by them unless they bring a life as a fee. People who have paid this fee are deemed to have the right to join in any rituals or feasts involving the pipe. Once the candidate has been accepted the imborivungu owner takes him to look at the pipe and blows a call on it, indicating that a life has been given.

It is believed that the flesh paid for 'seeing the imborivungu pipe' is not eaten in a communal meal but that everyone removes his own portion to his house where he shares it with his wife, if she is entitled to it, and other members of the witch group. Although meat may be shared outside the close family group, those grouped around an imborivungu pipe form a close corporation. A lineage and members of other imborivungu groups are not admitted whether they belong to the same clan or not, so that a man who has provided a life to join one group is not entitled to partake in

human meals provided by other groups merely because he has given a life to imborivungu pipes in general. Moreover, he is not entitled to become a member of any other group other than his own patrilineal one.

Making the land prosperous is one of the functions of the imborivungu ritual and Tiv say that for this purpose a man is killed and his blood poured into the pipe in order to prosper the land and to ensure a bumper crop and a high birth rate. Nevertheless the lineage attitudes to the imborivungu are ambivalent. The owl pipes are necessary and beneficial, since the performance of their ritual help to make crops and human beings fertile and abundant, but they are also evil and dangerous for their ritual requires the sacrifice of human lives. Thus, while the lineage agrees that the rites of the owl pipe must be performed for the benefit of the community, at the same time the lineage knows that it is wicked and horrible to bewitch and kill even for the most legitimate ends and even when it is entrusted to respected elders.

The Lega of eastern Zaïre and the role of the lineage in the Bwame cult

By far the most important institution in Lega culture and one which pervades the whole social structure, is the Bwame association. I have already treated similar cults—the Bambara associations were looked at from the point of view of their economic and religious roles, the Poro from the part the masks played in social control. Here I want to investigate the interplay of lineage and association and the role of masks and other paraphernalia in the Bwame society.

Membership of Bwame is open to everyone, both men and women, although they have access to different sets of rites and initiations within it. Each initiation involves a long preparatory period and a considerable amount of food and other valued goods are exchanged. Like other African voluntary associations it is built on an intricate hierarchical system of grades and subdivisions and operates within the framework of the lineage groups and of terri- torial based communities. Bwame has nine major grades.

Again, like other voluntary associations, its functions are multi- faced—they are political, economic, religious, recreational or aesthetic, but according to Biebuyck the primary purpose of Bwame is the pursuit by the individual of wisdom and moral

excellence. During initiation rites the Bwame ideology is conveyed in thousands of proverbs and aphorisms which directly or indirectly express the basis of Lega culture. They teach roles and statues, technology and moral principles—you must not fight, you must love your wife and so on. Apart from Bwame there are no myths and no complex cosmology. Those who are initiated into the highest grades have prestige and a kind of moral immunity.

The Lega are original, prolific and adept carvers and make fairly small sculptures of ivory and bone, wood and mud, resin and soapstone. They are used and owned by members of the association and are intimately involved in the dramatic performances, the dancing, singing and miming of Bwame initiations, along with a bewildering variety of natural objects, flora and fauna, minerals, pieces of rope, wood and pottery. Of art works proper we have masks of different sizes, made in wood and ivory elephant bone and hides, anthropomorphic figurines, usually in wood or ivory, animals and small human-shaped heads. All these are symbolic items forming a closely interrelated whole and the underlying meaning is used as a teaching aid. An object associated with Bwame has a special sacred status. The largest category are miniature masks with beards which are associated with the ancestors and graves and are owned individually, inherited within lineages. Larger masks are always, or almost always, made of old, heavily painted ivory held on behalf of the total ritual community, which is a clan or a pair of clans, by the most senior member.

For the owners, the sculpture is considered as wealth, although like many an antique its original worth may have been little. They have little direct religious functions, apart from their role as symbols of the relations between the community and the ancestors. Their functions, according to Biebuyck, are rather political and economic. Nevertheless, for the individual the masks and figurines have ritual significance—they have the power of increasing and strengthening a person's life force and health. If a man is ill, for example, he will drink water which contains dust from the figurines.

The figurines are from three inches to seventeen inches high and for a vast number of them their exact meaning can never be inferred by looking at their formal characteristics. Any specific meaning condensed in an aphorism may be illustrated by a number of figurines and other objects that are morphologically quite dissimilar. Most frequently the linkage between figurine and meaning is based on a purely conventional, traditional and arbi-

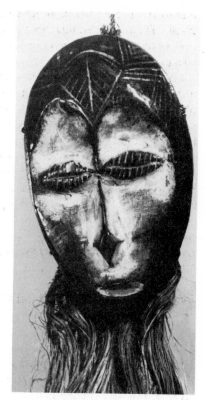

8.5 Wood mask with beard. Lega, Zaire.

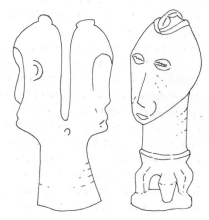

Fig. 8.3 Ivory masks. Lega, Zaire.

trary association, permitting no speculations about meaning. Tourist art, for example, can easily be adapted into the rites.

During the Bwame rites, individual masks are shown to the initiates, either worn on the face, on the temple or on the top or back of the head. They may even be worn on the knees or arms or dragged across the ground or whirled around in the air by their beards. All the masks and paraphernalia are manipulated, danced with, moved out by the singing and chanting teachers, to the accompaniment of drums and rattles. Proverbs and aphorisms are sung to identify and interpret the objects. The Lega use their art works to effect but do not make discriminatory statements about them. In the rites, outstanding and mediocre carvings are displayed together as complementary items that all converge in the moral philosophy and social functions of the Bwame. Great sculpture which is lost or sold is replaced by almost anything semantically equivalent. In one rite a figurine was replaced by a banana stalk.

Nevertheless, the initiatory objects form a vast storehouse of symbols that help to translate into metamorphic language the essence of Lega society and thinking. Each item is explained in terms of its relevance for the social and moral code and the meanings of the figurines are sharply differentiated, many different messages being provided by many different figurines. The number five symbolises the lineage community. The centre of a circle or a square suggests the significance of the sister's son. The sister's son is represented by a kidney—deep inside the animal sleeps the kidney (the sister's son). Besides interpreting codes and structures the Bwame rites celebrate actions, events, hunting, harvesting and warfare.

At the great culminating *Kindi* rite, the cult objects are placed on the ground and covered with a skin. The naked candidate is brought in on the back of his naked preceptor, the position of the candidate's body being that of a corpse. After being carried around the objects the candidate is put down and invited to jump over them shouting his special drum name as he does so. The revelation of the figurines is followed by silent contemplation and explanation. The symbolism of the rite seems to communicate to the candidate that his dead body will wake up and be perpetuated in the ivory images; they console him with the assurance that the dead are here among us. Kindi is therefore a promise of immortality and glory and the figurines help foster this belief. Nevertheless, there is a good deal of joking and enjoyment even in these serious rites.

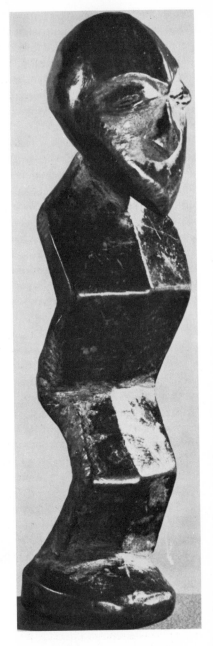

8.6 Wood statue. Lega, Zaire.

The candidate, during this performance, is nervous, naked and without ornaments of any kind. Supported by one of his teachers he watches silently without visible emotion. Sometimes he is made to move about, sometimes he is manhandled, rolled over and over on the ground, or the teacher roughly rubs his arm against the initiate's nose. A teacher runs past with an antelope figure, another faithfully enacts the contractions of a woman suffering painful labour.

Special statues in Bwame pertain to temporary possession (on behalf of a lineage) of collectively held initiatory objects contained in bags and baskets. Kindi, the highest grade of Bwame, symbolises its unity by its collective possession of a basket. When a candidate is initiated as a junior member he is given the basket by the most senior Kindi member in his clan. The man who holds the basket should belong to the same clan as the candidate and also this primary lineage, although their relationship may be based on a more distant agnatic tie. Other baskets are kept by the lineage and are transmitted in an agnatic line as the owners die or as they move up to higher ranks. High status is attached to the ownership of these baskets, up to three of which may be held by one person or by different persons within a lineage. This means that the most senior members of the Kindi grade hold in trust for members of his clan—as well as for the Kindi community—masks and statues often of great age and aesthetic quality.

At the same time since most of the masks are insignia of rank, specific types are automatically owned by all the incumbents of a certain grade. At the Kindi level there is no limitation to the number of art objects—mostly ivory figurines—which a high-ranking member can possess, or hold in trust for members of his lineage. Bwame enables individuals to acquire status and the display of the objects is clear proof of an individual's outstanding achievement, not only because of their number, but also because of their rarity.

Lega sculptures, therefore, validate individual statuses. However, the ivory and bone sculptures are not usually acquired by Kindi initiates through their own efforts. A most important distinction is made between objects held individually and those—the greater number—which are held in trust by specific persons on behalf of a community of individuals such as a lineage, a clan or a group of clans which are formed into a ritual community. On the whole baskets and wooden figurines and horned masks are collectively held and circulated at the death of their keeper, or if he is

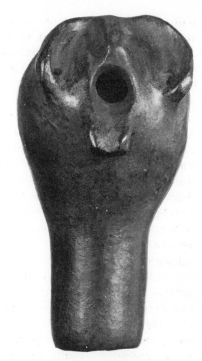

8.7 Terracotta head. Lega, Zaire.

seriously ill, they may pass before his death to the Kindi next in authority. Ideally the transfer takes place within a field of close agnatic relations and falls completely within the normal patterns set by the Lega kinship system. The individuals should be closely related although they may not inhabit the same village or group of villages. If a member of a lineage moves up from one Bwame grade to the next he must also transmit objects to a kinsman who is being initiated into the group he is leaving.

Kinship, therefore, plays an important role in the transmission of the symbols of the Bwame cult association. Sculpture passes from hand to hand and are symbols of continuity in lineages and large ritual communities. They are also symbols which link the dead to the living members of the lineage. The masks and figurines are mostly collectively held and lineages can trace back with pride the origin of a collection possessed by one of its members recalling the names of those who introduced certain objects into the group by naming the ancestors. Sometimes clan alliances are celebrated by these figures; two clans may own individual figurines which are thought to be complementary and they form an alliance—one may have a large male figure which forms a ritual entity with a similar female figurine owned by another.

The possession of collectively held art objects, usually in bags or baskets, therefore, establishes patterns which reflect very closely those conflicts and unities which occur in the segmentary lineage system of the Lega. Moreover, the higher the initiatory level, the fewer the sets of collectively held objects. Every Lega lineage has a larger number of ritual bags for lower grades and an extremely limited number of baskets in the Kindi grade. Bags, on the whole, are connected with small lineage groups, Kindi baskets, with the larger more encompassing lineages or clans. Since the small groups are segments of the larger groups, there are necessarily more of them, thus reflecting the well known principle of complementary opposition in lineage and clan. The component segments of the clan, symbolised by a Bwame bag, act as a multitude of autonomous, decision-making ritual units at one level of initiation and as a unified totality at other levels.

The ritual objects and sculptures are kept in bags and baskets which give a lineage or clan the right to become a ritual community. There are no rules as to the number of sculptures that exist in a certain clan nor is the strict level of the lineage group that possesses a basket fixed, although the possession of a basket allows it to act

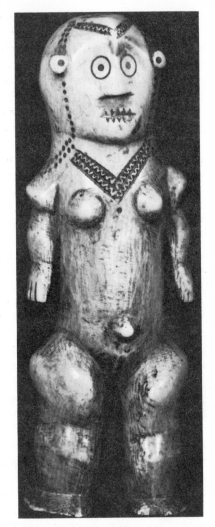

8.8 Ivory figurine. Lega, Zaire.

as an autonomous group in initiation ceremonies. The lineage level is related to the numerical size of cooperating groups and to the number of subdivisions in the clan, to matrilineage linkages that are recognised between lineages, and to territorial compactness or dispersal of the group and to the number of baskets purchased from outside the group by powerful initiates past and present.

Thus there is, for example, one Lega clan with eight lineages. One of these has no rights associated with a basket and sculptures and has many incorporated strangers. The second and third are paired as descendants of the same wife of the clan founder and so are the fourth and fifth. The first and the sixth are paired, so are the seventh and eighth as sons of different wives of the founder. As far as these lineages are concerned, numbers four and five have one basket. There are three to seven baskets in the other primary lineages. If several baskets exist within a primary lineage they are distributed among secondary lineages. In other words each secondary lineage has its own basket. If a secondary lineage is numerically strong and genealogically complex, the baskets are held within tertiary lineages but not every such lineage has its own basket. Individuals who actually hold the baskets in the lineages are all incumbents of the grade before the Kindi or Kindi itself, the highest grade. When the holder dies the basket is given in trust to a basket owner of another lineage in the clan 'to hide away' until a duly recognised claimant asks for it. The claimant is preferably selected from the extended family of the dead owner and the basket is seen as passing from a 'father' or a 'little father' to a son or from a senior to a junior agnate. If the claimant is selected from another family or lineage within the group associated with the basket, it must ultimately return to a person in the original owner's direct agnatic line of descent.

Even Biebuyck agrees that Lega sculpture cannot be easily analysed according to their ritual functions. The social significance of the objects is important as social symbols, signs of recognition and items for socialisation. One of the major functions of masks during the initiation rites for example is to inculcate respect for elders and agnates within the lineage. The mask tells you not to disgrace your agnates and at one stage a teacher, wearing a mask, lies on top of the initiate. The moral of this is 'don't seduce your father's wife'—a great taboo in Lega society. Another time, using the mask, the initiate is forced to stand behind the masker, holding his penis and the two then crawl around coupled, the masker

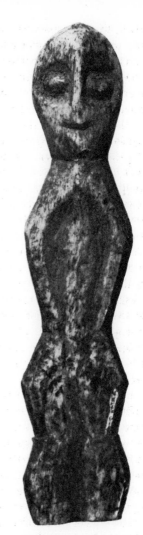

8.9 Ivory figurine. Lega, Zaire.

shouting wildly and protesting. Again songs are sung about the taboo against seducing your father's or elder brother's wives, or throwing your brother to the ground, or catching hold of his penis. Moral instruction in the initiation rites are primarily to do with lineage affairs, the education stressing the idea of seniority, of greatness, of power and dignity, of supreme authority and untouchability.

Individual masks, as well as baskets, are intimately linked with the lineage system, serving as symbols that tie an individual to an unspecific group of dead kinsmen and initiates who have been associated with a specific mask. Unimportant masks symbolise the perpetuity of a short line of initiated kinsmen. At a higher level a great mask celebrates the perpetuity of an entire kinship unit. Sometimes the masks are referred to in a group as 'graves': 'Bring together the graves that I may know the skull of my father'. A mask, therefore, will change hands at each generation and belongs in effect to a kinship group and will not be passed on to another agnatic group. In some cases the mask is only secondarily an initiatory object and primarily a lineage symbol.

Asante stools

It is not only in acephalous societies—without rulers—that lineages play an important role. The Asante have already been treated in this book as an example of a centralised state with a political system supported by trading monopolies of such things as gold, guns, salt and slaves. However, kinship and descent play a social, economic and political role on all levels of society.

The Asante are a matrilineal people and many of the affairs in the famous confederation were regulated through matrilineages. They believe that a man is related through blood to his mother (and to his father through spirit) and that the real link between generations is provided by the blood transmitted through matrilineage kin. An Asante therefore traces his descent through his mother and is a member of his mother's lineage which consists of all the descendants who trace their genealogy through female links to a common ancestress. The lineage is localised in the sense that its members live in the same chiefdom and may be very large, although it is always divided into smaller segments. The most important of these lineage segments is one which includes about four generations of

uterine descendants of an ancestress.

An Asante chiefdom is an aggregate of social units composed of lineages formed into villages. Each lineage is a political unit represented on the council by a headman chosen by the adult men and women of the lineage. In the same way the chief who rules the chiefdom is also chosen from a particular lineage by the heads of other lineages.

Asante lineage ancestors play an important role in maintaining the well-being of the community, the organisation of which was rooted in kinship. An Asante is always in contact with his ancestors; at meals the first part is always offered to the ancestors and libations are poured to them daily. It is believed that success and prosperity in this life depend on the ancestors: they punish members of the matrilineage who break the customs or fail to fulfil obligations to kinsfolk, while those who obey the customs and fulfil their obligations receive help and blessing from the ancestors.

The shrine of each lineage is a blackened stool. On this shrine the head of the lineage at the appropriate times offer food and drinks to the ancestors praying that they may protect the members of the lineage, bless them with health and long life, that the women may bear children and that the farms may yield food in plenty. As far as the chiefdom is concerned, it is the dead rulers, the ancestors of the royal lineage, that not only guard lineage members but protect the whole chiefdom. In the main rite of a chief's installation, the new chief is lowered and raised three times over the blackened stool of the founder of the royal lineage. Through this rite the chief is believed to have been brought into a peculiarly close relationship with his ancestors. His person as a result becomes sacred, a sacredness emphasised by taboos surrounding his person.

The carved stool is the soul of the lineage and the soul of the nation, the sacred emblem of permanence and continuity. The chief, the occupant of the stool and representative of all those who have occupied it before him, is the link, the intermediary, between the living and the dead. These sentiments are kept alive in the periodic ceremonies when the departed rulers' ancestors are recalled, food and drink are offered to them and a sacrifice is made to them with the stool as the central object. An Asante lineage head or ruler officiates before the ancestral stools and prays to his ancestors on behalf of his people that the earth may be fruitful and the people may prosper and increase in numbers.

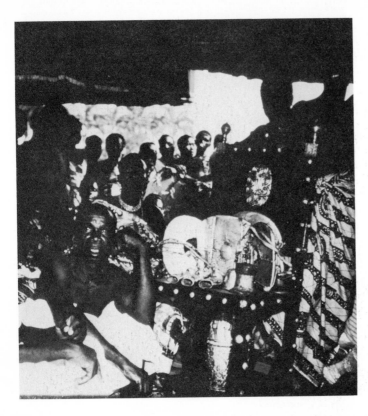

8.10 The Golden Stool of the Asante. The stool is placed upon its special throne, which in turn rests on an elephant skin. Kumasi, Ghana.

The stool, symbol of the authority of the lineage head, is preserved in his memory when he dies. Subsequent lineage heads will also have their black stools in the same room though some lineages keep only the stool of the founder of those particularly famous among the ancestors. The black stool is believed to be inhabited by the spirit of the head of the lineage and to possess magical qualities. The black stool is in fact seen as a substitute for the physical body of the dead person.

The stools are symbols of the ancestors and the lineage. They are rectangular pedestals with curved seats supported by carved stanchions. In the Kumasi stool house ten black stools are preserved as well as a bell representing the famous Golden Stool of Asante regarded as the soul of the Asante nation. These Kumasi stools are of historical importance as they commemorate the reigns of several of the Asante kings. They are also of social significance since they enshrine patriotic sentiments.

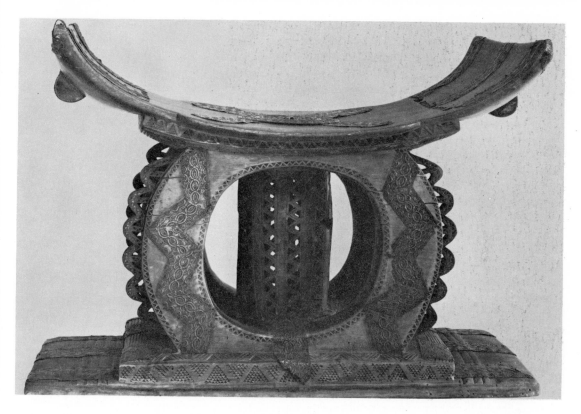

The Golden Stool was traditionally believed to have been brought from the sky by the first king's priest and counsellor. The priest promised the king he would conjure from the heavens a stool which would be the symbol of his authority and of the unity of the nation; it would be the repository of the soul of the nation and would bring prosperity and prevent adversity. The Golden Stool descended from the sky and dropped into the lap of the king to the accompaniment of thunder and lightning. The Golden Stool, a mass of solid gold, stands about half a metre from the ground (see Plate 8.1). The seat, about 60 cm long, has bells of copper, brass and gold attached to it and charms of gold and beads are added to it by each successive chief. It is fed at regular intervals and if left hungry the stool and the nation it represented would be in danger of dying. Being regarded as a sacred object the Golden Stool is never allowed to rest upon the bare ground but on a blanket of camel hair or on an elephant skin. Today it is kept in a secret place

8.11 Wooden stool for a Queen Mother, decorated with silver sheeting. Asante, Ghana.

and is represented in the Kumasi treasure house by a golden bell.

For an ordinary lineage head the stool chosen to represent his spirit is the one he ate from, or the one he sat on to have his bath —the daily bathing meant that there would have been a complete penetration of his soul stuffed into the wood. Others say it has to to be the one on which his corpse was bathed. The consecration ceremony consists in making the stool black. Black is the symbol of death and it also prevents decomposition of the wood, of course. The successor pours a libation on all the old stools. Eggs are broken and mixed with soot and the new stool is smeared with the mixture. A sheep is killed and blood is sprinkled on the stool. For chiefs this is performed by the chief of the Stoolbearers and his assistants. The queen mother of each lineage is also meant to have one, while the queen mother of the Asante nation had a silver one. The stool is kept in a stool house and many taboos surround it, such as that no white man or menstruating woman should go inside. It is kept on a bed or dais and the *kuduo*, the brass vessel for holding gold dust, is placed under it.

The Asante also have 'unlucky days' when the stools have to be worshipped. Cooked mutton or even raw meat is placed on the stools. If roasted small pieces are stuck on skewers and placed in bowls in front of the stools. Blood is also sprinkled on them. The stools also have positive ritual functions—they are the central symbol at child naming rites, the puberty ceremonies for a girl. Sacrifices are made to them when a member of the clan marries or if an offence has been made against the ancestors, the worst of which is incest. They also sacrifice before a long journey, before mortgaging land, before war. In some cases the stools were carried to war to bring good luck and strength. When the war was going badly the chief would stand on the stool—an act of serious insult to the ancestors. By annoying the spirits he hoped to make them more vigorous and bring more help to his soldiers.

The symbols of Asante chiefship, therefore, are carved stools which were originally symbols of lineage unity. Like Lega masks they represent levels of lineage segmentation and are revered through their association with the ancestors. Even the sacred emblem of the great Asante confederation was derived from this symbolism and demonstrates the segmentary nature of the Asante state which had as its basis the segmentary nature of the clan system.

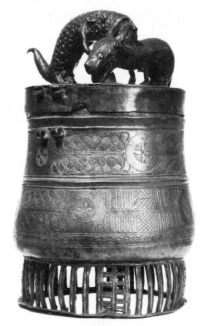

8.12 Brass *Kuduo*. Asante, Ghana.

Art and religion

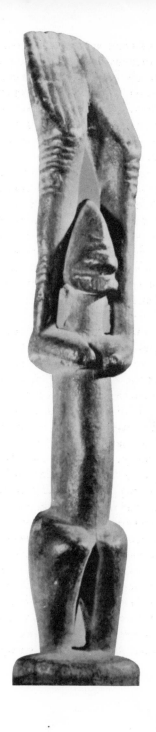

Until recently African art was 'religious' and that was that. Nowadays we recognise that it has political, economic and social implications as much as any art and that art for art's sake exists as much in the African forest as it did in the French drawing room. In many of our best text books however, the 'religious mystery', and 'supernatural awe' inherent in the 'fetishes' and cult objects which found their way from darkest Africa into museums derived from their religious character. Whether considered 'grotesque and monstrous' or 'soulful and impressive', the all-embracing explanation for portrait statues, dance masks, royal paraphernalia, even furniture, was that they were religious items—elements of witch cults, fertility cults, magical and totemic rites. This is how we Europeans wanted to see African art.

Nevertheless, it would be wrong to deny the essentially religious content and symbolism of much African sculpture, an element of which can be found in most secular art forms in Africa or Europe. Of course some peoples are 'more religious' than others: among the Yoruba, for example, the most prolific of all African carvers, the largest concentration of art works is devoted to the cults of the various *orisha* or gods. In other societies, masquerades and other ceremonial performances, using masks and carved figures, may be the enactment of a basic myth—this appears to be true for the dances of the sacred masks of the Dogon, Bambara, Bobo, Mossi and Senufo.

Dogon art is explicitly religious. A large series of statues depicts the genies of the ancestors; the appearance of the first beings, who, through an act of incest, upset the world order; the sacrifice of the *nommo* after their suppression of disorder, for the purpose of purifying the primordial fields, plus the arrival of the blacksmith; the horsemen with the ark carrying skills and crafts as well as the ancestors of animals and men. To understand Dogon art one does have to know the details of their myth—even the eight little people on the seats of some Dogon chairs are the eight genies, the ancestors of men. Moreover, the Dogon, unlike the Bangwa, have

9.1 Wood figure, said to represent a *nommo*. In Dogon mythology the *nommo* are the first ancestors, offspring of Ama, the creator god, and the newly formed earth. Dogon, Mali.

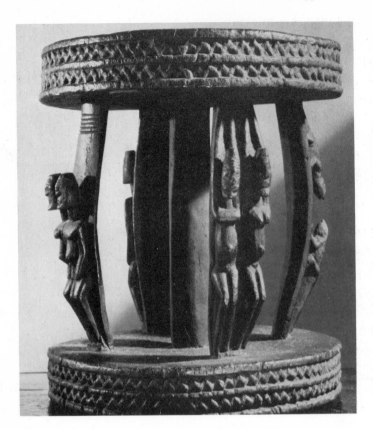

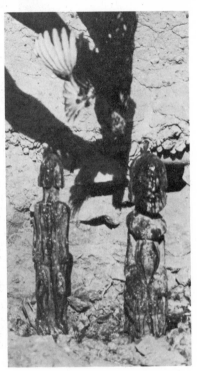

9.2 Wood stool supported by *nommo* couples.

9.3 These statues were carved for the funeral rites of Dogon men to provide a lodging for *nyama*, a man's life force, that is set free at his death. Every Dogon household regularly nourishes their ancestor statues, to ensure the wellbeing of the community, by allowing the life blood of sacrificial creatures to pour over them. These statues are receiving the blood of a chicken.

never tried to represent the symbols of political power, nor even their historical ancestors—their art is primarily based on the depiction of mythical events. The statues or figurines of these farmers of Mali are spirits of legendary heroes, not historically placeable characters. Among the Dogon, the dancers wearing the famous *kanaga* masks (kanaga means a god's hand), repeat, with the circular movements of their heads and shoulders, the gestures made by God when he founded space and created the earth. The kanaga mask, topped by a kind of Lorraine cross or a vertical pole with geometrical designs, symbolically expresses the myth of creation. According to Griaule, the cross is a symbol of the equilibrium between heaven and earth, of divine order in the cosmos. Others say that it is the crocodile in Dogon mythology; the first Dogon rode through the rivers on the backs of crocodiles.

The Dogon number about a quarter of a million and are patri-

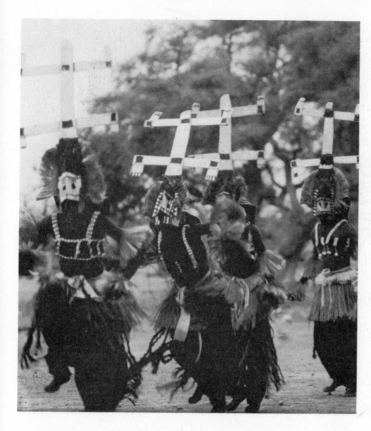

9.4 *Kanaga* masqueraders. Dogon, Mali.

lineal farmers who live in the cliffs of Bandiagara at the centre of the Niger bend in Mali. Their cosmological and social system has been explored in marvellous detail by a team of French ethnographers and linguists inspired by the late Marcel Griaule. Here I shall deal only with the Dogon Grand Mask, an important but rare kind of mask, from which all Dogon masks derive. It is the mother mask, the abode of the primaeval soul, the external source of human life. It is difficult to describe since examples are rare and dilapidated. In most of them, in a prominent position over an angular face, there is an open-work panel, with a geometrical design arranged in a step-like pattern, which joins on to great wide-open jaws. It is always attached to a long piece of wood or pole which may be as long as 9 metres.

To understand the meaning and the function of the Grand Mask we must understand the significance of the Dogon creation myth

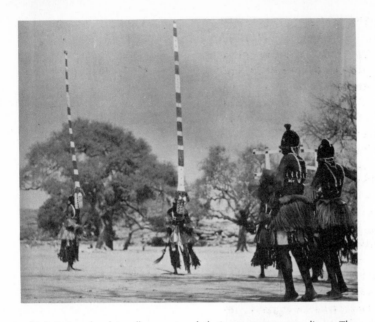

9.5 Grand Masks dancing. Dogon.

which is involved in all aspects of their contemporary lives. The
myth determines the sowing of seeds, and is recited at funerals.
At the same time the myth has not become petrified through being
written down and consequently changes from place to place and
from generation to generation. In this chapter I shall only be con-
sidering aspects of the myth concerned with the Grand Mask,
the initiation into the *Sigi* and the Sigi dance, where the close
integration of myth and ritual and art gives Dogon art its main
interest. The Sigi was instituted on the death of the common
ancestor of a section of the Dogon who is venerated by all Dogon.
His death was the first in the history of men and constitutes for the
Dogon a kind of original sin. Because of the sin, reparation was
necessary and this was the origin of the Sigi rites, the sacrifices and
the festivals, and the carving of the huge support for the soul of the
ancestors, the Grand Masks, and the consecration of a new
generation to the Grand Mask. The purification is thought to last
for the duration of the mask and the duration of the generation;
so it takes place every sixty years as the mask disintegrates and the
original initiates begin to die.

The original inhabitants of Dogon country were the *andumbulu*,
the little men, who for countless years were immortal until the
transgression of one of their elders brought about a cosmic dis-

equilibrium and along with it Death. The death of the man, or the Snake as he was called, caused great distress and a mask and a snake had to be carved to bring him back to life or at least ensure continuity in the world by preserving his soul. By means of a ruse, however, a woman now came into possession of the wooden snake, the mask and a number of other objects including the fibre costume and the bull roarer. Men fought her for these objects, defeated her, and thus sealed man's domination over women.

The Grand Mask thus originated during a period of disequilibrium, both the Grand Mask and the snake becoming associated with a mythical loss of human mortality. The Dogon diviner told their ancestors to carve a huge wooden pole in the image of a snake, sacrifice a cock and a snake, and dance the Sigi every sixty years. The diviner said they should get beer, tobacco, sesame seeds and salt and when the people were together, all the men and male children should take a calabash and dance and learn the secret language of the Sigi. Three years after the death of the serpent, the tree was cut down, the length of the snake. Then two children who had come out in red spots through their contact with death, became the first initiates and the Grand Mask was decorated with the colours of the serpent in order to tie his soul to it. The victims were then sacrificed and the Grand Mask became the shrine of the ancestors and the spot where the soul of the first dead man was concentrated.

In the cave shelter where the mask was kept the ancestors traced, with ochre and blood, the design of the wooden serpent. With the Grand Mask they touched the initiate's head and the painting. Then the serpent's image was installed in the cave and the youths lost their dangerous red spots and became normal. Outside the secret cave the men prepared for the Sigi festival when the initiates came out, were given a necklace and danced for seven days. The initiates became the caretakers of the Grand Mask—moreover, since they had been infected by the dead snake, but at the same time were protected by him, they could have contact with death and could carry the dead and build menstruation houses. The masks became things of the dead. The *dama*, or funeral rites, were invented to drive away the souls of the dead.

Sixty years later the first of the initiates died and was buried in the shelter. The next year the cave became bright red and they had to celebrate another Sigi, and since the original Grand Mask had disintegrated they had to make a new one. They made the same

sacrifice and chose three more initiates and all undertook to nourish the Grand Mask until the next Sigi. Part of their work was to paint the cave and sacrifice animals to the masks.

This is the myth of the Sigi and the Grand Mask. In Dogon land every village or group of villages has a Grand Mask which, along with the long pole to which it is attached, remains in a cave and is only removed for the death of certain notables and the Sigi. One particular village always gives the signal for the making of a new Grand Mask and holding the Sigi festival every sixty years. Then all parts of Dogon territory take their turn according to a fixed schedule—during the course of six years—to make a new Grand Mask and hold their own Sigi. Having harvested the millet the men, preceded by a man with an iron gong, go from village to village, dancing. Sigi is thus transmitted from region to region.

The Sigi can be seen as regulating Dogon religious life although it brings material advantages as well as fertility. During the preparations for the feasting and celebration, there is an unconscious reckoning of the resources of the group as they make a great effort to produce and consume as much food as possible. The Sigi also gives social prerogatives to all those who attend, particularly the initiates. The really great *olubaru*, or initiates, are those who have attended two Sigi, and there are even cases of old men who have attended three which means they must be at least 120 years old. Special women are also allowed to join the Sigi; their role is to help the mask when it dances, wiping the brows of the maskers and so on. They are not, however, allowed into the mask shelter, nor do they learn the secret Sigi language.

The Great Mask is carved a few months before the ceremonies in each village. The tree, after lengthy rites, is cut and the carving is supervised by men who had attended the last Sigi, sixty years before. The 'snake'—or the long post—is carved out of the length of the tree. During the carving, an elder recites the part of the myth referring to the discovery of the fibres by the First Men and the death of the ancestor in snake form. The finished snake-pole is painted in black and red triangles and a grass bracelet is attached to its end. It is then consecrated in the presence of the future initiates. Both new and old posts are taken to the cave where the old mask has been sheltered for the past sixty years and placed next to it on the shrine. In this way the new Sigi pole acquires the powers of the old one at the moment of sacrifice. The livers of a dog and chicken are pounded and spread on the masks.

The rites and ceremonies, which now follow, aim at getting the soul of the ancestor to enter the mask. The initiates arrive, having collected food, sesame grain, millet and cowries as payment, and go into retreat. They are welcomed at the cave of the Grand Mask by the aged initiates of the previous Sigi. Their heads are shaven, their clothes are taken away and they are only permitted a skin and leather sandals so that they should recall the time before the invention of cloth when they wore skins and lived in caves. Their initiation includes the learning of the myths, the taboos concerning the mask and the secret language of the Sigi. During this period they may not return to their village and are not allowed to frequent uninitiated boys or women. At the same time the villagers are required to stay in their home and not go to the farm. The harvest of millet has already been done but the cotton crop has to be harvested by the initiates.

When the new Grand Mask is in the cave, the elders, watched by the initiates, paint the mask with rice and red earth. Then the mask is made to touch the head of the initiates. The elders then paint the walls of the cave and the Great Mask is lifted up to touch the painted walls, to give it force—as it said in the myth. After the first days the oldest man sacrifices to the mask, wipes out the red signs and reproduces it in millet porridge. This sign means 'Amma —or god—lead me!' and becomes red, magically, sixty years later at the next Sigi. The painting reproduces what the ancestors painted in the original shelter and has power because it repeats a mythical action.

The background of the Sigi ceremony and the renewal of the Grand Mask, therefore, depends on a background of mythical and cosmological ideals of a much greater complexity than I have been able to recount here. It follows, for example, the perambulation of an invisible star, the star of fonio which may be compared with Sirus. Sixty, the number of years between each Sigi cycle, is the basis of Mande counting and denotes the passing of one generation to another, and the transfer of all men at the age of sixty into a superior domain. During the performance of the Sigi, two sequences of Dogon cosmology are represented. The first deals with the revelation to mankind of the spoken word. The everyday language was given to mankind by the mythical creator; the second language is the secret one of the Sigi which is taught to the initiates during the retreat of two months which takes place before the ceremonies proper. The second sequence deals with the appearance of death

among mankind as recounted in the myth.

The performance of the Sigi is a performance of the myth; certain performers represent the women and the ancestor who broke the taboo and brought about death in the human world, is represented by the presence of the Grand Mask. The costumes of the initiates are said to represent a fish or a foetus—the fish is a foetus because both swim, in the waters of the river or the waters of the womb. All initiates carry a special chair cut from a special wood and dyed red; sitting on it they are said to be sitting on the male organ of the genitor of humanity. They also carry half a calabash in which they drink the beer of the Sigi, and which is a symbol of the primordial calabash in which the gestation of the universe occurred. It represents the male genitals and the female womb. In the right hand the initiates hold a flywhisk which they wave during the dance to keep away disorder, represented by the Fox. Death exists but it is defeated.

The centre of the Sigi is the Grand Mask where the spiritual being of the first ancestor resides. Yet this 'mask' is really a long post, hardly ever seen and certainly never worn as a mask. Only men who have undergone the Sigi rites can look after the traditions of the Great Mask. The 'mask' itself is cared for by initiates who have observed a retreat of two months before the festival and who have learnt the Sigi language. For sixty years they will remain the guardians of the Grand Mask. The mask remains hidden in the cave, served by his 'children' who give him sacrifices.

The Grand Mask only comes out of the cave during the funerals of his servants or at the death of lineage heads of great age. Originally the souls of the dead were allowed to find refuge at a shrine on the flat roof in a Dogon compound but these souls grew too many and began to plague the living. The Great Mask is associated with the old man who dies as a snake and it is therefore appropriate that it should be used to drive away the souls of the dead from the land of the living. Even when it does not appear at the funerals it is still the centre of all rites and celebrations hidden inside its mask shelter. At the funeral of a Sigi man, the Grand Mask and the long pole appear furtively at night, the long pole being held by an initiate so that it faces the dead man's house. The spirit leaves, but the house becomes polluted and has to be purified.

After use, the mask is placed in their rock shelters according to the instructions of the myth. Hidden from view, it is allowed to rot. From time to time sacrifices are made to it—before secular masks are made, for example.

The Grand Mask is of the utmost significance to the Dogon. It is the double of the mythical ancestral corpse and this is its real *raison d'être*. In making the mask, in imitating the head, the body, and the snake's marks, they try to deceive the soul of the ancestor and try to get it from the rotted old mask to the new one. When the new mask is exposed to public view, only the pole is visible, since the head is buried under a pile of stones during the funeral. Other masks are quite different, although they may also represent and present aspects of the Dogon myth. These masks dance and appear to the spectators who are not expecting the imitation of an animal or an ancestor nor the portrayal of a myth. Yet these masks too reflect signs, symbols, parts of myths and act like sudden flashes, intuitive symbols.

The very complexity of Dogon cosmology and the intimate relation between rite, myth and social action, makes a clear description of the role of the Great Mask and other aspects very difficult. In many cases descriptions appear little more than esoteric jargon. Nevertheless, this is one of the few cases of an African cosmology which has been studied in great detail. We begin to realise that art does lift mythical experience—an activity which is crucial to Dogon community life—from the everyday world, giving shape to abstract truths which could hardly be expressed in any other way. Yet it is also clear that during the Sigi, important social 'functions' are served. Diverse communities and village groups are linked and the ceremony, symbolised by the mask, is an important factor in maintaining the homogeneity of Dogon culture. Kin, friends and strangers move about and exchange multiple contacts, food and ideas. Thus the Sigi not only merges the Dogon into their wider cosmological system, but also integrates their cultural and social institutions.

At the same time the masked society of the Dogon is also a governmental society, a community without a state. It sets up laws which go beyond the restricted community of the masks. It also links communities like a central power—remembering that the Dogon have only local priests as leaders. It is, as Griaule puts it, a government which depends on sculpture, cosmetics, choreography, painting and poetry. Other cults of the Dogon, such as their totemic beliefs, involve clans alone. The Sigi on the other hand concerns the whole people. The carving of the Grand Mask —the lord of all masks—and the sacrifice, renew the support of an ancestral spirit on which the whole society depends. 'The Grand Mask is the soul of the Dogon'.

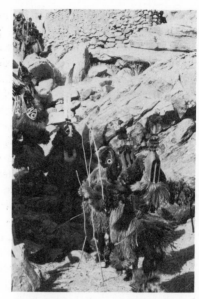

9.6 Masked dancers, entering a Dogon village. Mali.

Twins

The Grand Mask and the Sigi is only one aspect of Dogon cosmology. Among the Dogon, as in many societies throughout the world, special attention is paid to twinship and twin births. Twins are anomalous creatures—two-in-one, one-in-two, half-of-one—yet may symbolise the fusion of the couple, the perfect dyad. Among the Dogon as well as the Bangwa, twinness represent not only an original androgyny but the victory of order over anarchy through duality. Unlike those African peoples where twins are feared and put to death, the Dogon and the Bangwa fear twins and worship them—they are seen as perfect births representing a primordial world when twin births were the rule. In Bangwa a woman who gives birth to twins is feted by the whole population and elaborate sculptures are carved in their honour. Their neighbours in South Eastern Nigeria on the other hand, killed the twins and banished the mother. As for the children, they are wonderful creatures to be admired and feared, demanding, selfish and cantankerous; and they have to undergo rituals, which last for several weeks, and aim to adjust these 'children of the sky' to the world of the earth and normal human beings.

According to Marcel Griaule, twinship among the Dogon was the rule in the beginning of time. Creation was based on the principle of twin births and when this was disturbed the only way order could be restored was by creating human beings with dual souls, one female and one male. Many elements of Dogon culture reflect this emphasis on twinship. The griot (a caste of musicians and praise-singers) and his twin sister were made from those parts of the placenta where the sacrificed Nommo fell, and the blacksmith and his twin sister were made from the umbilical cord of the victim and the blood which came down to earth together.

Among the Bangwa, as among the Dogon, twins express complementarity and equality, as well as duality and order. Twins and their mothers and fathers are given special respect, one of which is to carve statues in their honour. On the whole it is the mother who receives the greatest attention: villagers bring her food and ask her blessing and a certain period after the birth, she and her children are dressed in finery and beads and paraded through the market place where the villagers congratulate her on her good fortune. Later she is initiated into a twin-mother association which is called on to dance at important ceremonies and funerals. I once saw two

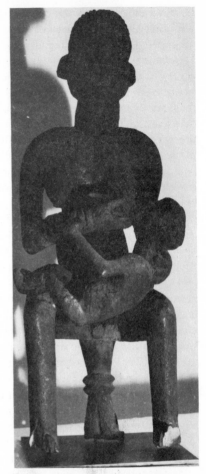

9.7 Wood statue of a mother of twins. Bangwa, Cameroun.

hundred of these women dancing at a chief's funeral. During annual fertility rites twin mothers appear wearing their special insignia—cowries, staffs and special leaves—and 'cool the earth' by offering sacrifices. Twin mothers and fathers may become diviners and priestesses—having given birth to 'little gods' they are considered to be appropriate vehicles for supernatural action.

Bangwa sculpture has taken inspiration from these twin parents and statues have been found both of mothers and fathers of twins in their roles as priests as well as parents of these special children. While some are carved with their children, others are only to be recognised by the symbols of twinship with which they are portrayed. There is little doubt about those shown wearing cowrie-shell necklaces and wristlets. There is also a statue of a father of twins flanked by his children, one of either sex. The best known of all Bangwa works (Fig. 9.1) was brought from Africa in the late nineteenth century. The collector records that the Bangwa called her *njuindem*, which literally means 'woman of God' and is the title given to mothers of twins in their role as diviners. These njuindem divine with cowrie shells or while in a state of trance. While singing and dancing the 'song of the earth' she carries, like the figure in question, a rattle in one hand. In the other she carries a bamboo trumpet of the kind used for calling the gods. This statue of a dancing woman then portrays a mother of twins in her role as priestess of the earth and witch-finder.

Dogon and Bangwa ideas about twins have much in common. The Yoruba, who have carved objects, *ibeji* figures, associated with their twin cults have similar ideas and the refined analyses of Dogon duality and adrogyny in relation to twinness may illuminate some of the darker corners of Yoruba twin iconography.

Yoruba religion flourishes in every aspect of their life and is celebrated in art and poetry. There are hundreds of Yoruba gods, or orisha and they form a complex pantheon which comes under a supreme being and includes the souls of those dead persons who are supposed to have had supernatural powers during their lifetime. Yoruba kings are a special kind of orisha separate from the ancestors of commoners. The king himself is a kind of orisha while alive, by virtue of his taking the office of kingship founded by a supposedly deified ancestor. Non-royal ancestors are, as a class, distinct from the orisha and concerned with different kinds of human offence.

In the Yoruba pantheon Oduduwa, for example, created and

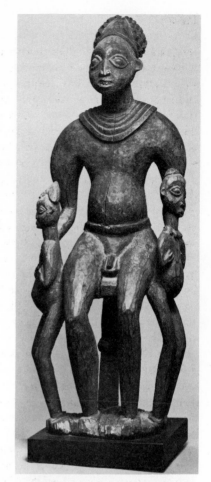

9.8 Wood statue of a father of twins. Bangwa. Cameroun.

ruled the land, while Orishanla, his elder brother, shaped human beings. One created kingship and the other mankind. Shango, the god of thunder and lightning and third king of Oyo, is destructive when angry but also provides his worshippers with the good things of life such as money and children. Another orisha is the god of iron, another of war, of smallpox. Eshu is a cult of a wandering, homeless and cunning orisha who is associated with the market because of the disputes which arise over money there. Each of these orisha provide his devotees with the complete services expected of a cult figure—children, money and health, for example; it is in relation to the community as a whole that each orisha has a distinct role.

Basically, therefore, an orisha, to which sacrifices are made and festivities performed, is a supernatural protector that ensures good health, long life and economic prosperity. Worship aims at direct results and if these are not forthcoming they may be abandoned. This attitude is directly comparable with Christianity where, among Europe's two thousand patron saints, we have such 'orisha' as St Catherine of Sweden for miscarriage, St Erasmus for pain in childbirth and St Concordia for nursing mothers. Orishas and saints are invoked in the same way and in both cases a channel of faith is often at work through the medium of painting or sculpture.

The artist creates visible forms of these religious conceptions, but they are not represented by anthropomorphic images but by material symbols—pieces of iron or iron tools for Ogun the god of iron; neolithic handaxes for Shango; divination apparatus for Ifa (the god of the oracle); pieces of bone or ivory for Orishanla. Very rarely, images may be identified with particular orisha.

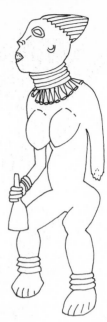

Fig. 9.1 The best known piece of Bangwa sculpture—a dancing woman. Bangwa, Cameroun.

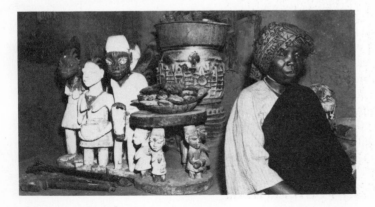

9.9 Shango shrine and priestess. The neolithic handaxes can be seen in a bowl on the carved stool surrounded by other paraphernalia of the cult. Iganna, Nigeria.

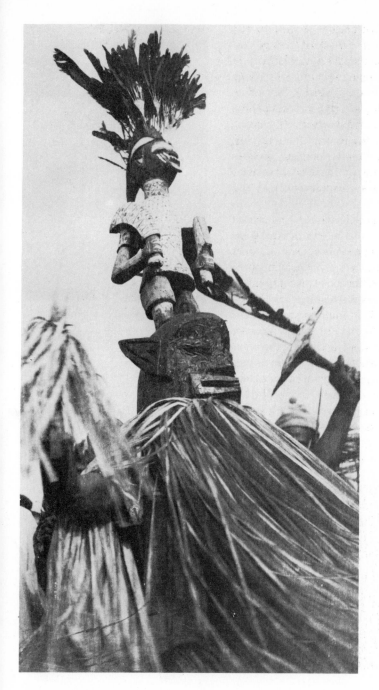

9.10 Wood mask, called *ogun*, that dances during the annual festival of Ogun. The masquerade carries an iron sword in his hand—the material symbol of Ogun, god of iron. Oye Ekiti, Nigeria.

The Yoruba twin cult is only indirectly concerned with the cult of the orisha, yet it forms an important element in Yoruba cosmology. Twins are spirit beings, but there are varying explanations to account for the phenomenon. In many ways the essentially ambivalent attitude to multiple births is solved by a belief that they are the fulfilment of an individual's destiny: twins are part of the fate of a certain woman, this idea serving the purpose of ensuring that the onus of guilt falls on destiny and not on the individual concerned. The Yoruba also believe that the ultimate responsability is that of God and that twins are a 'gift from God'. In this way twins may be said to be welcomed; on the other hand twins involve a good deal of expensive ritual and tedious taboos. Twins are also feared and the death of one of them converts him into a spirit being; in this way the Yoruba express their feeling that twins are special beings and that the manner of their birth is extra-human. For this reason twins involve the parents in special ritual from the moment they are born. If one or both of them die images (the ibeji) are made to represent the dead children. The ibeji figurines are carried round and treated as real children, nourished, washed and put to bed. One of the main reasons is that if the dead twins see that their images are being cared for they will send the mother more children. Throughout Yorubaland, there are countless ibeji figures worn by old and young women, found in market places, sitting on chairs outside houses, placed in farms.

Richard Lander was the first European to document the ibeji and describe a part of their ritual. 'None could be permitted to part with these affectionate little memorials. . . . Whenever the mother stopped to take refreshment, a small part of their food was invariably presented to the lips of these inanimate memorials.' Twins are linked to the *abiku* spirits, who lure children from their parents because they have a propensity towards dying. Abiku means 'born to die', and when a mother has a series of children who die in infancy, the same child is thought to be plaguing the mother repeatedly.

When twins are born, the placenta is buried, as usual in a pot; if there is a double placenta, it is buried in two pots. Then the Ifa divination priest is consulted for the type of sacrifices and rituals to be carried out. The parents will be advised to have a sculpture made if one or both of the twins die. The mother takes two cocks, two kola nuts—always two of everything—to the carver and asks him to begin the carving. When it is finished she brings a group

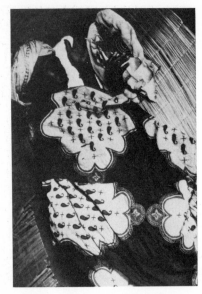

9.11 An *ibeji* sleeping beside its mother. Itasa, Nigeria.

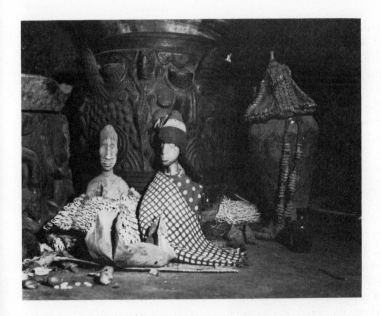

9.12 Two dressed *ibeji* in a Shango shrine with an offering of food, wrapped in a leaf, in front of them. The figure on the left wears a tunic decorated with cowrie shells. Oyo, Nigeria.

of her friends and neighbours to come and dance and feast and pick up the finished ibeji image.

When the carver has finished the figurine, the owner decorates it with beads and clothing. Camwood mixed with palm kernel oil is rubbed all over its body and indigo is applied to the headdress. Cowries and beads and other decorative effects are the appropriate way of honouring twins and ibeji. Some figurines also have amulets of lizard vertebrae or medicine bundles to ward off illness. No ibeji is ever allowed to stand naked and the owner makes new clothes for them when they wear out. They are treated exactly like the surviving twin in fact.

The ibeji is always of the same sex as the deceased and is named after it. Everything that is done for the live twin is done for the ibeji figure—it receives gifts, clothing and food—in order not to annoy the spirit. The mother wears the figure tied on to her back in the same manner as a real child. When the surviving twin grows up he takes over the statue and the cult from his mother.

Ibeji usually form part of a domestic cult only and are kept in the house of the parents of the deceased twin. Regular sacrifices are made to it in an attempt to prevent the souls of deceased twins from harming the living. There are weekly rites and annual rites,

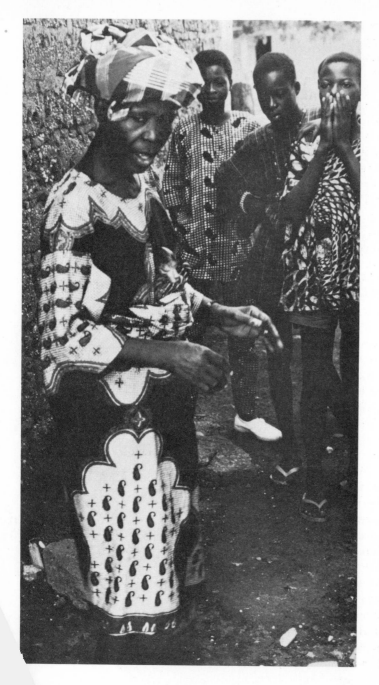

9.13 A mother of twins dancing with her *ibeji* figure. Itasa, Nigeria.

while others may coincide with the festival of another orisha. Sometimes they are carried to the central shrine in the market. In Yoruba—again like the Bangwa and the Dogon—the association between twinship and the market is strong. The twin mothers often dance in the markets, wearing their ibeji figures tucked in their wrapper. The reason for this is to have as many presents as possible from the people at the market, usually money.

According to most students of the ibeji, the figures are carved and the rites performed to deceive the surviving twin that the other is still alive. When a twin dies the other is not told—'he has just gone away'. The image is then laid down to sleep next to the living twin. This may be true when one twin is living, but if both twins die, the purpose would seem rather to keep the twin spirits placated. Among the Bangwa, when a twin dies, the parents fear that the irresponsible dead twin will cause the death of the other, seducing him back to the more agreeable world of the spirits. In fact, during sacrifices to the ibeji, the gifts are aimed to appease the spirit and control the orishas which are responsible for the birth and death of twins. The carrying of the image also protects the mother. If she fails to perform the ibeji rites she will become sterile.

However, neither purely benevolent nor malevolent aspects of twins are directly symbolised by the ibeji figures. Certainly the figures bring comfort to a bereaved mother. Part of the sacrifice, such as beans and the oil, are said to calm angry spirits. The cowries, on the other hand, seem to symbolise wealth and trade, another aspect of twinship. Cowries are perfect symbols of wealth and fertility and in the alms given the mourning mother, the cowries are tokens of the favour twins provide the almsgiver.

The ibeji cult, unlike the cults of the Yoruba orisha, is a domestic cult, limited to the immediate family and is connected with the well-being of a limited number of persons. It is also a single-focus cult and associated with it is a specific type of carving, not a body of symbols as there is in the other many-faceted cults. The only cult item, in fact, is the ibeji doll itself, a small standing statuette about 25 cm tall, which is basically uniform in style and type. The great majority are standing nude figures, although some have an apron-type garment. The head is usually large in proportion to the body. The face is oval in shape, with prominent eyeballs; the forehead is convex, the nose broad. The ears are stylised, the lips prominent, the arms heavy and long, the hands stylised and joined to the thighs. The legs are foreshortened. Male or female genitals are

carved. Ornaments are made on the waist, the neck or the arms, or sometimes added later. The ibeji figurines have different scarification marks and a great variety of hair styles. Though carved as miniature adults with adult sexual characteristics, they have the general body proportions of an infant.

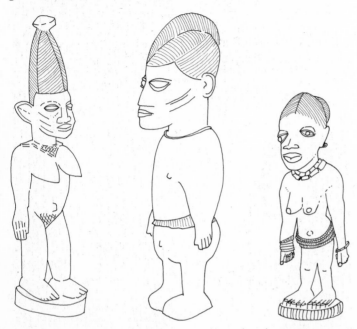

Figs. 9.2, 9.3, 9.4 *Ibeji* figures showing variation of hairstyle and ornament.

CHAPTER TEN

Magic and art

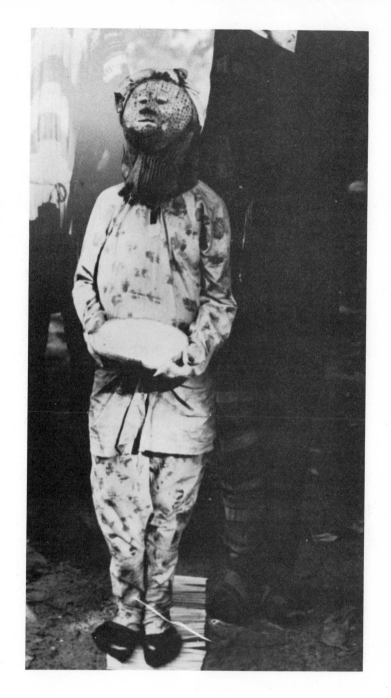

Witchcraft or sorcery usually refer to malign activities attributed to human beings who use supernatural powers to harm others. This idea—that death, human disease and misfortune are caused by the ill will of neighbours or kinsfolk or other members of the community—has played an important role in European and American history although to modern eyes these are perhaps the most illogical and despised practices involving the supernatural or religion. In fact in all cases the evils of witchcraft are also accompanied by some positive features. The belief is basically an explanatory device, fixing the causes of illness, death and misfortune experienced by a group when no reasonable explanation suffices.

There is a vast lore surrounding witchcraft and sorcery. It may involve the 'evil eye' or shape-changing. There may be mysterious ways of introducing foreign objects into the body. A witch may acquire his power through a physical factor, voluntarily or involuntarily. The Azande believe that a witch possesses a special organ called *mangu* attached to the liver which they inherit—sons from their fathers and daughters from their mothers. A sorcerer may manipulate special objects—fetishes and other magical paraphernalia imbued with sympathetic magic—to harm his victim.

To cure a sick person, therefore, the supernatural causes of the illness must be sought and allayed. The obvious first step is to identify the witch, often through divination which may take the form of ordeals to obtain confessions of guilt. Fresh magic may be be made against the suspected witch or sorcerer.

Throughout Africa there are some remarkable common factors in witchcraft. Most witches work by night, have the ability to fly and cover long distances rapidly. During their peregrinations the body of the witch usually remains behind, its other self travelling invisibly or in animal form. Witches are thought to be fond of eating human flesh. They make their victims ill and wait for them to die in order to consume their bodies after burial. In anthropology a distinction is often made between a witch whose powers are in-

10.1 This masquerade, seen during an Egungun festival, represents a youngster who has been blinded by smallpox and now has to beg. It is a reminder to the community of what happens if they cross those who control the smallpox *orisa* (see page 208). Egbado Yoruba, Iboro, Nigeria.

voluntary and a sorcerer who deliberately causes others to suffer.

Illness and its supernatural causes are frequently manifest in art particularly through amulets and charms, fetishes and cult objects. Some cult associations function as anti-illness societies—such as the Yoruba *egungun* society which uses its lore and masks to combat epidemics: smallpox is represented on the masks by spots. In other societies yaws and syphilis are depicted on masks. Among the peoples of the Liberian hinterland masks were made to get people well. Charms, amulets and talismans are carried on the person or kept in the house to protect the owner or the household from illness or misfortune. The protection of these objects may work either by attracting good supernatural powers or by repelling evil ones.

Sculpture, in particular, plays an important role in the vicious circle of witchcraft and sorcery. Witchcraft is removed through fetishes, which may also generally protect individuals or groups. They may also be used by sorcerers to carry out their activities. Diviners also use figures to carry out their geomancies. Ritual experts use similar fetishes to trap witches. In fact the same object may be used to carry out sorcery, find a sorcerer and for ordeals.

In the literature on African art, figurines and statues appertaining to religious cults have often been indiscriminately described as fetishes. The word should really be reserved for 'machines' which are fabricated by the diviner or sorcerer of various materials and medicines in order to draw upon the immanent life force of these substances. The sculpture itself may be of minor significance, the fetish being activated by the diviner or sorcerer by performing appropriate ceremonies and incantations over the symbolic paraphernalia attached to it. The first description of a true fetish we have from a work written in the 1700s by Charles de Brosses, *Du Culte de Dieux Fétiches.*

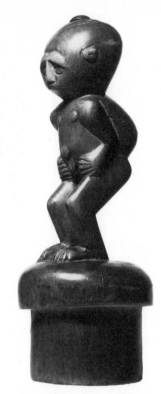

10.2 Wood bottle stopper depicting a 'hunchback'. Angola.

These divine fetishes are nothing more than the first material objects that attracted each nation, or is peculiar to them, to choose and to have consecrated in ceremonies by their priests; a tree, a mountain, a piece of wood, the sea, a lion's tail, a stone, a shell, salt, fish, a plant, a flower or certain species of animals. Fetishes may multiply by the addition of the first creature encountered and the choice may be a stone or a piece of wood, or any other object that qualifies them . . . They are adorned with blood and with rare objects, some of imported manufacture, to raise their importance.

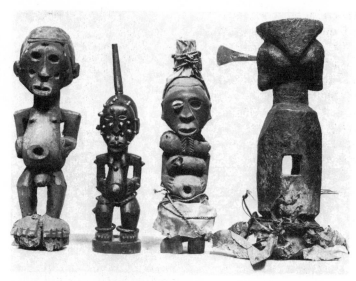

10.3 A group of Basonge fetish figures. Zaire.

This is a good preliminary description of a fetish. The word itself comes from the Portuguese *fetico*, from the Latin *facititius*, meaning an object made by the hand of man; in the case of the fetish it refers to the fact that they are often made up of additive materials by the ritual expert. In fact the extra materials are often of prime importance, particularly if the sculpture is a simple form, and range from the skeletons of crabs to animal bones, teeth, feathers, parts of birds, seed pods, gourds, European buttons, cloth, pieces of iron. The most common element possible is a horn of some kind and red cloth is frequently a symbol of power or evil. Even if at first sight this conglomerate of objects seems haphazard, the accountrements of a fetish—like the ingredients of a magical potion—all have symbolic value and meaning for the owners and persons affected by them. It should be remembered, however, that some powerful fetishes are sculpted forms with little additive material apart from the remains of sacrifice.

The most well known of African fetishes are from the Zaire region, and there are some very early pieces extant. In 1514 the Congo king, Alfonso, is reported lamenting the idolatry then prevailing among his subjects declaring 'Our Lord gave, in the stones and wood you worship, for us to build houses and kindle fire . . .' Hundreds of types of fetishes, representing animals, persons and

spirits have been made by the Kongo, although many ancestral portraits, divination objects or funerary statues have a quite different function and have been wrongly called fetishes. These fetishes—known generally as *nkisi*—are magical figures which are supposed to inflict serious illnesses upon persons who are believed to be the cause of supernatural harm. Despite their fame, the art forms have not been studied in great detail nor in their cultural context and to most readers of superficial art surveys they remain the typical African juju objects—ferocious, indecent 'scarecrows' which have been collected more for their oddity or magical value than for their artistic worth.

In fact the nkisi fetishes have many functions, may be benevolent or malevolent, are purely functional or may have great aesthetic interest. They may cause harm to enemies, protect a chief against witchcraft or seek out and punish a witch or sorcerer.

The fundamental medium of the nkisi figures is wood, but the figure used as a fetish is an assemblage of heterogeneous materials and objects, all of which, with the carved wooden part, make one single complex which can be appreciated as a work of art. When a person needs a fetish he buys a statuette from a carver, or from a trader in the market. This figurine is not yet a nkisi or fetish but only the basis for one since he has only bought a prosaic piece of sculpture. The fetish only comes into existence after a ceremony in which the force or power is put into the image and the magical paraphernalia added to it. This important aspect is achieved by the diviner who places magical substances on the figure, in a receptacle in the body and often in the head as well. He may shape the headdress, paint the figure's face and add various materials and small objects to the statue. Sometimes it is entirely covered with additive material

The fetish therefore leaves the artist's hands in an unfinished state. The ritual intervention of the diviner fundamentally influences the shape of the figures and of course alters its artistic effect. The artist prepares the figure for the diviner, roughly finishing the face and preparing a kind of peg or substructure on top for the diviner to add the moulded headdress which interacts with the carved face. He may also prepare the surface for the resin over-modellation to be added by the diviner and adds the containers for magical ingredients in its stomach or back. Sometimes the artist leaves the figure armless in order to give the diviner room for his own paraphernalia. In the division of labour, therefore, the artist and the

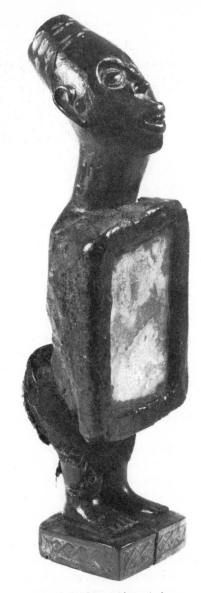

10.4 Wood *nkisi* figure with magical substances on the chest covered by a mirror held in place with resin. There are more magical substances on the buttocks held in place by a loin cloth. Bakongo, Congo-Brazzaville.

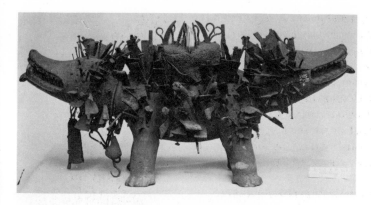

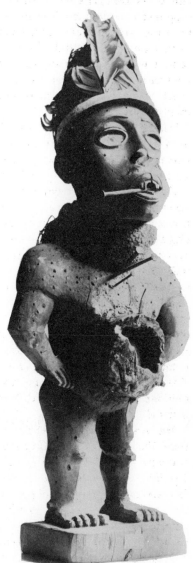

diviner have an almost equal role. Some would say that the role of the ritual expert was the more important—the cost of the sculpture made from a couple of yards of cloth; the price of a fetish might be ten or twenty times the original price.

Despite the symbolic significance of the additive materials, they were hardly intended to give an aesthetic effect; they were primarily functional and psychological. The sculptor often left the figure artistically unfinished, unharmonious, while the diviner indiscriminately covered the carved parts with cloth or resin. In some cases the diviner must also be considered an artist: the poses of the figures and the distribution of their mass suggest to him the approximate shape of the finished fetish. At all events, the final form of the nkisi does not result from the artist's vision and intention alone, but from a cooperation between carver and diviner and eventually of course the owner.

The best known of the nkisi figures—the *konde* nail fetishes—are mainly of interest to collectors for the additive material in the form of pieces of iron which have been driven into the original piece of sculpture by the diviner or the successive owners. In these cases the artist's role is minimal. The nails, not the carved wood, are crucial, for the aesthetic appearance of the fetish as well as its function. It is the ritual expert who gives the fetish power and most of its form.

Since the nail fetishes have been found in an area which has long known Christian influence and where there are many other reminders of the first period of evangelisation—in crucifixes and statues—it has been suggested that these fetishes may have been directly influenced by Christian symbolism. The nails would have been seen as symbolic of Christ's suffering on the cross, while the

10.6 *Konde* nail fetish in the shape of a human figure. Bakongo.

Virgin's bleeding heart was recalled as a symbol of great and parallel suffering—the Christian symbols may have been amalgamated into the Kongo symbolic system and become symbolic instruments of inflicting enemies with serious disease, pain and death. It is true that the fetishes as a whole did not undergo any major change in conception or form. It is the interpretation of the figures rather than their own character—which remained African—which sometimes corresponds to a Christian, Western view of the later part of the nineteenth century.

Recently a more refined analysis of the Kongo nkisi has uncovered a more complex system of thought governing attitudes to these fetishes. Altogether the nkisi shape a representation of the natural world to which men should try to aspire, where women are fertile, animals are not frightening, longevity is assured and so on. Religious activity involves submitting oneself to the will of the nkisi, who represent the law of nature.

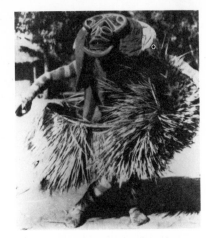

10.7 A dancer wearing the male mask *cihongo* (an akishi), symbol of the spirit of riches. Tshokwe, Angola.

Divination

Nkisi figures are made to ward off misfortune and control supernatural forces. During the process of discovering and punishing a witch or a sorcerer, the role of the diviner plays an important part.

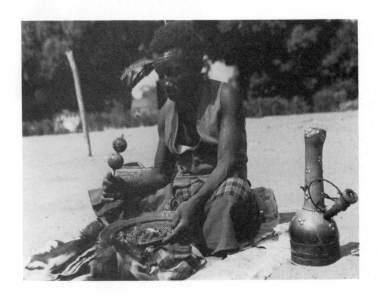

10.8 A diviner using a round basket. He has red and white marks around his eyes so as to 'see well' and discover the answers to his clients' questions. Tshokwe, Angola.

Unlike other forms of religious communication, divination does not attempt to alter the behaviour or judgment of the supernatural powers, but merely to discover their opinions, playing a role in diagnosing illness, in deciding the guilt or innocence of an individual. Some diviners work through spirit possession, others use mechanical means—the interpretation of cracks in mud, the liver of sacrificed animals, the flow of water, the position of thrown seeds or cowries. In the Cameroon the Kaka make a pack of cards out of stiff, trimmed leaves decorated with symbols. A bottomless clay pot is used to enclose the entrance of a spider's burrow. The cards are placed inside this pot, together with a bait to attract the spider and the enclosure is covered with plantain leaves. Later, the disturbance of the marked leaves caused by the spider's actions is interpreted by a diviner.

Often the diviner uses figurines or other art objects in his profession. Among the Bakuba four-legged animals are used. The smooth surface of their back is rubbed to and fro with a small piece of wood. As soon as the diviner mentions the name of the guilty person the wood sticks to the animal's back. We have slightly more detail from the Tshokwe, where witchcraft is called *wanga*, and is a power which is considered to be both conscious and unconscious and causes all deaths or at least all suspicious deaths. The diviner or ritual expert is called upon to uncover the witch during a

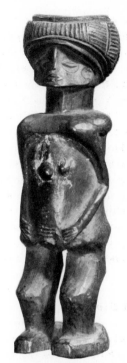

10.9 A female figure 'Maliya' that is used by the diviner. Tshokwe, Angola.

10.10 A diviner's basket. The circlet of leather with cowries attached and a *cikunza* figure can be seen near the top left edge of the basket. Tshokwe, Angola.

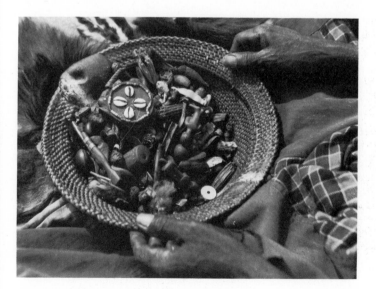

divinatory performance. To protect people from evil the diviner also invokes tutelary spirits—the *akishi*, which are incarnate in masks which are also called akishi. In all aspects of daily life we have the confrontation between witchcraft and these spirits and their sculptured representations; witchcraft causes all evil and unhappiness due to neglecting the cults and not wearing the akishi masks.

When the Tshokwe are ill they have recourse to the diviner. They also use his services in case of accident, death, sterility and impotence, bad luck in hunting and theft. Divining techniques are many: one is a simple technique where two pieces of board are rubbed together. Most common, however, is the use of a round basket, the hamba basket, containing more than fifty little objects and wooden figurines, metal fragments and objects, animal matter, horns, nails, feathers, bones and fruit.

The diviner performs an elaborate ritual with much protocol and ceremony. His eyes and chest are painted in special patterns and in special colours. His two acolytes are striped all over in white, one with a crown of feathers who holds up a cup of red-dyed water, dances with his master while the other squats down, spreading out the skins to protect the figures from the ground if they should fall from the basket. The divination is helped by an elaborate performance of drumming and xylophone music. Two female figurines, modelled in wood or mud which represent the good ancestor spirits, are placed behind him and a medicine horn is stuck in the ground. The diviner shakes the basket and begins asking his client questions after blowing tobacco smoke on the objects to encourage them to divine well. Songs and incantations follow and then the basket is given a great shake and the pieces which fall to the edge of the basket are the ones whose position will suggest a solution to the diviner. He sees whether the white clay or red clay is in contact with a certain figurine. A good diviner gets everything into the correct position by adroit shaking. The consultation with its complex interpretations takes hours; not only does the diviner inspect the carved objects in his basket, but during a seance the diviner may go and consult the female statuettes which stand behind the mat on which he squats.

All the objects in the basket have their precise or imprecise symbolic values which are linked to daily life, religion and witchcraft beliefs. There are two categories of hamba objects—those figurines whose symbolic content is known and those which are

Fig. 10.1 weeping virgin

Fig. 10.2 strong man

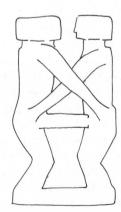

Fig. 10.3 act of coitus

idiosyncratic to each diviner. The first type may be compared to playing cards since they are immediately recognisable and their symbolic significance never varies. The other type, however, vary in significance according to their position in the basket. Usually one figurine is chosen to represent the patient and pronouncements are made according to the objects with which it associates. If it arrives at the edge of the basket in a standing position it means health and happiness. If it falls down it means illness, an illness which will be more or less serious according to the proximity of other objects. If it falls face downwards it means death. In all these figurines there is a great variation in posture and their meaning may be subtle and complex. Figure 10.1 is a weeping virgin, with hands on head, signifying sadness and anguish. Figure 10.2 is one of the most important of the hamba objects, and is said to reveal the hidden life of those persons involved in the client's predicament. The figurine represents a young, strong man wearing a hairstyle typical of Tshokwe youths. It is also worn by women as an amulet. Figure 10.3 shows the act of coitus and indicates an adulterous situation and venereal disease. The cause of the situation or illness will become clear only when these pieces come into contact with other objects, however. Figure 10.4 represents something miraculous and supernatural in either a good or bad sense according to where it falls. Figure 10.5a, a penis in naturalistic form, refers to sexual illness. Another figure 10.5b, a headless man, indicates that the person who has died was killed by a sorceress who took his head to make medicines. Figure 10.6 shows four people on the road meaning that the sorcerer must be sought outside the village, a long way away. Another figure (10.7a) is a calabash showing that the client has neglected his ancestors and must give them sacrifice. The headrest in figure 10.7b means that the illness came to the person while he slept and must be due to witchcraft.

Sculptured objects, therefore, play an important role in hamba divination but they are of varying aesthetic importance. Some are undoubtedly works of art (Figure 10.8, a woman with a load, is an example) while others have no artistic merit, only symbolic content. One of the most significant objects in the basket is not sculpture at all but a circlet of leather with cowries attached to it. Among the objects may be found miniature representations of Tshokwe masks and figures which occur in other contexts. The Cikunza mask is of prime importance to the Tshokwe. It is the image of the most important of their spirits which presides over daily life and plays

Fig. 10.4 something miraculous

Fig. 10.5 a) penis, b) headless man

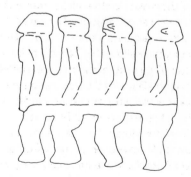
Fig. 10.6 four people on a road

an important role in initiation camps; it favours fertility and is also found on royal stool drums. Women carry it as an amulet to prevent barrenness. The odd fact here is that while Cikunza is a guardian spirit in his activities outside the divining basket, here he personifies an evil spirit. The figurines in the basket are therefore chosen from popular classical characters in myth and folklore. Moreover, the types of figurines in the diviner's basket have been taken from the general body of Tshokwe art. Neighbours of the Tshokwe have a similar system of divination but the further we go from this art centre, the rarer and cruder become the figurines.

Fig 10.7 a) calabash, b) headrest

Bangwa fetishes

While the material on hamba figurines provides insight into the functioning of divinatory techniques in an African society, I should like to present a more comprehensive and comprehensible picture of the situation of one people as regards misfortune and its counteraction, and the role of the diviner and sculpture. A first-hand account follows of my own studies among the Bangwa-Bamileke of Cameroon.

Fig. 10.8 woman with a load

Bangwa religion is complex and the cosmology involves ancestors, cult heroes, a high god, guardian spirits, cult associations, shape changing, the magical role of twins and their parents. The most striking manifestation of their beliefs, however, is witchcraft and magic bound up with their general notions of misfortune and supernatural attack. Men, women, children, chiefs, commoners and servants, are believed to be able to acquire powers of shape-changing and convert themselves at will into animals and natural objects—antelopes, elephants, a flash of lightning, a pungent smell, a thunderstorm. This power, which we translate as witchcraft, emanates from the body of a person, from those organs which are the seat of an individual's power to change his shape. The liver is an elephant, the spinal cord a snake, the heart a leopard. These witchcraft powers are linked with individual powers and ambitions and are therefore of an ambivalent nature. They can act for good or for evil. A Bangwa musician transforms himself into a sprightly, fluttery bird to acquire a light touch on the drum, a chief becomes an aeroplane to go to Europe and acquire white man's technology and wealth. A young man becomes a crocodile to make love to water maidens. A woman changes into a monkey to

ravage the growing crops in an enemy's farm. A frustrated wife of a chief with thirty wives becomes a wild boar and indulges in forest orgies. A child becomes a wasp to sting unkind parents.

These ideas, a few of a multitude of fantastic symbolic representations, give a clue to the kind of beliefs involved in witchcraft. Witchcraft is a power which important, powerful, clever people have. Chiefs use it to protect their subjects. Doctors use it to cure their patients. But in the minds of most, Bangwa witchcraft is the prime agent of misfortune, in lives which are constantly disturbed by illness and death. Human beings, always kinsmen of the witch, are taken by the animal-witch to a coven where they provide meals for their fraternity; the highest titles in this imaginary world are given to witches who bring their closest relatives—a first-born child or half-brother. What should be remembered is that we are describing a fantasy world, a world seen through the eyes of victims of witchcraft, not the world described by the witches themselves. Witchcraft is an imaginary belief which has virulent manifestations in accusations made against brothers, sons, wives, co-wives and servants; these accusations are an ever-recurring nightmare in the daily life in Bangwa. All deaths, but particularly sudden deaths and deaths of children, are attributed to the lust of witches. Autopsies are performed on corpses by experts; the stomach is slit open and the witch-organs inspected for signs of activity. Each organ with a swelling or an inflammation or discoloration tells its story to the diviner. If the liver (elephant) is swollen, for example, it shows that the dead person had himself assumed an elephant's shape and had died in the local swamps. If there are no signs on these organs it is proof that the death was caused by a jealous member of the family, and a long process of ordeals and proofs are conducted to discover and punish the guilty person.

At the same time, witchcraft is a power and chiefs have it in order to rule; their successful reign depends on a careful manipulation of this dangerous skill. A man's power to be a witch is mostly inherited from his father in the form of a witchcraft potential which is activated by learning and medicines. A paramount chief's successor is always given into the care of the Great Retainer, a kind of chamberlain who wields considerable political power and has access to the secrets of royal magic. The symbol of this chiefly witchcraft is the stone figure roughly carved into phallic form which is found outside Bamileke palaces and is believed to be rooted far into the centre of the earth and to grow and tower above the

10.11 The phallic witchcraft stone outside a Bamileke palace. This one has fallen over. Cameroun.

palace to protect it when the chief is away on a natural or super-natural journey.

The activities of royal witches, told in story form with great secrecy and fear, are magnificent. The witchcraft world is imagined in the sky, beyond the stars, in the fathomless depths of dark pools, behind the wild spray of the many Bangwa waterfalls. Chiefs meet other chiefs there, flying to their covens in full regalia, beautiful gowns, carrying long brass-studded crooks, sprouting fur hats and carved flywhisks. One chief was reputed to have flown through the air to an elegant coven accompanied by his complete German band. The chief is accompanied by a retinue—the secret society, the Night, with their masks, one or two favourite wives. This en-tourage floats, flies through the earth, the water and the air. They change their shapes, through the medium of the masks, the chief becoming a leopard, his wife a doe, the princess an elephant. The secret society, Night, become protecting animals, watching out for danger. They soar across the sky on a rainbow, protected by mov-ing mountains or a fast landslide. Thunder cracks, lightning flashes, signs to the ordinary people on earth that their chiefs are meeting in their witchcraft coven and are competing in a game of aerial acrobatics.

This is the imaginative background to more disturbing beliefs concerning supernatural attack and illness due to witchcraft. It is believed that all witches, not only chiefs, activate their were-spirits

at night. The 'bush soul' leaves the witch's sleeping body and enters his chosen shape to indulge with friends and associates a lust for food, usually human flesh. Witchcraft orgies take place in the 'bush' (the forest or the sky), the non-humanised or uncultured are of the Bangwa landscape. During the time that a witch's 'bush soul' is merged with the were-animal he is in a state of danger. If the animal is shot, for example, or poisoned by anti-witchcraft medicines, the sleeping child falls ill, the illness and consequent death being attributed to the accident that befell the were-animal.

Art plays an important role in these beliefs, as in all aspects of Bangwa life. Since sorcery and witchcraft are universal, feared and considered the prime cause of death, all Bangwa seek to protect themselves from its dangers. Amulets are worn. Houses are protected by bowls of medicines, bundles of objects or figurines, palaces by the stone column. Chiefs organise annual rituals to protect and ward off witchcraft from their chiefdoms, planting medicines at the boundaries of the chiefdom. During epidemics anti-witchcraft societies are called in to cleanse the area. In all these activities sculpture plays an important part.

Bangwa fetishes are of many kinds but may be divided into two kinds as the people themselves do. First and most common are the *njoo* fetishes, usually malformed, anthropomorphic figures con-

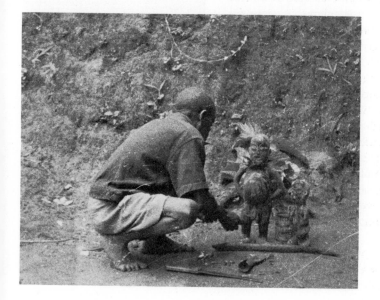

10.12 *Njoo* fetish figures during a rite. Bangwa, Cameroun.

taining ritual powers which protect individuals and their compounds from the attacks of witches, as well as thieves and adulterers. The figures are usually small and shown with bent legs, the typical expression of human affliction. They may be carved by amateurs in a few hours. Normally they are naked, without ornament although pieces of red and black cloth or a string of beads may be added during medication. They cause minor illnesses and their effects, revealed by divination or confession by the victim, may be revoked by a ritual performed by their owners. As with the nkisi figures, it is the functional success of these figures which the Bangwa are interested in, not their aesthetic appearance. Most of them, compared with the ancestor figures and other types of fetishes, are considered to lack aesthetic merit. They are merely objects which receive power from the medication of a ritual expert.

Kungang fetishes

The traditional Bangwa and Bamileke anti-witchcraft society, known as *kungang*, is a loosely knit society of ritual experts whose functions have now been mainly taken over by newer and more powerful anti-witchcraft cults from the western forests. Kungang is a society which comes under the aegis of the Bangwa chief who summons it during times of crisis and epidemics to cleanse the chiefdom by complex rites, in which its fetishes play a prime role. Kungang members must also purify the country after pollution resulting from 'evil' deaths, such as suicide or the death of a woman in pregnancy. The kungang fetishes are carved with greater care than the njoo and are usually old and greatly venerated. They are powerful agents capable of harming witches and criminals; the swollen stomach indicates the dreadful dropsy which is one of the supernatural sanctions of the fetish and is supposed to affect evildoers. The symbolism of these fetishes involves straightforward sympathetic magic—if you attempt to harm your kin this is what will happen to you—and this explains much of the symbolism which differentiates them from the royal portraits, although there are features in common. In the fetish, symbols associated with witchcraft and punishment have replaced those linked with royalty and fertility. The bent arms to the shoulder, in the fetish, represent the attitude of a begging orphan or a friendless person. The crouching position is the stance of a lowly slave. In the same way, although

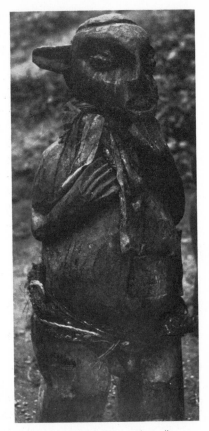

10.13 *Kungang* fetish figure with swollen stomach and bent arms. Bangwa, Cameroun.

different in form, the carving of the large fetishes is reminiscent of the type of masks associated with royal witchcraft.

The kungang fetishes play an important role in the beliefs of the Bangwa people. Unlike the lefem figures they are rarely sold to outside buyers. The chiefs are not convinced that the medication of a newly carved fetish figure would adequately replace the old ones. It seems that their powers are believed to have accumulated over the generations and no new carving can be expected to equal them in potency. Much more than ancestor worship, witchcraft is still a force in Bangwa religious beliefs and the fetishes of the kungang society are in constant use today. Such figures have a thick patina from the blood of chickens sacrificed during oathing rites. Most of them also have a small panel in their stomach or back which can be opened for the insertion of medicines.

Witches attack close kin and the victims or witches are therefore usually the inhabitants of one compound or neighbourhood, maternal or patrilineal kin. On the whole, the close family, centred on the mother, is seen as a sick person's protector against groups of kin who may have an interest in causing illness—co-wives may be jealous of each other or each other's children, or heads of kin groups may bewitch a man's children because certain financial dues have not been paid. In the first stage of the illness attempts are made to seek a cure through natural means, calling in a noted healer, but if the cure is not quick it is not long before a supernatural cause is sought. The signs of witchcraft may be evident— certain types of faeces or slime from the nose, or a chance phrase uttered by a child in a feverish sleep may give a clue that a witch has him in his control. In some cases people confess in a delirium that their illness is caused by their own witchcraft activity. In these cases the confession is followed by a rite of exorcism and the sick person should then get well.

Usually, however, the illness is believed to be due to the machinations of a kinsman and the culprit must be uncovered before the child can improve. In this case a visit is made to the diviner, whose role is to indicate whether the child is being afflicted by the ancestors or witchcraft. If the latter case, he indicates which group of relatives and what techniques are being used. He will simply declare whether the witch is a relative 'behind the mother' or 'behind the father'. Diviners use multiple techniques in their work. Some old men throw down cowries. Others use figurines. Some women, adept at the art of possession, use no instruments

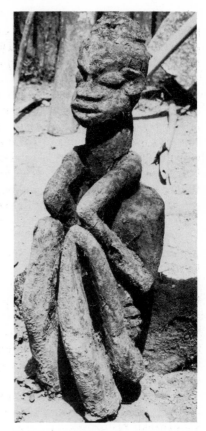

10.14 Kungang fetish in crouching position. Bangwa, Cameroun.

at all. Throughout the Bamileke area divination through the earth spider was common, a spider being kept in a hole in the ground and certain objects were placed at the door of its hole so that when it came out its movements among these objects determined the diagnosis of the diviner.

At all events, if the diviner attributes illness to a group of relatives, they must be called, usually in the big house of the local chief, where they must undergo an oathing rite in front of the kungang fetish. At the ceremony the ill person, if possible, is present. The person in charge of the rite tells the spectators the history of the illness, the money he has spent on medicines, the miles he has walked to find doctors and diviners. Then the diviner brings the statue out of its hiding place and with great care and ceremony it is placed on the ground in front of the group accused of witchcraft, all of whom, small children, adults and old women alike, are given a bean which they must throw at the fetish, at the same time declaring: 'If I have harmed this person let this fetish kill me'. The bean, which is considered a highly sensitive plant, carries an element of the person to the fetish, so causing the fetish to react on the guilty person. After the rite everyone returns home and the family of the sick person await anxiously the result of the rite. Usually if an illness occurs among the suspects it will be thought due to the action of the fetish and consequently pressure will be brought on the person to confess. A confession and the ensuing exorcism should then cure both sick people.

In a country where child mortality has been alarmingly high, the chief with his large polygynous compound is in constant fear for the health of their own children. At one time the whole palace, wives, sons and retainers were forced to take an oath on the kungang fetish in the public market place, swearing that they were not responsible for a series of deaths which had been occurring in the palace. At the present time kungang has been replaced by other cults which have come up from the forest and are employed with alacrity by local chiefs in the vain hope of keeping their palaces free from witchcraft and death. The sculptures of these new societies are often very different in form from the traditional Bamileke cults such as kungang and may depict animals reminiscent of art forms of south-east Nigeria.

Women and art

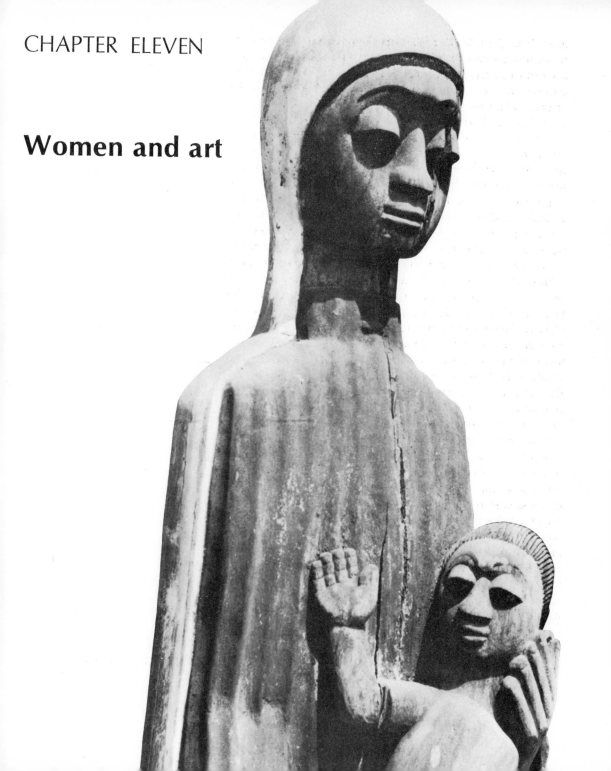

Throughout this book so far the emphasis has been on the masculine element in primitive art. Men sculptors, men diviners, men's associations, with a hint—in the Liberian and Sierra Leone Bundu and Sande and the Bangwa queen figures—that women do not play an entirely negative role in African art. Of course there are few, if any, women carvers, but as potters, weavers and ritual experts, their contribution is often a major one. Moreover, women provide many of the themes of art and the *rites de passage* which concern them—betrothal, puberty rites, marriage, death—are as often celebrated for women as they are for men. There has also been a traditional explanation for African masking, particularly when it concerns the so-called secret societies, that it maintained sex polarity and the dominance of men over women and the restricted social and economic role of women in the face of changing conditions. It is true that some societies restricted their performances and the viewing of their sacra to members, and excluded all women and children and non-initiates. Many more depended on women as their cooperative audience and often participant observers. The Bundu or Sande played a complementary role to the Poro. Not only did their masks watch over the initiation of young girls into religious, sexual, social and domestic tasks, but an internal role in the general cosmology of the Mande peoples.

Women as wives

From childhood, girls are involved in aesthetic manifestations primarily concerned with their roles as future wives and mothers. Girls frequently have dolls which serve to help them prepare for motherhood. Among the Lulua girls carry representations of pregnant women. The Fulani wear heavy anklets to announce their betrothal, their marriage, the birth of their children—they are symbols of each stage of their life. The Bangwa cicatrise a woman's

11.1 Virgin and child figure (see page 230). George Bandele, Yoruba. Oye Ekiti, Nigeria.

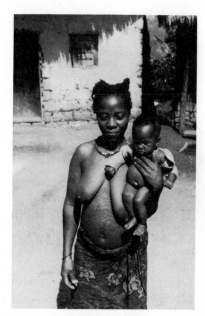

11.2 A woman whose abdomen has been cicatrised to celebrate the birth of her first child. Bangwa, Cameroun.

abdomen in complex patterns to celebrate the birth of a first child. The Bemba make clay figurines to teach young girls their roles as mothers and wives. As we have seen in Chapter 9, the birth of twins is often celebrated in sculpture.

In Africa the family is all-important, a universal institution, the core of which is the mother. Even in societies based on patrilineal descent, the centre of a person's kinship network is his mother and his closest kin are the children and close relatives of his mother. This fact contributes hugely to the very high status attributed to women as mothers in all African societies and conflicts with the often-held view that African women are deprived, pawns in a man's world, corrupted by the twin evils of polygyny and bride-wealth. The facts of polygyny and bridewealth are indisputable: many Africans do marry two or three, sometimes scores of wives; the major difference between monogamy and polygyny being that women share one husband and as a result the intense relationship between a husband and wife—which Western Christians accept as the norm—is not possible. However, the security of children and widows, the love of a mother and brothers and sisters is not en-dangered by polygyny. Even co-wives usually live happily and profitably together. Moreover, it should be remembered that African women do not always complain about their 'plight' as wives of polygynists. African women, traditionally, do not bear more than one child every three years or so, which is achieved by practising continence during a long nursing period. In this situation polygyny gives security to both husbands and wives during the nursing period. Since men believe they are incapable of undergoing celibacy for such a long period, more wives provide the answer. On the other hand, polygyny is not just about sex and is a state which some men enter with reluctance—two or three wives are much more difficult to cope with and support than one.

The position of women varies within a polygynous society. There are senior wives, first wives, favourite wives—and each status group must be treated in accordance with its rights. Moreover, the position of women in Africa varies greatly according to the society and on the whole has nothing to do with the amount of work they do; by and large African women have a higher position than women in nineteenth-century Europe: they have legal, religious and political rights as well as economic independence. If there are kings, there are usually queen mothers and princesses. Secret societies have their women members or female counterparts.

Women in Bangwa, for example, at first sight give an impression of the usual oppressed class of peasant women at the beck and call of their menfolk, existing to bear children and suffering the ignominy of farm labour and polygyny. They appear politically, religiously, economically and socially unemancipated—men marry them off, pray on their behalf, send them to work in the fields and trade in the markets and even—until lately—forbid them to wear clothes. Yet, while these facts are true, an observer soon learns that women are not negligible factors in private and public life. They control the economy insofar as they do all the farming and manage the produce; they keep most of the profits they make from trading; the education of their children is in their hands; they become respected ancestors; they may be priestesses and diviners, queens and princesses. More importantly, they have managed to maintain their own individuality and personality—as women— more than some of the emancipated females of our own society. In Africa there is specifically a woman's world which is highly respected and where men do not belong. Though bowed down with work and child-bearing—as well as from the necessity of their obeisance to men—they still retain an integrity and pride associated with independence and a downright femininity. By that word I do not mean the softness, the 'unmaleness' of the European feminine woman. Women in Africa are not 'man-made', they are not less or more than men—they are just women, and this is their salvation.

To make polygyny work, the relations between a husband and his wives and also between the co-wives must be carefully worked out; the difficulties of husband-wife relations depends on the fact that most women have to share their husbands with others. The answer is usually a high degree of formality between a husband and wife which is shown in the meticulous etiquette in a polygynous com-pound. A Bangwa husband and wife never use personal names. The husband cannot show any favouritism except within the limits allowed by the formal ranking system—there is a senior wife, a first wife and a 'great wife'. In theory an old and barren wife— usually the widow of the husband's father—should receive the same amount of cloth, oil, salt, meat and sexual attention as a new and pretty wife. Troubles usually arise due to jealousies, particu-larly concerning the children of co-wives. A husband must do everything in his power to prevent these jealousies—he takes an interest in each woman, her children, her kin, her farms, visiting all of them for a few minutes in their hut before the day's work begins.

Since marriage is a relationship involving rights and duties between both husband and wife, the Bangwa wife has her sanctions and if she feels herself wronged, may refuse to carry out economic and sexual services for her husband. She may take legitimate complaints to the women's association to which she belongs. One chief's wife told me that she had denied sexual access to her husband for six months when she felt she had been wronged —she covered herself with ashes each time he visited her at night time until he acceded to her demands. I saw the wives of my next-door neighbour beat up their husband for refusing to pay their children's school fees.

Bangwa men recognise their dependence on women and as a result recognise them as individuals and interfere as little as possible in their own world. As a mother she rules almost supreme. She may pass property on to the children. As a daughter she may inherit part of her father's estate, or all of it if there are no children. Women have their own societies for dancing, feasting and political discussion. Significantly, at no stage of her life or physical cycle is a woman considered dangerous or polluting to men. Women also have political roles. A chief has a titled wife, known as the 'Great Wife', who is crowned with him by the nine members of the Night Society. Having been installed with him, she may be party to political secrets, along with the titled chief's sister. An effigy is made of her alongside the chief and his titled sister; as the Great Wife she joins the collection of royal portrait statues associated with the ancestor cult and the Gong society.

Figure 11.1 is a ranking wife of the chief. The style is similar to that of royal princesses in that they both wear hairstyles which are forbidden to commoner women, and bead necklaces. However, they are shown with objects associated with wives—a calabash to fill their husband's drinking horn and a bamboo flute, used in dances reserved for royal wives.

Most of the female ancestor figures are royal wives and sisters. Strictly speaking, memorials in an ancestor cult would only be made for a chief's mother since only direct ascendants were worshipped in Bangwa cults. However, on the whole, while mothers' skulls are worshipped, sculptures are not made of royal mothers and custodians of ancestor portraits rarely declare the female figures to be 'mothers'. Although Bangwa mothers are granted great respect in Bangwa, they are not involved in the Bangwa ranking system; the Bangwa do not have 'queen mothers', female

Fig. 11.1 The ranking wife of a chief. Bangwa, Cameroun.

titles being held by the chief's sisters. These royal princesses are portrayed usually in the costume of a chief, wearing a man's loin-cloth and carrying either a pipe or a drinking horn. Titled women of royal lineages appear on ceremonial occasions in clothes borrowed from their brother, the chief, since they have the right to wear paraphernalia usually reserved for men. Portraits of women other than princesses characteristically show them naked.

Women as mothers

It is as mothers that Bangwa women receive the greatest respect. In the kinship system, an overwhelming importance is given to mothers as 'bearers' of children and as ancestors of both patrilines and matrilines. The sharing of a female ancestor imposes an irreversible bond between kinsmen which is much stronger than between those who share only male links. With the birth of each child a woman's status in the compound and community rises and with the birth of grandchildren she becomes a revered 'great lady'. On her death her skull is inherited by a favourite child and becomes part of the important Bangwa skull cult. The most splendid Bangwa female figures are those of mothers and children, some of which we have already described as part of a twin cult.

Mother and child figures have been found in various parts of West and Central Africa and have recently been discussed by Roosens, an art historian who has sought to unearth the primary meanings of these maternity statues. Are they connected with fertility cults or placed on tombs as prestige items? Are they closely connected with matrilineality? Are they African or influenced by Christianity? Or do they represent the role of women in the particular society where they have been found? Roosens, concentrating on the mother and child figure of Loango and Mayombe to the West and South of the Republic of Zaire, finds it difficult to accept the influence of missionary figures of Mary and the baby Jesus. He points out that the statues are always aristocratic women since like the Bangwa figures they wear caps and hairstyles usually associated with chiefs. Nevertheless, femininity is stressed in the physical traits and the posture, although since strong maternal contact is not insisted upon, it would seem that the mother and child figures represent a socio-cultural pattern rather than a psychological one.

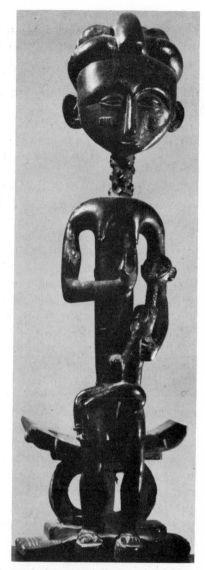

11.3 Mother and child figure. Asante, Ghana.

One is forced to the conclusion that the mother and child figures have diverse functions. It would not be difficult to show that the Bangwa and Kongo figures are linked to fertility cults but only if we accept a very wide interpretation of fertility and include Christian madonna and child figures. In some cases the beauty of the women is stressed. In others they obviously play a prime function as commemorative portraits representing the symbolic status of a dead man and his lineage.

It seems positive that these statues in all their variety and Africanness have not been influenced by Christian iconography. Yet the Christian influence has been insisted upon by African historians who maintain that they are the only examples of group sculpture known in African art. From my own material, I can present other group statues and a cultural background which absolutely precludes Christian influence. There is no Christian imagery in the Bangwa mother and child figures. Moreover, it is a fact that when an African artist sets himself to copy, he really does copy. In examples of the Virgin made by African sculptors, she is always portrayed with her clothes on and all the rest of the Christian paraphernalia.

The mother and child statues celebrate womanhood and the joy of being a mother, and exalt the general notion of maternity and fecundity. In different cultures the figures will fit into a slightly different context—among the Bangwa they are closely allied with a twin cult. Among the Bakongo they are involved in an ancestor cult. On the whole they are wonderful examples of the role of women as mothers, the principal affective centres of an African's life.

Art has even been brought into service to help in the premarital and marital relations between men and women. Among the Fon of Dahomey there were carved calabashes which played a role as intermediaries between courting couples. Motifs carved on the receptacle represented proverbs chosen by the boys in an attempt to win the girls' hearts. The symbolism is rich and direct in meaning and usually referred to requests for marriage. In the initial calabash the boy placed presents; if the girl felt inclined to accept, she sent him a larger calabash containing various kinds of food prepared by herself. In Cabinda south of the mouth of the Zaire river, there is a custom whereby the carved lids of cooking pots or eating bowls are used on special occasions to represent the wife's point of view to her husband, usually when he is in the company

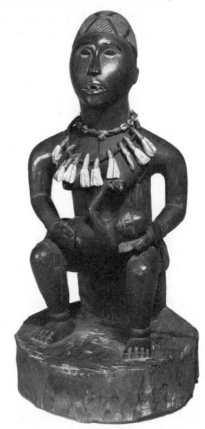

11.4 Mother and child figure. Bakongo, Zaire.

of his friends. When she is serving food for them and wishes to air
a grievance, instead of sending in the food covered with leaves or
a plain wooden lid in the normal way, she sends a carved lid
depicting a suitable proverb.

The functions of these lids and their message is to resolve
threatening tensions in a situation of conflict. The temporary
quarrel between the husband and wife is compared with a famous
case of the same kind, known in proverb and story form and carved
on one of these lids. In this way the situation of conflict loses its
exceptional character and thereby is robbed of one of its principal
conditions of existence. Art thus serves to neutralise a marital
situation of crisis.

Throughout Africa aphorisms and proverbs are used as word
symbols and sometimes translated in this way into image symbols
—Asante gold weights are often signs calling to mind proverbs.
In the Lower Zaire they are also found on combs, pipe stems, clay
pipes, bowls, woven into mats and even on ivory horns and staffs.
In this way they act as a means of social control through art
imagery. In the special case of the Cabinda pot lids, the situation in
detail is as follows. A wife receives as presents from her mother a
number of cooking-pot lids, although if she does not have the
appropriate proverb illustrated she may have one made, on the
advice of the local diviner. For an older woman her series of pot lids
—inherited and made for her—are all reminders of happy or sad
events in her life. They are very definitely women's things and only
in very rare cases could a husband communicate with his wife in
this way. It would seem an appropriate way for a woman to com-
municate with her 'lord and master', although the situation of
women here is not a debased one. The kinship system is matrilineal
and women have a certain strength and are practically indepen-
dent from men, socially.

The pot lid symbolism varies, of course, according to the situa-
tion. Usually the design represents a main figure with accessory
figures. One shows a cooking pot on three cooking stones with a
lid on the pot—the associated proverb is that 'Good things come in
threes' and indicates merely that something is wrong. In figure 11.2
a woman lies in the centre of the pot lid beating her head on the
ground like a frightened lizard, imploring pity. At her feet a shell
indicates that the woman is going to be frank. Again there are the
three cooking stones scattered around the edge of the lid; normally
they should stand together and support the cooking pot and if

they are removed the marriage is in danger. Another pot lid shows the upper half of a woman and a house and a chain and two fruits. One is a hard inedible fruit which splits open when ripe and resembles two hands spread out—this is supposed to indicate hospitality and the loving relationship of two people. Another wild fruit on this lid, through a linguistic double meaning, means 'that it is better for members of a domestic group not to have secrets'. The meaning of the whole is given as follows and is a clear indication of the difficulty of transcribing even this simple domestic symbolism. 'I have kept nothing from you. I have respected and loved you but you have not played your part. The woman on the ground was once young and attractive and everyone always wanted to be kind to her. Now she is old and ugly and no longer has a house of her own, no one pays any attention to her and she even has to sit on the ground'. This complex pot symbolism probably indicates the position of an old widow, inherited by her husband's successor, who finds herself ignored in favour of young and useful wives.

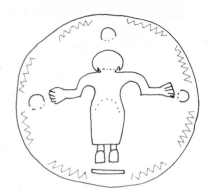

Fig. 11.2 Cabinda pot lid showing a woman beating her head on the ground.

Figure 11.3 shows a human form supporting a hut and a bird with a long tail in a snare. This means: if you have no relations in a particular village you must bring your own house—that is, only your own kinship group will help you. The bird with its tail in the trap means that, 'Since only the tail is caught I can always go back to my family'. In brief, this lid simply tells a woman's husband that she is leaving home.

Sexuality, marriage, maternity are all given great emphasis in story, legend, ritual, ceremony, education and art. Puberty rites are almost universal in Africa—although there are notable exceptions—and celebrate the attainment of sexual maturity in the girl and the possibility of parenthood. Initiations like the Bundu and the *Chisungu* of the Bemba represent attitudes to sex, fertility, marriage and the rearing of children and express and try to enforce the social obligations of husbands and wives, fathers and mothers. The rites also symbolise and express the full physical growth of the girls and the fact that they are adults and must assume adult roles. Puberty ceremonies, therefore, may stress the attainment of puberty, or parenthood or social maturation; whatever the case, nubility, fertility and motherhood tend to be the focus and the interest in the initiation rites for girls. The sentiments and symbols are universal. Menstrual blood, with its mysterious periodicity, is considered specially significant, even terrifying in some rites. In many societies this blood makes women polluting yet at the same time

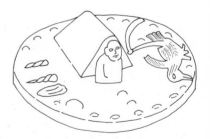

Fig. 11.3 Cabinda pot lid showing a human form supporting a hut and a bird with a long tail in a snare.

powerful, and is a symbol of creative power.

Puberty and puberty rites also serve to differentiate between the male and the female body, and circumcision and cliterodectomy stress this difference. At the same time hostility between the sexes may be expressed—in some rites girls who are bound to be humble and submissive in life are allowed to be obscene and violent towards their menfolk. In this way political and economic values are also taught.

In central Africa the Bemba Chisungu is a puberty rite for girls—a female initiation ceremony which consists of a long and rather elaborate succession of rites including singing, dancing and the handling of sacred emblems. The Chisungu always preceded the marriage of a young girl and was an integral part of the series of ceremonies by which a bridegroom was joined to the family group of the bride—the Bemba reckon descent through the woman and not the man.

The Chisungu

The Bemba are the dominant people of the north eastern plateau of Zambia and had a centralised government with a monarch who was most powerful in this part of Central Africa. Now they number about three hundred thousand and are widely dispersed in small villages where they practise the shifting cultivation of millet, sorghum, maize, and cassava. The world of the Bemba is divided into village and bush, the village representing the civilised orderly way of life and the bush a more mysterious, dangerous environment which must be cajoled to yield its resources for man's benefit. Spirits move around in the bush and trees can be used for their magical properties. The distinction between the forest and the village, between the untamed and the uncultivated sphere of life and the domestic and cultivated is constantly reflected in the Chisungu ritual.

A woman's role among the Bemba is ambivalent. She may be considered a slave and object from one point of view, yet as provider of food and children, she is predominant. The women are farmers and pottery is the only craft in the women's hands. In the Chisungu ritual, the pottery images which play such an important role are made by the women.

The Bemba Chisungu is an individual nubility rite, practised for each girl or two or three girls together, and it is preceded by a short

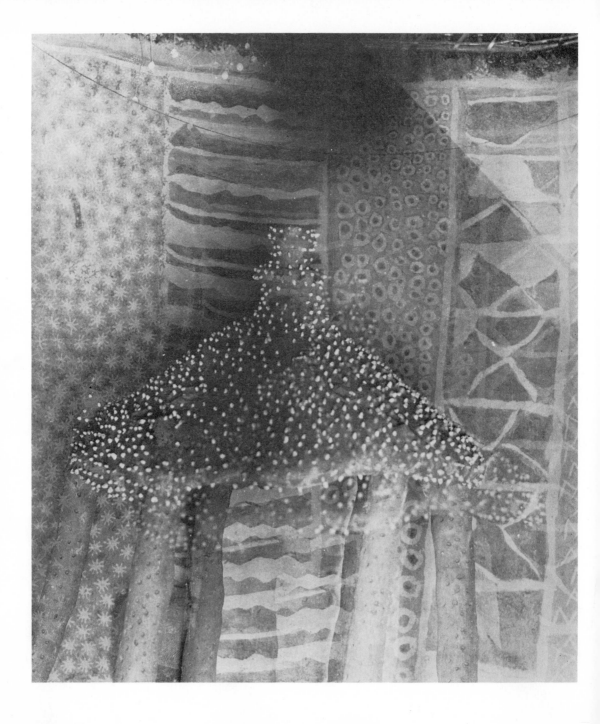

puberty ceremony proper. When a girl finds that her first period has come, she tells the older women and they must then arrange to 'bring her to the hearth' again or 'show her the fire' since her condition has made her cold. She is given medicated seeds to eat, burning hot from the fire, and then she is isolated indoors until considered free to eat again without harming herself or others.

The Chisungu, or the nubility rite, is concerned primarily with sexuality and marriage, not the fact of puberty. The bridegroom must contribute to the cost of this rite which protects the couple against the magical dangers of intercourse and gives the bridegroom the right to have sex with the girl. The ritual lasts about a month and is divided into eighteen separate ceremonies in the initiation hut and surrounding bush. Each of these rites can be split into a number of simpler ritual acts, the symbolism of which is obscure. Over forty pottery emblems are made and handled during the ceremony and a number of others are used in other rites. The walls of the initiation hut are painted with nine different designs and special songs are sung. The ritual includes dramatic episodes, interspersed with days and nights of dancing which play an indispensable part in the rite.

The actors are the 'owners of Chisungu', the parents of a single girl or two or three sets of parents whose daughters reach puberty at roughly the same time. They must provide the beer and the food and engage the mistress of ceremonies, the woman who organises the rites, leads the dances and arranges for the making of the pottery figurines. She has a detailed knowledge of ritual and is often an elderly woman and maybe a successful midwife. Along with these we have the candidates, the bridegrooms, relatives and special messengers.

The Chisungu is a popular ceremony involving a lot of merriment, dancing and singing as well as sacred ritual. There is a special drum beat which is characteristic of Chisungu ceremonies and also characteristic dances. Mimes are performed to represent domestic and farming life.

The pottery figurines are the secret emblems of the ritual. They are a series of models of common objects made of fired clay, usually painted with white, black and red dyes. They represent domestic objects such as a water pot, hoe, pipe, animals and birds such as the crocodile, fertility symbols and historical characters. Many of them are realistically modelled and easily recognisable. Others are conventional pot designs each of which has a name and

11.5 Wall painting in an initiation hut. The designs from left to right are: beans; the owl; the eyes; wild goose; butterflies (just visible). Bemba, Zambia.

WOMEN AND ART

235

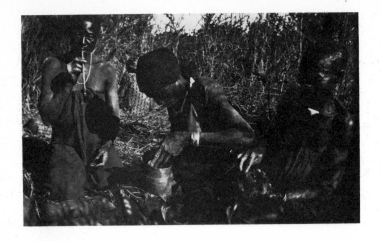

11.6 A group of women making the pottery emblems. The woman on the right is making 'the garden mound' while the woman in the centre is working on a conventional pot design. Bemba, Zambia.

a song. Some writers have considered them similar to pottery images found at Zimbabwe. Larger models—of unfired clay decorated with beans, soot, chalk, red dye—are also made in the Chisungu hut during the actual ceremony and then destroyed on the same evening. They include an enormous snake, the coils of which cover the whole floor; the figure of a man and a woman; and a lion made of logs covered with clay and with a head of hair.

Apart from the pottery and clay figures other sacred objects include the wall paintings and the small bundles of objects representing the domestic life of the Bemba—essential food of the people—snuff and camwood dye.

The rite begins once the girls have been blessed by the chief. They are covered with blankets and are made to crawl laboriously on all fours backwards as a symbol of their forsaking the old way of life, pushed and pinched along by the women. On the third day ten to fifteen women start to make the pottery emblems from clay which has been piled up there by younger helpers. They are all experienced potters. There is no sacred or holy tone about this work, but there is a lot of joking, particularly about the fertility emblems.

With these figures, the girls are taught facts about gardening and farming accompanied by a good deal of miming, teaching periods and ceremonies. The most esoteric part of the Chisungu involved the painting in whitewash of a special design which is said to represent the washing away of the menstrual blood. From this moment the women begin to hand over the secrets to the girl.

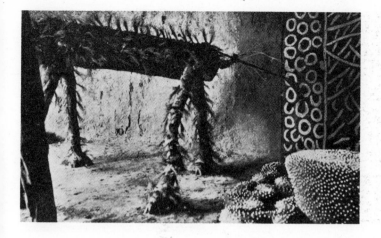

11.7 Inside the initiation hut. The decorated snake can be seen in the bottom right hand corner. The guinea fowl is in the centre foreground. The lion, whose head is not visible, made from a log and four sticks, is in the background.

The mistress of ceremonies and her helpers make the snake, the large pottery emblem, in coils to cover the whole of the hut floor. When it is finished legs are added round the outer coil. The whole thing is decorated in white, red and black earth and stuck all over with marrow, castor oil and bean seeds set carefully in it. 'It is the snake,' say the women. 'It is manhood,' say the others. This elaborate phallic symbol is suddenly pulled to pieces an hour or two after it is finished, immediately after being shown to the girls.

After the snake, a guinea fowl is made on the floor, then a lion is modelled. A log is set up on four sticks and a most lifelike head modelled in clay with reddened mouth and teeth of pumpkin seeds. The clay head is covered with grass and arranged to look like hair and the feet are studded with beans. Other pottery figures are fired then decorated with red, black and white. Some are kept permanently hidden away and are brought out for repainting. One depicts a brother and sister and is seen to represent the matrilineal system of the Bemba—the brother's obligation to look after the sister.

When the day of revealing the pottery images comes, the mistress of ceremonies, wearing a pottery helmet known as the 'plumed headdress', begins the long main rite. Each model is associated with a song which is sung by the older women and each of the two girls. With these emblems, which like the Lega masks could have two or three meanings, the girls are taught sexuality, correct behaviour, and morals. The mortar (figure 11.4) is accompanied by a song making clear that the women have to prepare

11.8 The pottery helmet (on the right) with a lion model, so called because the girls blow down to make a roaring sound. Bemba, Zambia.

WOMEN AND ART

11.9 Pottery figures. The figure on the left is a jaunty young man back from the mines who is—in the song—'all penis and no domestic virtues'. The figure on the right is a pregnant woman suckling a baby. Bemba, Zambia.

11.10 A model of a crocodile ready for firing. Bemba, Zambia.

food for their husbands. A garden mound depicts her industry in gardening. A large clay bracelet is put on each girl's arm in turn. The songs stress the husband's duty to provide clothes for his wife. The crocodile's song is about the dangers of a woman deceiving her husband. A figure of a man with a large head and no arms represents the man who stays in the house all day and never works.

Of prime importance in the teaching process are the duties of motherhood. One figurine about 20 cm high represents a woman suckling two babies and carrying two on her back. Another shows a pregnant woman. The teaching accentuates the value of fertility, as does the cult of twins in Bangwa, although the figure of a centipede shows different attitudes since the girl is told that she must not have intercourse too often or she will have twins and die.

The instruction is practical and reasonable. Adultery, for example, is discouraged, but a philosophical attitude is taken since it is recognised that it is too widely practised to be forbidden. Incest on the contrary is roundly tabooed. On the whole sexuality is discussed without reticence, in fact the whole of the initiation is imbued with sexual ideas and consists in a comprehensive summing up of known facts rather than as a revelation. Initiation also aims to instil discipline and increase self-confidence and punishments during the rites and were aimed at strengthening the character of the girls who would have to face daily dangers in the bush.

After this teaching on all aspects of a girl's life, the bridegrooms come in. The men take an arrow and have to aim at the round mark on the wall above their brides. They fire and then put their feet ceremoniously on the girls' heads. 'He has shot her,' the cry goes up. This is a very symbolic and romantic moment. During the last night of omisungu the atmosphere is more relaxed and the girls

Fig. 11.4 A mortar. Bemba, Zambia.

handle the figurines, sing the songs alone, dress in fine clothes and appear before the elders.

With the completion of this rite the girl's status has irrevocably changed; from being an unproductive girl, she has become a potentially dangerous but fertile woman. Before this rite they know everything there is to know about sex and farming, but during the Chisungu they learn women's mysteries, a secret language, secret terms, and touch the sacred emblems. They also learn socially approved attitudes to husbands and other persons and details of intimate behaviour of a wife and a husband. The rite makes farming and the activities of a wife honourable. It is also the public affirmation of the legal obligations of marriage. The girl is taught to be properly submissive to her husband and to distribute food to her family.

Other people beside the Bemba have similar clay figurines which are used at different rituals. Some use pottery figurines at rites celebrating the birth of a first child. The common factor is the pottery image, handled ritually and associated with a fixed form of words sung or recited as proverbs. The objects either represent common objects used in the life of the people or are highly stylised and exceedingly difficult for a non-initiate to understand. The songs and the meaning of the symbolism were secret and handed over to initiates by elders in the traditional teaching and learning process.

As far as the aesthetic judgments are concerned, the problems are as difficult as the symbolism. Are they disgusting, crude and ugly? Or should we talk of the vigour of their modelling and the ingenious use of simple materials and artistic conventions? They represent an art form which has a secret didactic purpose and do not owe their originality to individual talent, although some gifted women have added original elements to these clay figures, one of the major characteristics of which is their perishability. They are destroyed at the end of initiation by being thrown into a pool of water.

Figurines express countless ideas, the character of a person, the punishment for a sin or crime, the right way to do certain things. The great majority of figures show stereotyped forms. During the performance the figurines are kept in a corner of the initiation hut, covered by a cloth and are produced from time to time for closer examination by the initiates. Most of them have the context of a special song as their theme and through their symbolism add to

the meaning. The songs are learned by heart and the figurines have to be remembered and recognised and associated with the songs. Since boys and girls make clay figures when they play the use of the figurines comes as no surprise, but is really like the amplification of earlier games. Its elevation to use by adults and revered teachers has a great attraction for them and their attitudes are open to learning the words accompanying the figures.

The pottery designs are 'handed down' and act as signs that will go on and on as they have gone on and on. Many symbols have double meanings. A hoe signifies farming but also the husband who makes the wife fertile. This multiplicity of meaning associated with a fixity or form is basic to African art symbolism (see Lega art) and in the Chisungu the rituals and symbolism represent a cluster of ideas, wholly understood, half understood or merely felt.

What is the relationship between a complex and somewhat haphazard rite and the art objects? The figurines are all made with great care by the women instructors 'as the ancestors decreed' and are adapted to the symbolism and mortality of the rite—the domestic and sexual obligations of husband and wife, the husband's duty to provide for his family, the wife's submissive role, her public acceptance of duties which are represented by the sculptures and miming. In the Chisungu these related ideas are associated with certain symbols of the pottery figures and the mimes, the songs and the dances. The pottery forms an *aide mémoire*, the figurines representing certain sentiments, dances and mimes; women when they see a certain figure immediately begin to hum a specific song. The figurines also represent moral attitudes and obligations and represent them in quotable form—there is one about never leaving babies alone, for example.

'The Eternal Feminine'

Women as wives, mothers and ancestors are portrayed in art. So are women as women. Figures and masks are made to represent women and depict an ideal of female beauty, not because women had to be fertile or were important reference points in a descent system.

Among the Dogon, certain female masks were executed for no other reason than that the models for them had vividly impressed the artist by their beauty. In the execution of female ritual masks

worn by itinerant dancers, the sculptor increases the charms of the mask, as well as its efficiency by taking a well-known beauty as his model, reproducing her individual hairstyle and cicatrisation. Among the Tshokwe the dance mask *pwo*—the female version of the male mask—is the image of a female ancestor and is supposed to encourage fertility by depicting the hairstyle, tattoos and features of an ideal Tshokwe beauty. The mask realistically depicts a young Tshokwe girl who has reached puberty and is undergoing the second initiation in womanhood. Her special cicatrisation, nose rings and filed teeth are included. '*Pwo*' means 'young woman' and represents the Tshokwe girl after initiation and the ritual seclusion period preceding her marriage. The mask belongs to a dance society and is paid for by members in the copper rings which are the traditional currency used in paying bridewealth. The pwo dancer is a man in a string vest with false breasts and woman's wrapper. The dance is meant to do little more than 'teach women grace and beauty'. However, like all sculpture, the mask style is used for different purposes and in the hands of a diviner or sorcerer may play a very different role. As a symbol of beauty it is often carved on the heads of pestles or spatulas.

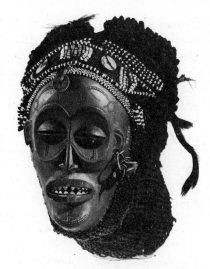

11.11 *Pwo* mask (see 2.10). Tshokwe, Zaire.

In looking at statues and masks of African women we must forget our own ideas of the feminine—whatever they may be—and try to imagine the sentiments felt towards beauty and womanhood in the culture concerned. What may appear to us grotesque in an English eighteenth-century portrait was certainly not so at the time. And what appears strange or even unfeminine in a Tshokwe and Ibo mask will certainly not appear so to the Tshokwe or Ibo.

Among the Ibo, masks are often carved to portray beautiful spirit maidens in a refined and delicate style; the masks are small with sharply defined features. The masks are often painted white with the hair and tribal markings on the face picked out in black or another colour in a decorative way. These maiden spirits are said to represent beautiful local girls and in most of them, even if they are not portraits, we have an idealised type of Ibo beauty. The masks are usually made and purchased within family groups and sometimes depict a mother and daughter, the hairstyle and clothing of each costume being appropriate to the age of the woman concerned. The mask may be bound with cloth and ornamented with tassels and bells and mirrors. Female masks appear during the main feast of the year, early in the dry season during the feast of *Ala*. Maskers copy and exaggerate the way women dance and some-

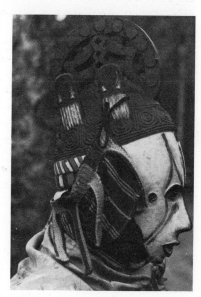

11.12 'Maiden spirit' mask, carved with a woman's elaborate hairstyle and painted. Called 'heifer'. Ibo, Nigeria.

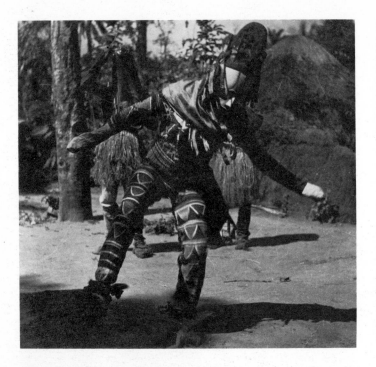

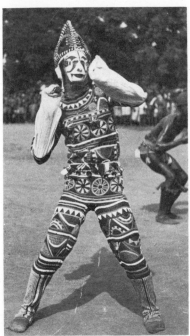

times mime the activities of women working and playing

Talbot says that these maskers were entirely covered by a voluminous kilt and knitted leggings and the masks of the spirit maidens and their mothers are sewn on to the costumes. In fact there seems to be two kinds of maiden spirit mask. The larger kind has a high crest running from the back to the front of the head and is highly ornamented with fretted carving. The top of the mask is carved as a cap to fit over the head while the face is long and triangular. The face is whitened and has black or blue-lined brows, eyes and lips. The second, smaller kind, fits in front of the face and has no headdress.

11.13 Left: 'Maiden spirit' masquerade dancing. The mask worn is the 'heifer' (see 11.12) and the costume is made of brightly coloured appliqué. Ibo, Nigeria.

11.14 Above: 'Maiden spirit' masquerade dancing. The mask worn here does not have a wooden crest. The hairstyle is fashioned from sticks bound with strips of cloth and coloured wool and attached to the appliqué costume. Worn in the *Ogbugulu Mau* play, Orlu. Ibo, Nigeria.

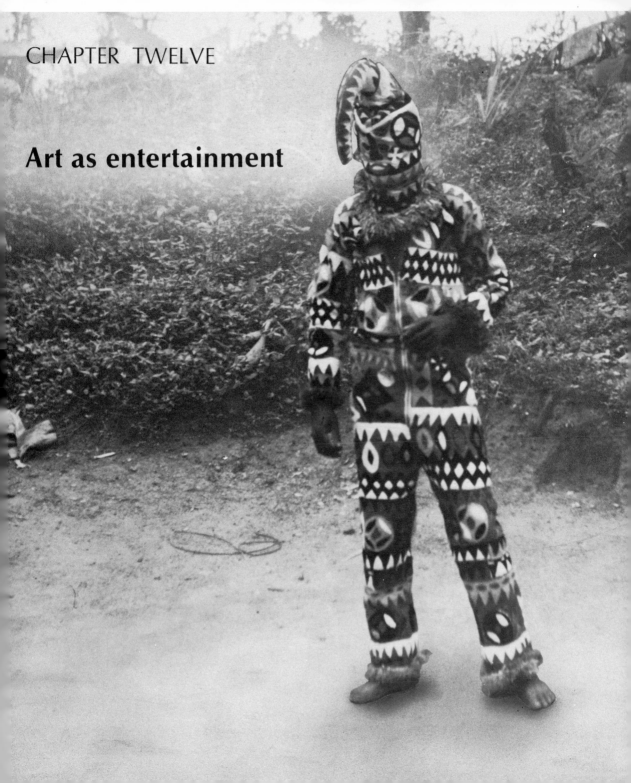

Art as entertainment

In the preceding chapters I have stressed certain aspects of African sculpture in order to illustrate social themes—social control, witchcraft, economic activity—and in doing so the role of art as art, as an aesthetic activity, may seem to have gone by the board. While this book set out to describe art in its social, not aesthetic context, nevertheless, I must emphasise, if it is not already obvious, that a piece of sculpture cannot merely serve as a handmaiden of government, of the church, of the anti-witchcraft society; it is there to be enjoyed, to impress, to entertain. The oft-described Bambara initiation society, the Kore (see pp. 79–82), has been described at different times by different observers as an 'organ of government', 'a means of acquiring status symbols', 'a fertility cult', 'an orgiastic spectacle', 'a religious institution involving an individual's progress to immortality', 'an anti-feminist association'; each of these labels are in some way true and it would be wrong to select one aspect and deny the others. For my purposes I chose in Chapter Two to emphasise the relationship between Kore and agriculture, as a means of illustrating a theme. Here I wish to stress the role of art as entertainment; there is no doubt I could equally well have described the Kore and its masks from the point of view of their 'entertainment value'.

I have already looked at the masks of the Kalabari Ekine society as manifestations of the cosmology of a fishing community. Here I want to look at the masquerades as entertainment and recreation, keeping in mind, of course, that they have functions other than providing 'fun'. Robin Horton points out that Ekine appears at first sight to be a religious institution designed to solicit the help of the water spirits, through invocations and dramatic representations of them by masquerades. In the past it seems to have been an important agent of law and order. The association also encourages economic initiative and membership provides important manifestations of status. A detailed description of Ekine's activities in any one community would reveal the several aspects of the masquerade—plus its role as public entertainer—to be tightly woven together.

12.1 *Massem* masquerader during a second burial ceremony. The costume is made of brightly coloured appliqué work stitched to red flannel and is probably one of the gayest of the Bangwa masquerades (see page 248). Bangwa, Cameroun.

ART AS ENTERTAINMENT

245

Ekine, at first glance, resembles the usual Kalabari rituals which solicit help from the gods—there are preliminary invocations and offerings to the spirits at the local shrines and during the masquerade the water spirits come and possess the dancers. However, there is a difference from the usual cult associations. In Kalabari religious ritual the usual aim is to acquire general benefits such as health, wealth, children and peace. In the Ekine society, the requests to the gods stress the success of the masquerade itself and include an inventory of things which make for a successful performance. 'They ask that the masker should be given nimble legs and light arms; that nothing should press heavily upon him; that his ears should be wide and clear to hear the drums; that it should seem as if he and the drummer had planned every step of the performance between them; that the drum should 'enter the dancer's legs', that the spirit of the masquerade should possess him. It is the performance which matters—and this is stressed in the hours of practice spent before every performance. The masquerade is not a means of getting something out of the gods; it is an end in itself.

Moreover, the spirits imitated in the masquerade are minor spirits, outside the normal range of spirits which help with the problems of life. They are spirits which are entertaining, sometimes thrillingly terrifying. Other masks are ordinary animals which are not spirits while others are pure fantasy figures. These facts show clearly that Ekine is as much an artistic as a religious institution.

What are these dramatic and fantastic theatrical themes? The most common is that of the ferocious male warrior, who wields a matchet or spear, his violence counteracted by the plump, comely figure of his wife. There is the huge character portrayed by the maskers of *Otobo*, who is a water spirit, thought of as part man, part hippopotamus. There is the cunning aristocratic tortoise and the noble Don Juan of whom they sing: 'His father sent him to market to buy yams; but instead he bought a woman's vagina'. And there is the native doctor grunting around like a pig in search of bad medicines and bad spirits. The characters and themes cover a great diversity of social life but the masquerades take no particular moral stand—their function is one of pure entertainment.

Dramatic representations and symbolism play a secondary role to the music, particularly the drumming and the dancing. The first requirement of every masquerade dancer is that he should 'hear the drum well' and translate its rhythm into the appropriate steps.

The skin-tight costume and headpiece play an important role. The mask has a prime function to establish the presence of a spirit. Horton maintains that the mask is designed so as to make its principal features face the sky and therefore invisible to the spectator except when the dancer bends. However, it is precisely this element of surprise, the sight of the hippopotamus or crocodile mask as it swoops down in front of the spectators during the gyrations of the dance, which makes it impressive. There are many masks of this kind, particularly among the Bamileke which are also worn flat on top of the head and which are eminently visible in their loping and crouching dances. Moreover, the additive decoration of the masks is not designed to make them invisible, but to make them more beautiful or more mysterious. Among the Bangwa masks are covered in cloth veils and glimpsed for only a second. Among the Kalabari in the *Egbekoro* masquerade it is enclosed in a wrap of animal fur; and in one version of the Otobo masquerade, it is buried in a stand of palm fronds.

The masquerade is not 'a police society', nor is it seen as a means of dominating women and children as it sometimes is in Africa. In Kalabari performances, the women are in no way victims of the masquerades but are the principal spectators. There is no feeling that the masquerade should be kept secret in order that women should feel terror for the objects they suppose to be spirits. Both men and women know the myths of origin of the masquerade plays; no one tries to keep them secret. Moreover, women are allowed to see the disembodied headpieces as masks when they are being painted or sewn and are set up in their shrines on the eve of the performance. The important aspect of the masking is not to conceal identity but reduce the tendency to react personally to the masker whom they will normally know in everyday life. In this way they react aesthetically to the mask and the costume, the women forming the spectator group of a theatrical performance of their menfolk. Their approval is expressed by throwing coins to the masker which are collected by his escorts.

Consequently, although Ekine has important religious and political functions, its aesthetic role is not minimal, the masquerade belying the generalisation that in traditional African cultures there is no such thing as art for art's sake. Although the performance is associated with ritual and belief, it is the religion which serves the art rather than the art which serves the gods and the spirits. Even in primarily religious performances, as in the Christian mass,

aesthetics and theatricality are not ignored. The Bambara Kore initiation rites, of profound religious and philosophical importance, were undeniably impressive, even entertaining, each mask playing a spectacular as well as a symbolic role. Monkeys scurry round the initiate's feet, hyaenas prance as they guard the secrets of the rites. Others mount hobby horses, wave swords and branches over their heads representing the spirits of Kore on their winged horses attacking the sky in order to produce rain. These masked figures perform mock copulation and have the right to amuse the members by making fun of the sacred activities and objects of this cult association.

Anybody who has attended performances of West African masquerades will agree that enjoyment of the performance and visual appreciation of the masks play more than a minor role even during specifically religious ceremonies such as funerals. In Bangwa the masquerades of their innumerable societies appear during the second burial ceremony and in most cases the aim of the performance is not only to imbue religious awe or seek ancestral protection—although these play a part—but to entertain the mourners and bring glory to the memory of the dead man and his successor. Most of the paraphernalia, except of course the terror masks of the Night Society, is aimed to delight the spectators. After the serious business at the graveside, attended by the members of the Night Society in their sacking and with their blackened masks, the entertainment and the feasting begin. Each masquerade is presented in a professional way; the dancers—chosen for their agility and not their ritual status—dress in a shelter constructed of palm fronds outside the compound and when they are ready their arrival is announced by costumed heralds who leap on to the field in front of the spectators, pushing back unruly children, and, in dumb show, grandly introduce the masks. Small children have been sent to climb trees at the entrance to the dancing field where they wave the branches furiously and hoot as the masks leave their dressing shed. Drums roll, there is a flash of colour in the bush, the maskers appear with a colourful retinue, leaping down the path to appear in the field for only a few minutes before disappearing back into the wings. Later they return and the spectators are invited to join in the dance—in some cases even women and children take part.

These are not performances of secret societies presenting their religious paraphernalia and banning women and children from any

12.2 Women presenting their own masquerade at a second burial ceremony. Bangwa, Cameroun.

knowledge of their sacred cults. These theatrical performances even include women and children as maskers or attendants; women usually accompany the main mask as its handmaiden, wiping its brow when it tires, ready to adjust a heavy mask if it slips, collecting money and gifts from an appreciative audience. Today these societies exist primarily to entertain—both the public and their masks—whatever their role in the past.

In all these societies it is the mask which matters. It is the mask which performs and for this reason the identity of the masker is unimportant and should not be known. The mask surprises the public, appearing from the forest as if by magic for a second or two in the world of men. For this reason the personality of the dancers is entirely subordinate to that of the mask and his face and body is always obscured by the headpiece and extensions of it made of cloth or raffia, often tied to holes in the base of the mask. For the members of these dance societies—unrestricted by ritual and symbolism in their choice of paraphernalia like the members of the Night and the Gong Societies—the masks should be as brilliant as possible and their performances spectacular. Nothing, from a monkey's skull to a European doll, is unacceptable on a mask which usually becomes much more elaborate once it has left the sculptor's studio, although not for ritual reasons. Dyed plumes are added to the centre; striated horns made from bamboo are

inserted at each corner. Cockades are made from the fine hair of a ram's beard and raffia is plaited and fastened to the chin in the form of a beard or is attached to the front and back of the head masks. Skin-covering is used to achieve textural rather than symbolic effects. Other masks are beaded, while most of them—always excluding the Night masks—are also coloured brightly with vegetable dyes or modern polychrome paints.

There is nothing sacred about these masks, therefore, and nothing sacred about the performances. The Bangwa want their dance societies to be as spectacular as possible and they scour the neighbouring countryside and further afield for dances and masquerades which are adopted into the general performance of the funeral. Those with songs in foreign languages are not more frightening or more secret, but more mysterious in the sense of impressive. During the masquerades comic performances are as popular as among the Kalabari, particularly the husband and wife team—of male maskers—who act out a constantly repeated sexual joke. The strange thing is that some of the masquerades imported by these associations have quite different functions in the societies where they originate—dreaded witchcraft, executioner or headhunting societies in one society become gay entertainers in another. What was a camouflage for cannibals in one society becomes a patchwork of red, orange, yellow and green sewn together in circles, squares, triangles and chevrons. The Bangwa Night Society when it appears as a masquerade in a different culture—among the Banyang, for example—is merely an excuse for dressing up, and the disguised voices and dreadful skipping which inspire terror among the Bangwa, succeeds only in entertaining the spectators who see no symbolic significance in the black hoods, the clanking dances and the surrealist masks.

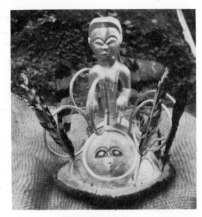

12.3 A 'gaudy' headpiece with stricted horns made from bamboo. Bangwa, Cameroun.

The Ibo mbari

Even in art which seems to have a religious motivation, there must always be an aesthetic impulse. A good example are the Igbo *mbari* houses which might equally well have been included in a chapter on 'fertility' or 'religion'. A study of mbari makes it clear that an art form can not be categorised as 'primarily religious' or 'primarily political' or even 'primarily aesthetic'—mbari has elements of all these things and is a tangle of moral, religious and artistic values.

The Ibo of south-eastern Nigeria form a great and large nation

in one sense; in another, their most significant groupings are small-scale kinship-based communities which rarely exceeded a few thousand people in the past. These local communities were virtually autonomous with their own organisation into groups of kinsmen and their independent systems of authority. Before the arrival of the European, the Ibo did not even have a common name and village groups could only be referred to by a common ancestor. They are nevertheless a single people in the sense that they speak related dialects, occupy a continuing tract of territory and have many features of social structure and culture in common. Among the Ibo, beliefs and skills could spread widely and a sense of Ibo cultural unity was maintained among a considerable number of communities. Nevertheless it should be remembered that different Ibo groups show very different cultural patterns and they have never been politically unified. On the whole it was the lineage system (patrilineal, matrilineal and even dual, according to region) which maintained solidarity within the group, but there were also village organisations with territorial, age set and status associations superimposed on the kin groups. The Ibo are usually divided up into larger groups and known as the 'Onitsha Ibo' in the north, the 'Owerri Ibo' of the south, the 'Western Ibo', the 'Cross River Ibo' in the east and the 'North-eastern Ibo'.

Mbari houses are made at the beginning of the farming season on the orders of the head priest of Ala. During the first part of the dry season, men and women specially chosen as representatives of local lineages and for their individual skills, work building and adorning the house, and before the planting of the yams the house must be finished and ready for the rites. The specific purpose of mbari is fulfilled on the opening day when the public visits the work of the artists. When the planting of the seed yams is over, men and girls bring dried fish, goats, sheep and fowls to a feast. The mbari house, therefore, is a symbol of the yam harvest, built in homage to Ala, a temporary display of Ibo art honouring the fertility of farms and women. A large mbari house contains hundreds of modelled human beings, objects and animals from life, myth and history. Different accounts of mbari have accentuated the religious, the artistic or the pornographic and orgiastic aspects of the cult, so that a clear presentation of its functions and activities has become well nigh impossible. The following description is taken from a number of sources, mostly referring to the southern part of Iboland.

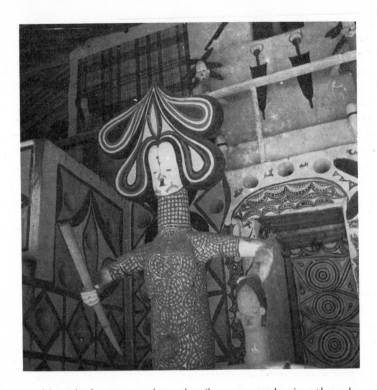

12.4 A figure of Ala in Ulakwo *Mbari* house. Ibo, Nigeria.

Although famous traders, the Ibo are predominantly sub-sistence farmers and even groups whose major occupation was trading held and cultivated land, the subsistence crops being yams and cassava. The yam is the preferred staple and there are dozens of kinds; around the cultivation, storage and consumption of this tuber there are stringent laws and taboos. At the opening of new farms and before the harvest, the Ibo sacrifice to Ala, the earth goddess, and also make offering to the 'king yam', the biggest of the crop in which the yam spirit is thought to take up its abode. In some parts of Iboland a phallic cult associated with agriculture and fertility seemed to be associated with the yam cult.

Ala is the most prominent deity of the Ibo and public rites, performed during the farming cycle, are addressed to numerous fertility spirits all subordinate to her. The cult of the ancestors is associated with Ala and she is the source and judge of human morality and accordingly exercises the main ritual sanctions in disputes and offences. Homicide, kidnapping, poisoning, stealing, adultery and twin births were all offences against Ala. Her cult is,

therefore, the most powerful integrating force in the Ibo community and in each village there is a shrine and in a parent village or the senior village of a wider group there is a senior shrine. Mbari and the building of the mbari house is made to honour Ala as goddess of the earth, mother of all peoples and generous giver of yams; it is made to honour her powers as child-giver, life-taker, peace-maker and arbiter in the affairs of men. In the mbari house, the place of honour is given to clay figures of Ala and her consort.

Although mbari is made before the planting of the seed yams, they may also be built at irregular intervals, prompted by local circumstances such as a dangerous epidemic or during a drought. When diviners begin advising the building of mbari houses, the head priest of Ala sounds out the heads of lineages and important elders, and if they are in agreement, the work begins. The priest selects the site and erects a stout fence around it to keep out prying eyes.

The priest, in the name of Ala, calls on certain persons to come and do the work. The workers are carefully sought out and once selected are seen as the slave of god; on the wall of each compound which has provided a pair of workers a chalk mark is made. There is no age limit, but the numbers of each sex must be equal. On the appointed day the priest ties a cord, with feathers attached, around the necks of the chosen workers as a symbol of their bondage to the gods and their clothes are dyed with a yellow pigment. They will only wear this traditional cloth during the months they are working on the mbari house, their bodies smeared with red camwood dye. During this time they are supported by their families and live together in a house specially built for them. When they first enter the sacred space of the mbari enclosure they walk on a symbolic bridge of iron rods; they are ceremonially killed and emerge as spirits with new names, new clothes and new habits. For the first month sexual abstinence is required, the workers being considered holy and taboo. During this period of seclusion they sing songs in honour of Ala and subsidiary gods and at the end of the period sexual licence is permitted as part of the whole institutional process of making the mbari which includes prayers, sacrifices, games and songs as well as the actual construction of the house.

Promiscuity is a feature of the relationship between mbari workers as sexuality is a feature of the sculpture. A man on entering the enclosure hands over the women from his compound to

another and temporary alliances are formed. They all eat, sleep and wash together and on no account are they allowed to be seen outside the enclosure although some escape to their compounds during the night. No quarrelling is allowed, particularly between lovers, otherwise there must be reparation in the form of a fowl offered to Ala.

The mbari people do the work, supervised by a professional artist employed by the priest. At night time they go out to look for the clay found in anthills. A ritual yam collected from the special mbari farms is pounded in a mortar and added to the mud used for the sculptures. Both men and women workers collect and puddle it and construct walls and do the general work, the actual modelling being done by the artist. First the exterior walls of the mbari house are made, then the solid step-like buttresses, then the mud columns built around the wooden roof supports. The mbari house itself is merely a box, enclosed by four mud walls rising two or three times the height of man. From each wall spring the stepped buttresses which with corner columns divide the space on each side into three niches. The mural decorations are not painted but applied to the walls like a gigantic piece of cloisonné—clay tinted with various dyes is filled in between strips of raffia palm which serve to outline the design exactly as does the brass-edging of the enamelled leaves and flowers of cloisonné.

In making the figures, a framework of light wood and cane is lashed together according to the model desired and upon this clay is pressed each limb and figure being gradually moulded into shape. When the figure has been finished—and smoothed and polished —they are 'initiated' with sacrifice. Only then are they painted—the colours are white and pink made from chalk, black from old long-buried ashes, ultramarine from washing blue, magenta from permanganate of potash, browns and yellows from earth and wood.

At the end of the work the workers are sent away for one night to sleep in a neighbouring village. When they return they are purified in the river—they are no longer mbari spirits and have been cleansed from the sexually promiscuous intercourse they have had, often with normally tabooed persons. The mbari house is then opened. The preparations are furious since vast amounts of food and wine must be assembled at the priest's compound for he has to entertain half the town and the visiting dignitaries. During the night the old door is sealed up and the compound is cleaned and

purified. Then, shouting virulent curses at mbari, the workers rush towards the new door, break it down and leave, walking out of the gate backwards, stripping off their mbari clothes and putting on new clothes held by waiting relatives. From that moment they all disown having played any part in the construction of the house. Then the villagers rush at the tall fence and smash it down and the mbari house emerges, as if by magic, in the light of the moon. Fires are lit, horns are blown, guns go off, gongs are beaten and the people dance. The yams will grow bigger and women will have more children since the goddess now takes up her residence in the mbari house, the priest and the diviner having ritually prepared a pot to contain her spirit. The public is now allowed to visit the house which remains open until the devastation of time and the weather has diminished it to a pile of mud.

The mbari objects are diverse and may represent gods, human beings, hunting scenes, women and men copulating, women giving birth, suckling their young, arranging their hair. The main figure is Ala, who is always sculptured and painted last and occupies the front of the house. Sometimes she is portrayed with her two children, sometimes she is portrayed as a hag with drooping breasts— 'an old man among women'—that is, past child-bearing. The extraordinary variety of scenes, on the whole, are all subordinate to the main theme which is to offer sacrifice to persuade the god to grant favours in the way of new life in the home and on the farm. For this reason procreation and birth scenes predominate. Associated with Ala are phallic figures, rounded posts and pillars constructed for the invocation of fertility. Wooden pegs are inserted into these phallic columns to help women have children. Other gods include the god of thunder, the lord of the sky, Ala's celestial counterpart. For the past generation or two he has been depicted in Western clothes and with Ibo status symbols including a belled staff, a drinking horn and an ivory horn.

Mbari is undoubtedly religious, therefore. It is also an entertainment and an outlet for aesthetic feelings. Mbari is beautiful and mbari is fun and the more beautiful and the more fun it is the more prestige accrues to the village which 'owns' mbari. The artist must be original if he is to entertain the people, and for this reason many figures are comic and many are obscene. Unnatural practices are illustrated with glee, usually from traditional themes. One common sexual theme shows a woman bending forward at right angles from the waist, her head resting on the square base of one

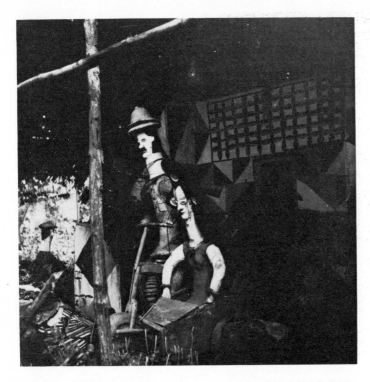

12.5 Figures of Amdioha, the thunder god, and his wife Ala on a motor bike and side-car. In the Nekede *mbari* house. Ibo, Nigeria.

of the roof pillars, while the male figure—the grotesque but popular 'chimpanzee'—is penetrating her from behind. This 'chimpanzee' is a mysterious and devious Ibo spirit, half man, half ape who wanders in the darkest forests, pelting lonely travellers with hard objects. Ugly Okpangu with an exaggeratedly large penis reminds the spectator of the countless stories they have heard about him.

The erotic scenes are strong magnets to the mbari house and amuse and entertain the public lured by the curious figures and the bizarre scenes painted in bright colours. Sexuality, even pornography, is definitely a favourite element and includes a variety of sexual imagery from myth and legend. Women brazenly display their private parts and scenes of copulation include scenes of sodomy between man and beasts. However it must be remembered that the Ibo have a strict moral code, and the sculptures have a moral, as well as an entertainment, value. Men and women in ordinary life are not allowed to see each other's genitals. They are not permitted to copulate during daytime or at least in the daylight and there is a strong taboo on their lying on the earth together

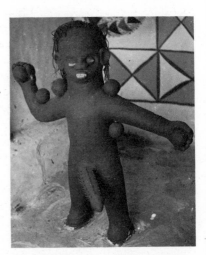

12.6 Ugly Okpangu in Umowa *mbari* house. Ibo, Nigeria.

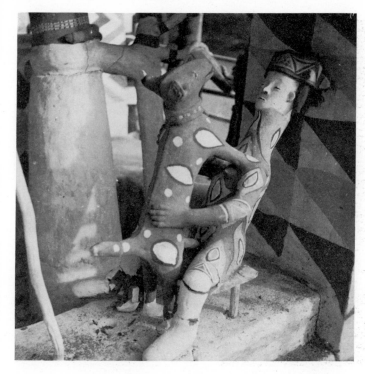

12.7 Figure of a woman copulating with a dog. The photograph fails to include the mud figure of a photographer taking a picture of them! Owerri *mbari* house. Ibo, Nigeria.

since this would defile Ala. In Mbari, the sculptures all express a breach of one of these rules: a figure of a naked woman lying on the ground or a man copulating with a sheep are not pure pornography but provide a moral message. Gross indecencies are explained on the ground that a mbari should reveal every phase of human existence, being a concentration of the whole social life of the community—including its taboos.

Apart from sexual scenes and figures of gods, the whole social background and life history of the people is reproduced with great care and fantasy. Good and useful things are depicted, usually in white—a well-dressed couple, childbirth, children at school. Modern and traditional occupations are shown, reflecting contemporary ethics and the Ibo's well-known receptivity to change and progress. There are bicycles, clocks, lamps, umbrellas. There are also elaborate scenes of modern maternity clinics, another building wired for telephones, with animated mud operators. Certainly the Ibo artist could never be accused of being hidebound by tradition, but faithfully reflects changes in his way of

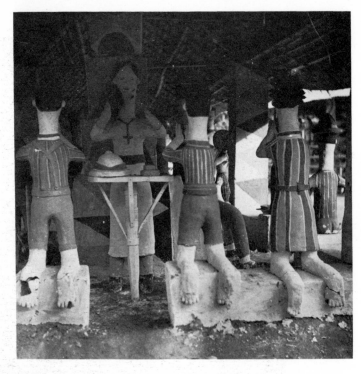

12.8 A figure of a European priest saying Mass. Umulu Ngor *mbari* house. Ibo, Nigeria.

life—the European war, the district officer, the priest and the judge, the teacher and his pupils. Europeans are shown coming out of a hole, bespectacled and gaudily clad horsemen with up to three partings in their hair and long sharp noses. They are portrayed realistically, but also in caricature, harbingers of progress but at the same time comic figures. In the second storey of a mbari house they can be seen peering out of windows surveying in a whimsical way the traditional world of mbari at their feet.

Ibo art, of which I have only touched one small part, is a marvellous example of the eclectic nature of African art. Christ on his crucifix mingles with Ala, the earth goddess; sexuality and religion are not seen as inimical. Tradition is renewed by the artist's inspiration and outside influences. Above all profound moral purpose and pure entertainment combined makes mbari a dynamic and immediate art form.

The artist: his inspiration and his materials

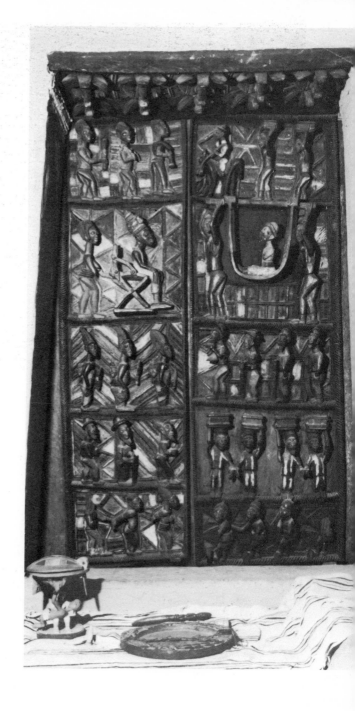

Throughout this book I have stressed the complementary nature of art and social institutions. An aspect which has been somewhat neglected is the role of the artist, himself—or herself. Without a knowledge of the motives, materials and means of the artist we shall continue to remain in the dark about certain elements of African traditional art. Until fairly recently, indeed, the artist in the tribal or traditional situation was considered of little or no significance in the aesthetic appreciation of masks, figurines and other art works since primitive art was considered, almost by definition, to be static, tribal and archetypal, with the artist counting for little since it was thought that ancient models of exclusively ritual or magical significance were slavishly copied from one generation to the next. Through more recent, detailed studies of African art we have learnt that 'tribal' styles are not by any means stagnant but in a constant state of modification, however gradual, and among the contributing factors are the skill and inspiration of individual craftsmen or groups of craftsmen.

In order to understand the role of the artist and particularly the interplay between the individual and a regional style we need to learn a lot more about his techniques, his materials and the way he treats them and the sources of his inspiration. We need to know how he is selected and trained; how he is paid; whether he belongs to a special caste, guild or kinship group; whether his role is a specialised one. Is the artist respected or despised? Is he restricted to certain kinds of materials? and so on.

Although one hesitates to generalise about 'the African artist' it does not seem to me a perversion of the truth to say that the African craftsman—and in this book I have been referring only to the traditional artist—is almost always a conforming member of his society, not the individualist and Bohemian stereotype of Western culture. The artist carves, paints or otherwise creates a work of art, not to satisfy an inner, private need, but for reward or because his father, his mother's brother or some other relation did it before him. Youths are usually apprenticed to master craftsmen,

13.1 Door from the palace of the Ogoga of Ikere, Ekiti, Nigeria. Carved by Olowe of Ise (d. 1939) about 1915. The Ogoga is seen seated receiving his first British Administrator. In front of the door, on the floor, there is divination apparatus for Ifa (see Ch. 9). The carved wooden bowl, in which the strings of seed pods or palm kernels are stored; the wooden tray with the two strings of seed pods (opele) that are used to interpret the wishes of Ifa; the wooden rattle (iroke) which is tapped on the tray 'to make the oracle speak'.

THE ARTIST:
HIS INSPIRATION AND HIS MATERIALS
261

frequently their relatives, and when they arrive at a certain level of skill, gradually begin to imitate their teachers and execute orders, thereby acquiring traditional modes of expression and available techniques. Originality is not encouraged and the young artist is not expected to express his own feelings, although this does not preclude innovation. He portrays 'universal' symbols, like the medieval European artist, symbols shared by himself and the whole society, rather than a private vision.

Traditionally the artist's role is an ascribed one, rather than achieved; that is, it is determined by birth, not by inclination or inspiration, and this is another reason why the African artist is an integrated member of the community. In some cases he belongs to special clans or lineages or a caste group. Among some peoples an entire village may have become specialised in carving, as among the Songe. Among the Yoruba art is a professional affair where specialisation is encouraged in kin groups, although individual members of the community are not excluded. Among the Dan and Ngere, the sculptor is most frequently succeeded by his son, although in these cases the apprentice may choose a specialisation which suits his talents.

In many cultures, particularly in the savannah zone of West Africa—known as the Western Sudan—a man becomes the village artist because he is also the village blacksmith. Among the Dogon the Bambara and Senufo (Siena) of Mali the blacksmith has long been associated with art and is its main exponent. It is he who produces the tools—the adzes and knives and chisels—and it is he who uses them. The mythical blacksmiths of the Dogon came down from the sky bearing the ark containing the first grain, the primaeval techniques of farming and the ancestors of all men and animals. Although a central and important element of the myth of origin, they play an ambivalent role and like blacksmiths throughout West Africa have hardly a privileged position in society. In many cases African blacksmiths live as outsiders in special hamlets and marry among themselves. Typically the wives of blacksmiths are also potters. Blacksmiths, as well as being artists, often perform circumcision operations, do body scarification and act as ritual experts. They are feared and despised, rather than honoured and admired. Dogon and Marghi blacksmiths are not even called 'Dogon' or 'Marghi'.

In African chiefdoms and kingdoms artists play an important role in providing important symbols of kingship and paraphernalia

for the royal family. In many cases they are respected retainers of the head of state and work under his protection in the palace. Bamileke artists were frequently royal slaves, their work becoming the property of the chief who might even claim credit for the sculpture itself. There are even legends that artists were ignominiously sold or executed on trumped-up witchcraft charges once they had completed an important royal portrait figure. The most famous 'historical' Bangwa sculptor was the slave of the chief of Fontem who lent him to neighbouring chiefs for pecuniary compensation.

In Benin court art was controlled from the palace. Bronze was a monopoly of the royal family and those who worked it belonged to special guilds. Corporations of blacksmiths, copper-workers, wood and ivory sculptors, weavers and embroiderers, drum-makers, all lived in the same section of Benin City which was also the quarter of priests, diviners and court officials. Each corporation or guild of artisans was linked to a palace association whose chiefs acted as intermediaries between the artist and the *oba*. In other African kingdoms the carver and the artist, while remaining closely associated with the palace played a positive political role. They might even acquire noble status at court—the Luba carver, for example, had a special title and was allowed to carry a ceremonial adze decorated with a head. Among the Luba wood carvers occupied first place among representatives of local crafts in the king's council which exercised a restraining influence on the king's power.

It is a far cry from being a member of a despised blacksmith caste to a royal councillor in the palaces of kings. Yet these are not the only examples of contrasting roles played by the African artist. In some societies, known for their art, the artist himself hardly has a specific role at all. Among the Tiv, according to Paul Bohannan, any person feels himself capable of producing fine works of art and there are no professional, specialised carvers. Moreover, the Tiv are more interested in ideas conveyed by a work of art than in its manufacture and the anthropologist found it more instructive to study the critic than the carver. Among the Fanti and the Ibo, at least until recent times, the artist is not a professional and no special prestige is attached to the work of individual artists.

Another problem in the analysis of the work of individual carvers is that in many, many cases (the Fang and Lega are two conspicuous examples) the great artists were dead long before the anthropologist arrived to study their masterpieces. The Lega Bwame cult had been

persecuted for years by the colonial authorities and ivory had been banned as an artist's material so that when Daniel Biebuyck arrived to study the Bwame cult and other aspects of Lega art he could only reconstruct historical cases of famous carvers.

In this situation we are very fortunate in having a straightforward account by Robin Horton of the Kalabari carver which is of immense value in gaining some idea of the role of the traditional African carver in a society where there are no special castes or palace groups of artisans and artists. The Kalabari artist has no professional training as a tied apprentice and works mostly part-time, always on commission and never for pleasure or his own satisfaction. His work is always ordered by a cult group of a person of high status, usually to replace a decayed object.

The selection of the wood and the process of carving are accompanied by rites and taboos which are taken very seriously by the carver. According to Horton the artist usually copies the traditional model associated with a certain cult, although new pieces are carved with the help of spiritual incentives and personal inspiration, sometimes with the actual guidance of spirits in the form of spirit possession of the medium of the cult concerned. The majority of carving commissions are restricted by the traditional and limited system of Kalabari symbols and signs (see pp. 47–53 and 102–3), although this does not deny the individual contribution of each artist. Individualism, however, is not something demanded by patrons or even consciously sought by the artist himself; individual style therefore is an incidental factor.

Criticism among the Kalabari does not stem from an aesthetic object's 'ugliness' or failure to achieve a perfection of form, but from factors involving the correctness of symbols used, the traditional style and resemblance to certain natural features. Once accepted the sculpture undergoes no further appreciation or criticism: it is simply there and does its work. The Kalabari find effusions from European art lovers very odd indeed.

As far as the Kalabari artist is concerned, there are no grand rewards and little room for imagination or the satisfaction of private visions. His satisfactions are those of a skilled craftsman who has done a difficult job well. In my limited experience of African artists Horton's description is pretty sound. Although recent art historians have reacted—rightly—against a too static view of primitive art by stressing the innovative role of the individual, we should not forget that, although styles change and the individual plays

his part, traditional African society was relatively conservative and the ritual and religion which the art expressed were by their very nature stereotyped in symbolic content. Moreover as a member of a caste group, specialised clan or an integrated member of his society there is little chance for the well-known Western phenomenon of the 'alienation' of the artist of genius. It appears that it is only when a culture becomes disturbed by sudden change, or even the more gradual transformation brought about by the introduction of capitalist-oriented values, that these 'individualist' elements begin to occur. Sometimes, however, it is difficult to ascertain whether the Bohemian, alienated artists of African society (see my discussion of Bangwa and Gola artists later in this chapter) are traditional or modern phenomena.

The traditional artist, therefore, did not work for his own personal satisfaction, inspired by an abstract quest for beauty and truth like his Western counterpart. The African artist, like the medieval—that is pre-Renaissance—artist in Europe, had comparatively little freedom in choice and treatment of his subject, although he was never denied room to elaborate a personal style. His work expresses the symbols of the cult association or the chiefship rather than his own personal experiences and individual states of mind. The African artist is, therefore, concerned with the general relevance of his work, not its individuality, and like the medieval artist aims at more archetypal forms or at least time-sanctioned forms. At the same time it is a truism that all art systems change no matter how tied up they are with ritual sanctions and functions and undergo constant stylistic change. There will be, for example, basic symbols which must be expressed come what may (like the cross in Christian art and the leopard in Bangwa royal art) and subsidiary ones which will be used according to the discretion or taste of the artist or the demands of his patron.

This concept of the traditional art as craftsman rather than 'artist', as an integrated member of society rather than an individualist is one which many anthropologists and art historians from the West have been unable to accept, and as a result the artist 'as bohemian' has been 'discovered' in many parts of Africa. Herskovits describes the Dahomean artist as a person who is respected in a sense but looked upon with scorn because of his lack of interest in the prestige and wealth that are primary goals for most Dahomeans. In greater detail d'Azevedo has described the Gola (Liberia) woodcarver who typified the role which would be

called 'artistic' in Western society, and betrays an example of individual genius which is different from that found in most traditional African cultures.

From d'Azevedo's account the Gola artist emerges as a creative artist at odds with society, who carves in secret and receives inspiration from dreams or spirit companions. Carving is not an hereditary occupation and becoming a specialist is an individual affair involving personal inclination and opportunity. Moreover, the Gola artist is highly eccentric, even Bohemian, and considered by society in general as irresponsible and untrustworthy. The artist is thought to seek flattery, squander his resources foolishly and live an impoverished, not quite normal life.

Gola artists are dangerous ambivalent people, their independence and their conceit removing them from the control of the family or local group. They are also thought to be sexually licentious and in fact their association with the women of the Sande women's association provides them with special privileges, the women visiting them in secret and arranging liaisons. 'In the setting of his society the master woodcarver is an individual whose role is imbued with the kind of romance and grudging admiration reserved for the brilliant and deviant as in many other societies.'

Personally I wonder if the attitudes of Western anthropologists are not sometimes obscured by the subjective views and prejudices of their own culture; or perhaps a complex modern situation is taken as the 'traditional' one, artists impregnated with Western values being described as typical. Perhaps again there is no typical African artist. We have already seen the caste-bound blacksmith, the palace retainer, the honest craftsman, the inspired individual and the gifted amateur. My own material from the Bamileke area shows that there is not even a typical artist within one small society. I worked in a chiefdom of a few thousand people and the artists whose work I studied were mainly concentrated in a much more limited area—Fontem, Bangwa. These artists are of many kinds—chiefs and nobles considered carving and leather-work as honourable leisure-time activities; some families specialise in certain kinds of headdresses; a blacksmith group fashion skin-covered masks; palace retainers work for the chief. Some artists reproduce stereotyped images of a certain mask form associated with a cult association; others are highly original. Most artists in Bangwa are integrated into society and acquire the attributes of wealthy men. Others are wastrels, philanderers—typical 'artists of genius'.

The Bangwa blacksmith provide a good example of the African artist who have an ascribed rather than achieved role and who show little originality for its own sake. They are a kin-group which runs an artistic enterprise, although they are primarily blacksmiths involved in a craft which requires cooperation and the hereditary transmission of skills. They carve masks, but also figures for the tourist trade today; one of them owns a sewing machine and makes brilliant appliqué costumes for a local dance society. The blacksmith group are palace retainers and today their work is mostly sold through the chief who stores their work, as it is produced, in the palace courtyard.

Quite different from this group of artists are individual carvers such as Atem and Ben of Fontem. Atem's prowess with the adze and his devotion to worldly pleasures are equally well-known. When he has completed a mask the money is invested in drink which he shares with innumerable friends. He is a great drummer and dancer. Unlike Bangwa men on the whole he spurns material comforts and status symbols: for example he has a decrepit house and only one wife. Another carver, Ben, is an eccentric, a wanderer who travels from chiefdom to chiefdom staying with his patrons. He is an introvert and his main interest is in the supernatural.

Bangwa artists, therefore, are members of groups and individuals, slaves or chiefs. Even in the past carvers are remembered as 'bohemians', wits and personalities who refused to conform to Bangwa norms, although the work of most artists is that of palace retainers or 'unsigned' anonymous pieces.

The individual artist and regional styles

One of the advantages of seeking out the individual carver or artist is that we have gradually come to recognise that individuals have their own style, even when working traditional themes, and are not only the skilled executants of an ancestral and never changing style. In recent years the work of Himmelheber, Fagg, Fischer, Willett and Carroll has distinguished the individual styles of many artists. William Fagg has established the work of many named carvers, the great number of them Yoruba, although he attempts to attach works of art to single unnamed authors in Benin art as well—'the master of the aquiline profiles', 'the master of the leopard hunt'. Perhaps more credibly Fagg, Willett and Picton have studied the work of known artists and it has become clear that no

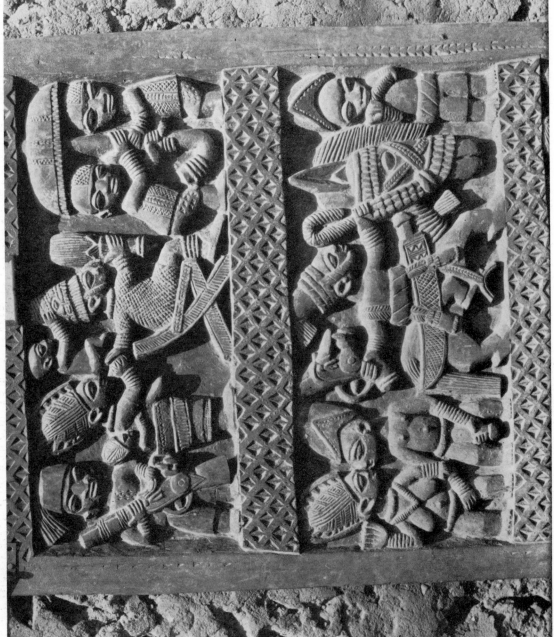

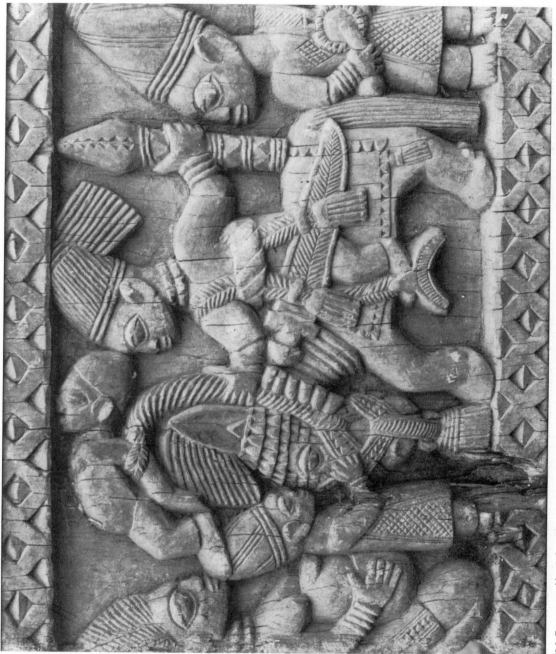

13.3 Door carved by Oshamuko, a pupil of Areogun. Compare the relative proportions of his figures with those of his master.

artist, however traditional his style, is a slavish copier and that in some cases individuals are able to influence and even dominate local styles and style periods. Quite reasonably the African artist is seen neither as a divinely inspired genius nor a passive transmitter of age-old stereotypes.

The work of a woman potter, Abata of the Egbado Yoruba, points the message that an artist is a person who learns his craft and follows rules based on aesthetic norms which allow room for individuality. Abata is an artist known for her mastery of traditional styles and her innovatory techniques. Her work has been studied over a period of time to show that she rearranges mass and volume in her works for the cult of Eyinle, a Yoruba river god, while remaining faithful to the symbols and general styles of the past.

A different approach to the problem of stylistic development ignore the problem of naming African carvers, most of whom probably worked in contented anonymity, and instead concentrates on the relationship between works of art of the same region, local culture or even workshop in an attempt to establish provenance and stylistic links. This is true of the work of myself and Pollock and particularly Pierre Harter in the Bamileke area where a famous mask-type has remained little more than an *objet trouvé* in museums for over half a century. Harter, following an art historical approach, seeks to analyse the provenance of these remarkable abstract masks, known as 'Batcham masks', from the origin of the first known example which was collected for the Museum für Völkerkunde, Leipzig, but destroyed during the second world war. Finding that none of these masks is of the style characteristic of the sculpture of Batcham he attempts to trace the original workshop by a refined analysis of form and style and technique. The Brain-Pollock approach complements his work by seeking to place the Batcham mask within a series of terror masks used by palace police societies among the Bangwa where one of the masks was found.

There are now fifteen of these Batcham masks extant, plus innumerable modern copies. They have been found very far afield, although always in the Bamileke zone, possibly as a result of the custom of trading pieces of sculpture between chiefdoms and even exchanging or selling the carvers themselves. The masks are of various sizes but all have the same, extraordinarily cubist, form. They are carved on two planes, the top half or two thirds being a vertical representation of two symmetrical concavities decorated

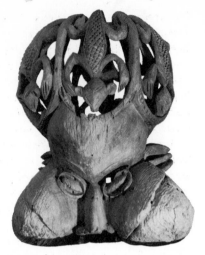

13.4 Batcham Mask.

by parallel chevron striations. The eyes are carved on the horizontal lower plane along with the nose and two jutting cheeks between which is the vast grimacing mouth. Harter discusses these masks, considering details of the carving, the woods used, the form and the general overall effect and concludes that it would be impossible to recognise a single carver in these very similar masks, pointing out that imitating *chefs d'oeuvre* is an honourable African tradition and that an artist's personal style and skill may vary to such an extent during his lifetime that similarities between two works by different artists are as common as differences between works of the same master, even of the same subject. In his attempt to identify different styles and recognise their influence Harter situates the original 'school' or workshop at Bandjoun, an important eastern Bamileke chiefdom.

The Brain-Pollock approach attempts to place the Batcham mask found in Bangwa in the general style of other similarly abstract masks of the Fontem chiefdom's police society. All of these masks showed bared teeth, blown cheeks and great over-hanging or over-arching brows. Facial features are exaggerated almost to the extent of being unrecognisable and move around the face at will in order to stress the ferocious, supernatural attributes of the society's policemen who were also feared as witches. By a comparison of a number of these masks it becomes possible to understand the meaning of the more abstract of them, including the Batcham mask. However different in detail—and no Bangwa terror mask is like another—there is a similarity in conception and symbolic content which brings them into the same cultural orbit. The Batcham masks have the same bared mouth ('the witch will eat you'), the same cheeks pushing out from the plane of the face, the same overhanging brow of all these masks. The ribbing and fluting found in other masks has been extended into one thin curving plane which rise from the hemispherical cheeks. The mouth has developed into a curved mass of fluting to represent teeth with no horizontal division between the upper and lower teeth to complicate the line and the lips have all but vanished.

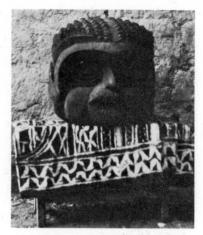

13.5 Night terror mask (see 6.7). Bangwa, Cameroun.

Techniques and materials

The African artist uses a vast variety of materials, each of which involves appropriate techniques. For the sculptor the basic material

13.6 Carver's tools, a mallet and set of curved chisels. Bangwa, Cameroun.

is wood and his tools are the adze, the chisel and the knife, although he may also carve in ivory, bone, stone and occasionally semi-hard clay. The woods used vary according to the type of work or the nature of the function of the finished object. Wood is chosen because it is hard or because it is soft, because it doesn't warp, because it comes from a certain tree with sacred affinities, because it allows a particular kind of finish. Among the Kalabari special woods are associated with heroes and the dead and another with the water spirits, although the rule is not a rigid one. If the sculpture is an ephemeral piece it may be made with soft, easily carved wood as for some Dogon masks. If it is made to last, like effigies of ancestors, a hard wood like iroko will be chosen, a wood which is resistant to termites. Ebony, interestingly, is only used for modern pieces which are made for the tourist trade. Among the Bangwa, hardwoods which are seasoned and selected with care are preferred by master carvers because they last better, resist the ravages of termites and also because they allow certain kinds of fine detail. Amateurs and slipshod professionals prefer softwood: the work is easier but accidents are more frequent, the modern pieces developing great cracks and the delicate parts chipping off.

The African carvers I have seen work with a deceptively careless skill, working consistently over the whole surface of a block of wood so that the piece progresses as a whole. The wood is pared down, taking the grain into consideration, until the various blocks composing the figure are visible. The rough work, including all the main shaping, is done with a matchet, the universal and rather bulky tool of the African farmer and woodsman. When the outline has been achieved the artist uses an adze, a mallet and a series of curved

chisels for detailing. Among the Bangwa a double-handed semi-circular blade is used to empty the inside of the masks.

Finished art works made of wood may be treated in several ways, sometimes being changed out of all recognition as we saw with the nkisi figures or fetishes (pp. 210–12). Some are merely rubbed in oil and placed in a warm, dry place. Among the Bamileke special patinas are acquired by smoking, but masks and figures may also be covered with skin, sheets of metal or beads. Others are coloured by the addition of vegetable dyes and modern masks, throughout Africa, are painted in bright polychrome. For masks and figures which have a ritual function—and also sometimes for purely decorative objects—a religious expert is called in to 'medicate' the masks. To many Africans the quality of a finished sculpture may depend more on this ritual preparation than the actual skill of the carver—some of the older fetish figures in Bangwa are deemed good works of art because of the power of a well-known historical ritual expert who treated the fetish rather than that of the carver. Among the Bangwa today all carvings—unless of purely domestic use—are treated by a priest and often important sacrifices are made over the object before it is considered 'finished'.

Often other materials are incorporated by the sculptor or those who use the object: grains, seeds, pieces of leather and cloth,

13.7 Wooden mugs. Bakuba, Zaire.

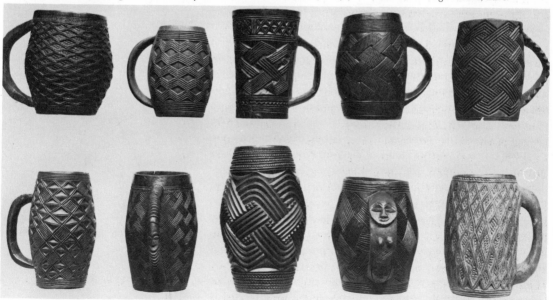

feathers, cowrie shells, metal objects, beads and other trade objects (such as bells,) teeth and animal horns. It should also be stressed that apart from dance masks and ritual figures which have been treated in detail in this book the African artist makes an elaborate collection of utensils: neck rests, stools, thrones, quivers, loom pulleys, beakers, boxes, drums, bells, musical instruments, royal and priestly paraphernalia and a host of other items which could be treated separately and in detail as works of art. Moreover wooden objects are only one aspect of African art, albeit the most important. One of the contributions of the anthropologist to the study of African art has been to insist that all aspects of a society's aesthetic production—be it an ancestor portrait, an incised calabash, weaving or body scarification—must be considered essential parts of the visual and symbolic system of one community, society or culture.

An analysis of the art of an African people therefore should attempt to consider everything which is visually relevant, disregarding our subjective ideas about what is Art. In this way, many societies once declared 'without art' now come into their own through the description of splendid system of face-painting, hair-arrangement, house decoration, calabash engraving etc. One of the advantages of this approach is that in the study of African art we have not had to try to define the meaning of art. Throughout this book a work of art is considered a work of art because it is *intended* as such, even if it is ugly and even if it is bad.

The Bangwa are known in European and American art circles for their splendid figures (beautiful) and their abstract Night masks (ugly) both of which are equally great works of art. Along with these two chosen forms there is a vast array of apparently different types of art-work which require diverse techniques and materials. Despite their varying forms and origins they all belong to one symbolic universe—fetish figures of different types, helmet masks with one, two, three—even four—faces, covered with skin or painted in polychrome, ivory ornaments, feather headdresses, beadwork, carved pottery, knotting, leatherwork, engraved calabashes, soapstone figures, *cire perdue* metal casting, embroidery and so on. And throughout Africa this variety is the rule, rather than the exception, particularly among settled groups. It is this great variety which makes writing about 'African' or 'Yoruba' or 'Bangwa' art so difficult; as far as this book is concerned, and despite what I have written above, it has forced me to exclude such art forms as

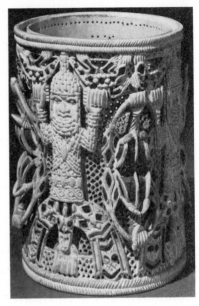

13.8 Sixteenth-century ivory bracelet, inlaid with bronze, made in two separate layers. Benin, Nigeria.

architecture, costume and jewellery apart from passing references. For example, in preceding chapters, I have dealt with several aspects of Tshokwe art, without in any way exhausting its variety —the Tshokwe artist makes wooden masks, wooden figures, bowls and other household objects; they decorate metal, plait baskets, file teeth, make elaborate coiffures and have been using the knitting techniques introduced by Catholic nuns to produce original works of art.

In the final pages of this book, devoted primarily to sociological rather than art historical themes, I should like to look at a few of these diverse materials and techniques used throughout the continent. Ivory, for example, is a material which has been worked wherever it is available. Unlike wood it can be carved without regard to grain and this allows for very fine work in patterning and low relief. The Yoruba, Benin and Bamileke made various decorative objects from sections of tusks such as armlets, bowls, boxes, all carved in intricate relief. Among the Benin work there are bracelets made in two separate layers like an interlocking puzzle. Ivory, unfortunately, is rarely worked today although the Bangwa chief where I worked still carved rings and ornaments and modern madonnas from old pieces of ivory or tusks which they had been able to obtain. Mostly, however, ivory as a material is banned; elephants are no longer killed and, as among the Lega, the old masks and figurines of ivory are no longer made.

Probably the first art works brought back to Europe from Africa were the ivories carved by Africans on European models. About a hundred examples of these so-called Afro-Portuguese ivories survive; they are mostly salt cellars, hunting horns, spoons and forks commissioned by Portuguese merchants and noble families. Some are of Portuguese form with Portuguese motifs, but the hand of the African artist is always evident. Some of these ivories were carved by Benin sculptors but most are in a style similar to the nomoli figures of Sierra Leone where the Temne and Bulom live and who were, until recently, still skilled in ivory work.

Clay is used throughout the continent for making essential domestic utensils and works of art of great beauty. In the majority of the cases the working of clay is the prerogative of women potters although men are not always excluded—in the Lower Zaïre men are potters for example, and in the Cameroon men carved semi-hardened clay into elaborate pipes. Pottery is known from Africa of pre-Christian times, particularly from Nok (Nigeria) and Sao

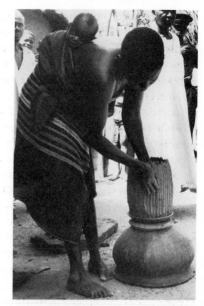

13.9 Woman potter scooping out a lump of clay to make a pot. Gbako, Nigeria.

THE ARTIST:
HIS INSPIRATION AND HIS MATERIALS
275

(Cameroon and Chad). Some of the most elaborate pots and clay sculptures are made by women who mould the clay freely by hand without the advantage of the potter's wheel, either scooping out a lump of clay or building up the object with coils which are then smoothed. The most well-known examples of the potter's art are the Mangbetu figure-shaped vessels, but quite splendid pots of intricate design and great originality are still made in the grasslands of the Cameroon.

As we have seen (pp. 235–40), the Bemba and related peoples make clay into symbolic figures associated with initiation rites. They are very fragile and therefore rarely seen outside the locality where they are made. Even more ephemeral as a material is the working of mud which is merely dried in the sun. In Southern Nigeria and Dahomey—and more widely—undried clay has long been an important medium of sculptural expression. One type has been described in detail: among the Kutep of the Benue Plateau State of northern Nigeria, who occupy the hills and valleys between Takum and the Cameroon border, mud sculptures are made in connection with the male punishment of female adultery and are kept in a shrine devoted to the cult of *Uta* (female) and *Utu my* (male), the latter being sculpted as a mud quadruped in the form of a lion or leopard. Mud sculptures are also commonly made by Fulani children and herdsboys to represent various aspects and values of their pastoral life.

Cloth has been made through the continent since recorded history, even where cotton and wool are not known: in these cases it is made from plantain fibres, bark cloth, raffia and other types of tree materials which are beaten or stripped into threads. Using the basic fibres—cotton, wool, raffia, plantain—patterns are made in the cloth either by weaving them into the basic structure or by printing. In other cases cloth may be embroidered with different types or colours of fibre or ornamented with different materials altogether. Perhaps the most beautiful African embroidery comes from the Kasai area in Zaïre worked by the Bushong and Bakuba. These designs are worked on a loosely woven coarse-stranded raffia cloth with fine strips of raffia first pounded in water. The best-known are the pile cloths worked on a woven base with an iron needle.

Weaving in Africa is highly developed, although mostly worked on a simple hand-loom: in West Africa women weave on a vertical loom while men have horizontal treadle looms. Weaving has been

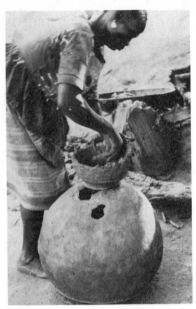

13.10 Woman potter building a pot with coils of clay. Oja, Nigeria.

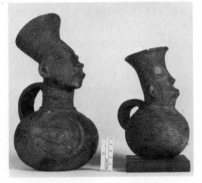

13.11 Mangbetu figure-shaped pots. Cameroun.

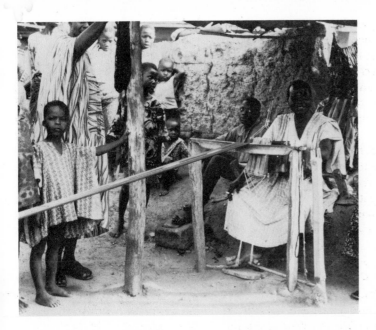

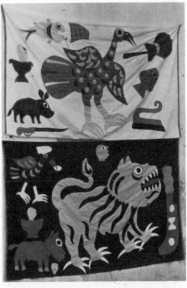

13.13 Example of appliqué work at the palace in Abomey, Dahomey. This cloth has been made in large quantities for sale to the tourist trade for many years.

recorded since the sixteenth century when the Asante used to unravel Oriental silk fabrics used in the gold and slave trade and re-weave them according to traditional patterns. Cloth is woven in long strips and then sewn together to make robes and tunics, often with embroidery.

Appliqué work, or the ornamentation of cloth by stitching on a piece of fabric of another colour or even completely different materials such as beads, cowrie-shells, metal plates, is also widely reported. Among the Asante royal symbols were sewn on the king's clothes. In Dahomey these appliqué cloths were made by members of a specially restricted family guild for men and women of rank and power. They used them for state umbrellas, chief's hats, banners, pavilions, hammocks and palace hangings. The motifs were mostly heraldic devices and royal symbols and insignia.

Cloth is also printed and stamped—the *adinkyra* of the Asante are made with stamps cut out in pieces of calabash. Often they are dyed, using the resist method or tie-dyeing, the most common dye being indigo. The Bambara on the other hand use a discharge technique, dyeing their cotton fabrics with yellow colour obtained from roots. On this yellow ground the women paint ornaments and

THE ARTIST:
HIS INSPIRATION AND HIS MATERIALS

277

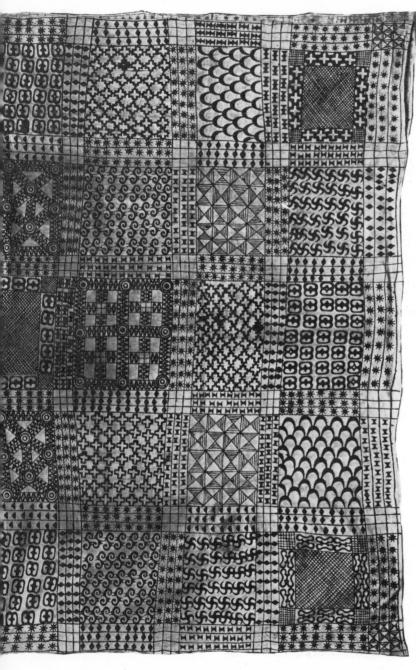

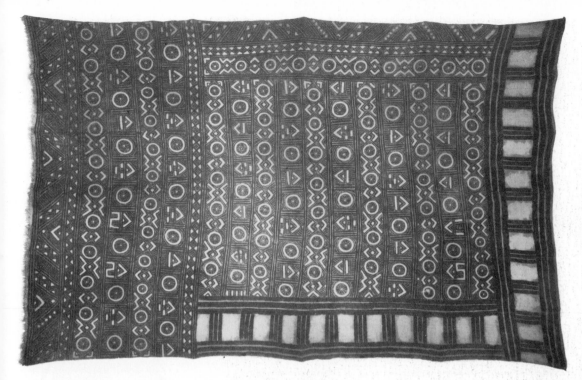

arabesques in mud, coating them with a highly corrosive soap. The cloth is then treated once more with mud and when the corrosive has taken effect it is soaked in water several times so that the light-coloured ornamentation stands out clearly against the dark ground.

As I have already pointed out (see p. 53), hunters and nomads cannot have bulky works of art in their equipage, but they compensate for this by the elaboration of music (Pygmies), poetry (Somali), rock-paintings (Tuareg and Bushmen) and body decoration (Fulani), and ephemeral drawings and earth statues painted in vivid colours. Leatherwork is the particular speciality of nomad cattle-herders. In East Africa different types of decoration are made on leather: they may use skins from which the hair has not been removed, shaving off certain parts, or thicker hides are carved in low relief. The Masai have very beautiful painted hide shields, while the women have leather capes adorned with fringes and beads. Leather is tanned and dyed in the savannah and sahel zone of West Africa; early travellers particularly remarked the elaborate Benin fans of green leather with appliqué work. Leatherwork is made with

THE ARTIST:
HIS INSPIRATION AND HIS MATERIALS

279

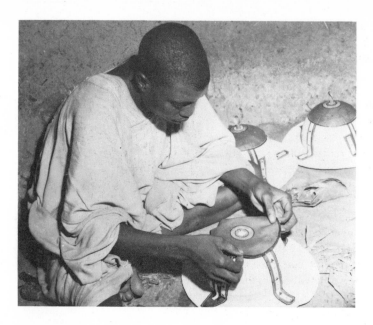

13.16 Masai painted hide shields. Kenya.

13.17 Leatherworker applying decorative leather patches to a basketry hat. Keffi, Nigeria.

elaborate ornamentation showing Berber and Islamic influence; the Hausa and Mande trader travelled through West Africa selling leather bags, cushions, harnesses, swords, ornamental daggers, powder horns, hats and shoes.

The decoration of calabashes is found throughout the continent. They are incised, burnt or scratched, usually into geometric patterns. The best known are the Dahomey calabashes with their illustration of proverbs. Others are found among pastoral people who use them as receptacles for their milk products.

Other minor forms of art include reedwork, the material being woven, sewn, plaited into mats and containers, and even masks. Beadwork is also done throughout Africa, being either sewn on clothing or used to cover objects such as calabashes, stools, masks and statues. Beads were once used as a medium of exchange. The older ones havè delicate shades; more frequently in the modern beadwork they are a dull combination of dark blue, red and white. Beads and cowries, both imported materials, the former from Europe and the latter from Asia, are used in making jewellery, which is also made in a great diversity of materials—metal, bone, beans, wood. Among the Bambara 'gold' jewellery is simulated by covering metal with coils of fine yellow cotton.

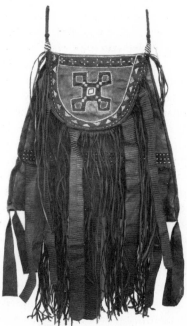

13.18 Leather bag, probably made by a Hausa. Kumasi, Ghana.

Jewellery, in fact, is an aspect of art in which Africans have long excelled: the glass beads of Bida (Nigeria), Benin corals, quartz, ivory in Zaïre, copper rings and torques, the silver and gold work of the Agni and Baule of West Africa, elaborate wooden combs, cast anklets and armbands.

One of the most interesting art materials and perhaps even the most common is the human body itself. A sphere of art to which Africans have made a unique contribution is that of the ornamentation and decoration of the body through painting, cicatrisation, the arrangement of hair and occasionally tattooing. Body ornament is found everywhere, sometimes as a means of beautification, sometimes to symbolise status changes or as a way of ritual protection; among the Dogon ear-piercing and toothfiling is done primarily to emphasise the difference between the sexes. Nuer men have six long scars on the forehead to indicate their arrival at adulthood. Fulani hairstyles indicate that the person concerned is a 'little girl', a 'nubile maiden', a 'young bride', a 'mother', a 'woman who has lost her first child', a 'widow'.

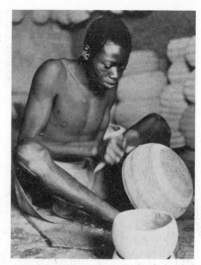

13.19 Calabash incising. Oyo, Nigeria.

In a number of cases, however, the inspiration is primarily, if not totally aesthetic, an art for its own sake. Thus among the southeastern Nuba of Kordofan in the Democratic Republic of the Sudan, the elaborate body designs are made to complement, enhance and emphasise the body's form. This art of body decoration appears to have evolved uniquely and *in situ* on a general basis of the use of ash, oil and sometimes colour—only pagans paint their bodies in this Islamic zone of course, although both Muslims and Pagans permit scarification. Four basic colours and terms—black includes blue and yellow includes all yellows and greens—are used. Nowadays the artist is the individual himself; formerly—before the days of mirrors?—it was the preserve of a professional. These people, like the Fulani pastoralists (see p. 55), demand and reward physical beauty and strength in their young men and the painting accentuates these values. At the same time body decoration follows precise social rules and can therefore serve as a status indicator. 'Colours, styles, hair-form, scarification and other aspects of personal art, serve to mark age group status, patrician membership, physiological condition and ritual status'.

Although I have deliberately excluded architecture from this book the art of painting and decorating dwellings deserves at least a cursory mention, since this is a phenomenon found throughout Africa from Morocco to Zululand. In some cases they may be simple

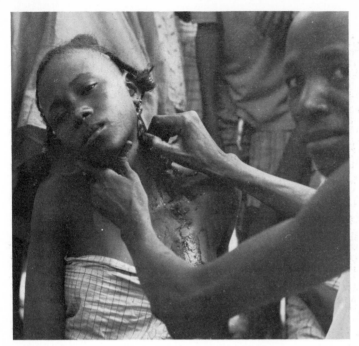

13.20 Fulani girl being cicatrised for a festival. Abuja market, Nigeria.

geometric engravings or cave paintings of basic earth colours as among the Dogon. Others demonstrate an elaboration of style, patterning and colour: the Mbari houses of the Ibo, Bamileke palaces with their carved poles and intricate bamboo panelling, the wall paintings of Tanzanian snake charmers, the carved door panels of the Senufo and Dogon, the clay panels in low relief of the royal palaces of Nigeria and Dahomey.

A well-known example of painting on house walls is found among the Ndebele of the Transvaal, around Pretoria, where the houses— built by men—are decorated by women and girls with geometric and figurative patterns in black, white, yellow, red ochre and earth colours, which include green. The paintings are done with the fingers and small brushes. Women also paint the Sudanese Nubian house-paintings, although in this case the professional artists are always men. Women, men and boys among the Nubians all have their own special motifs and styles—fish for example is considered a woman's pattern. Women painted their houses either because they wanted to or because a daughter was about to be married

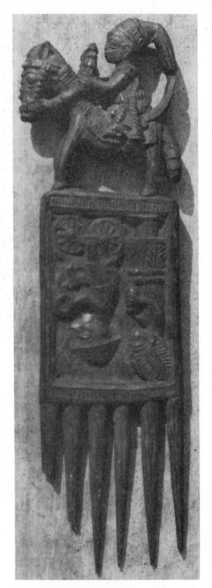

13.21 Elaborate wooden comb. Osi-Ilorin, Nigeria.

ART AND SOCIETY IN AFRICA

282

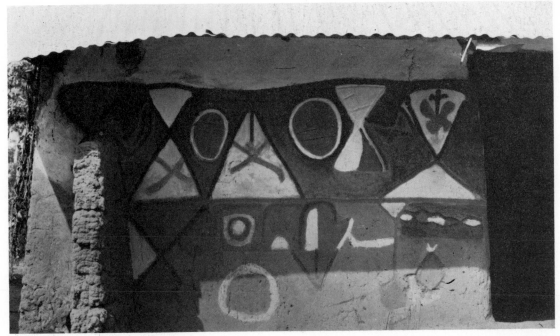

13.22 Wall painting outside a shrine. Aiyede, Ekiti, Nigeria.

and the rooms had to be painted to receive the bridegroom. The kind of painting done by women—simple marking a liquid colour on a given surface in decorative and figurative patterns—contrasts with the work done by men. Here decorations are sculpted in mud relief, the patterns standing out from the dark mud of the houses because the designs are given a contrasting surface of white lime. The design is cut through to the dark mud below or in some cases punched with a metal cutter. Although this geometric and figurative painting is a twentieth-century phenomenon—and have since almost disappeared since the flooding of the Aswan dam—images are taken from traditional folklore and popular religion as well as contemporary life.

BIBLIOGRAPHY

Allison, P. A. *African Stone Sculpture,* London, 1968

—— *Cross River Monoliths,* Lagos, 1968

d'Azevedo, Warren L. *The Traditional Artist in African Societies,* Bloomington, London, 1973

—— 'Mask Makers and Myth in Western Liberia', in Forge, ed., (q.v.) 1973

Basden, G. T. *Niger, Ibos,* London, 1938

Bastin, Marie-Louise *Art décoratif Tshokwe,* Lisbon, 1961, 2 vols.

—— 'L'art d'un peuple d'Angola' *African Arts,* Spring, 1969

Beier, U. H. *African Mud Sculpture,* Cambridge, 1963

Ben-Amos, Paula 1975 'Professionals and amateurs in Benin Court-carving', in McCall and Bay, eds, (q.v.) 1975

Biebuyck, Daniel P. 'Function of a Lega Mask', *International archives of ethnology,* xlvii, 1, Leiden, 1954

—— *Tradition and creativity in Tribal Art,* Los Angeles/London, 1969

—— *Lega Culture, Art, initiation and moral philosophy among a central African people,* Los Angeles/London, 1973

Boston, J. S. 'Some Northern Ibo Masquerades', *Journal of the Royal Anthropological Institute,* Part 1, 1960

Brain, Robert and **Pollock,** Adam *Bangwa Funerary Art,* London, 1972

Brandt, Henri *Nomades du Soleil,* Lausanne, 1956

Brentjes, Burchard *African Rock Art,* London, 1969

Brosses, Charles de *Du Culte de Dieux Fétiches,* 1700

Carroll, K. L. 'Three generations of Yoruba Carvers', *Ibadan,* 1961, 12

Carroll, K. L. *Yoruba Religious Carving,* London, 1967

Chappell, T. J. H. 'The Yoruba cult of twins in historical perspective', *Africa,* lxiv, 3, 1974

Cole, Herbert 'Art as Verb in Iboland', *African Arts,* Autumn 1969

Cooke, C. K. *Rock Art of South Africa,* Cape Town, 1969

Cornet, J. *Art de l'Afrique au pays du fleuve Zaire,* Bruxelles, 1972

Cory, Hans *Wall paintings by snake-charmers in Tanganyika,* London, 1953

—— *African Figurines,* London, 1956

Coulon, Virginia 'Niominka pirogue ornaments', *African Arts*, Spring, 1973

Dark, Philip J. C. *An Introduction to Benin art and technology*, Oxford, 1973

De Ganay, Solange, 'On a form of cicatrisation among the Bambara', *Man*, 49, 1965

Delachaux, Théodore 'Méthodes et instruments de divination en Angola', *Acta tropica*, iii, 2, 1946

Delange, Jacqueline *Arts et Peuples de l'Afrique Noire*, Paris, 1967

Dieterlen, Germaine, *Essai sur la religion bambara*, Paris, 1951

Douglas, M. M. and **Kaberry,** P. M. eds., *Man in Africa*, London/New York, 1969

Dupire, Marguerite *Peuls nomades*, Institut d'ethnologie, Paris, 1962

Dupré, Marie-Claude 'Le systéme des forces *nkisi* chez les Kongo d'aprés le troisiéme volume de K. Laman', *Africa*, lxv, 1, 1975

Evans-Pritchard, E. E. *Witchcraft, Oracles and Magic among the Azande*, Oxford, 1937

Fagg, Bernard 'Recent work in West Africa: new light on the Nok culture', *World Archaeology I*, 1969

Fagg, William B. *Afro-Portuguese Ivories*, London, 1959

—— *Nigerian Images*, New York, 1963

—— *Tribes and forms in African Art*, London, 1965

—— *Divine Kinship in Africa*, British Museum, London, 1970

Faris, James C. *Nuba Personal Art*, London, 1972

Forge, Anthony ed., *Primitive Art and Society*, London/New York, 1973

Foss Perkins, 'Festival of Ohworu at Eywreni', *African Arts*, 4, 1973

Fraser, Douglas ed., *The Many Faces of Primitive Art: a Critical survey*, Eaglewood Cliffs, 1966

Fraser, Douglas and **Cole,** Herbert M. eds., *African Art and Leadership*, Madison, 1972

Gabus, Jean *Au Sahara II Arts et symboles*, Neuchâtel, 1958

—— *Art nègre*, Neuchâtel, 1957

Gerbrands, A. 'Art as an element of culture, especially in Negro Africa', Mededeelingen van het Rijksmuseum voor Volkenkunde, 12, Leiden, 1957

Girard, J. 'Dynamique de la Société Ouobé, *Mémoires de l'Institut Fondamental d'Afrique Noire*, 78, Dakar, 1967

Griaule, Marcel *Masques dogons*, Paris, 1938

Haafe, E. and **Zwenemann,** J. 'Krankheitsdarstellungen an Afrikanischen Masken', *Tribus*, 20, November, 1971

Hampaté, Ba Amadou and **Dieterlen,** Germaine *Koumen, texte initiatique des pasteurs peuls,* Paris/The Hague, 1961

Harley, George W. 'Masks as Agents of Social Control in Northeast Liberia', Peabody Museum Papers, 32, 2, 1950

Harter, Pierre 'Four Bamileke Masks', *Man,* 4, 1969

—— 'Les masques "dits" Batcham', *Arts d'Afrique,* No 3, 1972

Hartwig, H. 'Wooden dolls for unmarried girls and childless women', *Baessler Archiv,* 1969

Henry, Joseph, *L' âme d'un peuple africain: les Bambara,* Münster 1910

Herskovits, H. 'The art of Dahomey', *American Magazine of Art,* 1934

Holas, Bohumil *Animaux dans l'art ivoirien,* Paris, 1969

Hopen, C. Edward *The Pastoral Fulbe Family in Gwandu,* London/ Ibadan, 1958

Houlberg, Marylin 'Yoruba Twin Sculpture and ritual', unpublished M Phil thesis, University of London, 1968

Horton, W. R. *The Gods as Guests,* Lagos, 1960

—— 'The Kalabari World View', *Africa,* October, 1962

—— 'The Kalabari Ekine Society', *Africa,* April, 1963

—— *Kalabari Sculpture,* Lagos 1965

Imperato, Pascal James 'Wool blankets of the Fulani of Mali', *African Arts,* 1973

Jones, G. I. *The trading states of the Oil Rivers,* London, 1963

—— 'Sculpture of the Umuahia Area of Nigeria', *African Arts,* 4, 1971

Kjersmeier, C. *Ashanti Weights,* Copenhagen, 1948

—— *Centres de Style de la Sculpture Nègre Africaine,* 4 vols., Paris/Copenhagen, 1935–38

Koch, Henri *Magie et Chasse dans la Forêt camerounaise,* Paris, 1968

Kyerematen, A. 'The royal stools of the Ashanti', *Africa,* xxxix, 1, 1969

Lafon, Suzanne 'La parure chez les femmes peules du Bas-Sénégal', *Notes africaines,* IFAN, 46, avr. 1950

Laude, Jean *Arts anciens du pays dogon,* Paris, 1959

—— *Irons of the Dogon,* New York, 1964

—— *The Arts of Black Africa,* Los Angeles/London, 1971

Lebeuf, J. P. *L'art ancien du Tchad: bronzes et céramiques,* Grand Palais, Paris, 1962

Lecoq, R. *Les Bamiléké,* Paris, 1953

Leiris, Michael and **Delange,** Jacqueline *African Art,* London, 1968

Lhote, Henri *The search for the Tassili frescoes: The rock paintings of the Sahara,* London, 1959

Lhote, Henri 'L'art préhistorique saharien', *Objets et mondes*, ii, 4, 1962

—— 'Le peuplement du Sahara néolithique d'après l'interprétation des gravures et des peintures rupestres', *Journal de la société des africanistes*, xl, 1970

Lima, Misquitela *Fonctions sociologiques des figurines du culte hamba*, Luanda, 1971

Lincoln, Bruce 'The religious significance of women's scarification among the Tiv', *Africa*, xlv, 3, 1975

Lips, Julius E. *The savage hits back or the whiteman through native eyes*, London, 1937

McCall, Daniel F. and **Bay,** Edna G. eds., *African Images. Essays in African Iconology*, New York and London, 1975

McLeod, M. D. 'Gold weights of Asante', *African Arts,* Autumn no 1, 1971

Mauny, R. 'Gravures, peintures et inscriptions rupestres de l'ouest africain', 1954

—— *Masques mende de la société bundu (Sierra Leone),* Dakar, 1959

Mazonowica 'Prehistoric rock painting at Tassili', *African Arts,* 1, 1968

Meek, C. C. *Law and Authority in a Nigerian Tribe*, London, 1937

Menzel, Brigitte *Goldgewichte aus Ghana*, Berlin, 1968

Monteil, Charles *les Bambara du Ségou et du Kaarta,* Paris 1924

Nuoffer, O. *Afrikanische Plastik in der Gestaltung von Mutter und Kind*, Dresden, 1927

Odugbesan, Clara 'Femininity in Yoruba Religious Art' in Douglas, M. M. and Kaberry, P. M., eds., (q.v.), 1969

Olbrechts, Franz M. *Les arts du Congo belge,* Bruxelles, 1959

Ott, Albert 'Akan gold weights', *Transactions of the Historical Society of Ghana*, 9, 1968

Pagnes, Viviana, *Les Bambara*, Paris, 1954

Paulme, D. *Women in Black Africa*, London, 1963

Perrois, Louis *La statuaire fang, Gabon,* Paris, 1972

—— 'La statuaire des Fang du Gabon', *Arts d'Afrique,* automne, 7, 1973

Picket, Elliot 'The animal horn in African art', *African Arts,* 4, 1971

Rattray, R. S. *Religion and Art in Ashanti*, Oxford, 1927

—— *Ashanti,* Oxford 1923

Richards, Audrey I. *Chisungu: a girls' initiation ceremony among the Bemba of Northern Rhodesia,* 1956

Roosens, Eugene *Images africaines de la mère et l'enfant,* Louvain/ Paris, 1967

Rudner, Jalmar and Ione *The Hunter and his Art,* Cape Town, 1970

Rudy, Suzanne 'Royal sculpture in the Cameroons Grasslands' in Fraser and Cole, eds., (q.v.), 1972

Salvadori, C. and **Fedders,** A. *The Maasai,* London, 1973

Sassoon, Hamo 'Cave paintings recently discovered near Bauchi, Northern Nigeria', *Man,* 70, 1960

Segy, Ladislas 'Shango sculptures', *Acta Tropica,* 12, 1955; 'The Yoruba Ibeji statue', *Acta Tropica,* 27, 1970

Shaw, Thurstan *Igbo-Ukwu: an account of archaeological discoveries in eastern Nigeria,* Ibadan, 1970

Smith, M. W. ed., *The Artist in Tribal Society,* London, 1961

Smith, Philip E. 'Problems and possibilities of the prehistoric rock art of northern Africa', *African Historical Studies,* i, 1, 1968

Söderberg, Berthold 'Antelope horn whistles with sculptures from the Lower Congo', *Ethnos,* Stockholm, 1, 4, 1966/7

Starkweather, F. *Traditional Igbo Art,* Ann Arbor, Michigan, 1966

Steinmann, A. *Maske und Krankheit,* CIBA Zeitschrift 89, Basle, 1943

Stenning, Derrick *Savannah Nomads,* London, 1959

Talbot, P. A. *The Peoples of Southern Nigeria,* 4 vols, London, 1921

—— *Some Nigerian Fertility Cults,* London, 1927

—— *Tribes of the Niger Delta, their religion and customs,* London 1932

Tardits, Claude 'Panneaux sculptes bamoun', *Objets et Mondes,* tome 2, Paris, 1962

Tauxier, Louis *La religion bambara,* Paris 1927

Thomas, Elizabeth Marshall *The Harmless People,* London, 1959

Trowell, Margaret *African Design,* London, 1960

—— *Classical African Sculpture,* London, 1964

Turner, V. W. 'A Lunda Love Story . . . Human Problems in British Central Africa', *Rhodes Livingstone Journal,* 9, 1955

Uchendu, Victor C. *The Igbo of southeastern Nigeria,* New York, 1965

Ucko, Peter J. and **Rosenfeld,** Andrée *Palaeolithic Cave Art,* London, 1967

Urvoy, Yves 'L'art dans le territoire du Niger', *Etudes nigériennes II,* IFAN, Centre IFAN, 1955

Vandenhoute, P. J. L. *Classification Stylistique du masque Dan et Gnéré de la Côte d'Ivoire occidentale,* Mededeelingen van het Rijksmuseum voor Volkenkinde, Leiden 4.

Vaughan, James H. 'Rock paintings and rock gongs among the Marghi', *Man*, 63, 1962

Verly, R. *Les Mintadi*, Louvain, 1955

Vinnicombe, Patricia 'Myth, motive and selection in Southern African Rock Art', *Africa*, xlii, 3, 1972

Volavkova, Zdenka 'Nkisi figurines of the Lower Congo', *African Arts*, 2, 1972

Weil, Peter M. 'The masked figure and social control: the Mandinka case', *Africa*, xli, 4, 1971

Wenzel, Marian *House decoration in Nubia*, London, 1972

Willett, Frank 'A hunter's shrine in Yorubaland, Western Nigeria', *Man*, 334, 1959

—— 'A further shrine for a Yoruba hunter', *Man*, 66, 1965

—— **African Art,** London, 1971

Willett, Frank and **Picton,** J. 'On the identification of individual carvers: a study of ancestor shrine carvings from Owo, Nigeria', *Man*, N.S. 1, 1967

Williams, G. *African designs from traditional sources*, New York, 1971

Woodhouse, H. C. 'Rock paintings of Southern Africa', *African Arts*, Spring, 1969

Zahan, Dominique *Sociétés d'initiation bambara, le Korè,* Paris/The Hague, 1960

Zeller, R. 'Die Goldgewichte von Asante', *Baesler Archiv Beiheft III* Leipzig/Berlin, 1942

Zwernemann, J. 'Eine aussergewöhnliche Aufsatzmaske von den Bangwa, West Kamerun', *Tribus*, 1972

INDEX

Ijebu, 113
Ijebu-Ode style, 113
Ijo people, 47, 48, 50, 65; see also Kalabari Ijo people
Ilunga (Tshokwe ancestor), 40–3
imborivungu see pipes, owl pipes
indirect rule, 124
individuality and originality, 168, 255, 261, 262, 263, 264–6, 267, 270
ipade (carved figures), 34–5
iron, 12, 92, 192, 198, 209, 211, 253
Isuana, 105
Ita Yemu, 15
ivory, 5, 92, 108, 111, 113, 117, 120, 124, 131, 134, 135, 136, 137, 141, 142, 169, 175, 176, 177, 198, 255, 263, 264, 272, 274, 275, 281; trade, 6
Ivory Coast, 34, 48, 97, 152

Jebba Island, 15
jellyfish, 52
Jeriba, 93
jewellery, 5, 15, 54, 56, 58, 59, 60, 63, 94, 97, 108, 114, 123, 125, 134, 135, 137, 141, 142, 164, 191, 197, 225, 228, 238, 241, 275, 280–1
jujus, 4, 105, 210

Kaka people, 213
Kalabari Ijo people, 21, 32, 47–53, 101–3, 245–7, 250, 264, 272
Kalahari desert, 21, 22–3, 33, 69
kanaga masks, 188
Kanem-Bornu empire, 5
Kangaba, 93
Karanga people, 6
Kasai area, 36, 276
Kasai River, 120
Katanga River, 120
Kenya, 53, 145
Kikuyu people, 145
Kindi rite, 176–9
'king things' see regalia
kings and chiefs: as artists, 124, 135–6, 266; and associations, 146, 148, 149–51, 155 222; patronage by, 91, 98, 120, 135, 145, 169, 263, 267; portraits of, 117–20, 123, 127, 131–6, 140–2, 220, 228, 263; status and power of, 118–36, 140–2, 151, 154, 181, 182, 197, 217–18, 275
Kissi (Guinea), 7
knitting, 275
knotting, 274
Kofi Kakari, 96
Komo association, 72, 78–9
konde nail fetish, 211
Kongo (Bakongo) people, 8, 108, 210, 211–12, 230
Kordofan, 281
Kore association, 72, 73, 79–82, 245, 248
Kota figures, 17–18
Kotoko people, 5
Kuba (Bakuba) people, 41, 120–4, 134, 213, 276; Nyimi of, 122; see also Bushoong clan
Kudu, 33
kuduo (brass vessel), 184

Kumasi, 99; stool house, 182, 184
Kumbi, 92, 94
Kung Bushmen, 26, 33
kungang fetishes, 220–2
Kutep people, 276
Kwango River, 120
Kwifo society *see* Night society

land ownership, 118, 125, 152, 157, 170, 171, 173
Lander, Richard, 91–2, 200
law and order, 120, 140, 148–57, 167–8, 170, 195, 245
leather, 56, 69, 70, 193, 215, 266, 273, 274, 279–80
lefern figures, 221
Lega people, 169, 174–80, 184, 237, 240, 263–4, 275
Leon Africanus, 95
leopard, 130, 134, 135, 141, 150, 157, 216, 218, 265, 267, 277
Lesotho, 31, 32
Lévi-Strauss, Claude, 32
Lhote, Henri, 62, 63, 64
Liberia, 152, 153–8, 208, 225, 265–6
Lima, Misquitela, 37–9, 41, 43
lineage systems, 169–82
lion, 42, 81, 85, 208, 236, 237, 277
litters, 119
lizard, 87, 201
Loango, 229
Luba, 120–1, 263
Lulua carvings, 35–6; people, 225
Lunda, 120
Lweji (female ancestor), 36, 40, 41, 43

ma mask, 157
mahan yale (stone figures), 7
maiden spirits, Ibo, 241–2
Mali, 12, 23–4, 64, 69–88, 92, 93, 187–96, 262
Maluti Bushmen, 26
Mamfe, 105
Mande peoples, 193, 225, 280
Mandinka people, 69, 151–2
Mangbetu vessels, 276
mangu (witch's organ), 207
Manjong society, 146–8
Mano people, 153–8
Marghi people, 24, 262
mami wata (river goddess), 48
marriage, 73, 184, 225–40, 241, 250, 282–3
Marshall, Lorna, 33
Masai people, 53, 145, 279
masks and masquerades, 4, 91, 106, 145, 185, 225, 249, 261, 274, 280; Asante, 96, 97,
 120; Bambara, 13, 70, 72–88, 151–2, 245, 248; Bamileke, 106, 126, 135, 136,
 147–51, 157, 216, 218, 221, 249–50, 266, 267, 270–1, 273, 274; Benin, 141;
 Bushman, 25, 27, 29; Bushoong, 120, 122; Dogon, 24, 31, 188–96, 240–1, 272;
 Fang, 17; Fulani, 63–4, 65; Ibo, 103–6, 241–2; Kalabari Ijo, 47–53, 101–3, 245–7,
 250; Lega, 174–80, 184, 237; Poro and Sande, 152–4, 167; Tshokwe, 36, 37, 38,
 41, 214–16, 241, 275; Wobe, 167–9

ART AND SOCIETY IN AFRICA

299

Shaw, Thurstan, 15
sheep, 25, 58, 63, 251, 257
shells, 30, 231; see also cowries
Sherbro Island, 5, 7, 108
Shilluk people, 118, 140
ships, 111
Shona nation, 6
shrine statuettes see Lamba figurines
Siena see Senufo people
Sierra Leone, 4, 7, 92, 152, 153, 225, 275
Sigi ceremony, 190–5, 196
silver, 117, 120, 184, 281
skulls, 127–8, 130, 131, 132–3, 135, 146, 147, 153, 228, 229, 249
slave trade, 48, 92, 93, 101, 111, 124, 137, 180, 227
slaves, 76, 94, 95, 99, 102, 103, 104, 106, 118, 123, 125, 130, 135, 137, 147, 220, 233, 253, 263
snake, 50, 82–3, 130, 135, 163, 191, 192, 194, 195, 216, 236, 237, 282
soapstone, 5–7, 175, 274
social status: and art, 60, 118, 123, 126–36, 171, 175–9, 263, 265–7, 277; and associations, 104, 145, 154, 162–3, 168–9, 175–9, 192, 245, 251, 264; and body decoration, 56, 57, 281; and gold weights, 98; and jewellery, 97; of kings and chiefs, 118–36, 140–2, 151, 154, 181, 182, 197, 217–18, 275; see also caste
Söderberg, Berthold, 37
Somali people, 279
Songe people, 36, 109, 262
Songhai empire and people, 54, 92
sorcerers see witchcraft
spider, 213, 222
steatite see soapstone
stone buildings, 6–7
stone carvings, 5–12, 108, 217–18, 272, 274
stone posts and columns, 7, 217–18, 219
stone sculptures, 4, 7–12
stools, 8–9, 119, 120, 126, 130, 169, 180–4, 274, 280
Sudan, 69, 93–5, 97, 281, 282–3; see also Western Sudan

taboos, 122, 136, 156, 171, 179–80, 181, 184, 193, 194, 200, 238, 252, 253, 254, 256–7, 264
Taghaza, 94
Takum, 276
Talbot, P. A., 242
talismans, 208
Tallensi people, 32
Tanzania, 282
Tasoumatiak, 62
Tassili frescoes, 23, 61–5
tata wa wiyanga (father of the hunt), 38–9
Tauxier, Louis, 79, 81
techniques, artistic, 271–83
tellem figures, 16–17
Temne people, 275
terracottas, 4–5, 13, 15
Thomas, Elizabeth Marshall, 26
thrones, 119, 274

CUMBRIA LIBRARIES

3 8003 03881 1345